T0052637

RAPHAEL

RAPHAEL

A PASSIONATE LIFE

ANTONIO FORCELLINO

TRANSLATED BY LUCINDA BYATT

polity

First published in Italian as *Raffaello: Una vita felice* © 2006, Gius. Laterza & Figli, All rights reserved.
This English edition © Polity Press, 2012
With the support of the Italian Ministry of Foreign Affairs.

Reprinted 2018, 2021, 2022 (twice)

The right of Lucinda Byatt to be identified as translator of this work has been asserted in accordance with Section 77 of the Copyright, Designs and Patents Act 1988

Polity Press
65 Bridge Street
Cambridge CB2 1UR, UK

Polity Press
350 Main Street
Malden, MA 02148, USA

All rights reserved. Except for the quotation of short passages for the purpose of criticism and review, no part of this publication may be reproduced, stored in a retrieval system, or transmitted, in any form or by any means, electronic, mechanical, photocopying, recording or otherwise, without the prior permission of the publisher.

ISBN-13: 978-0-7456-4412-7

A catalogue record for this book is available from the British Library.

Typeset in 10.75 on 14 pt Janson Text
by Servis Filmsetting Ltd, Stockport, Cheshire.
Printed and bound in Great Britain by TJ Books Limited, Padstow, Cornwall

The publisher has used its best endeavours to ensure that the URLs for external websites referred to in this book are correct and active at the time of going to press. However, the publisher has no responsibility for the websites and can make no guarantee that a site will remain live or that the content is or will remain appropriate.

Every effort has been made to trace all copyright holders, but if any have been inadvertently overlooked the publisher will be pleased to include any necessary credits in any subsequent reprint or edition.

For further information on Polity, visit our website: www.politybooks.com

CONTENTS

LIST OF ILLUSTRATIONS

INTRODUCTION

The heart-rending cry of Longinus, the red-cloaked Roman centurion, finally petered out as Christ's body was lowered from the cross. A doleful beat of drums echoed through the arcades of the Colosseum, reverberating under the arches and the dark vaults barely lit by the flickering torches. The crowd spilled slowly onto the levelled area that buried the first circle of the amphitheatre almost up to the impost of the arches, mingling with the cowherds, who were returning to their tents, and with the animals penned into makeshift enclosures. As metal wheels started to creak, angels suspended from wooden scaffolds behind the cross were lowered, as if in miraculous flight, to gather around Christ's body with a united cry of *ecce Agnus Dei*.

At long last Pilate could climb down from his wooden tribune, made from 'four round columns at the front, four in the middle and four behind, with a canopy, cornice and other furnishings'. He laid down the yellow silk standard with its black scorpion device, below which hung a fringe with the letters SPQR. Close by, Caiaphas and Herod took off their brocades and black robes. Judas freed himself from the harness in which, shortly before and to the crowd's general satisfaction, he had hung himself in desperation, off the branch of a fake tree.[1]

The disrobing of Christ was a more complicated affair, since the body had to be concealed, for dramatic reasons and out of decency, by

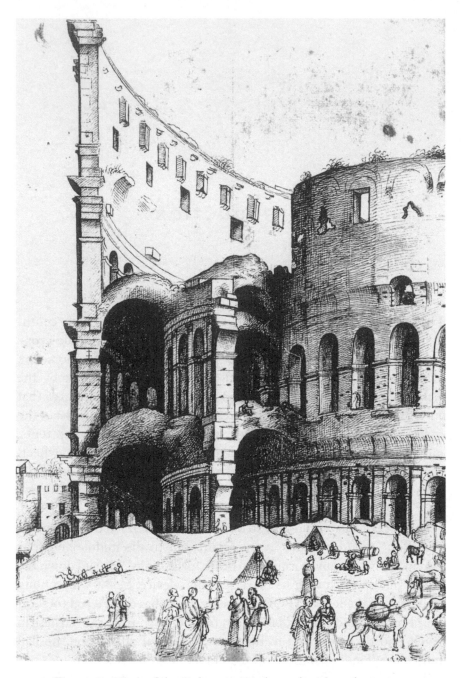

Figure 1 View of the Colosseum in the early sixteenth century.
Codex Escurialensis, fol. 24v

a flesh-coloured suede vest lined with leather and by a white loincloth. The tunics of the Pharisees, the hose worn by the thieves, and the precious pale blue and pink cloaks belonging to the Madonna and Mary Magdalene were carefully folded into baskets, together with the pitch-black wigs and artificial beards. One by one, the actors walked forward to leave their clothes and other props in the baskets, under the watchful eyes of members of the Confraternity of the Gonfalone.

Workmen from the Confraternity started to roll up the backdrops painted with scenes from Bethany and Golgotha and to unstitch the old sacks used to make the fake rocks at the foot of the crosses that had been set into the vaults of the amphitheatre. A volley of sharp blows, whose muted echo carried through the tunnels of travertine stone, accompanied the task of unnailing the wooden and metal scaffolds onto which angels and devils, clouds and starry skies had been hoisted during the performance. Above all, the gilded diadems worn by Christ and his apostles were carefully stored away, in safekeeping for the next mystery play.

One by one, the players made their way to the Confraternity houses, where they would be offered wine and sweet *ciambelle* [doughnut-shaped biscuits]. The others, the men, women and children who had watched the Passion play on Good Friday, 6 April 1520, still had the chance to take part in further acts of devotion in the city, which was now sunk into darkness and mourning. Some headed towards St Peter's basilica, where the most sacred Christian relics were on display that day: the lance used by Longinus to pierce Christ's side, a fragment of the True Cross, and the veil miraculously imprinted with the Holy Face. The dark crowd thronged past a wealthy palace almost overlooking the square – one of those palaces built by the fashionable new architects so admired by foreign visitors. That evening, inside the palace, there was a more immediate cause for mourning than the symbolic events being celebrated throughout Christendom.

The palace had a high *bugnato* [ashlaring] basement and a *piano nobile* ['noble level' on main floor in a Renaissance house] with double columns that separated windows surmounted by projecting tympani. Both the *bugnato* and the columns looked like real stone, although they were in fact stucco. All day long, people from all walks of life had entered and left the building – a miniature version of a royal palace – with a growing

sense of despair. The emissaries of the pope were seen hurrying discon-
solately to and fro, while the pope was himself engaged in an exhausting
round of liturgical functions but no less fully aware, for that matter, of
what was happening in the palace: this building was right below the
Vatican, an ideal extension of the papal court and its apartments. That
morning, like every Good Friday, the pope had kissed the cross in the
Sistine Chapel. Kneeling barefooted, he had waited for the celebrant
Leonardo Grosso della Rovere, Cardinal Aginense, who was dressed in
black from head to toe, to unveil the relic on the chapel altar by slowly
pulling away the dark veil. In keeping with the occasion, the altar was
completely bare of all paraments.* As soon as he could, he had sent a
servant to the palace outside to enquire about the state of health of its
tenant, a handsome man in his prime, much loved by all, who for days
had been racked by fever.

Into the room where the man was being cared for by a group of
youths, a large painting had been carried that seemed to reflect their
despair. In the lower part of the picture the life-size apostles gazed,
terror-struck, at a boy whose face was deformed by a demon that
had possessed him. Standing on the mythical Mount Tabor above
their heads, Christ, clad in a dazzling white tunic, hovered in the air
between Moses and Elijah. The agitated gesticulations of the apostles
depicted in that *Transfiguration*, whose drama was emphasised by pierc-
ing shafts of light, became even more desperate in the real-life figures
crowding the room when the man on the bed closed his eyes for ever.
Three hours after sunset, while the Confraternity of the Gonfalone
was still dismantling the scenery used to represent Christ's Passion at
the Colosseum and while thousands of citizens swarmed throughout
the city, specially darkened as it was for the Good Friday celebrations,
Raphael Sanzio of Urbino, painter and architect, died in one of Rome's
most elegant palaces.

Pope Leo X was immediately informed, in the time taken by his
chamberlain to run the few metres from Palazzo Caprini to St Peter's.
He was immensely saddened, as was the entire court. News of Raphael's
death spread throughout the city and then throughout Italy; it was pro-
claimed the death of a great prince, a leading courtier and a superb

* Technically, embroidered hangings for the altar. (Translator's note)

artist, three identities that the young man from Urbino had come to take on in the space of a few years, and his passing was deeply mourned by all the Italian courts. Such a treatment would have been unheard of for a real prince, a pope or a cardinal.

Raphael's pupils kept vigil over his body inside the palace in the Borgo. They were his family, even to the extent that they stood to inherit a good portion of his possessions. Raphael died so young that he had not had the time to create his own real family, but this is not to say that he did not enjoy passionate love affairs. Those closest to him were in little doubt that his death could be attributed to the excess of ardour bestowed on such intimate relations during the days leading up to 6 April. In Rome, and in Italy in general at that time, it was thought that overexertion through love would lead to certain death. But what Raphael was immediately blamed for was the excessive discretion that prevented him from telling the doctor summoned to his bedside about the exhausting lovemaking in the days prior to his illness.

As the news spread to the chanceries of every Italian court, Pandolfo Pico, Isabella d'Este's ambassador in Rome, neatly summed up the sense of grief that had fallen over the city: 'You will not hear talk about anything except the death of Raphael of Urbino, who died last night, the night of Good Friday, leaving this court in a profound and universal state of sadness due to the fact that the great achievements that were expected of him will now not come about.'[2] This sentiment was so strong that the simple fact that Raphael had died on his birthday (he was born on Good Friday 1483) alone seemed to suggest an unnatural event. Other signs were reported that were also seen as being supernatural, like the crack that appeared in the walls of the Vatican Palace, forcing the pope to leave his apartments.

The expectations, so clearly described by Pandolfo Pico, immediately give a glimpse of the unique position Raphael had held at the Roman court and in society at the time. Raphael was more than just the painter, the architect, and the stage designer who had created images of disturbing beauty. He had also acted as the interpreter of a very particular world, the dream of a golden rebirth to be brought about through literary studies and painting, and in this sense he had played an essential part in convincing the intellectuals of his time of the harmony, culture, and intellectual and sensual equilibrium that Rome attained during the

years in which he had dominated the artistic scene. Without him, and without his ability to give credibility to the ideals of renewed antique greatness, those ideals would have been stunted.

It was left to history to clear the stage in the following months and years, as the other great protagonists of that epoch vanished one by one: Agostino Chigi, the world's richest banker, died a few days after his friend, and so did, not long after, Leo X, the Medici pope who had turned the papal curia into Europe's most elegant court, alternating the magnificence of its liturgies with the banquets and hunts for which he is now remembered. The Sack of Rome in 1527 and the advent of the Protestant Reformation did the rest, erasing all trace of the theatrical miracle – albeit no less convincing for all that – that was Rome in the time of Raphael and Leo X. No other age would ever come anywhere near to the profound sense of freedom and sensuality of those years. What was more, the art of Raphael immediately began to lose its revolutionary overtones and profoundly intellectual roots, and instead was transformed into a rigid etiquette of formal perfection.

At varying intervals, Raphael and his painting would be seen as the expression of a perfect balance reached through form, something that was impossible to achieve except through an inner harmony closely resembling the state of 'grace' granted by faith, and this would lead to the imitation and veneration of his style. But it would also result in a complete lack of critical acclaim, above all in modern times. Owning a painting by Raphael meant turning your home into a 'place of worship', as one rich English noblewoman observed in pre-industrial Europe. However, as the industrial world developed, along with its contradictions and troubles and its conscious and unconscious contrasts, European artists in the nineteenth century were prompted to search for spirituality and purity, an alleged state of archaic simplicity in which art alone was expected to counter the complexity of a rapidly changing world, but in practice it merely ignored it. It was considered regrettable that the simplicity of Renaissance art had been lost, and the blame for this was laid squarely on Raphael, whose sensuality and seduction were deemed to have corrupted those moral values, when in fact they had been trampled by the burgeoning capitalism. For many years, Raphael became the enemy, and artists all over Europe increasingly turned to the art that had preceded him for their inspiration. Or, failing

that, if they could not erase him from the mythical devotion in which he was held by the general public, they looked to his early Umbrian and Florentine period, when he still seemed to express the spiritual integrity of the medieval world.

The Roman period, that liberating dream that even the artist had thrown himself wholeheartedly into, was too far removed from the tenor of European societies, with their dual burden of religious and social rigour, to be appreciated. Later, when avant-garde artists set out to shatter the myth of lost simplicity once and for all, it was the legend of Raphael's easy mastery and his calibrated style that aroused suspicion. This was argued with particular cogency by André Chastel a few years ago, when he commented on the sarcastic opinion on Raphael expressed by a leading twentieth-century intellectual, André Malraux: '[Raphael's] work bores me, but behind it there is this singular vision of the reconciled man.'[3] By the twentieth century, three centuries of imitation by art school students had taken the edge off Raphael's art. Nor was he redeemed by Leonardo's eccentricity or Michelangelo's tormented personality, traits that exalted these artists and made them more interesting to our restless, modern sensitivity.

Raphael's critical downfall is perhaps the most bitter outcome of a history of art that, over the past two centuries, has isolated his work from its patrons and contexts, viewing it as a discrete universe, to be enjoyed and judged solely through stylistic analysis. As if images could be anything but the expression of human passion. Those perfect images created by Raphael were isolated and enjoyed with an intellectual detachment that separated them from the man, and they were then handed down through history as finished models, providing a repertoire of behaviour and psychological expressions captured by the exquisite draughtsmanship that had generated them.

Anyone who ponders over his work immediately understands how Raphael the man has remained in the shadow, as *sfumato* in appearance as some of his own figures; almost as if, during his short life, he did not live up to the definitive perfection achieved by his painting. As a result, no biography of the artist has ever questioned seriously the legend handed down to posterity by Giorgio Vasari. Yet, even during the earlier part of his life, a close study immediately reveals awkward details, like his unrestrained sensuality, his free and passionate

eroticism, and his huge ambition, which was already evident during his adolescence and was fatally fulfilled by his prodigious career. These are all embarrassing traits for those idealist critics who, during the twentieth century, tried to assert that art was, or rather ought to be, the expression of high-flying sentiments such as religiosity or spirituality, understood as a philosophical inquiry of the human soul.

Even the latest generation of art historians, those who have offered a synthesis of current research to mark the fifth centenary of the artist's birth, has been at pains to show that Raphael's eros was nothing but the expression of a spiritual quest through which the artist and the man aimed to reach divine grace and knowledge of the spirit. This enforced 'spiritualization' of Raphael reached a climax in the work of the greatest contemporary Raphael scholar and connoisseur, Konrad Oberhuber, who was deeply imbued with Steinerian thought and interpreted the artist's life and work in the light of the soul's progressive development on its journey towards God. Thus the paucity of biographical documents offered an ideal opportunity to create thick filters of interpretation and prejudice and to apply lenses that, he alleged, brought the artist's life and work correctly into focus.

Over the past few years these prejudices have faded after the discovery of new documents relating to the artist and his milieu that made it necessary to change the parameters used to study Raphael. A detailed study of his father Giovanni Santi, both as a man and as an artist, has necessarily resulted in a revision of the Vasarian legend that was, until recently, accepted by the critics, although it is not based on any confirmed documentary source. Indeed Vasari identified Raphael as one of Perugino's pupils purely on stylistic grounds, instead of unravelling a much more complex filiation. Yet Raphael's training under such an extraordinary paternal figure allows the artist's later development to be seen in a different light. To this should also be added the highly sophisticated research that has been carried out on Raphael's artistic technique, and a reconstruction of his life reveals the exceptional importance of this aspect and helps to clarify the key stages of his apprenticeship and early activity – that obscure phase that affects our understanding of the adult man.

But, above all, it is by taking a lay approach to the history of the Renaissance and to art history that we shall have the greatest surprises

when the artist's biography is seen afresh. This kind of approach no longer sees spiritual or philosophical motivation as the necessary condition for creativity and perfection, but limits itself to acknowledging the powerful force of a passionate, unrestrained eros and of a fully gratified life as the roots that nourished the creativity of one of the greatest artists of all time. These are paradoxical results, which overturn all established notions. During the course of the past century there grew up, around art, a legend of torment and despair out of which artistic creation emerges with all its sublimating force. When viewed without prejudice, Raphael's life mercilessly dispels any trace of this romantic myth and, on the contrary, confirms that complete happiness and the gratification of the most basic impulses can lead to the highest creative achievements. These findings were censured by the bourgeois morality of the modern era, which instead focused on the search for spirituality, of which there is not a trace in the artist's life; although it has to be said that, owing to his sensitivity and unparalleled professional self-assurance, he could produce works that others used for their own devotion and spirituality. Of course, he also created works that are pure expressions of his free and positive eros.

In this way, it is paradoxical that precisely the artist who, lacking torment and anguish, appeared to have been discarded by modern society becomes, on the contrary, the strongest and most transgressive expression of modernity because he focuses our attention on the results of a life that overcomes all conflict, reconciles all cultural, social and erotic tension, and reveals a natural grace without necessarily presupposing divine inspiration, entirely thanks to the happiness resulting from his own sensual gratification. Moreover, this occurred within a short-lived period of Western history, the Roman Renaissance, when the turbulent contrasts between spirit and religion and between the individual and society were miraculously suspended and freed from ideological constraints. It was a period that, from this point of view, appears to have been much freer than our own.

1

GIOVANNI'S SON

1 A WELL-TO-DO HOUSEHOLD

The house bought by Raphael's grandfather, Sante di Peruzzolo, in 1463 on the steep street beside the beautiful church of San Francesco in Urbino is still there. It has not changed at all. The main room measures 12 paces along one wall and 10 along the other, because one of the short walls is oblique. The fourth and last ceiling beam meets the underlying wall at an acute angle, although this is partly offset by the coffered ceiling, in an attempt to disguise the unusual angle that makes the room look asymmetrical. One enters through a door off the landing, which is as wide as the stone stair leading down to the entrance hall. The landing also has doors into the kitchen and into the pantry, which in turn leads down to a small enclosed courtyard containing a well.

As you walk into the main room, the longest wall facing you has two wide windows overlooking the steep street. In one direction, the street leads 'to the hill' – that is, it winds to the top of the hill on which Urbino stands – while in the other it is only a short walk to the ducal palace. It was a busy, wide street, with room for two carts to pass side by side. However, this was the best area of the city and it was well ventilated, because all the houses were the same height and did not block the light from their neighbours.

On that particular day the women hurried to and from the kitchen, carrying hot water from the large fire that burnt steadily in the fireplace; they were careful not to spill it on the yellow and red floor tiles laid in diagonal lines inside a narrow frame, which ran round the walls and tried to accommodate the irregular outline of the room as best it could, in the corner along the oblique wall. As the hours passed, the screams grew louder. Growing increasingly agitated, the women glanced out furtively, now and then, at the busy street before entering the bedroom with its vaulted ceiling, piles of clean white linen and various basins constantly topped up with hot water. Lying on the bed in the throws of labour was Magia di Battista Ciarla. The twelve lunettes framed by carved stone pedestals that supported the vault seemed to absorb her cries, while the coffered ceiling in the main room amplified them, like the soundbox of a mandola.

The noise from the master's workshop drifted across the landing that led to the kitchen. It was below the house, but on the other side of the courtyard, and it opened onto the street through wide sills and windows, to let in as much light as possible. As the day wore on, the cries that could be heard in the workshop became ever more piercing, passing down the stairs, whose steps in Cesana stone had grown smooth with wear.

What did Giovanni do as he listened to the screams? Did he pace up and down the workshop, fiddling with this and that, because he could not keep his hands still? Did he move from one room to another, down the steps that kept the floor level with the steep incline of the street? Perhaps he picked up a brush and tested it for softness by stroking the blond bristles against the back of his hand; or maybe he lifted the leather cover on top of the glass jars filled with coloured pigment, holding his breath, so that it would not blow the pigments away. Then, shaking the jars gently, he would put them back, lining them up neatly on the shelf, in order of colour and value. First the *bianco di San Giovanni*, a white pigment produced by crushing calcium carbonate that had been dried after being washed for eight days in spring water. Then three varieties of the *terra di Siena*: umber, natural and burnt – all extracted from the hills around the Ghibelline city. Next in line came sinoper, the blood-red ochre from Sinop on the Black Sea, used to sketch drawings on walls and panels. Then the

brilliant blue made from crushed enamel and the mossy green of
verdigris, obtained by grating a copper plate immersed for days in a
newborn baby's urine – there, in the large backshop, with its gallery
and narrow spiral stone staircase.

Giovanni shook the jar containing cinnabar, which was made by
melting sulphur and mercury in a glass ampoule, and he watched
admiringly as the red powder undulated like a desert in a storm. It was
perfect, completely uniform, as red as linen dyed in blood. Then his
eyes turned to the yellow orpiment, arsenic sulfide, as beautiful as gold
but as poisonous as a viper's bite. Cennino Cennini's warning came to
mind: 'Take care not to wipe it on your mouth, so you don't come to
harm.'[1]

Kermes – a bright geranium-coloured liquid produced by squash-
ing insects in India, the home of elephants – stood out clearly in its
transparent glass bottle. It was worth a fortune, but not quite as much
as the precious ultramarine blue obtained by crushing lapis lazuli from
far-off lands, beyond the known seas. As the most expensive pigment,
it was almost always bought directly by patrons themselves, as was
gold leaf. But no Madonna's mantle, no sky could be described as
luminous if it lacked the oriental gem that reflected the profundity of
the spirit.

Some collaborator was carefully painting the background of a panel
or a saint's clothing. With a steadier hand, the apprentices filtered the
linseed oil that Giovanni would then mix into the colours, to form
brilliant pastes. The oil had to be absolute clear and free from impuri-
ties: for this reason it was poured repeatedly out of small glass bottles
and filtered through a series of cotton gauzes with increasingly fine
meshes. By then none of the painters in Urbino used the matt tempera
paints that had embellished church altars for centuries. Ever since the
Netherlandish paintings had arrived, with their fleshy fruits and dew-
soaked flowers lying at the feet of the Madonna, everyone wanted these
paintings, which seemed to burst open the walls onto dream-like para-
dises. In Duke Federico's *studiolo*, only a stone's throw from Giovanni's
workshop, there had been an explosion of colours never before seen
in Italy: deep ruby red lacquers for Cicero's robe; an acid green cloak
with iridescent yellow reflections for Boethius' jacket; the ultramarine
blue of Saint Gregory's cloak, which looked like enamel painted on a

sheet of silver. Even the whites were different, and dazzled as brightly as snow. Pius II seemed to be bathed in the blinding light of his white undergown, which stood out against the other colours. But, above all, it was the flesh-coloured pigments used by Justus of Ghent and Pedro Berruguete – so carefully shaded that you could not tell where the edge of a shadow began – that had really astonished the Italian painters. They were exemplified by Homer's vacant gaze, or by the calm beauty of a young King Solomon dressed in pearls.

A touchstone had been firmly planted in the duke's *studiolo* from which there was no escaping. Giovanni and his assistants, as well as other painters, above all from Venice, were the first to experiment with the new painting technique. Until they could dispense completely with the old tempera technique, they strove to blend it with oil or to finish it with an oil glaze that gave the panel the brilliance of enamel.

Outside, it was the sort of day that lent itself to contemplation. This was the best time of year for painters in the Marches. One only had to leave the house and walk a short distance, towards the narrow alley that ran headlong down into the fields below, to see that spring was nearing its peak, heralded by the pungent scent of apple and almond blossom drifting over the yellow orchard walls. The new season was triumphant, colouring the meadows a watery green and lightening the skies until they seemed as limpid as glass straight from Venice. All one had to do was sketch the silhouettes of dark palm fronds against it to conjure up Egypt, where poor Joseph had fled with Mary and the Child held in her arms. When the clouds, ragged and edged in white, were blown up from the coast by the cold east wind – the icy Auster that crossed the Adriatic still carrying the snows of Russia on its breath – the sky immediately acquired a moving quality, which was perfect for a crucifixion or a solemn court portrait, or even for wealthy merchants. Painters would remember such skies and these spring landscapes for the rest of the year.

But today there had been no time for painting outdoors. The sun had now set after casting a last triumphant flash of golden light onto the cornice of the building opposite. The workshop and the city, spread over the hillside, fell into shadow. When dusk had softened the contrasts created by the setting sun, the air filled with a stream of flickering flames atop of bronze rods carried by a procession of hooded white

figures. Bloody stains were starting to appear on their white robes from the wounds left by the crowns of thorns and by the whips with which the men had lashed themselves since dawn.

Growing brighter by the minute, the flames gathered in the main road leading to the cathedral. There they formed two stationary lines, hanging in the air in such tight array that they appeared to form a single river of light streaming up the steep street, right in front of Giovanni's workshop, just a short distance from the old church of San Francesco, whose bell tower was embroidered with bricks like a piece of Brussels lace. It was dark by the time the main door of the church opened, to reveal aisles that gleamed red in the light of thousands of candles, and a golden catafalque in which Christ's martyred body was watched over by Our Lady dressed in black. Not a sound could be heard in the pitch black city: even the air hung motionless, holding its spring-like breath. Then, in an unexpected explosion of yearning, the sung lament and drum music burst forth. Every year, for centuries, this was how the Good Friday procession began.[2]

The date was 28 March 1483, but the anxiety that filled the mind of Giovanni Santi, painter and *letterato* at the Court of Urbino, had nothing to do with the anguish that brought Christians all over Europe together in memory of the Saviour's sacrifice. Giovanni's worries were focused on the long-awaited and heartily desired birth of his second child, and the wait had distracted him from the solemn, cruel rituals with which Urbino celebrated Christ's passion and death. The obsessive beat of wooden hammers, on boards carried by monks and youths on their shoulders through the alleys and streets until dawn, failed to excite him; and so did the tales of massacres perpetrated by the Turks against the Christian knights on Rhodes. Nor was he moved by the news that the Madonna of Bibbona had changed colour, from blue to red and then to black – an event that had attracted flocks of pilgrims but had also aroused the curiosity of painters, who inevitably wondered whether a new mixture of pigments might have caused such iridescent effects during the course of the day. Instead Giovanni was thinking of the son who was eventually born three hours after sunset, when the altars were already draped with purple cloths. He called him Raffaello Sanzio, but the world would know him simply as Raphael of Urbino, the 'divine' painter.

2 A SOPHISTICATED COURT

The house where Raphael was born was only a short walk from the palace built for Duke Federico da Montefeltro by the Dalmatian architect Luciano Laurana. At the time it was the most modern palace in Italy, with towers, perfectly round arches and courtyards surrounded by slender columns of white stone. Lorenzo the Magnificent himself had asked for a survey, and the duke of Mantua had even requested specifications and detailed information on the system of chimney flues, the best ever built. But no one could have imitated the light that flooded the palace from the numerous courtyards built on different levels, or the way it enhanced the relief carvings made using soft stone quarried in the nearby hills of Cesana: an ivory-coloured material that could be polished to resemble alabaster.

Perched on the hill, the palace had transformed the entire city of Urbino into a court. This small city, whose economy was not worth a fraction of that generated by many other Italian centres of industry and banking, instead boasted the *virtù* [prowess or manly virtues] and riches of its ruler Federico da Montefeltro, whose standing was unrivalled throughout the peninsula. Hardly a picture of beauty even before he received the scars, he bore with such pride the disfiguring wounds on his face that they became a symbol of dignity comparable to glorious war medals. His career as a *condottiere* [military commander] had earned him not only those wounds, but also a vast fortune, which he had invested in a huge palace and fortress. It exuded both strength and gentility, immediately revealing the virtuous origins of his power and wealth and setting him apart from the brute force of tyrants and the vulgarity of the newly enriched bankers.

With its spacious courtyards enclosed by arches and columns, the palace reflected the precepts of ancient architecture and conjured up its beauty while still searching for the rules and laws of classical architecture and the strict canons – the very rules that, within the space of a few years, the child who had just been born in the shadow of its walls would ascertain by measuring Rome's classical ruins. The palace was filled with fashionable paintings executed by leading artists of the period, with windows embellished by marble surrounds, and with carved fireplaces covered in gold leaf. But, for all this, it remained an

austere building: the residence of an enlightened warrior who was so
mindful of the eternal value of culture that he invested huge sums in
order to assemble the richest library in Italy – one that contained rows
of Greek, Latin and Hebrew manuscripts – within these gilded towers.
When Elisabetta Gonzaga arrived at the palace to marry Federico's
son, Guidobaldo, the comments made by members of the sophisticated
Mantuan court were more than just admiring in tone:

> I will not write of the beauty and ornamentation of this palace because
> it is hard to express even in speech: I will limit myself to describing
> the decoration of the main hall. As you enter, on the right is the main
> sideboard with its silverware, which is very plentiful. On the other side
> is the tribunal, draped with crimson velvet and a number of lengths of
> golden cloth. Lengths of crimson and green velvet are hung on one
> side of the room, from the capitals to the benches, and they are divided
> into squares by painted wooden columns. This is the side where the
> women sit. On the other, there are *baltresche* [tiered platforms] with
> steps, where the men stand to watch, and here there are also lengths of
> green and Alexandrian velvet stretched between the columns, as on the
> other side. The body of the hall is clear for dancing. At the end of the
> sideboard is a pit where the wind players and the women who are not
> dancing gather, and from the capitals up to the ceiling there are frescos
> of classical festivities.[3]

But Federico was not concerned merely with dances and the value of
his silverware. Above all, he wanted to gather a refined court around
himself, made up of gentlemen, intellectuals and artists: a court that
is described in minute detail in the poem *Cronaca rimata*, written by
the same Giovanni Santi who awaited the birth of his son with such
trepidation on Good Friday 1483. It was he who described Federico's
palace as a building that was 'not human, but divine'; and, again, he
who recounted the valour and elegance of the court in rhyme, leaving a
testimonial that is still the most vivid portrayal of life in Urbino under
the Montefeltro rulers.

This passion for painting, Giovanni's main professional activity,
transpires from the lucidity with which he assesses the best artists of
his time, both those whom he knew directly and those whom he knew

through their works and through the reputation that accompanied them. His carefully weighed opinions are those of an accomplished connoisseur, and they predate the much more superficial judgements passed 60 years later by Vasari on the same artists – who, by then, had been sanctioned both by the market and by the critics. Sure of his own taste, Giovanni anticipated Vasari's work in his refined verses and spoke of those artists 'Whose splendid and gentle art / Has made them so famous in our century, / That every other artist appears worthless.' He mentions Masaccio, Filippino Lippi, Andrea del Castagno, Sandro Botticelli and Leonardo da Vinci. But, unlike the Florentines, he shows that he is aware of the more advanced studies undertaken by artists working well outside the universe centred on the Tuscan capital, like Piero della Francesca, Melozzo da Forlì, Cosimo Tura, Perugino, and Antonello da Messina, and even as far afield as the Dutch painters Rogier van der Weyden and Jan van Eyck – both of whom were very well known in Urbino – and the Venetian artists Gentile and Giovanni Bellini. Giovanni's knowledge was up to date and sophisticated, as is borne out by his choice of Andrea Mantegna as the model of a truly excellent painter.

A man who could appraise the work of his contemporaries with such critical perspicacity was undoubtedly also a man who would offer his own son the best training and the most advantageous starting point for a career that would prove to be meteoric, above all thanks to the nature of this debut. But Giovanni Santi's knowledge extended far beyond an extraordinarily critical sensitivity to painting. It overstepped the limits of the professional requirements of an artisan painter in the fifteenth century. He was a learned man, one who followed developments in arts and philosophy, and – a particularly important fact – also in contemporary pedagogy. His *signore*, Duke Federico, had been educated by Vittorino da Feltre, the most modern of the Italian educators, one committed to rediscovering the pedagogical rules of antiquity, but above all to following nature in order to create a harmonious situation that would allow children to learn and develop to the best of their abilities.

Vittorino prescribed simple foods and the benefits of physical exercise, play and amusement, to the point that his house in Mantua – where Federico da Montefeltro himself studied – was nicknamed 'The Joyous House'. In an age when childhood was virtually invisible, this

way of drawing attention to children came as something of a surprise. But, to the good fortune of Raphael and many other children, Vittorino had pulled off a feat verging on the miraculous, and by doing so had earned the political gratitude of the Gonzaga court, thereby spreading his fame throughout Italy: he had succeeded in making Ludovico Gonzaga drastically lose weight instead of dying well before his time as a result of the manifest obesity caused by his mother's anxiety and his tutor's weakness. With good reason, therefore, Vittorino's natural methods found many willing followers at the courts of northern Italy, and in particular at the court of Urbino. Duke Federico even immortalised Vittorino by including him in a painting by Justus of Ghent, in the *studiolo* in the ducal palace.

One consequence of this attention to natural processes in education was, among others, that mothers should be encouraged to breastfeed their own children. In a move against current custom, which dictated that newborn babies should be given to wet nurses, Giovanni insisted that his wife Magia should feed baby Raphael herself. This welcoming maternal breast was undoubtedly one of the factors that helped the future artist to capture and reinstate a generous and joyful femininity in his work, which other, less fortunate painters had not had the chance to know.

Judging from the results, Raphael's mother was very happy with this choice. We know very little about her, because fifteenth-century women rarely feature in contemporary biographies. However, from the size of her dowry, we know that her family was well off and that she kept a splendid wardrobe. This said, if she had been anything less than well to do, she would not have been accepted in a house that, still today, reveals the high-class standing of Giovanni Santi's family, a status that could certainly not be taken for granted for a painter at the time. As well as the dowry, in the will he drew up on 27 July 1494 Giovanni also mentions his wife's material possessions: a *gamurra* made of London cloth, with sleeves in crimson satin, and another, with purple satin sleeves and *fulcimenti* [props], as well as coifs, veils and four gold rings embellished with precious gems.[4]

Magia would certainly not have looked out of place at the court of Urbino, and her elegance complemented her husband's reputation as an intellectual – he was not only an artist, but also a stage designer, a

poet and a master of ceremonies. The *gamurra* was a sleeveless robe that remained highly fashionable throughout fifteenth-century Italy. It was worn by Battista Sforza, Federico's wife, in the official portrait painted by Piero della Francesca. Like Raphael's mother, she also combined the black cloth dress with sleeves in damask velvet; however, the ones Magia kept in her wardrobe, made by dyeing sateen velvet, probably could not match the value of Battista's sleeves, decorated as they were with large leaves embroidered in gold thread. But the red and black worn by Magia on grand occasions indicated her high social status, since the sumptuary laws in all Italian cities reserved these colours, symbols of the utmost elegance, for the most sophisticated figures at court; these were, nonetheless, banned from using fabrics containing gold thread, which were exclusively reserved for prelates and the nobility.

Magia must also have been beautiful and well loved, judging from the care with which Giovanni made arrangements for her funeral in October 1491: he paid the church of San Francesco, which was right opposite the house, 14 pounds of wax, eight more than he had paid to commemorate his own mother. Their married life in the house in Via Santa Margherita, which they bought from Giovanni's father in 1463 for 240 ducats, must have been very pleasant.[5] Giovanni was certainly one of the leading figures at Urbino's elegant and refined court. He was chosen to write and stage the most important comedy at the marriage of Federico's son, Guidobaldo, to Elisabetta Gonzaga. He was also commissioned to paint the portraits of Elisabetta and other courtiers. His role was glossed over by Vasari, who intentionally overlooked the figure of the father in order to highlight the unique nature of the son's achievements. And, in order not to belie the Vasarian myth, for centuries critics preferred to look the other way, towards hypothetical masters like Perugino or Pinturicchio. But the documents that have been increasingly assembled back Giovanni and allow us to see his teaching and the fortunate combination he provided, as master, tutor and most loving protector, as the basis for his son's success.

3 HOME AND WORKSHOP

As well as being involved in the preparation of festivities and stage settings for the court at Urbino, Giovanni was busy running one of the

city's most famous artists' workshops [*botteghe*]. Moreover, like every other major artist in Italy, he had to deal with problems concerning the transformation of the profession in response to rapid changes in Italy's social and business structure.

The arrival of a new group of wealthy middle-class families on the social scene had shattered the mystical and spiritual lens through which medieval society had viewed the world. Nature, in all its tangible and complex reality, was now the goal to be attained. For centuries painters had used a rigid vocabulary, whose colours and gestures were permeated by the religious devotion shared by all, laity and clergy alike. The blue mantle of the Virgin Mother, the golden yellow cloak worn by Joseph and Christ's red garments were immediately recognised as symbolic attributes of purity, royalty and passion, and these colours were reproduced in identical hues in every workshop and in every painting. For patrons, it was more important that a painting should be intelligible than that it should be unique, and there was no need – as yet – for a technical and aesthetic appraisal of a work that was not based on religious efficacy.

Based on tradition and developed over the course of centuries, the technique that evolved had now reached the peak of its perfection. The problem was that few found the results satisfactory. For several decades, changes had transformed the function of artists' workshops, as well as the methods used. From being a decorative activity used for purely religious purposes, painting was now called upon to meet the requests of rich patrons, the elite and merchant classes who were starting to draw on a wider range of subject-matters, far removed from the religious tradition. The humanists had rediscovered antiquity, along with its myths and fables, and while the *letterati* were translating and annotating the classical texts, painters were asked to portray them, coming into contact with the vast figurative heritage that had survived largely in the form of statues and relief sculpture on Roman monuments. For centuries, painters had reproduced the same images using the same techniques; now, their aim was to imitate nature, its complexity and governing laws, and to recreate that harmony that all could sense through the study of proportion and perspective.

In response to the new demand for realism, the Flemish merchants had spurred on a natural mimicry that used the transparency of oil to

imitate the depth and nuances of bodies in the light. In Italy, realism had moved in another direction by perfecting the strict control of space in art using a geometrical and mathematical system: linear perspective. It was this that gave the Florentines an unsurpassable advantage, above all in depicting interiors. These two trends met in around 1470 in north-east Italy, and more precisely in Urbino. It was here that, attracted by the refinement of Federico da Montefeltro's court, the leading exponents of Italian and Flemish art had gathered. On the one hand, Piero della Francesca in person, bringing the clarity of his drawing and his perspective views of architecture; on the other, the arrival of works by Rogier van der Weyden and Jan van Eyck, with their soft shading achieved through the use of oil.

Giovanni Santi had not missed the opportunity to absorb from such first-rate painters anything that would help him professionally. In 1469, when he was about twenty-five (his exact date of birth is unknown, but it was probably between 1440 and 1445), the Confraternity of Corpus Domini had summoned Piero della Francesca to Urbino to paint the altarpiece depicting *The Communion of the Apostles*, which was later given instead to Justus of Ghent, another excellent Flemish painter. Giovanni was commissioned by the Confraternity to help Piero with his work and to provide what might now be called logistical assistance, namely to prepare materials for him in the workshop and to get them ready for painting. This opportunity proved extraordinarily important for Giovanni who was able to spend time with the great master from Borgo San Sepolcro and learn the essential techniques of his art, which Giovanni then used to clear advantage in the Gradara altarpiece commissioned by Domenico de' Domenici, prior of the parish church.

At a single stroke, the methods that had been used for the past ten centuries to depict the solemnity of religious images were no longer deemed sufficient to portray nature, which the humanists placed at the centre of all their studies. The technique of using tempera, mixing ground pigments with a sticky binding agent almost always in the form of egg yolk or egg white, had been perfected in the Middle Ages. On Mount Athos, where tempera painting has been used uninterruptedly to the present day and still continues to produce its devout miracles, the procedures that Giovanni certainly used in his workshop beside the Montefeltro palace can be traced in minute detail. These procedures

had been handed down to posterity in the zealous precepts of *Il libro dell'arte*, written by Cennino Cennini, a modest painter and pupil of one of Giotto's pupils, who could therefore boast the best artisan tradition in all painting-related matters.

The yolk was separated from the white and rinsed before being placed in a glass ampoule, to which a few drops of vinegar were added, to make it more fluid and less perishable. The ground was laboriously prepared on a canvas glued on to well-seasoned wood panels that had been nailed together. Layers of gesso mixed with protein glue (made from glove leather, rabbit cartilage, scraps of parchment, or fishbones) were repeatedly applied and skimmed in order to produce an increasingly smooth surface. A perfectly even surface was essential to the successful outcome of the tempera painting. Our knowledge of this process has been lost for years, due to the changed conditions in which old tempera paintings have survived. At Saint Paul's monastery on Mount Athos, Father Gregoriou still tells his painter monks that, in tempera painting, excellence can only be achieved when the ground is as smooth as an egg shell: not only to absorb the fine pigment to the point of complete saturation, but also to reflect perfectly the spiritual light, which is the primary component of a religious painting.

When the ground was ready, smooth and compact, the preparatory drawing was traced from a drawing or cartoon, after its outlines were pricked to allow the charcoal dust to pass through the pinpoint holes when a pouncing bag was pressed against the paper. Alternatively, the outline of the drawing could be lightly pricked, with a pointed metal instrument, onto the layer of plaster and glue. An *imprimatura* or primer coat of clear liquid substance served to reduce the absorbency of the ground when oil paints were also used for the background.

The actual process of painting began at that point, by mixing the pigments with the egg tempera. Small amounts of pigment were blended to a paste by using drops of tempera and were then mixed with a brush, before being applied as a transparent background. In order to obtain an even background, several coats of the same colour had to be applied, and one had to wait for each layer to dry in turn. The colour was prepared afresh on each occasion and, to avoid any mismatches in tone, it was generally preferred not to mix the powders too much. This accounts for the simplicity of the tones used in tempera paintings

and for the lack of gaudy and vibrant colours. The lack of vibrancy is mainly caused by this technique of applying successive coats and of not allowing the tempera to blend when applied.

When painting a face, a uniform background of green and black (Cennini's *verdaccio*) was first applied; then a *colore di mezzo* [middle colour] was prepared by using white and ochre, with a hint of red, and it was 'divided', namely white was added to the highlighted parts and ochre and black to the shaded areas:

> Take a little verditer [*sc.* light-blue pigment] with a little well-tempered white; paint two even layers on the face, the hands, the feet, and any naked flesh. But for youths with fresh complexions, mix the couch, and the flesh colors too, with yolk of a town hen's egg, because those are whiter yolks than the ones which country or farm hens produce; those are good, because of their redness, for tempering flesh colors for aged and swarthy persons. And whereas on a wall you make your pinks with cinabrese, bear in mind that on panel they should be made with vermilion. [. . .] Just exactly as you work and paint on a wall, in just that same method, make three values of flesh color, each lighter than the other; laying each flesh color in its place on the areas of the face.[6]

Painting followed this extremely rigid process, which helped to turn the image into a rigorously closed system, although one perfectly intelligible to viewers. Lastly, in order to produce that brilliant glazed effect, the layers of colours were repeated, after lengthy intervals and in exactly the same shade, using the finest miniver brushes. This prevented large quantities of colour from forming lumps that would spoil the smooth, glossy surface. Egg yolk or animal sizes, which were used to fix the pigments, made the glaze opaque, reducing the impression of depth. The final gloss was obtained by adding a coat of varnish to the painting in the form of a layer of resin dissolved in solvents. Juniper resin, known as *sandracca*, was said to be best and was dissolved in turpentine or egg white.

The technique was slow, but it produced well-proven results: a matt background with clearly separated colours, above all primary, in which the pigments were rarely mixed, in order to avoid any chemical reactions. Shading was very difficult and painters got round this problem

by using small amounts of pure pigment, constantly mixed with egg, which dried very rapidly. It was not advisable to blend the pigments, also in order to avoid the need to create a new mixture every day. The mechanical nature of these techniques was described by Cennini as the undoubted apex of the craft. This rigid procedure was used even in painting a face, and exactly the same steps were followed every time. There was a mechanical connotation to painting, one linked to the technique of execution; but this technique responded to the requirement of an immobile representation, which, during the course of the Quattrocento, finished by satisfying neither the artists nor the clients.

The advantages of using oil as an alternative binding agent for pigments had been well known for centuries. But it was a long process, since the oil dried very slowly, which meant that, for days at a time, whole areas of the painting could not be touched until they had dried out completely. Following the discovery of the desiccative oils, especially linseed and poppy, the Flemish painters understood that drying times could be reduced to hours, or a day at the most. Moreover, if oil was used as a binding agent, different pigments could be mixed to create much more natural hues and nuances with a softer effect. The main virtues of these oil-based paints were the sheen of the finish, as well as the resulting delicacy and depth of colour and the possibility of freely mixing different pigments, almost without using a medium that might interfere with the various chromatic tones.

A period of agonizing research ensued, and, after the arrival of the first astonishing Flemish paintings in Italy, even the local painters were tempted to try their hand at this technique. Vasari mentions Antonello da Messina as being one of the first to paint in oil, together with the Venetians. But the presence of Justus of Ghent and Pedro Berruguete in Urbino in the 1470s, as well as the arrival of works by other Flemish artists, opened a new chapter in painting techniques. Yet, alongside all these advantages, the use of oil presented a number of drawbacks. In particular, some pigments became overly transparent when mixed with oil, making it necessary to revert to tempera again. At the close of the fifteenth century many painters used both techniques, employing procedures that are still partly unknown: areas of oil painting were added beside tempera, and often a clear layer of oil was added to a base of tempera that had already hardened.

Giovanni Santi was one of those most receptive to this new fashion, and his paintings closely resemble the technique and taste of Flemish artists. However, his Italian roots are clearly visible in the appreciation and care he dedicated to the drawing [*disegno*], which was regarded throughout central Italy as the fundamental principle of art. The throne of the *San Girolamo*, now in the Pinacoteca Vaticana, and the building shown in the *Visitation* in Fano are constructed with the rigour of a geometric theorem. Giovanni's ability to draw architecture was so convincing that his works were a match for any of the great Italian painters of the period. They certainly justified the frequent commissions for theatre sets he received from the court in Urbino.

Although his figures still struggled to assume natural poses in their architectural surroundings, he took the greatest pains to create a sense of perspective, revealing an approach to his craft that was both intellectual and profoundly rational. At the same time he had learnt from the Flemish painters who passed through Urbino or whom he met on his frequent trips to north-east Italy. His attention to detail, the botanical precision, and the skies that faded perfectly to a brightly shining horizon, drawing one's gaze to the very back of the scene, were the product of his knowledge of Flemish art. Even the unreal effect of the clouds, streaked as they were with light and placed on a flat base, as if they rested on a transparent glass surface, revealed the debt he owed to the northern school of art. Moreover, Giovanni – thanks, above all, to his direct contact with Piero della Francesca – had realised the importance of the central element in the rebirth of Italian figurative painting: that solemnity of the human figure, which was still unknown to northern artists and had nothing to do with the geometric system of constructing space, but much to do with an idea of the superior dignity that made humans the measure of all things. If the *Sacred Conversation* in Montefiorentino were the only work to survive, it would be sufficient to document the extremely up-to-date value of Giovanni's painting.

On the other hand, the repetitive form of his features, the strong triangular noses, the mannered and rigid inclination of the necks, and above all the hands – which almost always lacked any sense of vitality – were signs that his art still lingered in Quattrocento culture, dwelling more on the propriety of the narrative than on its spontaneity. But

if anyone were to choose to be born a painter in the Marches, then, without question, Giovanni's workshop would have been the best place to be born and grow up in.

A fifteenth-century *bottega* had more in common with a small factory than with an artist's studio as we know it today. In the workshop, painting was only the final stage in a long and laborious creative process, which involved the preparation of materials and the organisation of the ideas to be portrayed: there was an intricate hierarchy of positions, each responsible for precise tasks and for a small part of the business, under the careful guidance of the master artist in charge. Young Raphael spent the first ten years of his life in a *bottega* like this, full of colour and images. Here he became familiar with colours and pencils and was able to observe, from day to day, how painted images were slowly created and how his father gradually drew closer to the brilliant results of modern painting. Giovanni's workshop was right next to the comfortable house where the family lived: the two buildings, which were bought and joined by Giovanni's father in 1463, were only separated by a door. As soon as Raphael could walk, he would certainly have been able to get to the workshop, attracted by the colours and the sight of the apprentices at work.

Giovanni's success at the court of Urbino is borne out not only by the magnificent stage settings, which he created to mark key events – such as the visit by Ferrante of Aragon in 1474, when he staged *Amore al tribunale della Pudicizia* – but also by the important political roles he held. An example of the latter was his appointment as prior of the city in August and September 1487. The peak of his career was when Giovanni was asked to stage his own comedy, titled *Contesa tra Giunone e Diana*, in the late 1480s, at the marriage between Elisabetta Gonzaga and Guidobaldo da Montefeltro. 'The play lasted from XXI hours to the second hour after nightfall* and beyond [. . .] but I have spoken to Zohanne de Santo, the author, who has agreed to provide it all in a compendium, which I will then bring to Your Lordship.'[7]

* Time was calculated as a 24-hour cycle, starting from sunset (about 8 p.m. in summer). Therefore the play must have started around 5 p.m. and continued until after 10 p.m. (Translator's note)

During the same period Giovanni was also involved in the decoration of the Cappellina delle Muse inside the ducal palace. In 1489 he completed the altarpiece for the Oliva family chapel in the convent of Montefiorentino at Monteoliveto. Here again there is a strong resemblance to Piero della Francesca's work; indeed Count Carlo is portrayed in the same pose as Federico in Piero's famous altarpiece. It shows how fashionable Giovanni's work was, although, leaving aside the uniformity of his faces – which continued to be his greatest limitation – only time would bring to the fore a quality that would make him the most successful painter in the eyes of the court: the truthfulness of his portraits. It was for this reason that in the spring of 1493 Duchess Elisabetta Gonzaga sent him to Mantua to paint the portraits of Isabella d'Este and Francesco Gonzaga.

In Mantua Giovanni fell ill, and the sickness dragged on for so long that by the following April he had still been unable to sign off the portraits, which were subsequently lost. He died on 1 August 1494, leaving an orphan son of barely 11, whose apprenticeship, however, was already well underway in view of the special circumstances in which it had started.

4 ASSISTANTS AND MASTERS

In 1491 Raphael's mother died, together with his little sister. This was a hard blow for the little boy, especially since his brother had also died much earlier, in 1485. At the age of just 8, therefore, he found himself facing the world with a father who was loving but always busy. Giovanni soon remarried a younger woman, Bernardina, the daughter of Piero Parte, from whom he had a daughter, Elisabetta, who sadly did not live long. When Giovanni, too, died in 1494, the boy was taken in by his paternal uncle, Bartolomeo, an archpriest who, together with other members of the family, continued to look after him until he died. It was lucky that the relatives were very fond of the child, who was the only male in the family in a century that reserved scant appreciation for daughters – they were regarded as little more than an economic burden on account of their inability to work and of the dangers attributed to their weaker nature, more prone to sin. Raphael's maternal grandparents also left him a small legacy.

With such a large and caring family, young Raphael was therefore
not lacking in affectionate guidance, when all were determined to cul-
tivate a talent that was clearly visible even in early childhood. Knowing
this, we can imagine that, after his mother's death, the boy became
inseparable from his father's workshop, where he was also looked after
by the employees – out of deference, if for no other reason.

As soon as the attractive young boy – whose features would be cap-
tured shortly after, in his first pencil self-portrait – could walk on his
own, he made his way to his father's workshop on the other side of the
courtyard. The two wide rooms with their vaulted ceiling overlooked
the crowded street, and the child's immediate impression was that they
had been especially created for him. Colours, noises and smells brought
the rooms to life in a far more vivid way than in the elegant rooms on
the first floor. There the women slipped quietly around, while attend-
ing to their duties of cooking and cleaning; downstairs the boys, the
men and the youths worked endlessly, as they played with thousands of
coloured oddities.

Beside the windows worked the older masters, who painted the
large panels sparkling with gold, blue and red. All around them
apprentices of all ages helped in the laborious process that ended with
the masters' slow brushstrokes. Giovanni would certainly have warned
his young son straightaway about the difficulties of learning the trade,
repeating the same warnings that Cennino had given to painters all
over Italy:

> Know that there ought not to be less time spent in learning than this:
> to begin as a shopboy studying for one year, to get practice in drawing
> on the little panel; next, to serve in a shop under some master to learn
> how to work at all the branches which pertain to our profession; and to
> stay and begin the working up of colors; and to learn to boil the sizes,
> and grind the gessos; and to get experience in gessoing anconas, and
> modeling and scraping them; gilding and stamping; for the space of a
> good six years. Then to get experience in painting, embellishing with
> mordants, making cloths of gold, getting practice in working on the
> wall, for six more years; drawing all the time, never leaving off, either
> on holidays or on workdays.[8]

These words were familiar to another boy who had started work in the same way: Michelangelo Buonarroti, who in June 1487, at the age of barely 12, was already employed at the Ghirlandaio brothers' workshop in neighbouring Florence. For different reasons, he too would be spared the twelve long years that it normally took to become a painter.

In Urbino, as the young Raphael watched boys aged 10 or even younger grinding colours and gesso by crushing them in a red porphyry mortar, he refused to believe that he could not do the same. For hours at a time, day after day, they would use a small wooden stick to scrape up the powder dampened with water and push it back under the pestle until the pigment was as fine as dust.

The slightly older boys, above whose red lips the first traces of downy hair were already visible, mixed the gesso with size* and brushed it onto wooden boards that had been planed and then nailed together to form panels. As soon as the first coat was dry, they would use a razor-sharp scraper to skim the surface before re-coating it with thinner and thinner layers, until the surface became as smooth and polished as an eggshell. A frisson of anticipation accompanied the appearance of the master when he came to run the back of a finger in a light caress over the panel, to feel whether it was as smooth as it should be. A smile of satisfaction or a shout of rage abruptly signalled the result of weeks of work.

The eyes of the oldest boys, who now had all the accoutrements of manhood, grew melancholy with desire as they squinted over their charcoal sketches on parchment, or copied the drawing onto the panels by pricking the outlines and then pouncing a small bag filled with black chalk dust over the parchment, to transfer the profiles, which were then fixed with a brush.

As he watched, young Raphael grew accustomed to all these activities, but he had to wait until he had learnt to hold his breath before he could stand beside the youngsters responsible for gilding the panels, who in his view worked real magic. They seemed to have the same gift as the mythical King Midas, whose touch turned everything to gold.

* *Colla*: traditionally, rabbit skin collagen or glue heated with water, used as a separating layer between the canvas and the oil paint. (Translator's note)

They picked up a thin leaf of gold, which they slipped onto a piece of paper in order to transfer it onto the surface to be gilded. One was not allowed to breathe, because even the faintest exhalation, which could easily escape in apprehension, was enough to blow the gold leaf away and ruin it forever. Hovering above the panel, the apprentices held the gold leaf close to the surface prepared with bole – a red clay mixture that was pliable enough to be compressed and compacted without cracking. With a rapid gesture, as if warding off bad luck, they ran a brush through their hair. This created enough static current in the fine miniver to pick up the gold leaf and lay it carefully in the required spot.

Once laid on the bole, the gold was held firmly in place and it adhered perfectly to any surface, appearing to transform the object into solid gold, as if by enchantment. The final touch was given by the magic wand that every workshop guarded jealously as one of the master's most valuable tools: a wooden handle with a precious stone, set firmly into the point. The stones could be 'sapphires, emeralds, balas-rubies, topazes, rubies, and garnets: the choicer the stone, the better it is. A dog's tooth is also good, or a lion's, a wolf's, a cat's, and in general that of any animal which feeds decently upon flesh.'[9] What imagination could ever have conjured up a better spell to bind Giovanni Santi's son to his father's profession?

With his father's warm fist gripping his hand, the young boy learnt to draw using a stick of charcoal made from the straight willow twigs blackened in the baker's pan, after the bread was removed at daybreak. No one could refuse the master's son when he asked for scraps of paper. Nor could they refuse to lend him slender brushes made from miniver tail fur and tied with waxed silk thread inside a falcon's or duck's quill, or brushes made using hog's bristle. Nor did they refuse him the left-over coloured pigments in glass jars and the small gessoed panels used by the youngest apprentices. In the raised corner of the second work-shop room, where a spiral staircase led up to a store on the attic floor, young Raphael soon had his own workshop, from which he gradually began to amaze, admire and alarm the others working in that magical den. The earliest sketches and trial paintings drawn by Giovanni's son started to circulate outside the shop and it was not long before they reached the ducal palace nearby.

The seasons passed quickly, as did the activities of the workshop; the latter was always full of life and smells, not all of them pleasant, but reassuring to anyone who had spent the most fertile years of learning absorbing them. In the winter, when the fire was permanently lit, it was used to boil scraps of leather or fish bones for days on end. The room was pervaded by a sickly stink, in spite of the fact that a kind hand had cast onto the fire grains of incense, orange skins and other sweet-smelling herbs to alleviate the boys' disgust.

The workshop was more hospitable in spring, when scented resin was heated until it dissolved and was used to varnish paintings. The air then became impregnated with the pungent aroma of trees growing far away from Urbino's dark forests, which carried with it memories of the exotic landscapes that the masters sought to capture in their pictures. In summer the atmosphere was even more festive, when on long sunny days the light sparkled on the burnished gold of the paintings and the master took advantage of the dry weather to sort out the bole and sizes used for the thin gold leaf.

But it was on melancholic autumn days that Raphael learnt from his father to study human physiognomy and the movements of men's souls, portraying them in painstaking Netherlandish detail. The autumn also marked a break in the cycle of shop supplies, a moment whose suspended calm fostered the kind of reflective painting that Giovanni Santi now championed. It was neither technique nor his precocious experience of the materials that stimulated Raphael and laid the foundations for his extraordinary future. Rather it was his father's burning passion for mixtures and nuances, the impalpable depth of the oil glazes and, above all, his acute psychological observation: a quality that was universally recognised by contemporaries.

In the years leading up to his death Giovanni achieved a position of great renown for his natural portraits: another result of his passion for Netherlandish art and of his maniacal attention to detail. Isabella d'Este, who was already known at the various Italian courts for her passion for collecting leading Italian artists, summoned him to Mantua herself. She relied on Giovanni to paint portraits of the Gonzaga in the same way in which, 20 years later, she would call on his son Raphael to paint her own son, the wonderfully handsome Federico.

Those portraits, which Giovanni had started in Mantua, where he

tried to show off his skills, were finished in the workshop in Urbino under the knowing gaze of the 11-year-old Raphael: the boy was already consumed by passion as he watched his father hollow out the ivory-coloured flesh, soften the angular lines of the faces, or try to capture an inner mood, a quiver of the soul that gave life as well as nobility to the marquises of Mantua – as he had done with his own patrons, the dukes of Urbino. Raphael watched as his father hesitated for hours, with the tip of his brush poised over the curve of a smile or the gloominess of an expression. He watched him observe the paleness of the flesh colour in the soft autumn light. He understood this psychological exploration. From this experience, which he had during the last few months of his father's life, he acquired the priceless ability to bring out the personality of the men and women whose portraits he would paint. While many of Raphael's contemporaries had an outstanding capacity to depict the body in any pose, he was the only painter of his generation capable of revealing the souls of the men and women whom he painted, from whatever walk of life they came.

5 A PRECOCIOUS MASTER

The fairy-tale existence of the shop filled with colours, the shaded and welcoming arcade of grey stone, which formed an extension of his boyhood home, came to a bitter end in the suffocating days of summer in 1494. Raphael's father had fallen ill while he was in Mantua the year before, a victim of the legendary insalubrity of the swampy area around Lake Mincio. On returning to Urbino, he never fully recovered and finally died on 1 August 1494, leaving an 11-year-old son, grief-struck and worried by the difficult family circumstances in which he now found himself.

Raphael's stepmother, Bernardina di Piero Parte, immediately stirred up legal difficulties concerning Giovanni's will. Raphael's paternal uncle, Bartolomeo, stepped in to defend Raphael, who had also inherited from his maternal grandparents. There was considerable bad feeling on both sides, and the first judgement passed by the court of Urbino on 17 June 1495 sentenced Bartolomeo to provide for his brother's second wife and for his niece Elisabetta. But the dispute did not end there. In December 1497 the representative of the bishop of

Urbino himself ordered Bartolomeo to comply as far possible with his late brother's wishes and to respect both the rights of his widow and those of Raphael's stepsister Elisabetta. In a small city like Urbino it was not seemly to give such a public airing to a family row involving two of the city's most affluent families. It was not until 13 May 1500 that a final settlement was signed in favour of Giovanni's second wife.

Raphael, who was just then entering the tricky phase of adolescence, tried to escape this stormy atmosphere by throwing himself feverishly into work at his father's shop. Although still very young, he was already capable of executing increasingly complex paintings with a certain degree of confidence. Nothing is more reassuring than creative work, constantly visible, executed in the company of people whom one acknowledges as superiors – which is how Raphael must have regarded the assistants whom his father had gathered around him in the last years of his life.

Fortunately the whole family agreed that the youngster should take over the small but profitable business as soon as possible. Aged barely 12, he had a vocation for the profession that was already clear for all to see. If he had shown neither talent nor the wish to become involved with the workshop, his relatives and his shrewd uncle Bartolomeo would have been the first to sell the business or to transfer it to Giovanni's chief assistant, Evangelista from Pian di Meleto, after Giovanni's death. Evangelista had had time to complete a long apprenticeship and had looked after the shop during his master's long absences. Moreover, Raphael had no brothers or cousins on his father's side.

Leaving the business in the hands of a 12-year-old might have seemed unwise. But Bartolomeo was very perceptive and did everything to ensure that Raphael grew up quickly and took over his father's workshop. He was proved right. While he continued to fight legal battles for his nephew, the youngster was already accompanying Evangelista on trips that often took them outside Urbino. But unquestionable proof of his precocious ability and of his sense of responsibility for his father's legacy is provided by a contract he signed with his partner Evangelista on 10 December 1500, when he was barely 17 years old: it was a contract with Andrea Baronci for an altarpiece in the church of Sant'Agostino in Città di Castello.

FROM URBINO TO UMBRIA

1 THE FIRST TEST

Before rising up to join the rocky crags of the Casentino Apennines, the hills of the Marches part to form a wide valley, home to the source of the Tiber. Surrounded by dark woods of elm and chestnut, in summer the valley floor is streaked with gold, as the fields of corn ripen into the plumpest and sweetest variety – according to Pliny the Younger, who built a villa in this earthly paradise and named it, appropriately, Villa Felix [The Happy House]. The valley is not far from Urbino and lies on the road leading to Florence and Perugia. During the age of the Communes, the fertility of these forests and cornfields was boosted by the wealth of the cloth weavers, who made extensive use of the abundant streams winding through the woods.

Such a plentiful and productive setting could hardly fail to attract the attention of the Florentine merchants, who soon arrived to offer fabulous contracts to the local industries. Florence turned Città di Castello into a sort of economic colony, extending its boundaries into that strategic region, which lies between the Marches, Romagna, Tuscany and Umbria and offers them the best of its own markets.

The small city became very prosperous and very Tuscan, as can still be seen from the palaces in Florentine style, with their tightly jointed

masonry blocks and the *bugnati* [ashlars] in hard sandstone topped by graceful windows, which over the course of the fifteenth century abandoned the high arched lintels in favour of the antique-looking form of rectangular mouldings. By the late fifteenth century Florentine painting, too, had found an appreciative audience in Città di Castello. However, despite the economic attraction of Tuscany's principal city, the ruling Vitelli family, which had been in power for over a century, preferred to build increasingly close ties with the Montefeltro rulers of Urbino, patrons to both Raphael and his recently deceased father. It was to Urbino that Niccolò Vitelli had turned in 1474 in order to reclaim his title, with the aid of the Montefeltro. The family continued to show its gratitude to such precious allies over the following years, to the extent that, politically speaking, Città di Castello regarded itself as a protectorate of Urbino for the last quarter of the fifteenth century, until it, too, became entangled in the tragic and inexorable mill of the ambitions of Cesare Borgia, the pope's son, also known as 'il Valentino'.

Journeying to Città di Castello, Raphael knew that he would remain under the protection of the Montefeltro, who could introduce him to the upper echelons of local society, as indeed they did. The young painter was drawn closer to the irresistible magnet that lay between Florence and Perugia, where artists were held in high regard while they remained at home, within the walls of a city that was impregnable but at the same time extremely isolated.

The success of his visit to Città di Castello was instantaneous. As soon as he showed them his drawings – those small painted panels he carried with him to demonstrate his precocious talent – the rich inhabitants of that 'happy valley' were left in no doubt that art of such extraordinary brilliance had never been displayed in their homes or churches, which were nevertheless impressive in terms of size and wealth. The verdict included Luca Signorelli, whose work had been warmly praised but who, compared to this prodigious youth, now appeared to have made a poor showing of his ability. The massive town walls in pale-coloured brick closed in on the young artist from the court of the great Federigo and celebrated his talent for four long years, until even these walls became too restrictive for a man whose talent was by then renowned in neighbouring towns and cities; and he was ready to pursue his triumphal march towards Florence, and then to Rome.

The first documentary evidence of Raphael's work in Città di Castello concerns his relations with Andrea Baronci, one of the city's most influential figures, who had held the office of prior for two years in 1498. His social position required him to engage artists of proven ability; and the two heirs of Giovanni Santi's workshop – Evangelista from Pian di Meleto, his chief assistant, and young Raphael, then little more than an adolescent – undoubtedly fitted the bill. The contract agreed to a considerable price for an altarpiece that would represent the triumph of Saint Nicholas of Tolentino over the devil: 33 ducats, to be paid in three instalments – an initial advance of 11 ducats to be made on signing the contract, which would allow the two painters to buy the costly colours, and two subsequent instalments, also of 11 ducats each, to be paid halfway through the work and on its completion respectively.[1]

In spite of Raphael's youth, the contract refers to him as *maestro*: a sign that he was already capable of exercising in full the role of painter alongside Evangelista, and also an indication that this could not have been the first contract signed by the two artists. However, the importance of the patron and of the commission itself certainly merited a lavish celebration in the town's best hostel, with the finest wine and the cured meats from Norcia, which were already a local speciality, as were the sweetmeats eaten on the feast days decreed by the church and at private festivities.

Raphael's role as the creative force behind this project is demonstrated by the preparatory drawings that have survived for the painting (see Plate 40). The young man already had very precise and innovative ideas for the realisation of an altarpiece. He could have timidly used the standard figures taken from his father's or other artists' repertoires, but instead he proceeded, with extraordinary originality, to study new poses for the figures he chose to depict, developing that sense of theatricality inherited from his father. He had such confidence in his control of the design that he ventured to construct a new narrative, already intolerant of the set traditional models. At the age of 17, such confidence eclipsed the talent of older masters, who, even at the end of their careers, would not have dared to make innovative changes to the reassuring models inherited from the past.

In order to portray Saint Nicholas' triumph, Raphael asked his

workshop assistants to pose as the saint, as God the Father, and even as the Virgin, in an improvised and makeshift tableau in which they can be seen dressed in their own clothes, their expressions simple and eager. Even the devil lying on the ground is a young apprentice: in the preparatory drawing he looks puzzled, an expression that in the final painting would be replaced by the absolute evilness of a completely black devil. The light-hearted and joking atmosphere inside the young master's workshop, for whom the change of scene came as a welcome adventure, is apparent from a detail that could only be imagined by an ingenuous adolescent mind. The apprentice posing as God the Father is wearing such a tight codpiece that it shows the outline of a passable erection; this did not detract from the solemn pose of the figure, but it certainly must have entertained this group of youngsters embarking on a new and alluring life. They were reinventing Italian art but doing so through child's play, whereby the youngest member of the group arranged them in poses, painstakingly adjusting the angle of an arm or the position of fingers and mimicking devout expressions before he ran back to his table and used confident lines to sketch the models destined to embody the heavenly court.

The bodies were still simplified through a fifteenth-century technique that sketched them in contour, making them similar to geometrical abstractions; but in the nude sketched above the devil it is already possible to glimpse the search for spatial depth and anatomical congruity that brought Raphael close to another master who searched for nervous corporeal expressivity: Luca Signorelli. Raphael may have met Signorelli in person, but he was certainly familiar with his works, which abounded in the area.

When the preparatory drawings were ready, Raphael started to paint the large altarpiece, which was almost three metres high. He used a compass to draw an arch seen from below and decorated at the front with delicate grotesques, in keeping with the latest fashion in Italy at the time. At the centre of the arch he placed God the Father holding a crown for the head of the saint, who was positioned a little lower down and in the act of trampling on the devil flanked by three angels. To God's side, amidst clouds, stood the Virgin on the right and Saint Augustine on the left; the latter was wearing a mitre and ecclesiastical vestments.

The crowns held in the hands of the upper figures are the same as those that Giovanni Santi had used in many of his works. This was natural, given that this panel can be regarded as being entirely the fruit of Santi's workshop tradition, although the content was already much changed. Even the colours and the poses of the figures recall Giovanni's works. But what is most reminiscent of this father–son continuity is the lack of fluidity in the hands. The elongated and accurately detailed fingers of God the Father are foreshortened in a way that is not entirely successful. In this naïve attempt to position the hands, the little fingers appear deformed, in a gesture that tries to be elegant but instead looks awkward: this was a trait that Giovanni Santi had used repeatedly, almost as a stylistic trademark, in an attempt to refine his female figures.

The colours are also very close to his father's palette. The soft folds of the drapes worn by God the Father also show how the young artist instantaneously overcame Luca Signorelli's characteristically stiff drapery, a feature that the great artist retained until his death and that Raphael had already identified as an old-fashioned impediment to a more naturalistic portrayal of the human figure. It is no coincidence that the surviving sketches for the altarpiece include studies of drapery, a sign of Raphael's growing intolerance to those metallic flaps for which his father was renowned.

However, the most surprising innovation can be seen in the faces, which no longer show the geometric construction used by his father. Giovanni, it is true, only used this abstract technique when portraying literary figures, whereas in his portraits and in the secondary figures of his altarpieces he explored the natural physiognomy in greater detail. But Raphael took portraits as his starting point, in order to experiment with a more naturalistic depiction, which sought a dignity of expression far removed from the accepted geometric norm. While Giovanni's work is immediately recognisable from the regularity of his long noses, which are triangular like cones, and from his arched eyebrows, resembling arcs of a circle on a forehead that is always strikingly prominent, in Raphael's portrayal the physiognomy of the Almighty is very lifelike and the solemnity of his expression has very little in common with iconographic abstraction. Even the Virgin's simplified face reveals a calm sweetness and freshness about her full mouth that is as enthralling as that of a girl encountered by chance as she draws water from a fountain.

The painting technique is already very mature, the shading is unified by fine brushstrokes, and the colours are perfectly balanced: in the three years since his father's death, Raphael had immediately set, with extraordinary intelligence, to enhance his legacy.

2 RECOGNITION

The altarpiece was a tremendous success and everyone in Città di Castello envied Baronci's shrewd decision, which had enabled him to celebrate himself and his heirs with a work of exceptional value at a relatively low cost. He had had the courage to commission a young emerging artist and had been amply rewarded. Unfortunately the memory of this talented collector was wiped out by a catastrophe that struck Città di Castello in 1789. An earthquake destroyed the church of Sant'Agostino, where the altarpiece, having escaped the clutches of rich collectors, was still housed; it was broken into pieces that were then scattered all over Europe. The largest fragment is in the Museum of Capodimonte in Naples.

The success of his first work immediately earned Raphael another prestigious commission, this time for the *gonfalone* [processional banner] of the Confraternity of the Holy Trinity, again in Città di Castello. These banners, carried at various processions throughout the year, were regarded as major works of art; but they had to comply with precise technical requirements. They had to be very light, so as to be carried easily during processions; this meant that they were painted on canvas rather than on heavy wooden panels. The accepted procedure was to glue two canvases together and then saturate them with a glue-rich compound. Because there was no rigid surface to act as a support, instead of the rigid layer of gesso, a glue was used that also doubled as a binder for the colour. This procedure inevitably limited the expressive possibilities of painting, which became rather an expert craft; its dominant traits were the freshness and immediacy of the brushstrokes.

The other technical aspect that was decisive in the production of banners was the speed at which they could be painted. The canvas had to be painted while it was still damp, otherwise the colour would not be absorbed well and would easily peel off later. It is easy to see why artists

with proven experience and consummate skill were commissioned to execute these projects, even without regard for the quality of their style. Speed and experience outweighed style in works that did not command excessive sums, given the clients' very modest financial means. But here, in Città di Castello, the appearance of this prodigious youngster had clouded even the proverbial common sense of a bureaucratic body like the Confraternity Council. Raphael's self-portrait, which can be attributed to this period, shows us a youth of almost feminine beauty whose regular features are softened by a lingering adolescence of the physique, which contrasts with his professional maturity (Plate 41). It was with this youth, whose lineaments seem princely in their delicacy, that the Confraternity drew up an agreement for the banner, fascinated as it had been by that rare quality of sweetness and by the prodigious ability displayed in the Baronci altarpiece.

In 1500, the year to which the banner is generally dated (and on good grounds), Raphael made his debut in this expeditious style of painting, producing one of the most beautiful banners ever made for a confraternity in Umbria. On one side he showed the Trinity, with Saints Roch and Sebastian at the foot of the cross (Plate 1), while on the other he painted the Creation of Eve in which an old God Almighty surreptitiously plucks a rib from Adam, who lies sleeping in a tranquil spring landscape.[2]

Here, too, there are numerous citations from Santi, above all the bluish landscape at the centre of the Trinity scene, with the luminous horizon that draws the eye further into the picture, amongst the rugged rocks. Similarly the trees – whose vaporous canopies on slender, pliant trunks thrust up, contrasting with the clear sky – form a cipher repeatedly used in Santi's paintings. The speed at which the banner was painted is apparent from the lack of elaborate detail, although in the Creation of Eve the fig leaves covering Adam's nudity are so precise that they pay renewed homage to Santi's Flemish influences. What is surprising, in spite of its poor condition, is the exceptional quality of the work, which is worthy of a panel painting. Painstaking details like the beard of God Almighty, the golden embellishments round the hems of the garments, and even the tiny leaves on the trees are more suited to an altarpiece than to a banner to be carried in procession. In order to display his talent, Raphael uses an exaggerated quality of

painting, raising the possibility that the banner might even predate the Baronci altarpiece and act as a Trojan horse through which the young painter turned a commission of modest importance into a gleaming and seductive masterpiece. The mellowness of the flesh painting, for example on the face of the Almighty, the realism with which he shapes and shades the arch of the eyebrows, and the choice of colours – for example the lilac used for Christ's loincloth – are absolute innovations in Umbrian painting and definitively quash the Vasarian legend of Raphael's apprenticeship under Perugino. If, in what can be regarded as one of his first works, Raphael already shows such mature skills, stylistically different from those of the Umbrian master, there are no grounds at all for alleging a subsequent apprenticeship. Any resemblance to Perugino's style displayed by Raphael in some of his later works can be attributed to competitive reasons, as will be seen in due course.

The success of the Baronci altarpiece also attracted the attention of another powerful family from Città di Castello, the Gavari. They were very closely linked to the Baronci and lost no time in attempting to emulate their fellow citizens by commissioning an altarpiece for the chapel of San Girolamo, destined to become the burial chapel of the head of the family, the banker Domenico Gavari, in the church of San Domenico (The Mond Crucifixion: see Plate 2). All that was needed to complete the chapel, already richly decorated with a carved arch in *pietra serena* supported by two Corinthian columns, was a painting to match the architect's talent and the patron's prestige. The rich and extremely shrewd princes of local finance could hardly believe their luck when they discovered a young artist of such ability, yet affordable and, moreover, one who would accord the family due respect; this meant that they would not have to wait for more distant master artists, who often disposed in great haste of the commissions of small provincial towns, delegating the work mainly to their workshop. These patrons had now a prodigious young painter to hand, and they decided to make the most of his talent. It has to be said that, in a small centre like Città di Castello, the families that were in a position to commission a major altarpiece in order to celebrate their status could be counted on one hand, but Raphael lost no time in shaking that hand.

The patronage stimulated the progress of Raphael's art; and, having reached an impressionable age, at which his style was evolving rapidly, he was keen not to miss the chance to use this painting as a way of demonstrating his ability to compete with the most established masters of central Italy. And with Perugino in particular. Raphael must have met Perugino during this period because, alongside the increasingly diluted traces of his father's style, this painting shows the first signs of Perugino's influence. Moreover, Perugino was the dominant artist in Umbria, and Raphael's chances of accessing the richest slice of that market called for direct competition between them: a competition that had to show future patrons that the youth was capable not only of emulating the graceful and harmonious compositions with which Perugino had seduced the rich merchants and bankers of central Italy, but also of adding something new and more attractive to that style – a fact of no small importance. Raphael's soft, effeminate gaze, the delicate physiognomy of a prince raised in luxury, as the 1506 portrait conserved at the Uffizi in Florence reveals it[3] (Plate 43), concealed a relentlessly competitive spirit, one that seized upon the key elements of his profession and devised winning strategies to gain the upper hand.

The subject he was commissioned to paint, a *Crucifixion*, lent itself perfectly to this radical challenge. It was the oldest image, most dear to Christian devotion and also the most codified in the Western tradition, encapsulating the drama of the faith while also having to move and redeem; it had to inspire prayer while also arousing admiration for its refined elegance, for the composure of the poses and for the beauty of the drapery. Comprising no more than five figures, which included the flying angels, it was a fixed scheme that condensed a millenary tradition of figurative art.

The ambitious young painter devoted himself wholeheartedly to the opportunity, since his success depended on competing against the old master who, for decades, had held sway on the Umbrian stage – particularly now, when it was so flourishing and up to date that it closely rivalled Florence and Venice. Raphael would have to create a work that would outshine the old Perugino, the maestro from Città della Pieve, without straying too far from the taste for the softly *sfumato* style, now consolidated in the ranks of Perugino's own public.

The best techniques from the workshop of Raphael's father were to be used in the painting commissioned by the Gavari family. With great care, he chose six planks of poplar seasoned to perfection in order to avoid any movement caused by the dampness of the preparatory size. They were tied together, standing on end, so that the centre rose to the considerable height of 283 centimetres and, at the widest point, it measured 167 centimetres across. Having been firmly joined, the boards were then covered with a layer of gesso and glue in several coats. Each coat was left to dry and then scraped with a finely honed blade, so that the surface gradually became smoother and shinier, like an eggshell.

Once the gesso and glue mix had reached a certain thickness, concealing any differences in the level of the underlying boards, Raphael started the *imprimatura*, brushing the gesso with priming liquid, to make it less absorbent and to allow the brushes to glide smoothly over the surface. This was followed by a coat of linseed oil mixed with white lead, which bonded well to the oil, to the lead-tin yellow and to the very finely powdered glass – a device used only by a few painters, to create a translucent surface and to reduce its permeability even further, until it resembled a matt slab. The inclusion of yellow pigment shows that Raphael preferred to paint on a background that was already faintly tinged, so as to play down the sharp contrast between the dazzling white gesso and the white lead. The addition of yellow made it easier to create the mellow effect of amalgamating the colours and of delicately blending in the backgrounds, on which he had been working for years.

When the panel was ready, with the help of his assistants and using a very sharp stylus, he marked the lines of the large cross that divides the scene. This gave the panel a geometrical framework into which he could place the figures. The circles for the sun and moon, at symmetric distances from the cross, were drawn using a compass. Then he started to work on the preparatory drawings for the figures, outlining their poses freehand. He alone was capable of drawing directly onto the surface, without using a pounce – a sign of the level of excellence he had attained as a draughtsman.[4]

After the layout of the painting was complete, with the black outlines in place, he started to paint the sky, using first a layer of azurite and

white lead, which were designed to act as a support for subsequent glazes. He had in mind the highly prized lapis lazuli. A banker of Gaveri's status would certainly not be content with anything less than crushed gemstone. But, even for a banker and a great master, lapis lazuli was too costly a pigment, although it was essential to give that translucent depth of colour to the sky. Therefore it was best to help by preparing the background with a less expensive colour. Azurite was perfect for this purpose. It was made from a mineral widely available in Germany and it was a beautiful pale blue, although under some conditions it could turn green, as had happened in the choir at Assisi: there Cimabue's extraordinary skies took on a greenish tinge as a result of the mineral's altered properties.

For the background, Raphael was careful to use azurite mixed with white, blending the whole with linseed and walnut oil. When the oil had dried and stabilised, the sky was completed by using a glaze of the precious lapis lazuli, which gradually deepened in intensity towards the zenith while leaving a glimmer of pure morning light on the horizon. The lapis lazuli glaze saturated the upper part of the altarpiece little by little, giving it body and an enamel-like quality.

The cloak that completely envelops the Virgin, who stands behind the kneeling figure of Saint Jerome, is not the usual blue, but a transparent variation with purplish tones. In order to achieve such a refined, silky colour, reminiscent of the fabrics woven in nearby Florence and worn by rulers the world over, Raphael first applied a coat of blue with azurite and then covered it with transparent glazes made by mixing vermilion red with colder lacquers. No tempera would have produced the sum of transparent glazes and the optical effects created by the layered coats of oil glaze. To start with, the effect would have been a dark purple, although the pigments have become greyer over time. The shadows were hatched using dense brushstrokes of lacquer mixed with black that would not obscure the tone of the underlying purple. Saint Jerome's robe, which has now turned a uniform grey, would have also been painted in fine red lacquers mixed with azurite and white. As a result of the omission of white, the shadows on the robe are outlined in lacquer and azurite, without using black, which would have dulled the colour. The fabric acquires a sense of impalpable depth, encasing the old saint's body. Against such a delicately pale violet, Raphael's choice

of a fiery red for the scarf knotted around the saint's waist creates a striking contrast. Saint John the Baptist's robe is a real masterpiece of unctuous red. An initial layer of vermilion and lacquer of kermes (produced by crushing cochineal insects from India) is then coated with transparent lacquer, to which a small quantity of black is added for the shadows.

This expertise in the use of pigments and binding media reinforced a fantastic vision and a rigorously balanced composition. Moreover, the artist's margins for creativity were heavily constrained by the iconographical composition; and such attention to detail, coupled with the rare gem-like preciousness of the painting, could give that winning edge the artist was looking for. The altarpiece contains very few 'poor' pigments such as the various earths – except for traces in the cross, where they are mixed with vermilion and black. Even the landscape makes extensive use of lead-tin yellow and verdigris. The fineness and value of the pigments used in the altarpiece had to be worthy of a banker; a profusion of gold leaf was inevitable, even though recent trends in painting confirmed the overtly 'garish' use of large amounts of gold as outmoded. The value of the painting was increasingly measured not just by the preciousness of costly materials like gold, but rather by the artist's genius. However, Raphael did not forgo the use of gold for the spherical sun and of silver for the moon and for the inscription on the cross; above all, he used gold to highlight Christ's loincloth and the angel's wings, although these are scarcely visible today. Nor did he refrain from using that toxic but marvellous pigment, yellow arsenic, made from orpiment, with which he delineated the sun's rays, giving them a golden gleam and softness that could never have been achieved with gold leaf.

The altarpiece created a perfect balance between the technological and iconographic tradition of fifteenth-century bourgeois painting and the new adventure on which Raphael and other Renaissance artists had embarked. This balance, which was already pushing the boundaries of tradition relentlessly, can be understood even more clearly through the composition and design of figures. This large, high painting of the crucifixion is set in a clear, open and luminous landscape, with pale blue mountains fading into the distance. Already this landscape has developed a long way from the dry, geometrical Quattrocento style, and even from

the mountains that Raphael had painted on the Città di Castello banner. The shapes and the light fade softly, accompanying hills and rivers, and green shifts into the blue of the furthest outlines, adding a sense of infinity to the scenic space. The figure of Christ is moved upwards and isolated against the sky, so that the landscape does not impinge on his centrality. The head hangs gently, without giving way to the final abandonment of death, which would undermine the royal character of the figure. The body is abandoned but not suffering, beautifully proportioned yet nervously stylised. The figures at the foot of the cross stand in perfect symmetry and seem engaged in meditation rather than being witnesses to a tragedy. Their composure must not interfere with the contemplation of Christ's drama. They live in a calm world, one where they are not even disturbed by the wind that stirs the landscape above their heads, at Christ's level. A corner of Christ's red loincloth flutters as restlessly as the angels' banderoles, clearly paying homage to Giovanni Santi's angels and muses. Once Raphael was faced with a choice between Perugino and his father, his decision was quite definite: the drapes in the crucifixions painted by Perugino during the same period were already quieter, while Raphael's angels wore robes whose metallic ripples were modelled on those drawn and painted by his father.

Raphael's most important innovation was in developing the psychological expressions of the saints and of the Virgin Mary. In the search for a spatial verisimilitude based on reality and not on stereotype, he achieved excellent results in the slant of Saint Jerome's body and in the inclination of the Virgin's head. Moreover, an excellent proof of anatomical congruence is provided by the successful foreshortening of Mary Magdalene's head.

In contrast with the precisely and intricately elaborated poses and appearances of the individual figures, Saint John's physiognomy so closely resembles the stereotype of Perugino's saints that it appears to pay intentional homage to the old master. Or, perhaps, it was intended as a warning to his patrons, and to art connoisseurs in general, that this youngster was capable of recreating how and when he liked these figures for which Perugino was renowned and appreciated: he could make them graceful to the point of affectation, and even improve their execution. Compared to Perugino, Raphael already shows greater anatomical consistency and a more studied treatment of

drapery. There is no uncertainty in the three-quarters pose used for the figures here, while Perugino struggled to position them in a credible manner. Saint Jerome's robe, which opens to reveal his chest and is held by a sash round his waist, is particularly original, abandoning for good the unreal tunics or torn rags of previous portrayals. The beautiful drapery of Mary Magdalene's cloak, delicately painted using iridescent lacquers, is so well folded below the waist that it achieves a sense of verticality unmatched by other contemporary paintings. His careful study of drapery was paying off and, at the age of just twenty, Raphael had already repaid his debt to Umbrian tradition and was ready to move rapidly on to another type of research. The most mature achievement of the altarpiece lies in the shaded density of colour, the drapery, the choice of delicate contrasts, but also in the brilliance of the flesh, for which the artist no longer used pale-coloured earth pigments but instead white blended with vermilion and lacquers, creating subtle nuances and bringing an exquisite blush to the young women's faces.

The repercussions in the learned circles of Città di Castello were immediate and, as soon as he had completed the large *Crucifixion*, Raphael was commissioned by Filippo Albizzini to paint an altarpiece depicting the *Betrothal of the Virgin* for his chapel in the church of San Francesco, also in Città di Castello. The time had come to challenge Perugino again, now openly and in an explicit manner.

3 CHALLENGING THE MASTERS

A good horse could cover the distance between Città di Castello and Perugia in an afternoon; this proximity allowed the two centres to be regarded as the most closely linked markets in Umbria. Families and envious gossip also took very little time to establish a network of connections among the dark woods in the northernmost part of the region. In the early sixteenth century the patronage of famous artists and the quantity of gold and lapis lazuli lavished on these works were the most elegant way of measuring social success.

This was no new phenomenon in Italy. In the fourteenth- and fifteenth-century cities artistic patronage had already become a fashionable game, in which everyone who could afford it took part

at the earliest opportunity. What was new, however, was that now the quality of the artist was valued more than the preciousness of the materials used, a development that sparked an intellectual debate in the chapels of those churches that were open to the public. The ability of a patron to secure the talent of a particular artist became a prize that added to the one demonstrated by accumulated wealth. Many princes ordered their courtiers to select the most fashionable artists in Italy, who would enable them to cut a fine figure in this unusual competition. In 1490 the duke of Milan wrote to his ambassador in Florence asking him to single out the best local artists. He would then do the rest: these early signs of a complex critical opinion regarding the merits of central Italian artists became a stimulating factor in the development of art and an aspect that would acquire growing importance in the following century, leading to lively debates and clashes of taste that proved more violent than duels to the death.

The Albizzini family owned a stone palace in the small town of Città di Castello that would have been regarded as a fine building even in the larger city of Perugia. The fiercely competitive mood between patrons, even more so than between the artists themselves, explains why the wealthy Filippo Albizzini asked Raphael to paint an altarpiece featuring the same subject that had been commissioned from Perugino just a few years earlier, in 1499, for an altar in the cathedral, Perugia's most frequently visited building (Plate 4). This rivalry between Raphael and the old Umbrian master in their representation of the *Betrothal of the Virgin* brought not only their patrons but also the two neighbouring cities into competition.[5]

The handsome 20-year-old was certainly the more hawk-like, not only for the quills that held the miniver tails of his brushes in place, but also for his far-sightedness and even higher flight. He was merciless in a confrontation that, even today, seems to have been deliberately planned, with sadistic intent, to humiliate the old master and the conceited patrician families of the powerful neighbouring city. Albizzini would certainly have seen Perugino's altarpiece and wanted to give Raphael the chance of a final showdown. The point is that Raphael turned the competition into a cruel battle and copied Perugino's composition in detail, while reworking it sufficiently to banish the ungainly prototype into the backwaters of the previous century.

In both cases the scene takes place in an enormous piazza with a classical-looking building in the background, and all the figures are gathered on the edge of the painting closest to the viewer. But, while in Perugino's painting the members of the group stand rigidly in a row parallel to the edge of the painting, in Raphael's they form a circle, occupying the space in a much more plausible manner (Plate 3). Perugino's figures are crowded together, forming an incongruous throng that forces the Virgin's left arm against the right arm of the woman behind her. Instead Raphael gives room to each figure, underlining its individuality and spatiality. The graceful poses of Perugino's figures are echoed in Raphael's painting, but in greater detail and with improved clarity: the officiating priest in the old master's painting stands as stiff as a poker, acting as a dividing line in the group, while in the younger artist's version he bends forward, to indicate his deep involvement in the ceremony. A more beautiful Virgin than any ever seen that far and an incredibly young Saint Joseph do the rest, making the scene as unforgettable and attractive as the most successful theatrical performance. The Virgin has a rosebud complexion and the curving neck of her robe sinuously traces the line of her neck and bust, while in Perugino's painting the dress has a square yoke that cuts off the Madonna's profile. There is no sentimental link between her and Saint Joseph, and they appear to be taking part separately in the ceremony that unites them. On the other hand, Raphael's betrothed couple is moved by the ceremony the two are celebrating together.

Raphael shows precocious architectural talent in his construction of the urban scene, in anticipation of what would later become his Roman wonders. The square, rough building in the background of Perugino's scene is transformed in Raphael's painting into a central-plan volume surrounded by a colonnaded portico, which is in turn joined to the main building by curved brackets with showy scrolls; the building is carefully studied and shown as a working project. Perugino has drawn a cardboard cutout, without any particular care and without bothering to scale the levels of shadow that define the overhang of the various architectural mouldings. Raphael, on the other hand, elevates the viewpoint slightly, to make room for a view of the wider piazza with marble inlays; their lines converge perfectly on the door at the centre of the building, which opens onto a shining, distant horizon. The steps that

follow the building's polygonal structure are drawn in minute detail and with implacable rigour, being perfectly in proportion with the figures walking around them.

Raphael also introduced new features to the setting by including minor episodes from everyday life. Even the landscape becomes less abstract. The conventional slender trees, which are still present in Perugino's altarpiece, disappear and are replaced by glimpses of a landscape worthy of a genre painting. Moreover, Raphael carefully uses natural light to illuminate the landscape, while Perugino does not bother to differentiate between the architectural shadows and those cast by the mountains.

The challenge was a complete triumph. From then on, even in wealthy Perugia, if anyone wanted to celebrate their status, he or she would have to call on the new star from Urbino. And indeed, shortly afterwards, Raphael was offered the commission for the *Coronation of the Virgin* (the Oddi altarpiece: see Plate 5).[6] The patrons were the Oddi, one of the city's leading families, and the work was intended for their chapel in San Francesco al Prato.

On this occasion, too, the iconography followed a rigorous tradition, which had produced important models in the last quarter of the Quattrocento. Raphael seems to have drawn inspiration from one in particular in order to satisfy his patron, Leandra Oddi. The model he had in mind was the *Assumption of the Virgin* painted by Pinturicchio and his school for the chapel of Santa Maria del Popolo in Rome, where the apostles stand around an ancient-style sarcophagus and comment on the miraculous assumption of the Virgin and on her heavenly coronation, while she appears in the heavens surrounded by angels playing musical instruments and by a circle of cherubs. More to the point, at that time Raphael was working with Pinturicchio. The master had been commissioned by Cardinal Francesco Piccolomini to execute the frescos for the library of Siena Cathedral, and he had approached the younger and prodigiously talented artist to ask if he would provide drawings for the paintings. Some of these have survived.* It is a sign of Pinturicchio's exceptionally open-minded attitude that he did not

* Such is the drawing for *The Journey of Enea Silvio Piccolomini to Basel* (Florence, Uffizi, Gabinetto di Disegni e Stampe, inv. 520E). See also p. 59 below. (Translator's note)

spurn the help of a much younger artist in whom he recognised extraordinary talent, above all as a fount of new ideas. In turn, Raphael also demonstrated a professional intelligence that, as was becoming increasingly clear, was the real basis for his unstoppable success, together with his innate manual talent, of course.

The *Oddi Coronation* is a clear demonstration of how this proximity and competition with the two great Umbrian masters was moving towards a conclusion that was resoundingly in favour of the young artist. In the joint work for Siena, Raphael undoubtedly studied the various alternatives for the design set with Pinturicchio, as they looked over the drawings stored in the workshop – a legacy of inestimable value that each artist guarded jealously. Among the drawings – which they scrutinised by candlelight or in the pale sunlight that filtered through the small windows, since the workshop should never be too brightly lit – were certainly those that had been prepared for the Roman painting, showing the sarcophagus dividing the picture plane along a diagonal line from bottom left to top right. The separation between the earthly scene, with the apostles contemplating the empty tomb, and the heavenly one, with the Madonna and the angels, who define two clearly distinct areas just above the distant horizon framed by hills, must have seemed wholly convincing to Raphael. What could not have satisfied him, however, was the aridity of the apostles' manner, which he immediately began to rethink, once again using real life studies. He was well aware of the constraints of imitating other artists' styles. He knew what could be re-used in order to make a painting recognisable and appreciated by its patrons. But, unlike almost all the other artists, he was keenly aware of what had to be reworked and redesigned. Therefore, with one eye on the paintings by Perugino and Pinturicchio, both of whom were renowned for their gentle poses and spatial congruity, Raphael reinvented the apostles by positioning them around the tomb once again, but he gave each one his individual space and a physiognomy that would attract the viewer's gaze. By updating the physiognomies and gestures through his life studies, he introduced a completely new and tangible sense of freshness without changing a single detail of the Assumption's rigid iconography.

The valuation of drawing as a tool for creative exploration rather than as a record of successful prototypes is now widely acknowledged as a pivotal aspect of Raphael's ideational process. Hands, in particular,

were a focus of his study, since their highly expressive gestures could
be used to recount the succession of events. The Virgin's sarcophagus
is empty: instead of her body, the apostles find the girdle that Saint
Thomas holds up as proof of the miracle, as he stands, profoundly
moved, between Peter and Paul. White lilies and pure white roses
grow on the tomb, symbolising the Virgin's purity and highlighting the
whiteness of Thomas' cloak right at the centre of the painting. Within
this cleverly created framework of luminous whites, the single red rose
stands out as the symbol of the Virgin's Passion and grief at the death
of her son Jesus, who now crowns her in heaven, surrounded as he is by
angels playing instruments and dancing.

In the scene below, Thomas' white cloak immediately draws atten-
tion to the event. Holding the Virgin's girdle in his extremely affected
hands, he shows it to the others, and his foreshortened, upturned face
sums up the apostles' wonder and devotion. The tones of the latter's
garments are carefully balanced so as not to disturb the psychological
bond that unites them in their silent commentary on the event and
marks their distinctively individual features with the same emotion.
The degree of solemnity revealed by the figures, each standing within
his own free space rather than being restricted, and the more lifelike
quality of the drapery offer stylistic evidence for dating the *Coronation*
after the *Betrothal*.

Lastly, here too, just as in Pinturicchio's painting, the scene is com-
pleted and balanced by a fertile hilly landscape crossed by a river, whose
clear blue water leads the eye, across its winding course, towards the
horizon and the sea in the far distance, where the green fades into blue
and into the eternity of spiritual light.

4 TURBULENT LANDSCAPES

Like many other painters of the time, Raphael sought success in the
main cities of Umbria, travelling in search of new opportunities: during
this period many came his way in Città di Castello, where nearly all
the richest inhabitants commissioned a work from the fashionable
young artist. One of the most striking aspects of his paintings at this
time is the harmonious calm in which his scenes are set. The clear skies
promise nothing but fair weather and they frame reassuring landscapes,

which are offered to the spellbound admiration of viewers, as if they had no other purpose than to soothe souls. Even the vistas of unspoilt nature are softly rounded and harmonious, as if some considerate hand arranged it especially for contemplation. The mountains are never rugged; they dissolve into valleys that sparkle with spring blossom, crossed by quietly meandering rivers; and sometimes these flow into a far-off sea, which shines as brightly as the sky above it. Raphael gives the impression of being immersed in a state of peace, in a world that comes closest to heaven on earth.

However, contemporary diaries reveal a pitifully different reality: the dawn of the new century came as a harbinger of devastating dramas, which took the place of the longed for benefits of the golden age predicted by Italian philosophers and astrologers. People seemed set on turning Italy into an inferno; and nature, too, wanted to play its part. The French king, Charles VIII, who had inherited a state that had remained virtually unchanged over the centuries, was tempted by the prospect of an easy Italian venture: the conquest of the kingdom of Naples and of the duchy of Milan. He started his 'descent' into Italy in 1494; his aim, disguised under the pretext of crossing afterwards to Jerusalem in order to recapture the Holy Sepulchre from the Turks, was to conquer as much as possible. The Turks, on the other hand, had never been in such a strong position and so close to conquering Europe. In September 1500 the news arrived to Florence that the Turks had defeated the Venetian fleet, killing 30,000. Over the following months they would land in Puglia and would come close to threatening the fortifications of Piombino.

Undoubtedly the pope, Alexander Borgia, was, in his own way, up to the task of dealing with these events. In an unscrupulous letter written to Sultan Bajazet in July 1494 he had tried to establish an agreement with the Turks to foil the French king's plans, which threatened his nepotistic ambitions. The unresolvable differences between the religions – called upon, through rousing sermons delivered over the past four centuries, to justify the conquest of Oriental markets and to continue the military slaughter of entire peoples – became irrelevant at that moment. The courtesy with which the pope wrote to the sultan, asking for his support in an alliance against the Catholic French king, reveals how little the religiosity of the curia counted by comparison with the pope's own family interests:

For these reasons, the said King of France has become our enemy. Not only is he pushing on in order to wrest from us Sultan Djem and to seize the kingdom of Naples, but His Majesty must know that he also intends to cross over to Greece and subjugate Your Celestial Highness' homeland: they also say that he intends to send Sultan Djem to Greece with a fleet [. . .]. You shall therefore persuade and exhort His Majesty that we are obliged to inform him in the name of the true and sincere friendship that binds us, so that He does not suffer any damage.

In return, the Sultan was no less generous in his profession of affection and friendship:

Sultan Bajazet Chan, son of Sultan Mahomet Chan, by God's grace Emperor and Lord of Asia, Europe, and all seas, to the Father and Lord of all Christians by Divine Providence, Alexander VI, worthy Pontiff of the Roman Church. With due and sincere greeting, We inform Your Highness that We have heard of Your good health and learnt of Your news through Giorgio Bucciardo, Your Greatness' servant and messenger [. . .].[7]

The self-assurance with which the pope threw himself into the arms of the church of Rome's secular enemy is a sign of how determined he was to pursue his own political plans. Alexander Borgia embarked on the most complete catalogue of atrocities in Western history, in an attempt to provide a kingdom for his own offspring, his son Cesare, also known as Valentino, who appeared to have stepped out of the pages of the Apocalypse. He seized control of the small central Italian states, with a display of unscrupulousness and greed that appalled those who had experienced the wars of the previous years. When he was in Tuscany in May 1501, his men, after conquering Faenza and Pesaro, carried out a sack of unprecedented violence and sadism – which, fittingly, characterised the next few years –

robbing and committing every sort of cruelty. Some they beat on the head, others they hung up in various cruel ways, whenever they could, in order to extract from them where things were hidden. [. . .] And it was said besides, that there were some, worse than the devil in hell,

who, finding a woman with her brother of about seventeen years old
[. . .] having found that woman and the seventeen-year-old, as I said,
and forcing both to act dishonestly, and several of them despoiling the
youth and leaving the woman for dead [. . .].[8]

Later on Machiavelli would lucidly describe, in a special treatise, how
Valentino used to assassinate inconvenient allies or dangerous enemies.
But the entire region was subject to the violence of his campaigns of
occupation. The green paths of Umbria were filled with lines of peas-
ants carrying their miserable belongings and seeking in the cities refuge
from the approaching armies. Fields were burnt if the harvest had not
yet ripened. At night lanterns remained lit inside the houses, because
even then people did not feel safe from attack.

Between the Adriatic and the Tyrrhenian coast no one felt certain
that they would live to see in the new year. The local rulers did the rest
by committing the most ferocious crimes, in a series of internal feuds,
as Raphael would record in one of his most successful masterpieces,
the *Baglioni Entombment*. Having been pillaged by soldiers, in 1500
the countryside had to bear the brunt of a series of natural disasters
that offered no respite to the poor families already devastated by war.
In Rome, where the pope had been forced on more than one occa-
sion to seek refuge, in Castel Sant'Angelo, from the riots incited by
the Colonna and the Orsini, on St Peter's day a tempest accompanied
by hailstorm ruined part of the Apostolic Palace in the Vatican and its
timing was seen as highly inauspicious. Pope Alexander's own apart-
ments were hit, but he was miraculously unharmed by the catastrophe
and turned the interpretation of the incident to his own advantage,
although many saw it as a portent of divine wrath against the crimes
perpetrated by the pope and his family. Three people were killed beside
him, but a niche created by the random fall of the beams saved his life.
The following day, with renewed vigour, he resumed the decisive phase
of the war of annihilation that he, alongside his son, waged against the
central Italian states.

In September it rained so heavily that the Arno flooded, wreaking
damage to all the surrounding countryside. But the worst blow came
in late November, when it snowed throughout central Italy for five
whole days. It was so cold that not a single drop of water fell from the

ice-covered roofs for days. The people devoted themselves to prayer and there were many processions of flagellants, during which hundreds flailed their backs with iron scourges. On the day of Corpus Christi in 1501, Federico of Aragon, king of Naples – threatened by the French king, by the Turks and by a pope who, if given the opportunity, would have occupied his kingdom himself – organised a procession around the cyclopic walls, which he followed barefoot for the entire dura- tion as a sign of devotion. At the end, he turned in desperation to the Neapolitans and announced his decision to ask for Turkish aid against his own enemies; it was a possibility that the people welcomed enthu- siastically, so strong was the sense of exasperation against Italy's rulers.

In short, Italy was close to collapsing point and fear stalked every street. Even Città di Castello, where Raphael continued to paint his halycon skies, fell into Valentino's fatal clutches and became the scene of one his most heinous assassinations, when he strangled Vitellozzo Vitelli and his brother, a priest. The court of Urbino, which Raphael always remembered as a place of complete harmony and happiness, also fell victim to the fury of the pope's son.

No place was spared. Under the Borgia the eternal city, where in previous decades every artist nourished ambitions to work, had become the most infamous place on earth. Yet these disasters did not appear to discourage Alexander and his court. In spite of his age, his sexual appetite and his perverse fantasies stunned the other Italian courts, even to a greater extent than the memory of the great Roman emperors and of their exploits. At the same time when Raphael delivered his first major altarpiece to Baronci, for example, the pope and his son found a highly original way to celebrate the eve of All Saint's Day. The Master of Papal Ceremony, Johann Burchard, an upright German cleric, recorded in his diary the description of a feast that would soon be cir- culated throughout Italy through dispatches hastily composed by the various ambassadors in Rome:

On Sunday evening [. . .] Don Cesare Borgia gave a supper in his apart- ment in the apostolic palace, with fifty decent prostitutes or courtesans in attendance, who after the meal danced with the servants and others there, first fully dressed and then naked. Following the supper too, lampstands holding lighted candles were placed on the floor and

chestnuts strewn about, which the prostitutes, naked and on their hands and knees, had to pick up as they crawled in and out amongst the lampstands. The pope, Don Cesare and Donna Lucrezia were all present to watch. Finally, prizes were offered – silken doublets, pairs of shoes, hats and other garments – for those men who were most successful with the prostitutes. This performance was carried out in the Sala Reale and those who attended said that in fact the prizes were presented to those who won the contest.[9]

The erotic choreography reveals a level of refinement that other princes and dissolute characters would find it hard to match in the future. The lampstands placed on the floor served to highlight the women's buttocks and intimate parts, offering the guests a florid display thanks to their compromising position on all fours. The excitement rose to fever pitch, and the promise of the final prize made their embraces even more passionate and urgent as they lay on the floor at the feet of the pope and his family. Some doubts arise as to the possibility of checking the actual number of times the most vigorous and well-endowed guests had intercourse with the prostitutes. A smaller scandal was created by the presence of Lucrezia and of her brother in that room filled with the choked gasps of orgasm and with the odour given off by sexual arousal. Lucrezia had already been bedded by her father and brother and was not a novice to the excitement of such peculiar games. All Italy was aware of her reputation, and when the pope imposed his daughter on the recalcitrant heir of the duke of Ferrara, the father, Ercole d'Este, had to threaten to marry Lucrezia himself in order to convince his son Alfonso of the utility of the marriage. Indeed, the pope's daughter certainly had many surprises in store for her third husband.

How Raphael's patrons could separate their devotion from the conduct of the spiritual head of the church of Rome remains today one of the great mysteries of the Italian Renaissance. The fact is that no aspect of what we see in Raphael's religious paintings of the time is sullied by the brutality of this period. The artist continued to celebrate the devotion of the richest families in the Umbrian cities, reassuring them with his images of perfect harmony and, while not giving them certainty, he could at least give them the hope of a world of grace from which every sign of the brutal present had been erased.

Along one of those paths immersed in the green hills of the Marches, on the evening of 21 June 1502, a cloud of dust could be seen rising behind a group of five galloping horsemen, who desperately spurred on their mounts in order to reach Mantua and the safety of the Gonzaga domains as quickly as possible. They were led by Guidobaldo da Montefeltro, Federico's son and heir to the duchy of Urbino – Raphael's home town, where he returned as often as he could, to supervise his family affairs and his property. The leading rider wore only a doublet, as the elegant Isabella d'Este immediately noted, not because it was hot, but because he had had to make such a hurried escape from the palace after one of Cesare Borgia's lightning and merciless attacks, in which no prisoners were taken. Moreover, for good measure, the pope's son usually ended by physically eliminating the rulers in order to take over their possessions. This version of events is told, in dry and dramatic tones, by Isabella d'Este herself, sister-in-law to Guidobaldo's wife, Elisabetta Gonzaga. The two women were close friends and had nourished the illusion of spending the summer happily at the cool and welcoming property in Porto Mantovano. The fugitive's arrival cancelled any hope of peace:

> We have been here for a while quite quietly and happily, and since returning from the Carnival Her Most Illustrious Magnificence the Duchess of Urbino has been with us until now [. . .] we have tried to console ourselves, hoping repeatedly that Your Ladyship might join us to complete our pleasure. But after the unexpected and wicked case of the loss of the Duchy of Urbino, and the arrival here of His Lordship the Duke, dressed in his doublet, with just four horsemen, having been betrayed and suddenly placed in great danger, we are all so shocked, confused and grieved that we ourselves hardly know where we are [. . .].'[10]

Isabella d'Este had every reason to be embarrassed as well as sorrowful. Her husband was the brother of Elisabetta, the fugitive's wife and a sincere, lifelong friend. Her own brother, Alfonso d'Este, had just married Valentino's sister, Lucrezia Borgia; therefore Isabella was related to her, and this resulted in a terrible tangle of affection and politics, which only a woman of refined intelligence could resolve.

Barely three months earlier, Elisabetta and Isabella had been the most elegant guests at the wedding ceremonies held in Ferrara for the marriage between the beautiful Lucrezia and Alfonso d'Este, and the latter had become the laughing stock of all Europe for having welcomed into his bed the concubine of both the pope and Duke Valentino. It had been a difficult ceremony, because rumours of the nonchalance with which Lucrezia had leapt into bed with male relatives and many others had spread like wildfire throughout every court. This sequence of disastrous marriages had ended with the assassination of Lucrezia's last husband on Valentino's orders. What other bride – since the time of the Atreides, who had stained the myrtle-scented walls of the royal palace in Mycenae with blood – could claim such an inauspicious dowry? Yet dynastic requirements overruled not only Alfonso d'Este's objections, but also those of the Italian courts that sent representatives to the wedding, although all were careful not to make any ironic comment on the bride's innocence. One could lose a kingdom or one's life for considerably less.[11]

5 THE END OF THE TERROR

By the late spring of 1502, therefore, Urbino had become a city drained of legitimate power and lived in terror of the pope's son, who was now a notorious household name throughout Italy. It is hardly surprising that Raphael moved further away from his native city and from his father's house, where there was no one waiting for him except for his uncle – who scrupulously continued to oversee his interests.

In 1502 Raphael was in Siena with Pinturicchio. In spite of his youth, his talent as a draughtsman – the skills he had honed as a boy under his father's tuition – outshone even the old artist's experience: his sketches showed how far he had progressed in the organisation of a three-dimensional space that created a more natural setting for the narrative.

One of the scenes that were certainly drawn by Raphael represented Aeneas Silvius Piccolomini accompanying Domenico Capranica to the Council of Basel. Both are shown in a splendid setting, with moving horses in foreshortened poses. Pinturicchio changed the model when the painting was executed, simplifying the young artist's complex

spatiality. But the scene that contains traces of Raphael's intervention is undoubtedly the most successful, thanks to the creation of a profound sense of diagonal space: this sets it apart from the other neighbouring scenes, in which the figures irremediably face the viewer and are aligned on overlapping registers.

His collaboration with Pinturicchio also included a *predella* [a small painting beneath an altarpiece] for an altarpiece in the church of San Francesco, again in Siena. In such turbulent times Raphael had to accept work where he could find it. In January 1503 he was back in Perugia, where he had to face a dispute with a creditor who refused to pay him for a mule. During the same months, not far from Perugia, he started to paint the *Crucifixion* for Domenico Gavari, a work of such beauty that it catapulted him into the goodwill of Umbria's most learned and high-ranking patrons.

As he continued his explosive rise to the forefront of Umbria's artistic limelight, in the autumn of 1503 Raphael would certainly have heard the news from Rome that radically changed the outlook of the century that had just started. Although harmony and measure had been key characteristics of his paintings right from the outset, the two works he completed between the latter half of 1503 and the first half of 1504 – the *Betrothal of the Virgin* and the *Coronation of the Virgin* – reveal, perhaps only by chance, a particularly happy vision and a renewed hope in the life to come.

The outlook of the century was changed by the death of Alexander VI, after which the terror of the Borgias dissolved like spring mist. No one could have imagined how the violence and arrogance of that family would be transformed, within the space of a few days, into the miserable defeat of a man on the run, pursued by countless enemies. The pope died on Friday, 18 August 1503, in his bed in the Vatican, after an agony lasting six days. His body was still warm when his son, who was also ill and at home, ordered his henchmen to break into the palace with their daggers unsheathed and to threaten the cardinals in attendance until they handed over the keys to the coffers. Under the terrified gaze of the five cardinals who had attended the pope while he lay dying, the henchmen carried off jewels and several thousand ducats. No sooner had Valentino's men left the palace than the servants started to ransack everything they could find in the apartments. The papal

secretary, Johann Burchard, commented with Teutonic zeal: 'nothing of value remained except the papal chairs, some cushions and the tapestries on the walls'.[12]

It was the same secretary who dressed the dead pope and prepared him for the funeral rites, putting him in the red and crimson vestments that rested on cushions covered in gold brocade. No one attended, not a single cardinal or nobleman. Even the thick Vatican walls failed to keep out the heat, which accelerated the decomposition of the corpse. The pope's dead body was carried into the Sala del Pappagallo and placed on a table covered in an old tapestry. Two wax tapers were found, but no one offered to keep vigil. The corpse was left alone all night, and only the armed intervention of the palace guards convinced the leading members of the Roman clergy to attend the following morning and to escort the bier into St Peter's. Lying on a litter draped with a purple cloth and bearing the papal insignia, the mortal remains of Alexander VI, the 'Bull' of Spain, were accompanied by a disorderly procession, largely made up of paupers and retainers, carrying 140 tapers in all. Having reached the basilica, no one could find a book from which to recite the 'Non intres' ('Enter not into Judgement'). The improvised chant was interrupted by a brawl between the retainers who were trying to steal the tapers. The church emptied rapidly and, with the help of two men, the papal secretary had the foresight to move the bier close to the stairs behind an iron grill, where it could be more easily defended against all those waiting outside the doors to desecrate the corpse.

Again, no one offered to keep vigil that night. The dead body swelled to monstrous proportions and the skin turned black. There were those who interpreted this horrible transformation as the resurgence of the evil that had permeated Alexander Borgia and driven him to dominate Italy. Others, more realistically, saw it as the effect of the poison administered to him by his own son. Throughout the pope's illness Valentino had stayed away from the palace, and he even had studiously avoided asking for news of his father's health. Alexander, in turn, was said not to have enquired once after his son. Over and above the blood tie between the two men, they seem above all to have been linked by a dynastic project.

The carpenters completed the coffin the following day and, because the measurements were wrong, they pushed the body into it with their

fists and with kicks. This was the Roman people's viaticum to the arrogant Spaniard who had plunged the city into crime and infamy, solely for the purpose of conquering a state that he could pass on to his descendants.

This grotesque episode brought to an end the reign of one of the most hated and certainly most feared popes in all Christendom. But, for Rome and Italy, countless other problems remained unresolved. The election of a pope who was universally regarded as good and generous, Cardinal Piccolomini, was motivated by the need to quell fears rather than designed to tackle the crisis. It was a short-lived illusion. The new pope was elected in September 1503, but by October he, too, was dead and, in their desire to kiss his feet in St Peter's, the inhabitants of Rome faced a torrential downpour that only added to the sorrow of their dashed hopes.

It was at this point that the man came forward who was destined to lead the church out of the crisis: Giuliano della Rovere, cardinal of San Pietro in Vincoli, a 60-year-old with the energy of a general. His opposition to the Borgia had obliged him to spend years of exile in France; but, as soon as he returned to Italy, he immediately announced his firm intention to recover the territories that had been lost to the church, as well as the temporal dignity left in tatters by the Borgia.[13] His political bargaining was so shrewd that the conclave that elected him is remembered as the shortest in the history of the papacy. By the night of 31 October 1503 Rome already had a new pope, who would rule it with the firmness of a *condottiere*.

The election of Cardinal Giuliano della Rovere as pope resulted in the immediate restitution of the duchy of Urbino to Guidobaldo da Montefeltro. For the duchy, this marked the start of a happy new period, under the new pope's protection. Guidobaldo's wife, Elisabetta Gonzaga, who was resigned about his impotence, focused all her energies on building a court that, from then on, would return to being a centre of Italian intellectual civilisation. Sexual abstinence was not a burden, although she continued to regret not having lived life to the full. Indeed, seeing her niece Eleonora in bed after the latter had made love for the first time, she asked her whether the joys she herself had missed for so many years were really so wonderful.

But, while a lack of carnal love might be sublimated into spiritual

perfection, dynastic necessities made it imperative to name an heir. Guidobaldo's sister, Giovanna di Montefeltro, had married one of the pope's brothers, Giovanni della Rovere, who, according to custom, had been appointed prefect of Rome. Their son, Francesco Maria, was chosen as Guidobaldo and Elisabetta's adoptive son and heir to the duchy of Urbino. Through this consanguinity the duchy came under direct papal protection and the Montefeltro family soon acquired a leading role on Italy's political and social scene.

Secure in the knowledge of his recognised talent and prompted now by this extraordinarily fortunate circumstance, Raphael did not hesitate to celebrate the newly acquired standing of his protectors. However, he had no intention of returning to Urbino, where the miniscule size of the duchy meant that major commissions were in short supply. Instead he set his sights on more substantial projects, and he was too intelligent not to realise how to achieve them. In 1504, at the age of just 21, he was already planning to become Italy's best painter. The conditions were favourable. He had been a child prodigy who had benefited from everything he had learnt at a young age in his father's workshop, and the achievements through which he had triumphed over his Umbrian rivals were widely renowned. But he knew that he needed much more. His father had taught him that art is the outcome of study and learning, apart from natural talent. And there was a place where art was progressing in furious leaps and bounds, thanks to a series of coincidences that had created a cradle for a renaissance comparable to that of antiquity. That place was Florence, and Raphael understood at the right moment that he needed to confront his work with that of the best Florentine artists, who, miraculously, were still alive and working on the banks of the Arno in autumn 1504.

Raphael asked Giovanna Feltria della Rovere for a letter of recommendation that would open the doors of this most beautiful but cruel city, the venue of a contest of excellence that he could not afford to miss. Giovanna was the right person to sponsor his Florentine debut. The ambitious youngster did not want to waste time trying to make his way into a cut-throat market like that of the Tuscan capital. Giovanna was pleased to help him. On 1 October 1504 she wrote directly to the city's leading authority, the *gonfaloniere a vita* Piero Soderini, to recommend this extraordinarily talented youth.

The bearer of this letter will be Raphael, painter from Urbino, who showing good talent in his work, has resolved to spend some time in Florence in order to learn. I knew his father, who was very virtuous and much loved, and likewise the son is discreet, and a kind young man. I love him most dearly in all respects, and I desire that he should perfect his art. Therefore, I recommend him as warmly as I can to Your Lordship; praying that, out of love for me, you will help and further him in whatever way is necessary, and that all this, and any kindness and favours that he receives from Your Lordship I will deem to have received myself, and for this I will be most grateful. For this I recommend and offer myself to you.[14]

The letter contains a lively description of the 21-year-old artist's situation and his ambitious plans. Such a warm and powerful recommendation was based on the high esteem in which his father Giovanni had been held by the reigning family at the court of Urbino; but it also shows that, in Urbino, they were perfectly aware of the youth's continuing successes. Indeed Raphael maintained his relations with the court by producing a number of small paintings of an exquisitely courtly nature, such as the *Vision of a Knight*, now in the National Gallery, London, *Saint George's Combat with the Dragon* in the Louvre and *The Three Graces* in the Musée Condé in Chantilly: refined paintings in which the artist expressed his pictorial achievements with a decorative grace destined for a court that at the time was experimenting with the value of grace understood as a virtue of civility and intelligence, around which the convivial relations between men and women, lords and courtiers could be built.

The fact that the letter was addressed to Piero Soderini proves that Raphael had clearly understood that, in Florence, republic of wealth and law, the artistic scene was dominated at the time by public patronage. It was certainly he who suggested this strategic approach to the 'Prefettessa', as Giovanna was called, knowing that, if a young artist was subsequently introduced by the leading public authorities, there would be no difficulty with the local artists. Even the allusion to the young man's discretion and kindness, as well as to his talent, appears to identify at this stage one of the social qualities that would be remarkably influential in Raphael's success. Discreet, kind and young: this is

how Raphael was seen by princes and how he was perceived, when he appeared on the banks of the Arno a few days later, by the merchants and well-established bankers who had relations with the court of Urbino.

THE FLORENTINE PERIOD

1 IN THE CITY OF TITANS

In 1504 Florence was burgeoning. It was emerging from the crisis that had followed the expulsion of the Medici and was now trying to consolidate its position on the Italian scene. To do so it had to strengthen the republican institutions that allowed it most efficiently to manage the huge wealth produced by its entrepreneurial middle class, whose members were firmly convinced that they would not be ruled by the hegemonic designs of groups of oligarchs, or even of a single family for that matter. The desire to experiment with broad forms of government also spread to the cultural policy of the Signoria, which used the talent of its own artists to celebrate the position of uniqueness and solidity that the city had succeeded in maintaining amid fluctuating fortunes over the previous three centuries.

There were no riches that were not devoted to augmenting the glory of the whole city through palaces and churches unrivalled in the rest of Italy – even in the eternal city, which could boast glories with a millennial history. The most beautiful palaces in Florence had all been built by now. The most recent and grandest was the Strozzi palace, bulging with giant rusticated blocks of pale sandstone quarried around Florence, whose construction had been followed apprehensively by the

entire Florentine population. The competition among rich families was reflected in rivalries between the architects who served them, and the designs for the new buildings were increasingly closely modelled on the gracefulness [*gentilezza*] and on the classical rule adumbrated by the most illustrious of adoptive Florentines, Leon Battista Alberti, in the elegant palace built for the Rucellai family, not far from the church of Santa Maria Novella. For that church, too, he had designed a façade that combined antiquarian research with medieval geometry. The prodigious size of the Palazzo Vecchio and its high tower acted as the hub of the city and the focus of political choices, as well as of decisions about who would represent those politics through art and architecture. In the piazza below, changing tastes were reflected in the new statues commissioned to embellish it precisely around the time when Raphael arrived, on the orders of a commission set up by the Signoria that brought together the best artists of the time. So, in May 1504, the arrival of Michelangelo Buonarroti's *David* in the Piazza della Signoria was indicative of a political choice to use art as an instrument of collective identification.

For at least a century, the most striking progress in painting had been made in Florence, and it culminated in the credible depiction of a space controlled by the rigid rules of perspective geometry. The new generation of painters, Andrea del Sarto and Filippino Lippi, as well as the Ghirlandaio brothers and Fra Bartolomeo, were now concentrating their research on creating a new monumentality of the human form, positioned in a space that increasingly mimicked the natural world. Raphael was familiar with their work and had already been able to admire the movable paintings of Tuscan artists in Umbria and in the Marche, and also in Siena while he was there. But, on his arrival in Florence, something even more extraordinary was happening: something that would not happen again in any other part of the world for many centuries to come.

The Signoria of Florence had commissioned two artists to decorate the walls of the Grand Council Chamber in the Palazzo Vecchio, the hub of the city's political power. Leonardo da Vinci and Michelangelo Buonarroti, the two titans of Italian art who were head and shoulders above the rest, were in direct competition for the first time. Leonardo was 52 when the young Raphael met him in the streets of Florence. He

was very handsome and had a thin nose, a shapely mouth with a slightly pouting lower lip, and a powerful physique, which revealed an athletic strength, certainly above average. As he walked through the streets, he attracted a flock of attentive pupils and the admiring yet anxious glances of his fellow citizens. This otherworldly appearance emerges from a contemporary description: 'He was physically attractive, well proportioned, graceful and handsome. He wore a short pink surcoat which was knee-length at a time when long garments were more fashionable, while his curly hair was chest length and neatly kept.'[1] But the eccentricity of Leonardo's clothing was the last of the oddities that impressed the Florentines. Highly practical merchants as they were, they had learnt to get on with a man of such restless intelligence and even to love and respect him, recognising him as a master of life and knowledge in spite of a public trial for sodomy, which had risked sending him to the scaffold in 1476 and had tarnished his image.

Not that sodomy was rare in Florence. But what was uncommon at that time was the brazenness and liberty with which Leonardo vaunted his inclinations, as did those in his circle of friends. The zealous anonymous informant who felt the need to warn the authorities [presumably by posting a letter in the 'mouth of truth' in the wall of the Palazzo della Signoria in 1476] that Jacopo Saltarelli, a handsome apprentice goldsmith, generously shared the freshness of his 17 years by sodomising older men, including 24-year-old Leonardo di Ser Piero da Vinci, had no hesitation in adding that Jacopo 'veste nero' ['wore black'], and that his better off client, 'Lionardo Tornabuoni, known as Teri, wore black' too.[2] Black was a very difficult colour to obtain in fabric, requiring repeated overdyeing as it gradually became darker. This extremely laborious process meant that black fabrics were regarded as highly prestigious, and they emphasised the refinement of those wearing them. To the anonymous citizen [who denounced them], not only sodomy itself was repugnant, but also the ostentatious elegance that accompanied it, particularly since, in Florence, any show of excessive luxury was regarded as a waste of the resources that kept its inhabitants in their enviable condition of freedom. The elegance of men like Leonardo and the originality of his lifestyle might therefore have been seen as a threat to the well-disciplined Florentine community.

From the outset Leonardo had been an incomprehensible figure to

most of his contemporaries. The biographer who knew him best, his lifelong friend Paolo Giovio, described him with a dryness that is still the best antidote to the myths that grew up around the man while he was still alive and rendered him incomprehensible after his death:

> Leonardo, born in the little Tuscan village of Vinci, added greatly to the glory of the art of painting, for he established that this art could only be practised successfully by those conversant with the sciences and the higher disciplines, which he considered its indispensable aids [. . .] According to him, nothing is of greater importance than the rules of optics, for they permit him to distribute light and to utilise the laws of shade [. . .]. Furthermore, he learned to dissect the corpses of criminals in the schools of medicine, despite the inhuman and disgusting nature of this work, in order to paint the bending and stretching of the different members according to the action of the muscles and the natural articulation of the joints.[3]

The words of those who knew him, and who had the best chance of understanding him, reveal a fragile boundary around the elusive figure of the artist, who was also a philosopher and a scientist. A scientific approach to the study of nature oriented towards painting, sculpture and architecture was not new. It was recommended by workshop masters and by all the great treatise writers of the Quattrocento, from Alberti to Filarete. But, for Leonardo, the study of nature and her laws soon became a cannibalistic instinct, which devoured much of his talent: an empirical, obsessive and endless study that, unfortunately, did not have the backing of a systematic education, if only in geometry and arithmetic – subjects that might have helped him to bring to a more tangible conclusion the countless projects he started. Therefore, when he arrived in Milan in 1482 to offer his services to Ludovico il Moro with the consent of Lorenzo the Magnificent, he proclaimed his own expertise and knowledge in a catalogue that had nothing to do with art as it was generally understood at the time:

> I have a process for constructing very light and strong, portable bridges, with which to pursue and at times escape from the enemy [. . .] I can also construct a very manageable piece of artillery, that is easy to

transport, with which to hurl small stones in the manner almost of hail: causing great terror to the enemy because of the smoke [. . .].[4]

Only at the end of this catalogue did Leonardo refer, in a rapid afterthought, to the services that he could provide in peace time – if such a period should ever come in a country that, through repeated invasions by foreign armies, had discovered war and the devastating new military techniques as the real foundations of modern history: 'Also I can execute sculpture in bronze or clay, and also painting, in which my work will stand comparison with that of anyone else, whoever he may be.'

Lost in the enormity and vagueness of his thoughts, Leonardo could not boast a vast artistic output until then. In Milan, too, he had not succeeded in holding with any consistency to a vision that matched the extraordinary perfection of his optical understanding. Yet he did enough for it to be acknowledged that he possessed an inimitable style. This is borne out by the lengths to which Isabella d'Este – unquestionably the most refined and determined art critic and collector of the Quattrocento, who never tired of harassing famous artists – was willing to go to obtain one of his paintings, giving him a degree of freedom that she was not willing to grant other artists. With relentless determination, between 1500 and 1504 – acting either through her agents or writing directly to Leonardo – Isabella obtained at least one drawing, if not also a painting from the master, showing an understanding of the unique quality of his art well before many others. In a letter dated 14 (or 25?) May 1504, the marchesa of Mantua asked him to paint for her 'Christ as a young boy about twelve years old, which would be his age when he debated in the Temple, and done with the sweetness and gentleness that you have to an excellent degree because of your special skill.'[5]

Sweetness and gentleness of sentiment that dissolved in the air around his paintings: that this was at the heart of Leonardo's artistic language had not escaped the attention of the marchesa, nor did it escape Raphael's; indeed he was so stunned, or so inspired, as to take his own style a step further. In the city that had made drawing the most powerful instrument of expression, Leonardo had developed his optical studies, displacing drawing and dissolving it into airy transparency, into a delicate play of light and shadow that immediately

became sentimental, capable of expressing those movements of the soul that were the real focus of his painting. His study of optics had convinced him that light and the way it illuminated bodies was what determined perception, more than the vision of objects. Using the new oil painting techniques, he tried to reproduce that complex and elusive perception that fascinated people. While other artists tried to capture a credible fragment of reality by focusing on a gesture or pose in a drawing, Leonardo had made such a detailed study of anatomy and of the mechanics and diffusion of natural light as to be able to re-create nature on the canvas and to use it for the benefit of narrating an emotion or a state of mind. His research focused on how objects were positioned in space, how they turned and intersected – whether they were horses, Virgins with Saint Anne and the Holy Child, buildings or landscapes, as the occasion demanded.

When Raphael arrived in Florence, Leonardo was working on two very different tasks: devising the means to take the city of Pisa by force after it had rebelled against Florence; and painting the Battle of Anghiari on the wall of the Palazzo Vecchio, an epic moment when Florentine troops had clashed with the Milanese, winning a triumphant victory that, in civic mythology at least, was celebrated as a victory of reason and emotional control over the enemy's brutal fury. In order to storm the Pisan defences, Leonardo studied ways of deviating the course of the Arno, and the strength of his reputation with the Florentine government confirms the consideration that was given to his engineering and military studies. At the same time, in order to depict the battle scenes on plastered walls without being forced to comply with the rigid timing of fresco painting, he was experimenting with a type of oil paint that could be mixed with plaster that had been insulated using resinous materials such as Greek pitch and white lead, for which accounts survive detailing the generous supplies made at the expense of the Florentine exchequer.

The two tasks ended in different but equally disastrous results. Pisa did not fall, and the painting was only partly completed. Moreover, to the dismay of Gonfaloniere Soderini, who had naïvely placed his trust in the artist, the fresco started to decay under his very eyes. In 1506 Leonardo left the city once again, travelling first to Milan in pursuit of new mirages, and then to Rome to the papal court, before he left

again, driven by restlessness until he reached France; and there he died in 1519. What little of the battle scene he had succeeded in fixing on the Palazzo Vecchio's wall, and especially the preparatory cartoon for the fresco, were sufficient to arouse a new and extraordinary wave of admiration for the artist. Moreover, they stimulated new iconographic studies starting from the unprecedented naturalness with which Leonardo had portrayed the clash between horses and riders in the heat of the battle.

What Raphael certainly saw and admired among Leonardo's works were two paintings that Florence guarded jealously: the *Portrait of Ginevra Benci* and the cartoon of the *Virgin, Saint Anne and the Holy Child with Lamb*, which was placed on show in the church of the Santissima Annunziata in 1501, causing an interminable procession of admirers who pushed and shoved to stand before those enigmatic smiles.[6] Even the humblest tanner in Florence had learnt to look at art and to comment on it like – indeed better than – a learned expert or an elegant courtier. Raphael was so struck by Leonardo's cartoons that he started to imitate his technique, drawing cartoons in black chalk with highlights for *Saint Catherine* (Plate 42) and the *Belle Jardinière* – the painting closest to Leonardo's style in Raphael's output. From the 1490s onwards Leonardo had made massive use of black and red chalk, because this technique enabled him to soften the shadows better than metalpoint and pen, which left sharp lines on the paper. By rubbing the chalk with a wet brush, a fingertip or a linen rag, he could achieve imperceptible and unprecedented transitions from dark to light, which closely resembled the airy vapours that had entranced him as a child in the ravines and gorges around the small town of Vinci. This technical revolution was immediately taken up by Raphael. Those cartoons alone, together with the *Madonna with a Flower* (the *Benois Madonna*, now in the Hermitage in St Petersburg; see Plate 6), served to clarify precisely the starting point for his new painting. Raphael was also deeply impressed by the portrait of *La Gioconda* or by the preparatory studies for it, and in his portraits of women he copied the sideways position given by Leonardo to the female figure against a background of open landscape.

In Leonardo's works the figures make gestures that have no relation whatsoever to the viewer or to the established 'catalogues' of the icono-

graphic tradition. Raphael, too, started to spy on the intimacy of the Virgin and Child, no longer posing them before the viewer but instead catching them at playful moments, while they quietly communicate, unaware of being observed. In the *Madonna of the Pinks* (Plate 7), the Holy Child uses his left hand to hold the Virgin's right hand while he takes the flower, a natural gesture made by an infant trying to remove an object from his mother's hands. The sacredness of the image is celebrated through its perfection and no longer through attributions of abstract regality. The Madonna and her son abandon the sacred throne and move instead into a room in an affluent household, where the painter can watch their emotions.

In the *Portrait of Ginevra Benci*, Leonardo started to explore another extraordinary aspect, which was characteristic to him: a woman's inscrutable smile, a theme that emerged in all its complexity onto the Italian art scene. No longer mortified by a devotion that had become a decorative cipher, a serious and rigid submissiveness of gaze, Leonardo's *Ginevra*, the first in a series of disturbing and intelligent women, seems ambiguous, revealing a fragment of the world that the artist was the first to sense in a femininity freed from religious prejudice. We do not know how he gained an understanding of this femininity, given that he loved men and viewed carnal relations with women as repugnant. What is certain is that he succeeded in capturing the enigmatic traits of a woman's mind, also as a result of the love of his natural mother, by whom he was raised as a young child, on the instructions of his father, Ser Piero. That unsettling smile, the window that started to open on a world that, until then, had remained prudently closed off to Italian art, would return in the faces of the Madonna and Saint Anne as we know them from the later workings on the cartoon for the *Annunciation*, and then from the painting now housed in the Louvre, in which the Virgin and Saint Anne are united by a sentimental bond that excludes the rest of the world. It almost seems that Leonardo deliberately gave the greatest resonance to this sentiment by painting women who were set well apart from those in the real world: women with a highly individual physiognomy – high forehead, straight nose and wide cheekbones – all identified by their spirit, which explains why, even today, they are immediately recognisable as women born by Leonardo alone, and by no mother.

This acute insight, used by the artist to lift the social veil that

banished women to a realm behind lifeless masks, had also been noted by Marchesa Isabella d'Este, who, at the age of 30, was at the peak of her physical and intellectual strength. She was a woman with a rare self-awareness, a fact that gave her certain advantages over her contemporaries and made her stand out. In another letter addressed to Leonardo, she asked for a 'sweet, devout Madonna, as she is in nature'. Unfortunately for her, her request came at a time when Leonardo, lost in his scientific fantasies, hated the very idea of painting, as his agent Pietro de Nuvolaria replied bitterly from Florence: 'his mathematical studies have so estranged him from painting that he cannot endure to use a brush.'[7]

Soft light, perfect anatomy, accurately portrayed muscles and flesh, all were used by Leonardo to reveal sentiments that, previously, people had only found in everyday life; they had never seen them portrayed in art. His search for perfection of sentiment became almost an obsession and prevented him from completing many works, while he was forced to work on others for decades. But Raphael was quick-witted enough to identify and isolate from this delirium the aspects of Leonardo's painting that he could develop in his work, because they were in tune with his own creative sensitivity. In turn, Leonardo was certainly pleased to meet this youth with the long neck and fine features of a Greek ephebe, who wore a flat black hat and a black doublet under which an edge of brilliant white linen was just visible around the collar, softening the contrast between the jacket and the youth's pale skin and chestnut curls, which brushed his collar. To Leonardo, his beauty was undoubtedly a reflection of his inner harmony, because the older man was convinced that an untidy appearance was incompatible with a balanced intelligence, capable of fulfilling the artist's task of penetrating the secrets of nature and of the human mind. This said, Michelangelo proved an exception to the rule and, to Leonardo, remained an unfathomable enigma owing to the contrast between his physical roughness and the graceful ecstasy he conjured in the marble faces of his statues. In contrast, the youth newly arrived from Umbria was perhaps the best proof of the convictions that underlay the Florentines' obsessive attention, throughout their lives, to outward appearance.

Raphael enthusiastically absorbed the mystery of Leonardo, the man and the artist; so profound was the impression made on him that it would

resurface a few years later, while he was working on the Stanza della Segnatura in the Vatican and decided to give Plato Leonardo's magnificent face. Among the Madonnas that Raphael painted in Florence, *The Madonna of the Pinks*, now in the National Gallery, London, faithfully reproduces the older artist's model, having simplified and adapted it to the younger man's expressive poetics. Raphael captured the sentimental theme of Leonardo's dialogues between mother and son, the naturalness of their gestures and the carnality of their expressions, and he re-created them in the more restrained gracefulness of his drawings and with the refined expertise of his colours. Their hair and skin tones were tinged by his golden light, illuminating the shadows that darken the room in Leonardo's *Benois Madonna*.

Raphael's light is the first clue to the changes that came about as a result of his contact with the older master's works. In the end, the simple, clear light of Umbria became the creative and intellectual light of late Florentine humanism. It was as if Raphael had to retrace Leonardo's development in painstaking detail in order to appropriate his results. After this meeting he was ready to turn the Madonna and Child into a new icon: a sweet, natural icon that would later, perhaps too forcedly, become the cipher by which he was recognised by his contemporaries and admirers.

Yet Raphael had a special advantage in his understanding of the female mind and of the complexity of the world of women in general. Unlike Leonardo, who never had relations with women, and unlike Michelangelo, who refused even to approach them, Raphael loved women with a carnal passion that would continue throughout his life. His understanding of femininity was immediately transformed into an expression of profound admiration, a desire never fully withheld, which led him to redeem women from the unreal and sentimental atmosphere in which Leonardo had placed them. Raphael brought back to them an entirely worldly dimension of sensuality, which would come to fruition in his Roman works, a few years later.

2 A NEW WORLD

The other titan whom Raphael was destined to meet in Florence, and with whom he would clash in Rome later, falls into a completely

different category. A few years older than Raphael, Michelangelo Buonarroti was born in 1475 and had already made his name throughout Italy with two sculptures of incomparable perfection, which outshone even the ancient models: *Pietà* in Rome and *David* in Florence, which stood triumphantly in front of the Palazzo Vecchio, as a symbol of the city's genius and pride.

The colossal nude of a young man who is putting away – or unrolling – the slingshot with which he killed Goliath was among the first things that Raphael saw in Florence; and he drew it in painstaking detail. But his interest also turned to the cartoon that Michelangelo was drawing for the painting on the other wall in the Palazzo Vecchio. In this work, which was to represent the battle of Cascina, Michelangelo violently attacked, and disintegrated, all of Leonardo's speculations on the fury of battle, his sentiments and poses, as well as the *sfumato* atmosphere created by his new study of optics. He concentrated instead on the anatomy of the male body and its capacity to express strength and virility through the beauty of its proportions. For all its perfection, his was a terrifying vision. As soon as Michelangelo left for Rome in February 1505, the young Florentine artists drove themselves to distraction studying and copying his cartoon, to the point of destroying it in their eagerness. If a copy – now in Norfolk – drawn by Aristotile da Sangallo had not survived, we would not even know what this work, which altered the representation of the male nude in Florence, was and how it was done.

Michelangelo had worked in jealous isolation in the rooms offered to him by the government of Pier Soderini, which in the autumn of 1504 sent him the large sheets [*fogli reali*] from Bologna, to be glued together for a huge preparatory cartoon. He would not allow anyone to see the work without his permission, but all his precautions proved futile. Driven by admiration and competitiveness, the young artists would stoop to nothing, especially after popular opinion awarded the palm of victory to Michelangelo rather than to Leonardo.[8] Unlike the others, Raphael certainly did not have to defy the law in order to let himself furtively in and spy on the huge cartoon that portrayed nude men on the banks of the Arno. He could count on the protection of Pier Soderini – one of the few friends to whom Michelangelo remained loyal throughout his life, well after the end of the former's political career.

So the cold winter of 1504 was heated by the challenge between these two titans, who were the subject of gossip at every street corner, around roasting chestnuts, in taverns where good cheap wine was served for the artisans and painters from the workshops. One talked about them on the stone benches built against the palaces, where men of rank and culture discussed philosophy and poetry, as if in a new Athens, opening the debate to all and sometimes ending in regrettable arguments between celebrities. This was recorded by a witness to one of those learned discussions that degenerated into a fight. The setting was somewhere close to the cool banks of the Arno, at the *pancaccia degli Spini* ['bench of the Spini'] – an old bench beside the Spini palace in the neighbourhood of Santa Trinità. A group of men were talking about Dante and, seeing Leonardo appear elegantly dressed and surrounded by his followers, they asked him for his opinion. As chance would have it, Michelangelo also happened to be passing, and so Leonardo put the question to him; and the younger man took it as a challenge. Michelangelo was terrified of being an object of mockery, and he thought Leonardo's question was a trap designed to highlight his ignorance. He immediately launched into a violent verbal attack on Leonardo, just as he was doing in his drawings, in order to destroy the elderly artist and the reverence in which he was held in the city. Instead of commenting on Dante, he attacked Leonardo and taunted him with his artistic failures: 'You made a design for a horse to be cast in bronze, and, unable to cast it, you have in your shame abandoned it.'[9] Without any preamble, Michelangelo forced the old philosopher to acknowledge the harsh reality of the technological challenge on which he had chosen to stake his reputation as a new artist.

It was fortunate that the spring sunshine, which had melted the last snows of the winter of 1505, also magically dissolved the tension that had built up between the two men. Michelangelo hurried to Rome, where he had been summoned by Julius II, and by March he was already in the eternal city. In 1506 Leonardo returned to Milan, where he had already spent 15 years exploring interests that were closer to his heart. Without the two rivals, Florence started to reap the difficult fruits of their encounter. Unfortunately, Leonardo's painting started to disappear almost immediately. He had experimented with a new way of consolidating the plaster mixture onto which he painted, namely

by using heat, and he was sure he could reuse the procedure on the walls of the Palazzo Vecchio. But, when he lit a fire under the large painting in the Great Council Chamber, the fire only heated the lower edge and the paint higher up started to weep a rainbow of tears, which stirred those of disappointment shed by many Florentines. Faced with this failure, which undermined the entire Leonardesque theory and its authority, Michelangelo's clarity and essentiality and his emphasis on research, which was obsessively focused on the male body, seemed to outweigh the vagueness and the immensity of his rival's impulsive pursuits, which thwarted his craving for perfection in a project that, once again, had proved unfeasible.

One of the artists in Florence who tried to understand which of the two titans had won this round was Raphael, and in this momentary void he found the ideal psychological state to advance his research, since he was free to observe, copy and draw without the physical encumbrance of their presence. Indeed, immediately after this clash, happy to be no longer involved in the competition, Raphael started to hone his skills. He immediately saw how much there was to learn also from that wild but brilliant sculptor, whose other works were dotted throughout Florence and could be carefully studied and copied, in addition to the cartoon and the colossal *David*. While the young painter from Urbino found it nigh impossible to understand the bizarre *iter* of Leonardo's formation, Michelangelo's was easier: indeed, finding himself in Florence, he could follow it backwards, to the extent of actually retracing the path that had enabled Michelangelo to develop such terrific ability, which the younger artist was now trying to understand by identifying the works that had influenced the older artist.

After training in the Ghirlandaio brothers' workshop, Michelangelo had received a special artistic education in the garden of San Marco, where, by way of emulating the ancient academies, Lorenzo de' Medici had gathered together the most promising young Florentines in order to re-create, through their art, the semblance of a court, which political expediency prevented him from displaying openly. The boy was solitary and suspicious by nature, and also because he had a dramatic family life behind him. He came from an old and solid middle-class family, which had played a dignified role in governing the city during previous centuries but had fallen into disgrace in the generation before that of his

father, Ludovico. Michelangelo had been obliged to start a career as an artist, which seemed a poor substitute and a social humiliation, in view of his bourgeois origins. In the Medici garden he had shown extraordinary talent as a sculptor, but also the signs of an unstable and anguished personality. Indeed, as soon as his protectors had been chased away after Lorenzo's death, he escaped to Rome, where, in just four years, he astounded the papal court with two statues that elicited an outcry about the rebirth of ancient sculpture: a *Bacchus* for the Cardinal of San Giorgio, a sworn enemy of the Medici; and a *Pietà* for a French cardinal who pronounced Michelangelo the greatest sculptor of the day. After such an extraordinary debut, Michelangelo's city invited him back by offering him the difficult commission of a six-metre tall David, to be sculpted from a block that had already been partly carved and damaged by other sculptors, who, one after the other, had abandoned the task in despair. Michelangelo created such an extraordinary statue that the principal artists in Florence in 1504, who were renowned for their competitiveness as well as for their excellence, were forced to give it a position of exceptional public and symbolic prominence, automatically raising its young sculptor above other masters.

But Raphael would have found Michelangelo's masterpieces incomprehensible if he had not started by studying on the walls of Florence the long and unstoppable renaissance of modern painting. He visited the Bardi Chapel in Santa Croce, where Giotto had given weight and substance to the bodies of the monks keeping vigil for Saint Francis. He spent much time in the Brancacci Chapel at the Carmine admiring the way in which the dazzling young Masaccio had managed to strip a Florentine shop-boy and to place him in Paradise – where he moved with such naturalness that one almost expected him to walk off the wall, together with his Eve, despairing and repentant as she was for having succumbed to the temptation of evil. He stopped at Santa Trinità, where Ghirlandaio had resurrected a notary's young son in a city square that was as white and orderly as a geometrical theorem. He studied the new grace of Botticelli and Filippino Lippi, the poetics of the gestures barely hinted at and of the light steps of Florentine women. He stopped to watch the Arno as it shimmered placidly in the spring sunlight, and he understood the direction of the breeze that stirred the gossamer light veils over the women's hair and seemed to waft their perfume towards

him. He saw how, in every light, the gold of the altarpieces had been replaced by precious rare pigments and clear lacquers, by the minute leaves brought to Florence in the Netherlandish oil paintings, and by the transparency of glass vases filled with flower stems. He marvelled at the richness of the entourage of the Magi painted by Benozzo Gozzoli in the Medici palace – those rulers in all but name who, through the wealth of Eastern kings, displayed their own ostentatiously, as bankers. Lastly, he came to the monumental altarpieces painted by Fra Bartolomeo, perfectly drawn and with a *sfumato* that placed the saints' figures in an afterlife where only the spirit could be seen: these solemn figures left the merchants and bankers speechless through the gravity of their movements and the harmony of their proportions, the brilliance of the fabrics and the realism of the folded cloth. He felt the freshness of the clean air that seemed to be steeped in the words and ideas preserved in those books – the books acquired by Florence when the Turks routed out of Constantinople the wisdom of two millennia of Western philosophy.

After this astonishing introduction, guided by his thirst for the new, Raphael retraced his steps to observe the details and techniques of Florentine painting at greater leisure. This time he studied the altarpieces and the tondi, alongside the perfect portraits of rich bourgeois men and women who sought new ways to celebrate themselves. He carefully analysed these paintings, which had very little in common with the devotional spirit and whose backgrounds revealed scenes of impeccable realism, glimpses of the world controlled by the Florentines through their double-entry accounts. The precise shading, the transparency of the brushstrokes, the grandiose scale of the architecture: everything was strictly governed by the rules of perspective, which were taught in the workshops together with instructions on the priming of panels and how to grind colours.

The new world of large-scale painting could all be found within those walls, which stretched only for a few kilometres yet opened up unending vistas. Moreover, they revealed a world framed by architectural gems carved with chisels as sharp and finely honed as a surgeon's lancet. The Florentines had even reinvented chisels capable of sculpting stone into the finest embroidery. In Rome and the rest of Italy anyone wanting to build architecture comparable to the ancient splendours –

of which Florence could boast countless examples, both old and new, imported by rich collectors – would be sure to use Tuscan sculptors. Only in Florence had stonecutters revived the art of carving the hardest marbles – and even porphyry, which for centuries had been regarded as an impossible feat. Only in Florence could one see men dressed in tunics and cloaks of red, black and yellow silk brocade and velvet walking over the grey stones of dressed sandstone or over the red brick edge courses; figures solemn enough to re-appear effortlessly on the painted walls of palaces and churches, where other, similarly dressed men awaited them, held in place by brushstrokes, masters of an immutable eternity that made them conscious of being at the centre of the world.

Young Raphael could now see it all with his own eyes, and ideas started to grow inside his mind. To begin with, he found an outlet through the fast sketches, at which he was unbeatable. But he was waiting for an opportunity that would offer a real challenge. It had been easy to compete against the Umbrian masters, who repeated the same old, well-known styles. Here in Florence matters were different: something new was created every day, and it was a novelty that raised the bar, helping to build a fragile new myth in the shadow of the two protagonists, the two awe-inspiring and unapproachable masters who had agreed to compete, head to head, in the same place and on the same theme.

Raphael did what common sense would have prompted any young man of his extraordinary composure to do. Overawed by the innovation he had seen in Florence, he clung to his professional standing by reinforcing ties with his patrons in Umbria. In December 1505, only a few months after he had arrived in Florence, he returned to Perugia and signed a contract for the *Coronation of the Virgin* with the nuns of Monteluce, who had chosen him as the best painter.

But the influence of his time in Florence made itself felt even more strongly in another painting that Raphael started at this time – with the Trinity and the saints seated on clouds, as if in an amphitheatre – only to leave it unfinished in the church of San Severo in Perugia. Here the monumentality of each figure, the spatiality and the naturalness of gestures and expressions offer unequivocal evidence of what Raphael had already absorbed from Florentine culture, and especially from Fra Bartolomeo, who had painted a *Last Judgement* for the Ospedale di

Santa Maria Nuova: Raphael openly refers to this piece. At the same time these commissions confirmed the prudent nature of his professional stance, guarding his reputation by sheltering it within his own market niche, which he only abandoned later, when he was offered new and decidedly more attractive commissions. Raphael had fallen for the beauty of Florence but had managed to keep his head. Although he was determined to conquer the city, he forced himself to produce work of exceptionally good quality in Perugia until the first commissions for Madonnas started to arrive in the Tuscan city and his clientele expanded day by day.

After meeting Leonardo, Raphael discovered an immediate affinity with the theme of the Holy Family, and he would always attain the psychological depth that Leonardo had first tried to create. But Raphael was also ready to make the great master's teaching inform his own particular interpretation of the female spirit, transforming into grace the mystery whose threshold Leonardo had been unable to cross. He successfully combined that mystery with the plastic power of the Madonnas in Michelangelo's marble tondi. They were there for Raphael to see in the homes of the rich patrons whom he, too, was starting to serve: Taddeo Taddei, one of Michelangelo's close friends with whom Raphael also enjoyed excellent relations, and Agnolo Doni, a wealthy banker and the undisputed doyen of these sophisticated Florentine collectors. In these surroundings Raphael could study Michelangelo's work at leisure: what could be better?

Agnolo Doni also owned the painting commissioned from Michelangelo for his marriage to Maddalena Strozzi (Plate 44). The work, which is the only one of its kind to use tempera on a panel, portrays a scene with the Holy Family in which the Virgin twists round to take the Holy Child from Joseph's arms. This was certainly the work by Michelangelo that Raphael was able to study most closely and at the greatest leisure. He would have held the light at an angle in order to see the consistency of the brushstrokes, the way the drawing had been incised, the dense criss-cross of the chiaroscuro. He would have discovered how the space inside the painting was given greater depth by foreshortening the figure of the young Madonna, transforming a flat panel into a telescope pointed at the countryside. Unlike Leonardo's hazy and atmospheric spatiality, Michelangelo's used metallic under-

drawing to outline the twisted and foreshortened muscles, in particular her arms and legs, in a pose that carried the view of a body in perspective to new heights of perfection.

Raphael took note of these studies, as he had of Leonardo's. And, although they developed in completely the opposite direction to that taken by the older master, he realised how extraordinarily modern they were and assimilated them immediately. Indeed, Raphael's forte was the ability to absorb from other artists' talent what he needed to enrich his own. As soon as he could, he reused this magnificently foreshortened female form, reinterpreting it, but without striving to simulate it – which in any case would have been pointless in a world where there was no direct comparison between works that were kilometres apart. In the *Baglioni Entombment* (Plate 8), which he painted in Florence during the same period, he would use the twisted body of Michelangelo's Madonna for the kneeling woman who twists round to catch the swooning Virgin.

He had now absorbed the best of Florentine painting. The journey to Florence had produced unhoped for results and the artist's work was beginning to make itself known to a highly sophisticated circle, which would soon lead him to Rome; and there the struggle for supremacy would take place in full view of the greatest intellectuals of the day.

3 THE WAY UP

Having arrived at Florence with an introduction from a person of the stature of Giovanna Feltria della Rovere, Raphael did not take long to obtain an entrée to the city's rich market. It was Agnolo Doni himself who offered him the chance to make a debut that would prove highly consequential: he commissioned his own portrait and that of his wife Maddalena (Plates 9 and 10).[10] There could hardly have been a safer bet for Raphael than portraiture, because his father, Giovanni Santi, had excelled precisely in this art. Indeed, Santi's painting of Isabella d'Este, which was commissioned by her sister-in-law Elisabetta Gonzaga, had won the approbation of the entire court.

When deciding how to approach these two portraits, Raphael kept in mind the lesson from Netherlandish art that he had learnt from his father, but also Leonardo's lesson, which consisted in blurring the

body's objective appearance through subtle psychological introspec-
tion. The atmosphere in both portraits is clear and radiant, yet the
wealth of detail pushes natural imitation to the limit, while allowing for
an interpretation of the sitter's frame of mind. Agnolo, who was still
young at the time, displays the strongly marked features of a man of
action: the decisive banker, conscious of his role in society. His dress, as
severe as his gaze, is emphasised by the deep black of his velvet doublet
fastened with gold buttons. The brilliant white ruff of his shirt garners
light from the clear sky and reflects it onto his minutely observed face.
The large nose is straight enough to be noble, and the thin mouth,
clearly outlined by the light on the upper lip, has an almost feminine
fullness. But his face looks like an island adrift in a sea of black, his
doublet and the hat, while his curly hair, barely subdued even by ener-
getic brushstrokes, acquires the appearance of cloth fringes silhouetted
against the sky and offers another sign of the man's strong vital energy,
which makes him resemble a luxuriant tree. The sternness of this por-
trayal achieves the aim of exalting the banker's dignity, a sensation that
is slightly muted by the blue sky and the peaceful landscape.

While Maddalena is not beautiful, her appearance is enhanced by the
richness of her jewels, by the landscape, softened as it is by the golden
haze of the approaching sunset, and by her extraordinarily elegant
clothing. The light skims over the brocade sleeves decorated with
clearly visible dark flowers, to highlight the purplish blue, which looks
even deeper against the white puffs of her undershirt escaping between
the sleeve ties and her red dress. Against the brilliant ultramarine of the
background, the purple lacquer of the folded fabric occupies almost
the entire bottom half of the painting, giving the observer a pleasant
sense of beauty that extends to the young Maddalena. Her chestnut
hair frames her wide, solemn face in warm light and hangs down over
her left shoulder. Tendrils escape from the rigid hairstyle, fraying
out against the sky, as if a mischievous breeze were trying to breathe
a quiver of life into such immobility. It is precisely these fine locks of
hair, hovering like filaments in the air, that bring the woman closer to
the viewer, placing her into an everyday world that balances the profu-
sion of wealth and propriety symbolised by veils, ribbons, jewels and
heavy brocade.

In both paintings, the sitter's gaze takes on a magnetic quality and

acquires a new force, which resulted in lay portraiture attaining heights of unprecedented refinement. The woman's three-quarter pose is reminiscent of the *Gioconda* [the Mona Lisa], but Raphael abandoned Leonardo's *sfumato* technique and instead used light, to enhance the softness of the flesh and the tactile quality of the cloth.

The ability to balance an ideal psychological vision with an actual somatic resemblance made the portraits of the two spouses an absolute novelty in Florence. The descriptive approach mediated through Netherlandish painting turned Leonardo's spiritual atmosphere into a much more concrete vision. By adding a touch of anecdote, the two paintings became a magical box inside which a fragment of the real world, subjugated into perfect balance and elegance, could be encased in a golden frame and displayed forever before the patron's gaze.

Florentine bourgeois society, which for the past two centuries had done all it could to rationalise and to invest profitably in the world around it, could hardly have failed to be won over by such a happy synthesis. Raphael arrived from Umbria brimming with scintillating ideas and ready to give the city on the Arno the perfect dimensions and elegance of a world from which all vulgarity had been smoothed away. Rich bankers started to exchange opinions about the young painter from the Marches. He was all the talk at wedding feasts and after deals had been signed and sealed in the banks, under the Loggia della Mercanzia, and on the stone benches that lined the outer walls of the palaces. He was also a subject of conversation in the palace built by Cronaca for the Dei family in Borgo Santo Spirito. This rich family of merchants had managed to buy one of the chapels laid out with mathematical precision on both sides of the nave of their neighbourhood church, rebuilt by Ser Filippo Brunelleschi, so that each of the rich owners could display his status in accordance with his resources and taste.

When Rinieri di Bernardo Dei died in September 1506, his heirs were sufficiently clued up to realise that the best celebration of his wealth and memory would be to commission an altarpiece from the artist from Urbino, now barely 23, whose reputation had spread like wildfire through the city (Plate 46). They therefore asked Raphael to work on a *Sacra conversazione* with Saint Augustine, Saint Peter, Saint Bernard and perhaps Saint Rinieri. Raphael would leave it unfinished when, shortly afterwards, he hastened to Rome in search of princely

glory; but the distance that now separated him from the city's greatest artists, including his friend Fra Bartolomeo, was so clearly visible, in the solemnity of the spatial configuration and in the dignified grace of the figures, that the unfinished painting was purchased, after Raphael's death in 1520, by an important collector of the time, Baldassarre Turini, who installed it in his chapel in the cathedral of Pescia without any concern for what critics might say.

The close relations that Raphael had established with the Florentine world of high finance are borne out in one of his own letters, in which he asked his uncle to welcome his good friend Taddeo Taddei to Urbino when he visited the city for Guidobaldo da Montefeltro's funeral. Taddeo Taddei was not just a rich banker. Together with Agnolo Doni, he was the most influential collector of the time, and his palace in Florence housed one of two marble tondi carved by the inimitable Michelangelo Buonarroti. The Taddei Tondo (Plate 45) showed the Holy Child stretched over the Virgin's lap, furiously trying to scramble over her knees: this image so struck Raphael that he came back to it again and again in his works, even years later. The first instance can be found in one of the most beautiful Madonnas of the Florentine period: the *Bridgewater Madonna*, who tenderly gazes at the child as he wriggles out of her embrace and clasps the golden scarf covering her shoulders.

Taddei, Doni and Dei, young, rich and intelligent, were the best possible patrons for an artist in search of perfection. Raphael used his canny business sense to forge lasting relationships that went beyond the courtly recommendations through which he had been introduced to Florence four years earlier and which were always viewed with a degree of suspicion in a city with marked republican leanings. Now the artist was patronised by the wealthiest sector of the city, the merchants and the bankers, who could boast taste and culture as well as riches.

It was no easy matter for a foreign artist to win the esteem and friendship of such powerful people in a city that, for years, had regarded itself as pre-eminent in art. The hostility of the Florentine painters – always jostling amongst themselves but closing ranks against incomers, to retain control of the burgeoning domestic market – can be easily imagined. Later, around 1516, when Raphael tried again to win over the city's market and the Medici's commissions, he would fail; and the work on San Lorenzo remained exclusively in Florentine hands.

But, under the republic of Piero Soderini and of the merchants who exported all over the world, the young immigrant rapidly climbed the professional ladder to the topmost rung of lay patronage.

4 CHRONICLE OF A TRAGEDY

Having become an uncontested leader on the Florentine stage, Raphael did not take his eyes off the other 'piazza' that his talent had conquered: the wealthy city of Perugia. There the young rising star was commissioned to paint the most important altarpieces between 1500 and 1506, while virtually none was placed with Perugino.

The Coronation of the Virgin, which was commissioned by Leandra Oddi around 1503–4, had shown the extreme maturity of Raphael's painting; and the two putti peeking through the clouds, hidden by Mary's and Christ's cloaks, announced a clever new idea, which would soon become an unmistakable feature of the artist's own devotional and lay iconography. The extraordinary grace that Raphael conveyed through his paintings in order to move viewers and transport them to that purely spiritual world is summed up in the tenderness with which he portrayed these apparently minor figures. After work of this calibre, it is no surprise that he was offered a major commission while he was still in Florence. Once again, it was a woman, touched by the tenderness of his art, who asked him to paint a decisive work – a woman who, also thanks to Raphael, for centuries would remain symbolic of the cruelty of the Italian Renaissance. Atalanta Baglioni.

A member of the family that had dominated Perugia in the fourteenth century, Atalanta had married, at a very young age, another Baglioni: Grifone, her relative and the son of Braccio Baglioni, the courageous founder of the lineage. Shortly after the wedding her husband was killed, and she turned down another offer in order to care for the only child of a union that had been prematurely cut short. Her young son Grifonetto seemed to combine his mother's beauty with his father's valour. This handsome young Adonis was also blessed with the gift of true love, which was consummated with a depth of passion that was admired by the entire city. At just 18, he married the beautiful Zenobia Sforza and in five years they achieved everything that was humanly possible by producing four children.

In the summer of 1500 the entire Baglioni family was preparing to celebrate another important event in its successful rise to power: the marriage of Grifonetto's cousin Astorre to a beautiful Roman noblewoman, Lavinia Colonna. When she arrived in the city on 28 June she wore a golden robe whose silk sleeves were embroidered with such an array of pearls that her young face appeared to shine brighter than the moon. Astorre went to meet her, also dressed in gold, followed by all the citizens: they regarded the nuptial celebrations as a regal occasion, on which they spent not less than sixty thousand florins. The streets crossed by the wedding procession were strewn with fresh flowers – lilies, roses and myrtle – which gave off a heady perfume. Triumphal arches were erected at several points to celebrate the fashion for all things classical, with which Perugia felt closely associated. One arch even cost as much as 1,500 florins. Groves of ilex and strawberry trees blossomed in the piazzas, as if conjured up by love; and they looked even more magical against a backdrop of tapestries woven in Flanders that were hung in public, surrounded by flowers and golden banners. Even the buildings had been restored, so that visitors from the Urbs [Rome] could not fault the welcome offered by their hosts to one of its noblest daughters.

Each *rione* [district] drew up its own calendar of festivities, inviting the happy couple to take part in a series of public celebrations over the following days. The most splendid and magnificent were offered by the *rione* of Porta San Pietro, where the food was so plentiful that there were not enough trays and the dishes had to be served in the bushels used to measure corn, while in the afternoon Simonetto Baglioni arrived standing on a cart filled with sugared almonds, which were distributed to the crowds with the help of a shovel.

Contrary to the happy mood of the public, nature suddenly saw it fit to overshadow the festivities by a tragic epilogue: a terrifying storm broke on the night Lavinia arrived in Perugia. While the bride was resting on a bedspread made from strips of gold braided with ruby silk, the hailstones battered the lilies and roses that carpeted the streets of the city, knocked down the arches and garlands of fruit, drenched the sugar sculptures of animals prepared by the pastry master chefs – the pastry scorpions and the frogs, lizards and other bizarre creations that would have made the wedding ceremony unique. The next morning, all the

inhabitants were hard at work to repair the damage, so that everything would be as orderly as possible for the celebrations to continue.

However, not everyone blamed the disaster on the untimely and unwelcome arrival of autumn at the height of summer. A member of the Baglioni family arranged for a message to be sent to Blessed Colomba, a nun who lived in the odour of sanctity in a convent just outside the city walls. Her reply was as horrifying as Cassandra's had been inside the walls of Troy. In her vision Colomba foresaw the bridegroom Astorre crucified and his body burnt. But, once again, such dramatic forebodings were cast aside in the general mood of optimism, and the feasting continued.

The celebrations continued until early July, with the appropriate sumptuousness called for by the political situation, after which the guests started to leave the city and Astorre thought the moment had come to enjoy Lavinia's company in private, in a palace lent to him for the occasion by his cousin Grifonetto, since his own was still being built. Indeed, the houses owned by the family were all very close to one another: the roofs touched and you could practically jump from one window to another. Moreover, the Baglioni were so powerful in Perugia that there was no need to place guards at the doors. But they were wrong to believe that attacks could only come from the outside; as always, the most insidious and most apocalyptic threats came from within, from the heart of the very same family. On this occasion, too, following the same tragic plot that has been played out throughout millennia of history, the less well-off members of the family were tempted to believe that they could replace those who had more power, whom they saw simply as being more fortunate.

Atalanta's son Grifonetto was one of the direct heirs of the most able head of the family, Braccio Baglioni, and the plotters had little trouble in convincing him that he should claim his rightful position. However, the boy was too happy to nurture any real hatred for Astorre and his other cousins, all of whom held him in great esteem, and he had been too well educated by Atalanta to be lured from this position by his cousins and uncles. However, the true source of all his happiness, his passion for his beautiful wife Zenobia, proved to be his downfall. He could not bear doubts being raised about her fidelity. So, when the plotters dripped devastating poison into his ears concerning an affair

with Gian Paolo, Astorre's brother, Grifonetto gave in and agreed
to join the shameful conspirators – who planned to do away with the
happy bridegroom, his brothers and his father Guido. They waited
until the first guests had left the city walls, and then they broke into the
palace where Astorre lay and into the other houses where his brothers
and cousins were sleeping unguarded.

The attack was led by Grifonetto's uncle, Filippo, and by Barciglia,
a man whom contemporary chroniclers described as being more of
a beast than a human, since he had already committed every kind of
infamy. The door into Astorre's wedding chamber was battered open at
midnight and the young man was dragged naked from the bed and mas-
sacred in full view of his terrified bride. Not even in Rome, under the
bloody rule of the Borgias, had Lavinia imagined such brutality. The
savagery of this attack, which was, moreover, totally unmotivated, was
such that not even the crimes of the Atreidae, notoriously the cruell-
est family in history, could match it. Filippo split open Astorre's chest
in a single blow, he ripped out his heart while it was still beating and
he tore it apart with his teeth, petrifying those unfortunate enough to
have witnessed this most revolting meal ever eaten on Italian soil. The
young man's butchered body was then dragged into the street, while
the slaughter continued in the other houses. Gian Paolo managed to
escape by jumping from the eaves and fled from the city, swearing to
reconquer it as soon as possible.

The plot was only half successful, and in the morning Perugia's
inhabitants woke to the apocalyptic sight of the mutilated bodies of the
Baglioni family being dragged through the streets. Students, citizens,
and Raphael himself, who seems likely to have been in the city at the
time, were struck by the heroic beauty of Astorre's corpse despite
the havoc wrought on it by the plotters. But this was not the reaction
that the traitors had expected. There was no rejoicing following the
assassination of those whom they accused in vain of tyranny, and it soon
became abundantly clear that Gian Paolo would re-enter the city and
regain control. Despite all their efforts to dispatch messages to allied
cities, the traitors would be punished.

Atalanta was the first to understand what had happened and what
fate awaited her. Taking her daughter-in-law Zenobia, her grandchil-
dren and the children of those relatives who had been killed or had

fled, she barricaded herself into her father's fortified house, on top of the city's highest and best defended hill. Grifonetto, too, understood the enormity of his actions and his weakness. Sensing his confusion, his allies tried in vain to kindle his sense of vindication, but to no avail. All he could think of was his mother's forgiveness, and he ran to the house she had shut herself into and beat on the door in tears. Atalanta was unyielding. She refused even to let Zenobia speak to him, and she cursed him for what he had done. As he hammered on the massive wooden door, the neighbours peered out from behind the cloth of their window-panes. The day passed between the conspirators' ineffectual attempts to establish their legitimacy and Grifonetto's harrowing cries, as he knelt before his mother's door and besought her pardon.

In the end the youth gave up all hope and cried out a terrible premonition for his mother to hear: 'I shall never return to you, and although you will often wish to talk to me, you will be unable to, cruel mother in your dealings with your unhappy son Grifone.'[11] Even if she had agreed to speak to her son at this point, it would have been too late: he knew that death was now a certainty, and not even her longed for pardon could save him from a destiny that in a single night had turned to tragedy.

Just as he was leaving his mother's house, descending the steep cobbled streets of Perugia, now deserted, Grifonetto, dazed by his own part in the horrific events, encountered his cousin Gian Paolo, who in the meantime had resumed control of the city. Unable to credit that the youth was wholly guilty, or perhaps conscious of Atalanta's magnanimity – thanks to her, his own children had been saved from the fury of the conspirators – Gian Paolo motioned the youth away with a scornful gesture, condemning him to exile. But the horsemen in his retinue, keen to show off their courage and spurred on by the anticipation of an easy victory, sought to win their leader's praise by viciously attacking the youth and leaving him writhing in agony on the street – the street that only a few days earlier had been carpeted with flowers and now was drenched in the blood of the city's finest young men.

On hearing Atalanta's screams as she rushed towards them closely followed by Zenobia, the assassins fled before they could administer the final blow. The crowd that had gathered to enjoy the bloody scene of the vendetta fell silent before the two women and their grief. Atalanta

embraced her dying son, to whom she had sacrificed her life. Those present could hear her words, which were recorded in the chronicles of Perugia's most violent massacre: 'My son, I am your mother and against all my most fervent wishes, my words fall on your deaf ears, as you predicted.' Atalanta pardoned her son before he died. But she also asked him to pardon his assassins, in the hope that this would bring to an end the feud that threatened to wipe out her entire family. Grifonetto forgave his murderers in exchange for his mother's pardon and, together, the two women carried his mutilated body into the house, where they could at least console themselves with the funeral rites. The sight of them lifting his body and of Atalanta's heart-rending grief were much more moving than the ritual performances of Christ's Passion, at which Perugia's faithful were regularly reminded of the price Our Lord paid for redemption.

A few years after these terrible events, and for her own consolation, Atalanta wished to commemorate them in a painting for the family chapel, which was dedicated to Saint Matthew, in the church of San Francesco al Prato in Perugia. The chosen subject matter was inevitably the lamentation over Christ's dead body, that age-old expression of maternal grief in the face of the unnatural death of a beloved son (Plate 8). And, of course, the artist would be Raphael of Urbino, who, although now in Florence, was still reputed to be the best painter in central Italy. Furthermore, Raphael had spent some time in Perugia during the period of the massacre and had probably attended both the wedding and its tragic epilogue. At any rate, he would certainly have been told all about it, since it was the most important event to have happened in the city for quite some time.

The painting was executed shortly before 1508 – given that, in a letter addressed to his uncle at that time, Raphael complained of payments still outstanding from 'Madonna Atalanta'. The theme was reconciled with a profound understanding of the drama it intended to evoke, while still complying with the precisely defined parameters of a codified iconography, which had found two first-rate interpreters in Perugino and Mantegna. The key feature reminiscent of the tragedy of the 'blood wedding', as the massacre of the Baglioni was referred to henceforth, is the presence, in the foreground, of the youth holding the two ends of the cloth over which the dead Christ's legs hang. His hair is

blown back, to reveal a strikingly handsome young profile, with the full red lips of someone still in his adolescence. The neck, the strong and well-shaped arms, the elegant footwear and the taller stature mark him out as a young nobleman and the absolute protagonist in the group of men carrying the body. His presence is an inexplicable departure from the traditional iconography, unless it is seen in the light of Atalanta's private motives. His physical effort emphasises the tangible carnality of Christ's body and the human tragedy of his death.

Behind the youth, the Virgin, dressed in doleful purple and with a beautiful regal profile, collapses into the arms of a woman whose hair is styled with surprising elaboration. Raphael uses the twisted figure of the kneeling woman to give a perfect emphasis to the swooning figure, adapting the already famous painting by Michelangelo in the tondo for Agnolo Doni. While working on the portraits of Agnolo Doni and his wife Maddalena, Raphael would certainly have had time to copy every detail of that Michelangelesque gem hanging on a wall in their house. With a self-assurance beyond all imagination, he now took the Madonna's twisted body and transformed her into Mary, who swivels around to catch the Virgin's fall. His admiration for Michelangelo is apparent in a citation that becomes a genuine expression of homage, while also helping Raphael to highlight the aspect that most concerned his patron: a mother's anguish at the sight of her son's dead body, an anguish so great that it causes her to faint.

The chronicles describing the carnage do not state whether Atalanta fainted when she entered the hospital where her son's butchered body lay. But it is likely that she was supported by Zenobia, who was as beautiful and graceful as the figure in the painting. One might even imagine that the commission for the altarpiece arrived while Raphael was busy working on the portraits in the Doni household: it would be hard to imagine that the presence of Michelangelo's tondo did not make an unconscious impression on him.

Furthermore, the painting shows the perfect mastery of composition that Raphael had attained by the end of his time in Florence. The sky, the mountains, even the grasses painted in the foreground were sufficiently descriptive to satisfy the Netherlandish taste cultivated by Umbrian painters and dear to patrons from a city like Perugia. But the disposition of the figures was entirely Florentine; it had that

sense of solemnity and space that Fra Bartolomeo had captured in his altarpieces, drawing on the research undertaken by the great Venetian painters. The facial expressions are revealing without being theatrical; they are far from the cold rituality of fifteenth-century figures. The bodies, which are shown in foreshortened poses, are all surrounded by enough space and light not to seem awkward, even if the overlapping feet reveal a degree of ambiguity, a residual difficulty in the control of space. The harmony of colours is perfect, and the lapis lazuli of the sky fades into the wide-open landscape of mountains and countryside that frames the backdrop.

Christ's body lies across the foreground of the entire painting. It is shown as a tortured body in pain, and only the darkened flesh reveals the death of a man still in the prime of his vital beauty. The pale pink loincloth is an unusual colour, chosen in place of the customary white in order to provide greater contrast with the livid corpse. Raphael takes painstaking care to contrast Christ's inanimate flesh with the rosy arms and legs of the men carrying him and with the pink skin of the Magdalen who supports his lifeless hand, while the wind blows her golden hair against her breast, to emphasise the emotional agitation caused by the sight of his body. Hers is the most luminous figure, and it marks the centre and the dramatic high point of the painting. The grey overgarment with mauve nuances forms a pale column, while her uncovered shoulder reveals carmine sleeves made from lightweight fabric. The focusing of light on her face serves to underline her wounded expression, which in turn points to that of the abandoned Christ. Having drawn attention to this point by using the gentle pressure of colours, gestures and facial expressions, Raphael had the brilliant idea of duplicating Christ's lifeless face in the other figure carrying the body, just above his head. The man's face is identical to Christ's, both in pose and in physiognomy, and this serves to highlight the sense of abandonment by amplifying it.

Both appear to implore the heavens or to seek heavenly justification for such pain. Following their gaze upwards – that of the bearer, with his entreating expression, and that of Christ in agony – the viewer looks up at the sky, where the dramatic energy and tension are dispelled: they fade slowly into the luminous horizon, where far-off mountains and a gentle river soothe and console the soul perturbed by this sacred drama.

A circle of reds draws attention to Christ's body: the sleeves of Mary Magdalen's dress; the shirt worn by the bearer traditionally identified as Grifonetto; and Saint John the Evangelist's cloak to the far left-hand side of the painting. The golden yellow tunic worn by Joseph of Arimathaea slices through the painting from top to bottom, like a shaft of light, drawing the eye to the interweaving bare feet of the figures in the background, which unite them in a light-footed dance and separate them from the shod feet of the bearers.

The entombment therefore becomes a dynamic narrative that immobilises the viewer. A classic model existed, the so-called Meleager relief showing a corpse being carried, which Raphael would almost certainly have known – if not directly, then through the engravings made by Mantegna, who was inspired by it and in part copied the arrangement; yet, as always, Raphael knew how to appropriate the models as intimately as to render the influence invisible, while he retained their substantive character. The altarpiece commissioned by the grieving Atalanta became so famous throughout Italy that a century later, in 1608, Cardinal Scipione Borghese ordered it to be removed, in the dead of night, from the church for which it was made, promising the angry Perugians that he would replace it with a copy executed by a leading painter of the time, Cavaliere d'Arpino. The latter's copy was duly returned, but it was darker. D'Arpino may have been misled by the layer of dirt that dimmed the colours, or perhaps, more simply, he felt that Italy was no longer characterised by the clear spring-like light that illuminated even the most dramatic scenes painted by the artists of the High Renaissance.

5 A SUDDEN DEPARTURE

While he was finishing off the painting for Atalanta Baglioni, Raphael was also working on an altarpiece for the Dei family. It was an extremely important painting, both on account of the patron and on account of its intended location (Plate 46). Indeed, unlike the various Madonnas and portraits that had been destined for private enjoyment in highly exclusive, albeit powerful circles, the altarpiece of the *Sacra conversazione* would be publicly displayed in one of the main Florentine churches, Santo Spirito, in a neighbourhood where many of the wealthy new

merchants and bankers had settled. Via Maggio was becoming lined with increasingly sumptuous buildings and the whole district now rivalled the old historical centre on the other side of the Arno as the most exclusive place to live in.

The painting was remarkable for its size: 279 centimetres by 217, quite an undertaking for a movable work. Moreover, because of the nature of the chapels at Santo Spirito, the entire architectural design of the chapel would serve as a frame to the painting.[12] This meant that the *Sacra conversazione* had to be set in a classical-looking apse whose vault with lacunars was just visible, decorated with rosettes and strictly antiquarian in style, supported by Corinthian columns that narrowed to flat pilasters against the curved wall. For what was one of his first architectural 'interiors', Raphael drew his inspiration almost literally from the Roman Pantheon, a building he knew from the collection of drawings circulating in Florence at the time, which have survived to the present day under the name *Codex excurialensis*.

At the centre of this apse, which extends ideally the real space created by Brunelleschi, which Raphael felt was too cramped, stands a *baldacchino* [baldaquin] that blends echoes from the Quattrocento with antiquarian motifs, also assimilated from collections of Roman drawings.[13] The Virgin and Child are seated on a dais under the *baldacchino*, while the saints and two singing putti stand at a lower level, the latter occupying the foreground of the painting and introducing an emotive and appealingly human 'genre scene', of a kind already anticipated by the two putti, who peek out behind Christ and the Virgin in the *Oddi Coronation*. The presence of the two putti and the fact that they are singing adds to the sacred conversation a sentimental note, apparently aimed at cheering the Mother and Child through their graceful gestures and looks, which are wholly admired for their happiness. Lastly, hovering above are two angels who lift the green curtain of the *baldacchino* to reveal the sight of Mary and her son to the saints and to the viewer. If they were to drop the curtain, both would immediately disappear from sight. The conversation is therefore seen as an apparition, a temporary gift of divine grace that can only become permanent through faith.

The narration here is solemn and monumental, but it is also imbued with a grace and a sentimental gentleness that were far removed from the colder interpretations given to the same subject by artists like Fra

Bartolomeo, Andrea del Sarto or others outside Florence. For the painting, Raphael chose to use the oil technique, over which he had acquired perfect mastery, and, because it was more flexible, it also allowed him to work for longer periods, as well as on other paintings. The fact that the painting remained at an advanced but still unfinished stage offers us an insight into Raphael's working methods at this time and reveals important traits of his character as an artist.

Other paintings, almost contemporaneous and from the same milieu, have survived at a stage of non-completion similar to that of Raphael's Dei altarpiece, and these offer a useful comparison. One is *The Manchester Madonna*, which some art historians of the last century attributed to Michelangelo. Another is the *Entombment*, which has also been attributed to Michelangelo, more on account of the suggestion of incompleteness linked to the Michelangelesque legend in the nineteenth century than on the grounds of any documentary or stylistic evidence.

In both paintings the contrast between the finished and the unfinished parts is much more evident than in Raphael's altarpiece. The anonymous author of the *Entombment*, for example, leaves some figures or parts of them at a very early stage, while perfectly completing other areas of the picture. Raphael adopted an entirely different method, gradually working over the whole painting, so that only careful observation reveals that some parts are still unfinished by comparison to others. This gradual way of painting, which brings everything to the same level in order to reconcile it at the same stage, confirms how far Raphael had progressed from the 'iconic' faith still visible in late Quattrocento and early Cinquecento painting. For him, the final outcome of each figure was not fixed a priori, but was gradually defined as the entire painting developed, allowing the vision to emerge gradually, as the mist enveloping the figures cleared away.

In the *Entombment*, which is now in the National Gallery, the artist could finish the figures separately because he knew exactly to what point they would be developed. This explains why some of the faces and draperies seem perfectly finished, while others are merely at a preparatory stage. On the contrary, Raphael left no one area behind the other, but progressed gradually with the whole painting, reconciling the parts at each stage, as they took shape. What interested him were

the relationships between the various parts. In a very modern sense, he thought of every work as a unique one, which was carried to completion through its own originality. This was an extremely modern attitude that led, for example, to the equal care being taken by the artist when he painted both drapery and flesh. Therefore the Dei altarpiece lacks the 'finishing glazes'; but the structure, the interdependencies and the chromatic relations are already established. Once the figures had been completed to the stage of *mezzi toni* [shades of grey], Raphael would have started on the next level of colour, because the final result had to be balanced.

In short, the artist sought the harmony for which he became famous. But the unfinished state of the Dei altarpiece shows that that psychological harmony, which charmed contemporaries right from his earliest works, relied on a special technique of painting, which developed gradually as the image materialised, even though Raphael's perfect drawing technique allowed him to study and plan both the composition and the individual figures in full.

Of course, this procedure was made possible through the use of oil paints, which meant that the same palette of colours could be kept for days, allowing the gradual saturation of the glazes. In an altarpiece painted in tempera, the artist would have had to finish one face or drapery at a time, because the colours were very complicated to prepare and preserve. The luminous quality of the painting is an undoubted beneficiary of this technique, allowing the light to be carefully calibrated so as to illuminate the flesh, and reconciling drapery and bodies as if they were immersed in a material atmosphere of the kind imagined by Leonardo. Here again, Raphael's style was dominated by Leonardo's bizarre genius, in a response to the market's demand for recognisability and to the need to complete the painted image without too many complications (as is also borne out by the *Madonna and Child* sketch in the Louvre).

While he was busy trying to finish the Dei altarpiece, Raphael wrote to his uncle in Urbino, Simone Ciarla, a letter dated 21 April 1501, which remains one of the key documents to understanding his state of mind during these months:

Dearest as a father. I have received a letter from you from which I learn of the death of our illustrious Duke. May God have mercy on his

soul! I could not read your letter without tears, but transiat, it cannot be altered; one must have patience and submit oneself to God's will. I wrote recently to my uncle the priest that he should send me the small panel which is the cover of the Madonna of our Prefetessa [Giovanna Feltria della Rovere, widow of the prefect of Rome]; but he has not sent it to me. Therefore I pray you let him know whenever there is a person who is to travel so that I can satisfy the gracious lady, for you must know that now one has good use for them. [. . .] I should like very much if it were possible to have a letter of recommendation from the prefect to the Gonfalonero [Pier Soderini] at Florence. A few days ago I wrote to uncle and to Giovanni da Roma [Giovanni Cristoforo da Romano] that they should procure me this, for it would be of much use to me with regard to the work of a certain room, the matter resting with His Holiness [Pope Julius II]. I entreat you, if it be possible, to send it to me, as I think that if you ask the prefect for it, he will have it prepared. Commend me a thousand times to him as his old servant and *familiare*.[14]

Once again, with unparalleled business acumen and courtly *savoir faire*, Raphael sought the protection of the court of Urbino before making the boldest move yet in his bid for success: the final sprint for Rome. There the interested parties were vying against one another to decorate the Vatican rooms – '*la stanza*' [the room] that he mentioned in his letter. In this sense a recommendation from Piero Soderini – who was accustomed to sending the best Florentine artists to Rome, following a tradition that had continued for at least a century – might prove crucial to Raphael's bid.

Once again, however, it was the Montefeltro family that helped him, and Francesco Maria della Rovere in particular. The latter was closely connected to the powerful court that Raphael had now in his sights, determined as he was to succeed by using every means at his disposal. Once again, the letter was duly sent and the outcome was so positive that Raphael did not think twice before abandoning his Florentine commissions and hastening to the eternal city. Nothing would have stopped him – neither the Dei altarpiece nor the frescos for San Severo, which did not progress further than the upper register and would only be finished years later by Perugino, in such a desultory fashion that

they became a lasting admonition of the extent to which the youthful artist had surpassed him. Raphael had had the intelligence to see which way the wind was blowing and where he had to be in order to fulfil his boyhood ambition of becoming Italy's leading painter.

4

IN ROME

1 THE HALF-HIDDEN RUINS

Raphael had spent the first 25 years of his life among the gently roll-
ing hills of Umbria and the rugged Apennines that bordered with
Tuscany. Now he started to journey towards Rome, the city that fired
the imagination, dreams and desires of those who shared his longing for
a renaissance of classical art and civilisation. Like all travellers from the
north, he approached the city along the Via Francigena, the safest route,
which was also used by pilgrims; it passed through the Val d'Orcia and
the countryside around Viterbo to arrive at Porta del Popolo.

Raphael had already seen drawings of the eternal city brought home
by travellers: in particular those made by the Florentines, who had
come to Rome over the past century or so to measure its ruins and
monuments in order to decipher the classical rules used to design them.
Many of these drawings had subsequently inspired the mysterious,
royal backgrounds seen in painted altarpieces, especially in the most
fashionable ones, which contained ideal reconstructions of monuments
and views of the ancient imperial capital. Raphael had copied them
and probably also discussed them with architects and painters in the
workshops and inns along the banks of the Arno. But he had also seen
the maps drawn by geographers and the statue collections at the courts

he had visited. In short, he already knew enough about the city to be
enamoured by it and to join the ranks of other Italian artists who had
fallen under its spell, convinced that, in Rome, art had once created
paradise on earth.

He also knew about the enchanted city where the almond trees
flowered just after Christmas and the sky, which seemed higher and
brighter than elsewhere, reflected the light from the sea nearby – the
Mediterranean, across which faith, art and philosophy had travelled.
Hence, when the call came to go to Rome, he did not hesitate for one
minute. Casting his usual rationality aside, he decided not to finish the
frescos for San Severo in Perugia, thereby disappointing the city. Nor
did he do more justice to Florence, where he left the *Sacra conversazi-
one* for the Dei family incomplete. Before the oil had even dried on his
brushes, he set out along the road that led to the papal city.

As he approached from the north, the damp volcanic tuff of the
Cimini Hills, aflame with the last golden leaves on the century-old
sweet chestnut trees that had stubbornly resisted the onset of autumn,
finally gave way to the holm oaks and laurels of the hills around Rome.
A short distance from the woods surrounding the Tiber, he found
himself in front of the Aurelian Walls, whose incredibly even brick-
work towered over the Porta del Popolo from an unimaginable height.
Passing through the enormous gateway between tall square towers, he
entered a piazza whose grandiose scale gave him a foretaste of the entire
city. On the left-hand side was the Augustinian church of Santa Maria,
butted against a wall some hundred metres long, which enclosed the
convent's vineyards – an area of cultivated ground, accessed through a
gateway marked by the mere suggestion of an arched lintel. There was
only a modest opening in the centre of the wall, on which the purple-
black *pozzolana* [pozzolan, volcanic ash] served as a foil for the brilliant
red bricks and greenish yellow blocks of tuff known as *tufelli*, whose
plaster was already worn. In contrast, the church at the north end of the
wall was sufficient to proclaim the rich artistry that was embellishing
the city again.

As he climbed the short flight of steps and entered the church,
Raphael was dazed by the innovations of the interior. The choir had
been renovated by Donato Bramante, the architect whose classical
knowledge and expertise in creating illusions was pre-eminent in the

city at the time. It was this skill, based on draughtsmanship alone, that had enabled him to transform a small fifteenth-century choir into a large space filled with references to classical architecture. Then there were the paintings by Pinturicchio with whom Raphael had already worked in Siena, and the tomb for Cardinal Girolamo Basso della Rovere, carved by Andrea Sansovino according to methods the like of which had not yet been seen in Florence. Raphael had only to walk across the main nave to understand that this church contained the very latest works of sculpture, painting and architecture in Rome – all in a building flanking a wall that, for a thousand years, had divided the civilisation of the Urbs from the barbarian countryside.

On the other side of the piazza was a maze of small houses and narrow streets running alongside the Tiber. Opposite the vineyard belonging to the Augustinians were other, less well-to-do gardens, which separated the piazza from the river and from the walls, and which in time would be turned into rather dingy houses used by the city's new inhabitants. The young artist had never been in a large city, and this first sight of Rome undoubtedly left a deep impression, which he would develop over the years by using the rational approach that was the hallmark of his genius. It was still possible to glimpse the greatness that, a thousand years earlier, had made the city home to millions. Now its skeleton was virtually buried by the countryside, the vineyards and the woods; but fragments of the imperial monuments still emerged, like a giant's indestructible bones. The Colosseum was still buried up to the lower arches, which were now used to shelter herds of cattle and sheep; but it was virtually intact, and the immense ring of travertine stone was gilded by the patina of time, like the rock faces of an abandoned quarry. The gigantic columns of the Temple of Saturn and those of Venus and Roma rose up from the tangle of undergrowth – great shafts of granite and marble quarried in a single block, with the help of long-forgotten techniques. Transported from Africa on strong boats, yet easy ones to manoeuvre, they had been hoisted into position 15 centuries earlier and crowned with capitals and friezes carved with a refinement that was on a par with the natural grandeur of the stone.[1]

The hardness of these materials – marble, granite and the travertine quarried only a few miles outside Rome – meant that even the reliefs had remained miraculously intact, down to their detail. This, too, was a

sign, or so it seemed, of the city's eternal destiny. In Florence the flaky and crumbling sandstone rendered the vague outlines of works made by sculptors only two or three generations earlier already difficult to decipher. Yet in Rome works by sculptors and masons who had worked 1,500 years earlier were distinct and sharp in the clear southern sunlight. Even the works that were still buried were well preserved, as was evident from the statues excavated precisely during this period, which came out of the soil like some sort of miraculous harvest. This much had been understood by Brunelleschi and Donatello, who, tired of the tales and incomplete sketches reaching Florence, had decided to come straight to Rome to see the excavations for themselves and to draw the column bases and pedestals still half-buried in the earth, among roots of vines and apple trees. In order to understand exactly how a *cyma reversa* [part concave, part convex moulding] was twisted, or how foliage or an *ovolo* [quarter-round convex moulding] motif on a cornice was tapered, they examined these details with the pragmatism typical of Florentines accustomed to believing only what they saw with their own eyes. They paid the porters and workers with their own money, as Brunelleschi's biographer Antonio di Tuccio Manetti was at pains to emphasise:

> [S]ince they undertook excavations to find the junctures of the membering and to uncover objects and buildings in many places where there was some indication, to do so they had to hire porters and other labourers which involved costs and no small expense, given that no one else had attempted the same.[2]

The missing parts of ancient monuments had been lifted to build medieval Rome. The bricks, formed according to exact measurements and baked by the Romans, had been used to create new floors. The marble and the tuff blocks from the walls had become cornerstones for buildings constructed by the *opus incertum* method [of irregularly placed stones]. Even the *pozzolana* had been pulverised and remixed with lime, to create mortars and plasters for new buildings. The whole city had become a miraculous open-air quarry from which materials were plundered whenever required. Moreover, no one thought twice about burning ancient statues to make lime in the furnaces huddled around the walls, even though one needed not go further than Tivoli to find

the same compact Travertine blocks that had given the Romans the best lime in Italy.

Columns, architraves, capitals and every other construction detail used in the imperial palaces had been deconstructed, like the words of a speech that could no longer be understood; then they had been reassembled to create a new language, which gradually began to sound less like a babble and more like the poetic language that Raphael himself, together with others, would develop in later years. In an intricate maze of towers, arches and twisting passages, of small churches and palaces barely deserving of the name, the population, which may even have been around 200,000, including the vast numbers of pilgrims, appeared to live without too much difficulty, eking out a living in the wreck of this huge vessel. But they had started to embrace the dream of a rebirth, whose tangible realisation lay in the construction of new monuments as grandiose and harmonious as their ancient predecessors.

Raphael knew that not all the ancient monuments had turned into ruins. He had seen drawings of the Pantheon, which was still standing, and it was known as the church of Santa Maria dei Martiri; its interior was clad with the finest polychrome marbles, whose beauty could not be equalled by any drawing and which certainly amazed the young man on his arrival. Although the magnificent building was besieged by swarms of dilapidated houses that climbed it like parasitic plants, its huge dome, swelling softly like a mother's breast, dominated the entire city and was visible from the nearby hills, from the gardens of San Silvestro al Quirinale, from the vineyards on the Gianicolo and from the terraces of the convents on the Aventine hill. This monument alone sufficed to show the perfection attained by Roman architects.

The convents had enclosed major areas of ground; and so had the local nobility, for centuries locked in a power struggle with the popes for control of the city. The Colonna, the Orsini, the Savelli and the Caetani had all laid claim to parts of the city, fortifying them and making them impregnable against other rivals. They constituted a lay power, constantly torn by in-fighting, with which Peter's successors had to come to terms – as had the city government, a merely formal body that represented the weak Roman bourgeoisie of agrarian origin, whose power had dwindled away for over a century. The minor nobility, who reared cattle and sold grain, had harboured the illusion of becoming a

mercantile class in the fourteenth century. But other prospects lay in store for Rome.

It was not a city of bankers or industrialists, but rather a city of craftsmen whose survival depended on the papal court. The lay city, which served the papal court and its visiting foreign ambassadors as well as the unending stream of pilgrims from all over Europe, had developed in a minute area of the old imperial city, between Piazza del Popolo and the glorious Campidoglio, bordered to the west by the Tiber and to the east by the fora and by the Quirinal and Esquiline hills. On arrival Raphael made his way past the rows of wretched hovels that lined the streets and had crept in even among the old buildings, clear evidence of the city's economic mediocrity. No comparison could possibly be made, not just with the ancient monuments that emerged from the ground, but even with the palaces that had been built in Florence over the past two centuries, by merchants and bankers whose accumulated wealth was envied throughout the known world.

One only had to ride a short distance beyond the portico of San Pietro in Vincoli, or behind the monumental arches of the Colosseum, to find oneself in open countryside, invaded by wolves. The *luparii* [wolfcatchers] had their work cut out to protect, not only the herds of cattle that wintered inside the city walls, but also the flocks of naïve pilgrims who, after taking their vows, ventured into the ruins of Augustus' house or behind the convents on the Aventine, in pursuit of decidedly less spiritual ends, and happily loosened their breeches in the arms of the prostitutes – who exercised one of the city's most prolific and productive trades. At the more affluent end of the scale, the population of Rome was swelled by pilgrims from all over Europe who provided work for hotels, inns, tailors and, once again, prostitutes. Indeed, the latter catered both for the noble foreigner enamoured of the legendary charms of the city's courtesans and for the poor craftsman from Milan who, having made the journey solely for devotional reasons, spent his last few pennies on more basic needs. The next day they would both have been absolved by one out of the hundreds of confessors on hand in churches, who were willing to pardon even less trivial sins in return for a modest oblation.

Among the woods and vineyards enclosed by *tufelli* and brick walls, Raphael saw the large arches of baths, fora and imperial palaces, which

were now used as grottos and caverns in whose shadow all manner of dangers lurked. Francesco Guicciardini cut to the chase when he described the city as 'a den of thieves and assassins' where the law was a vague and distant memory. But the artist's eye was focused elsewhere: it skimmed rapidly over the ruins, imagining their primitive appearance, their grandeur, and the harmony and wealth that he would dearly have liked to emulate in his works. Nor was he alone. Having already reached the end of Piazza del Popolo, his wandering gaze spotted a cyclopic wooden framework on the Vatican hill beyond the placid Tiber, which was now swollen by autumn rains: the framework linked the old basilica to the Villa del Belvedere, built by Innocent VIII on the highest point of the hill. Thousands of workers were moving among the chestnut uprights and the fir planks tied together by ropes and nails. They were building the first grandiose work through which the man who had summoned Raphael to Rome intended to alter the city's image and layout. Together with the new basilica of St Peter's, this construction had already won renown as the greatest Italian enterprise of the age: it was the Belvedere 'corridor' – a three-storey portico that linked the highest part of the hill to the Vatican basilica and offset the difference in height between them by creating a dramatically stepped terrace. The man was Giuliano della Rovere, and he had been elected pope in 1503 and took the name of Julius II.

2 FROM CHALICES TO HELMETS

The city spread before his eyes, which seemed endless to him (and to all European travellers) more on account of the memories it evoked than for the space it occupied, was a difficult one to win over. But Raphael arrived with an advantage that no other artist could boast. To win Florence over to him, he had used the influence of Giovanna di Montefeltro. To ease his arrival in Rome, he had sought and obtained the support of her son, Francesco Maria della Rovere, who had become duke of Urbino when his uncle (his adoptive father Guidobaldo da Montefeltro, Giovanna's brother) died in the spring of 1508. Raphael never forgot that political contacts were as essential to professional success as talent and artistic effort.

He made his request in May 1508. On 13 January 1509, barely

seven months later, his name already appeared in the register of payments made by the Apostolic Chamber: he had received 100 ducats for painting the rooms of the Vatican Palace.

> *Die XIII januarii 1509. [. . .] magister Raphael Johannis Santi de Urbino pictor confessus fuit habuisse et manualiter recipisse a S.mo domino nostro, per manus R.mi domini Thesaurarii Sue Sanctitatis [. . .] ducatos centum de carlenis ad rationem decem carlenorum pro quolibet ducato veteris monete, ad bonum computum picture camere de medio eiusdem San[c]titatis testudinate.*[3]

13 January 1509. [. . .] master Raphael from Urbino, painter of Saint John, has acknowledged receiving in his own hand, from His Highness our lord, through the hand of His Sanctity's lord treasurer, 100 ducats of *carlini*,* at the rate of 10 *carlini* for any ducat in coins of the old style, on good reckoning of the painting in His Sanctity's room, whose middle part is arched like a turtle shell.

As with Michelangelo Buonarroti, there was an instant understanding between the pope and the young artist. Julius II had a gift for sizing up those he met; add to this the fact that he had already been able to appreciate Raphael's talent on one of his military expeditions, when he visited Perugia and Urbino, both of which boasted examples of the artist's work. The pope must have been particularly struck by the fresco in the chapel of San Severo, given that he asked Raphael to include an enlarged version of it in the first work he commissioned for the papal apartments, *The Disputation of the Holy Sacrament*. Raphael's initial drawings for this fresco continued to show Christ in an identical pose of triumph, although he altered the composition in the final work.

The man whom Raphael met in the winter of 1508 was over 60, his raven black hair now greying, but he had lost nothing of the charm and extraordinary energy that had made him legendary throughout Europe. With broad shoulders strengthened by rowing, as a young man, off the coast of Savona, and with sinewy legs that had climbed the stone steps between the cultivated terraces cut into the hillside of Albissola, where

* A carlino was a Roman coin in use throughout medieval and Renaissance times. (Translator's note)

he was born in 1443, the pope was a skilled rider even on the roughest ground, where the rest of his followers would sink into the mud.

He had a prominent but handsomely straight nose and wide cheekbones that gave his face a masculine strength, more suited to a *condottiere* than to a pope. His pale skin became flushed during the frequent angry outbursts that terrorised everyone within the range of his thrashing stick. He could not bear to be gainsaid and thought nothing of throwing any object he could lay his hands on, even sacred paraments. The pope came from a humble background; his family had tended the hilly land in foothills to the Ligurian Alps, as well as managing a small textile company that barely met the needs of its members; but his youth was a wild and happy one, which he spent on some the most beautiful coastline and hillsides in Italy. His uncle Francesco – a man of uncommon intelligence who had acquired his learning as part of a strict education as a theologian under the Franciscans, an order he joined as a very young man – was the one who had altered the fortunes of the entire family. Thanks to his erudition, Francesco abandoned the rugged, stony mule tracks of his homeland and started to climb the much steeper steps of the fifteenth-century social pyramid, aiming straight for the top of the ecclesiastical hierarchy.

His ambition was fulfilled in 1471, when, not long after becoming minister general of the Franciscan order, he was elected pope and took the name Sixtus IV.[4] The turning point that decided his rise to the highest office of the Roman curia was the final settlement of a dispute about the nature of Christ's blood, which had raged throughout Europe since the middle of the century, dividing the Catholic world and pitting Franciscans against Dominicans. To settle the controversy, Pope Pius II had invited both orders to debate their points of view publicly in the Vatican in December 1462. Francesco della Rovere made such an erudite case for the Franciscan view, according to which any remains of Christ's body not reintegrated into the divine body must be objects of devout worship, that he had completely undermined the Dominicans' arguments. It was widely acknowledged that the dispute was therefore settled unequivocally in favour of the Franciscans, entirely thanks to the first della Rovere cardinal. After being elected pope, he revealed very clear-cut ideas about the role of the papacy and the church. Only the effective reinforcement of the popes' temporal power would allow the

church and its clergy to escape the whims and oppression of lay princes
and barons, thereby also enabling the popes to fulfil their spiritual
and evangelical mission. To implement his strategy for the political
consolidation of the papacy, Sixtus called on his most able relatives,
as was natural and appropriate. One of these was Giuliano, who was
nominated bishop of Carpentras and then made cardinal of San Pietro
in Vincoli on 15 December 1471, and before long he became his uncle's
most trusted ally in the energetic policy of defending the papacy's
temporal interests. As papal legate, Giuliano was sent to France and
Avignon to oversee the tricky political scene of northern Europe; it
was there that he proved his mettle, with an energy and determination
rarely found in a prince of the church.

Even after the death of Giuliano's uncle, Giuliano's political exper-
tise was invaluable to the Roman curia, which entrusted him with
increasingly delicate missions. These suited his warrior's tempera-
ment, but they also brought him into conflict with the Borgia pope,
Alexander VI, who had the same temperament but pursued ends that
did not always coincide with those of the papacy. Cardinal della Rovere
had been so active in temporal politics that, when he made his entrance
into Rome on 31 December 1494, together with the allies who had
temporarily defeated the Spanish pope, he rode alongside Charles VIII,
surrounded by the latter's troops. The crowds who thronged the city,
carrying burning torches to light the way and heat the air, welcomed
him as a prince, with shouts of 'France, Colonna and Vincoli', as if he
were another *condottiere*.

This triumphal entry heralded the start of ten terrible years for
Giuliano, who was forced into exile in France in order to escape the
aggression of the Borgia. But in 1503, when Alexander VI died, he
returned promptly to Rome. His political *savoir faire* was such that,
immediately after the short-lived pontificate of Pius III, Giuliano was
elected pope within the space of a few hours, on the night of 31 October
1503, after a series of perhaps overly self-assured negotiations with his
allies and enemies. By the morning of 1 November Italy and Europe
were well aware of what lay ahead. His predecessor had dismembered
the papal states, in an attempt to create a kingdom for his son Cesare.
Julius II would not rest until he reconquered the lost territories, and
in the meantime he threatened powers like Venice and France, which

had taken advantage of the situation to annex entire cities belonging to the papal states – as small local despots had also done, in particular the Baglioni in Perugia and the Bentivoglio in Bologna.

Julius' plans focused not only on restoring the integrity of the papal states, but also on making them the fulcrum of Italian politics, with the aim of excluding foreign powers – those 'barbarians' against whom he promptly started to wage a battle without quarter. It was not long before politics was transformed into military action, and Julius set down his chalice and crucifix to don a war helmet and sword. The most incisive depiction of the atmosphere in the eternal city during this period has been left to us by another great artist summoned to Rome by the pope, Michelangelo Buonarroti, who described in verse the experience of finding himself at the centre of a military fortress rather than in Europe's spiritual capital. 'Here from chalices helmets and swords are made; the blood of Christ is sold by the bucketful; his cross and thorns are lances and shields – and still Christ shows patience.'[5]

On 17 August 1506 Julius called a secret consistory, without regard for the sweltering heat that exhausted the elderly cardinals and church dignitaries, accustomed as they were to the welcoming half-light of age-old monasteries. As dawn broke on 22 August, he rode out of the Vatican. The rest of the curia followed, fearful of his indignation should they refuse. Only the infirm and aged were left in the city. After giving a last benediction to the crowds gathered at the foot of the city walls, he and his army rode swiftly to Formello, and then north, to Viterbo and Orvieto. There he rapidly changed his clothes, taking off his armour and once more donning the papal vestments, so that he could give blessings and celebrate masses before the enraptured crowds. In the square in front of the cathedral of Orvieto, towering like a mountain and sparkling with gold mosaics, the citizens erected an oak tree whose branches were thronged with boys dressed as angels reciting Latin verses, accompanied by a man dressed as Orpheus. Even at the height of a military campaign, no one could ignore the refined culture of a pope who wished to evoke classical antiquity.

The gates of the enemy cities opened as if by magic, without any blood being spilled. The despots were overcome by the force of the pope's willpower alone. His triumphal entrance into Perugia on 13 September was marked by bell-peeling and colourful displays.

Triumphal arches were erected and the finest cloths and tapestries hung from the windows, and the pope's success amazed even Machiavelli, who witnessed the event. A more difficult enterprise was the conquest of Bologna in what was already proving to be a singular triumphal march, captained by a man whose presence as the first warrior pope in history dumbfounded the world. Autumn arrived in a flurry of rain and wind, but the pope did not stop. He got off his horse and continued on foot, up the impassable gorge of Mutilano. He was exhausted, but unwilling to give in or fall behind his army. Instead he urged his followers on by reciting the *Aeneid* to them as they struggled over the rough terrain: *Per varios casus, per tot discrimina rerum / Tendimus in Latium* ('Through varied fortunes, through countless hazards, we journey towards Latium').[6]

But the worst was over. On All Saints' Day the Bentivoglio fled from Bologna. The pope entered the city incognito a few days later, and then he made his triumphal entry on 11 November. Once again it seemed that his plans had been given divine approval and that nothing could stand in the way of his success. The Indian summer thawed the frosts and encouraged the roses to bloom: his triumph was complete. The musicians, the standards and the costumes worn by the knights and by the members of Bolognese nobility who escorted the papal procession did the rest.

After he had sorted out the government in Bologna, Julius II left the city to return to Rome. He arrived on 27 March. He was convinced that his policies would meet with no further obstacles and that nothing would now detract him from other battles: propaganda battles that would act as a magnet for artists from all over Italy and, before long, would draw Raphael himself to Rome.

3 THE WAR OF IMAGES

The creation of a strong temporal state, which finally safeguarded the apostolic see, placing it within securely established and well-guarded boundaries, was also intended to resolve a series of questions relating to the government of Rome. It was vital to undermine the power of the noble families that, for centuries, had contested the papacy's military and political control of the city: from now on the Colonna, the Orsini,

the Savelli and the Caetani would be honour-bound to become obedient feudatories. On the other hand, the timid city merchants who sat as conservators and senators, those ancient institutions housed on the glorious Campidoglio, had to understand that there was not room for another centre of power in Rome, or at least that any communal powers had to be hierarchically structured under the pope's authority. In his attempt to centralise the curia, the pope also curbed the influence of the consistory of cardinals, notwithstanding the theological consequences of this choice.

Julius II allowed the enthusiasm of the Roman people for his military energy to express itself in the marvellous ephemeral architecture that welcomed him in 1507 on his victorious return from Bologna. For a few days the triumphal arches, paintings and festoons of flowers transported the city back to the days of its imperial splendour. But immediately afterwards he issued a series of measures aimed at curbing and weakening the autonomy and power of the ruling classes in lay and communal Rome. The fixed price imposed on bread and prime necessities was intended to put a brake on the wealth accumulated by noble families, since they could not buy grain except for their own use and therefore could not profit from price rises at times of shortage. Imposing new taxes and issuing a new coin formed part of a lucid programme aimed at undermining the power of the communal and baronial factions in Rome.

There was another aspect of this policy of reinforcing papal authority in which Julius firmly believed, also because it echoed his own innate conviction and overwhelming passion: the papal city had to demonstrate visibly its strength and power, and this could only be achieved through art, in all its forms. This was the project closest to Julius' heart, the one to which he could at last dedicate himself, after the exhausting military campaign that had occupied all his attention the year before. According to the chroniclers, he engaged in lively discussions on the subject with his art agents in the evenings, over dinner. His fondness for red wine made daring ideas seem more feasible and gave an ironic edge to the angry outbursts that made the foreign ambassadors assembled at the papal hearings tremble in fear. Luckily enough, his passionate determination, brought into focus by his clear-cut political plans, coincided with that of others, who were driven by an equal commitment to

transform the image of the city: to 'establish' – as Donato Bramante, the pope's chief collaborator, liked to say – the ancient and glorious image of imperial Rome.

Julius had one enormous advantage in this project, one that would make his papacy the culmination of Italy's renaissance of art and culture. He was an extraordinary collector. Already as cardinal of San Pietro in Vincoli, he had used the garden next to the church as a setting for the best sculptures unearthed from the growing number of archaeological digs, which were becoming one of the city's prime economic assets. The first and most renowned of these statues was the Apollo named after the small building where Julius housed it as soon as he moved into the Vatican: the Belvedere. He was so intoxicated with the statue that cruel gossip and the poisonous hostility of his political enemies started to spread rumours about that passion, comparing it to other passions for much warmer but equally handsome men. During the Bologna campaign, a number of satirical sonnets against the pope had circulated throughout Italy and, like others that tried to smear his image later on, did not leave much for the imagination. The most explicit accused him of being 'well supplied with Corso, Tribiam [Trebbiano], Malvasia [the finest wines], and versed in the fine ways of sodomy; you will be less blamed in company of Squarzia and Curzio in the papal palace keeping a bottle in your mouth and your cock in an arse'.[7] Wine and the male organ were said to be the real passions of the della Rovere pope. But if the former seemed to give him superhuman physical energy during his battles, the latter never affected his manifest virility – as indeed was true of the other Julius, whom he took as a model: Julius Caesar had been equally famous for his strength as a warrior and the range of his sexual preferences.

Julius II also had lengthy love affairs with women, from which he had three daughters. The last, Felicia, was at his side throughout his pontificate and in exchange received a profound but measured degree of fatherly love, in a show of devotion that was exemplary for the time. Moreover, Julius found moral support in female company even before he fathered and cared for Felicia. This was seen in his relationship with his youngest sister Luchina, who had moved to Rome to be close to her brother and whose death so affected the pope that he could not restrain his tears in public.

This vitality, complete in all its aspects, was another contributing factor that made Julius II a patron of the kind never to be seen again in Western history, one capable of understanding, without a moment's hesitation, the possibilities offered by art and of promoting it regardless of costs. His gifted and trained eye needed no further confirmation to judge the worth of a project or artist. It is for this reason that he reached an immediate understanding with Michelangelo, only a few days after summoning him from Florence to Rome: an understanding that led to the commissioning of a huge project – the creation of his tomb – and that he reached even without waiting to see a wooden model, as was generally the custom for such financially onerous works.

On 18 April 1506 Julius personally visited the mouth of the six-metre deep trench, to lay the first stone of the new basilica of St Peter's. As he slowly descended the rungs of the ladder standing on the tuff bedrock that would serve as foundations of the new building, he carried a small silver vase containing two gold and ten bronze medals. On one side of the coins was his profile, on the other the new church, designed by Donato Bramante. The cardinals watched him with a mixture of horror and admiration. In consistory they had unsuccessfully tried to halt the plans to tear down Constantine's old basilica and to build a new one, designed to cover an area of 24,000 square metres. But, faced with the pope's fury, they had had to give way. Who could have resisted him?

In all the projects pursued by Julius II, we know with certainty that the starting point was the figurative world of classical antiquity. On the ceiling of the Sistine Chapel the angels were removed to make way for Apollonian divinities, which were godly only in their nudity. For his tomb, which he continued to design alongside Michelangelo, pagan allegories with their perfect bodies replaced Christian allegories, barely leaving room for a Virgin and Child that had to distinguish the tomb of a Christian pope from that of a Roman emperor. Even the great architectural projects he embarked on with Bramante – the Belvedere 'corridor', the new St Peter's, the tribunal palaces on Via Giulia – were all characterised by their form *all'antica* [antiquising, in the style of classical antiquity].

The project on which Raphael, together with other leading Italian painters, had been summoned to work was the decoration of the Vatican apartments, which Julius had recently ordered his architect

Donato Bramante to renovate. These apartments, the focal point of
public and diplomatic life at the papal court, became the centre of
the pope's propaganda campaign after he came back from Bologna.
He could no longer tolerate the idea of living in the rooms decorated
by Pinturicchio and occupied by his predecessor, Alessandro Borgia,
whom he loathed. So he decided to refurbish a new apartment, on the
upper floor of the palace built by Nicholas V. His living quarters were
designed to celebrate the pope and the church in an antiquising style,
following a precise cultural scheme implemented by the papal court
at the time. This scheme aimed to reincorporate the best of ancient
philosophy into the Christian tradition, so that the latter could show
itself to be the heir of the culture that was unanimously recognised as
the foundation of Western civilisation. At the same time the Christian
theological tradition had to be represented as a natural development
of the pagan, but without revealing the contradictions and conflicts
between Plato and St Augustine.

Julius was the first modern man to understand that the persuasive
force of art and images could, if well executed, overcome any politi-
cal circumstance or radical conflict. For decades, the society he lived
in had thought of ideal representation as a miracle capable of altering
reality itself. Fifteenth-century rulers had done this by decorating their
palaces with images that gave legitimacy to an authority founded all too
often on crime and tyranny. Now it was the turn of the church: when
it came to images and their use, the church could call on millennia of
experience, as well as relying on the support of intellectuals and schol-
ars – who were never before concentrated in such great numbers in a
single place as at the court of Julius II.

But the decoration of the new papal apartments also had to cel-
ebrate the della Rovere pope, his family and his achievements. Julius
II knew that a skilful propaganda campaign could serve as one of the
most effective instruments in bringing about his ambitious plans and in
convincing the world of their legitimacy. During the early days of his
pontificate, he started to alter and reinforce his own visible appearance,
replacing some of the jewels in the papal tiara with pearls and rubies of
fantastic value. He amazed the old master of ceremonies in the Vatican
by personally deciding which liturgical robes to wear on the various
ceremonial occasions. On 5 December 1503 he finally donned the new

tiara and the precious white cope that had belonged to Innocent VIII, but he refused to wear the fanon, the cord, the dalmatic and chasuble, or even the maniple or the pallium – ornaments that made him look less like a warrior and more like a priest: 'he argued that the pope should only dress in these garments when he celebrated mass'.[8]

If his wardrobe was unconventional, it was matched by the choices he was about to make for the decoration of the rooms: these would amount to nothing less than a new manifesto of papal power. The programme for the new apartments was drawn up under the pope's close supervision. Although he was not a sophisticated theologian, he was a cultured man with a sharp intellect, as was already clear from his collections and his way of reciting poetry at critical moments of his military campaigns. Therefore, just as his uncle, Pope Sixtus IV, had done when decorating the walls of the Sistine Chapel, Julius gathered the best Italian painters to work on his project. Giovanni Antonio Bazzi, known as Sodoma, came from Vercelli; Bramantino came from Milan, together with Cesare from Sesto, Lorenzo Lotto from Treviso, Jacopo Ripanda from Bologna, Baldassarre Peruzzi from Siena, and Perugino and Luca Signorelli from Umbria. Michelangelo, who at that time held a special place in the pope's affections, was commissioned – not without a considerable struggle – to paint the Sistine ceiling, right below the rooms that were to be decorated by the other artists.

By early or mid-1508 at the latest, all these painters were put to work. Julius oversaw the work anxiously, while continuing to plan new campaigns, undoubtedly inspired by the sense of grandeur that he saw burgeoning around him. After the victory against Bologna and Perugia, he now set his sights on Venice, with the aim of forcing the republic to renounce the areas of Romagna that it had occupied at the time of Cesare Borgia. Julius' policy involved the foreign powers in a game where the stakes grew ever higher.

Raphael was summoned to Rome at some point between the autumn and the winter of 1508. The affection, or at least the ready acceptance of the man behind most of the pope's projects, Donato Bramante, was almost certainly added to the warm recommendations of the Urbinate court – which had become by then another court of the della Rovere family and a lay extension of papal power. Bramante's birthplace was only a few kilometres away from Urbino, which meant that he was

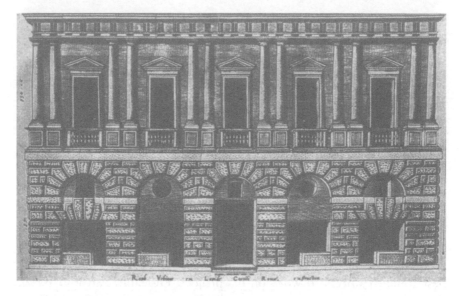

Figure 2 Bramante, Palazzo Caprini, Rome, c. 1510.
Engraving by A. Lafréry, 1549

linked to the young artist by shared local allegiances. Julius knew that, for an ambitious programme like the papal apartments, he needed a new man, someone who could grasp the subtle but vital link between politics and image and bolster conviction and understanding around the prince. This would require more than the devout fifteenth-century painters of sacred images or the decorative bourgeois fantasists who had made Florence shine in the past. What was needed was a new artist, someone with exceptional talent, who was familiar with the latest trends but who could also fit in with the complex intellectual life at the papal court.

Who could have filled that role better than Raphael, the son of an artist who had played exactly that role, albeit in a more restricted setting? The singular circumstances of his birth, his connections, and even his way of life were the best guarantee for the pope's bold project. The young artist arrived, with his swan-like neck and his round dark eyes, which stared avidly out at the world. Even the clothes he wore were much more elegant than a painter's. Yet his manner was made amiable

by the unassuming air of being someone who did not expect to receive any more than he was given, for which he was sincerely grateful. This was the persona fashioned in the self-portraits that Raphael included on the walls of the *stanze* [rooms].* It was also one of the traits that the old warrior pope found most convincing, since, first and foremost, he was a skilful diplomat whose hooded eyes peered deep into the souls of those he spoke to. Raphael's elegant ways were an expression of Urbinate culture, which saw in naturalness, harmony and restrained detachment the key to modern existence. *Sprezzatura*, to use a term coined by Raphael's close friend Baldassarre Castiglione, was precisely this ability to make appear natural anything that was strived after or passionately desired: a seeming detachment from everyday objects that, for Raphael, was a way of being.

We can imagine what the pope felt when he first saw the young man who had already demonstrated so much talent and who ranked alongside the other colossus who was pacing up and down the wooden scaffolding in the Vatican, Michelangelo Buonarroti – in contrast with him, but with equal greatness. Julius had immediately realised that, with Michelangelo, he was dealing with an indomitable personality. After quarrelling violently, the pope, whose military prowess made rulers quake, had left the artist to his own devices: 'we know', he wrote resignedly to Piero Soderini, 'what such men are like'.

Banished to the scaffolds of the Sistine Chapel and left mainly on his own in the dim light of oil lamps, Michelangelo did nothing but express himself, pouring out his immense torment, to the glory of his patron. His relations with the pope and with the court were non-existent. With the young artist from Urbino everything was quite different: he left Florence when he was first summoned, downing his brushes without even bothering to finish the commissions he was working on. He was exactly what Julius and his court were looking for, and from the outset Raphael found himself enveloped in a web of increasingly complex relationships. Julius knew that he could mould this talent to his project, and therefore he offered every possible form of support. Raphael repaid him straightaway by exceeding all expectations. The papal court that

* In the present context, this term refers specifically to the rooms decorated by Raphael for Julius and then Leo. (Translator's note)

he painted on the walls of the first room was the best possible image
of triumphant civilisation, and only a mind that was fully engaged in
the project could have depicted the figures in the painting with such
warmth and sympathy, bringing them to life and making them so
extraordinarily seductive.

4 THE RISE TO PRIMACY

When Raphael started to paint the rooms intended to be used as Julius
II's apartments, he was at something of a disadvantage compared to
other artists. He was the youngest of all those involved, and, although
he had had plenty of experience with easel painting, painting directly
onto the wall was still something relatively new for him. Above all, he
had no trusted assistants to help him.

However, in the keenly competitive atmosphere that Julius deliber-
ately created, so that each artist would do his utmost to excel, the older
ones soon began to show considerable concern as they watched the
young man from the Marches, with his courteous manners and angelic
smile, paint the wall with his vair brushes and copy the drawings in a
confident hand from a sketchbook as thick as a travel case. Any disad-
vantage rapidly turned to his benefit, because it allowed him to produce
a painting that was entirely his own work, yet suffered no downfall
in quality. The sum he was paid in January 1509 was a considerable
amount, in return for a work of huge proportions.

To start with, Raphael dedicated an enormous amount of time to
making studies. This is borne out by the numerous preparatory draw-
ings for what was the first painting he completed for the Vatican *stanze*,
The Disputation of the Holy Sacrament (Plate 11). These drawings show
how the figures, positioned in a circle on two levels and intent on
commenting on the sacred books, were gradually adapted to various
architectural scenarios, perhaps echoing what Fra Bartolomeo had
done in Florence in the frescos for the Ospedale di Santa Maria Nuova,
but above all what Raphael himself had done in the church of San
Severo in Perugia. In the end the figures occupied a spatial arrange-
ment that broke free of any Quattrocento influence. Using a criterion
that can already be described as wholly classical, the organisation of the
figures was dictated by their individual poses, by the way they stood

and by the psychological dialogue in which they were engaged. There was no longer any need for a setting. Above all, in the upper register, the saints and prophets sitting on the clouds appear naturally at ease. The sense of balance conveyed by the figure of Adam, who sits with his legs crossed, had never been achieved before. The entire story was told by the figures and by the way they inhabited the space. In the frescos in San Severo the same figures, seated on clouds, were rigidly lined up through a simple perspective, which made the rows of clouds converge towards Christ's body. Those lines were now curved instead, re-creating a feeling of space that was much more profound and natural. The psychological relations between the various groups in the scene, and the attention paid to the anatomical foreshortening – these alone structured the image. The rest was achieved through the softness of expressions and through the refined harmony of colours – all tones of blues and complementary contrasts.

When spring finally loosened the grip of the icy winter of 1509, which had held central Italy fast in ice and snow, allowing the soft plaster to absorb the colour smoothly and without hindrance on the wall section entrusted to Raphael, the other artists watched as draped robes gracefully appeared on bodies that were first studied nude and then clothed with the expertise of a tailor. Day after day they saw the throng of actors move into place, in orderly fashion, one beside the other, as in a well-rehearsed production in which the outline of their feet was marked on the ground and that of their bodies was marked against an invisible backdrop. The onlookers watched as the space was populated without becoming a crush. Then, overwhelmed by surprise, they witnessed the appearance of touchingly graceful and credible expressions on the figures' faces.

Their concern grew more acute as soon as Raphael turned a portion of the wall into a calm sky to provide the setting for the upper part of the *The Disputation of the Holy Sacrament*. Lastly, it turned to condemnation when the theologians and doctors of the church took their place below the semicircle of saints and of the blessed, embodying such an elegant and composed dispute that this alone formed the best seal on the divine dignity of the scene. Only the succession of gold circles – starting from the ostensory at the centre and broadening into the aureola around the dove and then around Christ, and culminating finally in the immense

sun that framed God the Father – seemed a concession to Quattrocento iconography, with its more pedantic view of doctrinal illustration. These gold circles, fixed to the wall with blobs of wax embossed to resemble studs, were reminiscent of major contemporary painting cycles, like those of Pinturicchio in the Piccolomini Library at Siena, embellished by metal appliqués, or like those of Signorelli in the San Brizio Chapel at Orvieto. Such a profusion of gold was characteristic of medieval icon painting, and it had survived in a courtly and elegant guise in the narrative paintings of the late fifteenth century.

The fact that Raphael resorted to such craft virtuosity reveals how closely he was still linked, on arrival to Rome, with the late Quattrocento figurative culture of central Italy. In later paintings he would abandon any surface embellishment of this kind and concentrate on reinstating an illusory space founded on architectural congruity and on the monumentality of the human figure. But the painting of the *Disputation* already shows a renewed awareness of space and the redis-covered centrality of man's image. In the fullness of this experience, which seemed a perfect means to control the representation of reality, one that artists had been searching for in Italy for the past century, Raphael even indulged himself by including a naturalistic background vignette of scaffolding on a hill on which workers laboured to build enormous walls. He was paying homage to the city he had just arrived in, where building works were everywhere: this was a *renovatio*, as Julius' own propaganda claimed. The large white pillar on the right was that of St Peter's, 'photographed' by Raphael on arrival and included to reinforce the propagandistic message of Pope Julius II's sanctity.

In the *Disputation* the pope and the court could also recognise the debate that actually took place in 1463 between Julius' uncle Francesco and his Dominican adversaries, which ended with a victory seen by all as the start of the della Rovere's ascent. With extraordinary skill, the event was fixed in history, at the same time giving credibility to the founding moment of the della Rovere family myth. On the one hand, the *Disputation* celebrated theology as the pillar of faith. On the other, with sublime sophistication, it celebrated Sixtus IV and legitimated the sacredness of his family's power by blending it with that of the founding fathers of the church and of the scriptures.

The distance between Raphael's painting and that of the other artists

was too wide, and too blatantly displayed only at a few metres' distance, for the first prize not to be conferred to the youngest artist, the most recent arrival. Raphael had foreseen this outcome and took no risks; he did nothing that might damage the myth of elegance surrounding him. He merely waited for events to take their course, for the highly cultured Roman curia to come to see for itself what rumours had already hinted at, with growing insistence. He waited for them to ascertain the talent of a young genius who had arrived on the banks of the Tiber just when the favourite Michelangelo, who had been given the most important commission of this programme of works, was experiencing the worst artistic crisis of his career, in the early months of 1509. As the 'mildewed' mortar on the Sistine ceiling was spoiling the work he had just done, while he watched with helpless incredulity, Michelangelo, too, heard the murmur of gossip along the palace corridors, which was filled with superlatives vis-à-vis the work of the elegant and handsome youngster, newly arrived in the city. Raphael waited for the inevitable to happen.

When Julius II saw the *Disputation*, he was entranced. It fitted perfectly with his ambitious propaganda. Nor had he ever seen anything so beautiful and graceful. Negotiation was not his strong point, either in war or in artistic patronage. He had no time to lose. So, with the same decisiveness that prompted him to declare war on another state, red in the face with excitement, he ordered the destruction of all the paintings already done by other artists summoned from all over Italy. Raphael alone would paint his *stanze*. Everything that had been accomplished and paid for had to be removed. Nothing inferior to Raphael's talent would appear on the walls.

For the older masters this was a stinging humiliation, as well as a financial catastrophe. They had brought assistants and equipment to Rome only to be chased away because a youngster, aged barely 25, was idolised by this terrifying pope, a man who would not brook discussion and, for far less trivial matters, would threaten those daring to speak with the mace or any other object within reach. But the artists knew all too well that they could not argue either with their patrons' taste or with their colleagues' talent. At this point Raphael once again demonstrated a shrewd business sense and tact that few others would have shown. Michelangelo, for one, certainly had lacked it, since in the

summer of 1509 he sent home old friends and assistants who had trav-
elled from Florence to come and help him. Instead, Raphael did what
he could to ensure that at least part of the work was saved. Giovanni
Antonio Bazzi, whom everyone called il Sodoma on account of his
homosexual passions, had worked on the ceiling. He was a skilled and
sensual painter, and Raphael appreciated the warm, mellow style that
made his fortune in spite of his extremely unorthodox tastes in the
erotic sphere. So a part of the ceiling was saved, and Raphael included
only panels painted by himself.

It was a meaningful gesture, which certainly other great artists would
never have made. In Rome, a city full of braggarts always quick to pick
a quarrel, nothing else was spoken of for months. Above all, not much
else was spoken of among the immigrant artists, one of the city's most
turbulent communities. Clinging to the high scaffolding of his aerial
cavern, Michelangelo struggled single-handedly with the difficulties
of fresco painting; while Raphael, to whom the pope had unexpect-
edly granted an exclusive favour, negotiated the recovery of the work
of those artists who had been excluded, and even their continuing
collaboration.

Raphael had arrived in Rome with superlative talent, but his expe-
rience at the time was undoubtedly limited to easel painting. His
itinerant life and his youth meant that, unlike all the other artists, he
could not boast a workshop of fresco painters: an operative structure
that involved perfect familiarity with how to make and apply mor-
tars, how to reproduce cartoons [cartoni] and everything else that was
needed in order to prepare a wall painting of monumental size. That
the technical question was far from irrelevant is shown by the large
number of irregular cracks revealed by the recent restoration of large
portions of the plaster in The School of Athens (Plate 12). Studies of the
plaster mix confirm that many giornate* contain an unbalanced ratio
between lime and inert material, which had been calculated using the
methods of central Italian painters rather than those in Rome. The
latter were well aware that, in order to stop the mortar from shrink-
ing, the pozzolan [volcanic ash] had to be mixed using a ratio of almost

* A giornata was the area of plaster applied over one day on a fresco painting, hence one
day's work on a fresco. (Translator's note)

three to one, rather than the two to one ratio used for the river sands of central Italy.

Raphael now suddenly found himself with a commission of enormous proportions. Moreover, the fact that the frescos were very close to the viewer and the lighting conditions in the rooms were also excellent would have been a concern for any artist, because the work was comparable to easel painting. While Michelangelo might have hoped for the clemency offered by the dim light of the chapel (although in actual fact he never did), Raphael had to be ready to fend off erudite judgements made by experts standing very close.

The prospect was terrifying, but Raphael tackled and resolved it with the calm intelligence that had catapulted him to Rome after his brilliant debut in Umbria and the short interlude in Florence. He understood straightaway that he needed to set up a school. He was young, of course, and in order to have any authority he would have to turn to painters even younger than himself, boys who would be trained and schooled both in hierarchy and in quality. But he also needed expert collaborators, the very ones that had been penalised by his talent. It was at this point in his career, when facing obstacles of this magnitude, that he showed a psychological sensitivity that would enable him to leave all the other artists in Italy behind him, once and for all. The personal skills he revealed for organising the work of others were as important to his final success as his own artistic talent.

He managed to convince some of the old master artists to work with him. One of these was certainly Lorenzo Lotto, who continued to work on the *stanze* and accepted Raphael's guidance. But there were also others, whose identity has not yet been discovered. He then started to select a team of young artists, a task in which he showed extraordinary intuition. More importantly, he completely renewed the structure of the fifteenth-century artist's workshop, transforming it from a highly hierarchical structure – in terms of roles and methods of learning – into an atelier where each artist's individual strengths were harnessed and used to ensure the successful outcome of the work as a whole. In reinventing these relations between the artists themselves, Raphael's actions were revolutionary; but the process was helped by his warm and affable nature, which charmed his pupils to such an extent that they regarded him as a father figure. Raphael, too, regarded them as his sons;

they formed part of his family life and were included, as a whole, in his last will and testament: a step that was unprecedented in Italy.

This choice also shows that Raphael felt that art was his sole destiny, unlike Michelangelo, who always drew a line between his work interests and those of the family, putting the latter first. Not to speak of Leonardo, who was often irritated by the vulgarity of the artist's trade. But this was not all. Raphael had received a unique artistic education in his father's workshop and, most importantly, he had avoided the tough and often frustrating years of apprenticeship that young adolescents training to be artists had to complete. This experience made him much more open to his collaborators. At the age of 17 he had already been described as *maestro* in contracts. But he may have felt that he deserved that status even earlier. Unburdened by years of frustration, which might otherwise have been vented on his apprentices, he could, as head of the workshop, re-create the kindly and supportive relations he had enjoyed during his own apprenticeship. Nor did the generous tributes that he received during his short life focus solely on his artistic talents. As emerges from the friendships he made as soon as he arrived in Rome, he formed part of a rich and multifaceted social network, which he would later describe to one of his closest friends, Baldassarre Castiglione; indeed Castiglione took as his model of courtly elegance the court at Urbino, where Raphael had grown up and which had inspired him, mainly thanks to his father Giovanni. Throughout this stage of Raphael's life, his critical choices were guided by the memory of his father, who had given him a unique education: it allowed him to adopt an extraordinarily open-minded approach to all forms of talent and research and to display an intellectual sensitivity that surpassed the craft mentality and brought him very close to Julius' refined court, which was made up of leading scholars, philosophers and theologians.

If these were the intellectual reasons that prompted Raphael to embark on his personal revolution in the manner of tackling the Vatican *stanze*, the other aspect that he consistently developed, taking his own specific sensitivity and experience as the starting point, was the production tools he used. Raphael established a new way of communicating with his collaborators through a masterly use of the drawing [*disegno*]. At the same time, the drawing – partly elaborated by his pupils – became the way to involve them in the creative procedure in order

to optimise the end result. Fortunately this aspect of his work is documented by the preparatory cartoon he drew for the second painting in the *stanze*, the scene that subsequently became famous as *The School of Athens* and that, in the minds of contemporaries and later observers, was rightly regarded as one of the culminating achievements of the High Renaissance.

5 THE SCHOOL OF RAPHAEL

The painting known as *The School of Athens* is on the wall facing *The Disputation of the Holy Sacrament*. The programme drawn up by the pope and his advisors also included the other two walls, one showing a scene from Parnassus, the other the Virtues.

By the mid-sixteenth century the room became known as the Stanza della Segnatura, because it was here that the apostolic briefs were signed. But Julius had plans to turn it into a library to house his most precious books. For this reason the decorations had to extol the learning of the church, which, at the time, was seeking a new legitimacy – one that incorporated the highlights of pagan knowledge, synthesised so as to give a premonition of Christian doctrine. The library would celebrate the disciplines of knowledge – understood as the paths that, through different channels, led to the truth of the Christian revelation and as a foundation for good government, both spiritual and temporal – which were indissolubly linked under Julius II's pontificate. Theology, philosophy, poetry and law were also regarded as ways of revealing divine knowledge and of supporting papal government. Theology had been represented in the fresco of the *Disputation*. Poetry was celebrated through the depiction of the mythical Mount Parnassus, governed by Apollo and the Muses and surrounded by a throng of poets, both ancient and modern. Homer as a blind old man is instantly recognisable. He was one of Julius' particular favourites and in October 1512 the pope ordered his verses to be recited by a blind old man playing a lyre. Rather than just evoking antiquity, the court of Julius II revived it.[9]

The allegory of law was more complex. It was divided between the tondo of the vault, containing an allegory of justice, the lunette with the three Virtues – Prudence, Fortitude and Temperance – and two distinct scenes on the lower part of the wall: Gregory IX, depicted as a

likeness of Julius II, approving the Decretals, and Tribonian presenting
the Pandects to Emperor Justinian, thereby symbolising ecclesiastical
and secular law, respectively. Lastly, philosophy raised the more tricky
problems of recognisability, which explains why Raphael resorted to
a sophisticated new invention, one that escaped the frigidity of medi-
eval allegories to create a story that at the same time celebrated the
multifaceted nature both of the papal court and of classical thought.

In order to celebrate philosophy as natural knowledge of the world,
Raphael portrays a debate between philosophers and other ancient
sages, partly recognisable by their attributes but separated by an enor-
mous gulf, both in psychological character and in background, from the
theological disputation he had recently completed on the wall opposite.
There the vastness of the natural universe and the solemn symbols of
theology informed the viewer about the supernatural world in which
the confrontation was taking place, and which was founded on the eter-
nity of faith. Here it was history that provided the solemn legitimisation
of human knowledge.

Raphael set this philosophical debate in a luminous architectural set-
ting, in which the graceful and decorative use of perspective, the typical
background for fifteenth-century 'narrative' paintings, was replaced by
a spatial concept of architecture, in harmony with Donato Bramante's
research, which located the meaning of classical architecture no longer
in the articulation of surfaces, but rather in the proportioning of
members and space. Raphael's design for the background – a sequence
of stone arches, open to the sky and decorated with lacunar panels,
like the roof of the Pantheon – was closely modelled on Bramante's
architectural studies and on his plans for the new basilica of St Peter's.
The grandiose prospect is bathed in a golden light that envelops the
scene and predisposes the onlooker to yield to the radiant calm of the
narrative. On the front walls of the architectural structure, serving
as a backdrop to the philosophers' discussion, two statues are clearly
visible. They portray the gods of reason: Apollo, recognisable on the
left, holding a lyre to indicate clarity of thought, and Minerva, on
the right, symbolising the sharpness of intelligence, whose lance and
shield, with its fearsome Medusa head, ward the shadows of irrational-
ity and monstrosity away from the lucidity of philosophy. In Julius II's
syncretistic project, philosophy was a subject that sought to prove the

divinity through enquiry: this strained interpretation had attracted all the Italian intellectuals of the time. Under no circumstances would it be possible to renounce such a noble cultural heritage and, at all costs, it had to be made to converge in the legitimisation of the Christian revelation.

In order to portray this magnificent building in classical ancient style [*all'antica*], Raphael drew it – or it would be more correct to say he designed it – in minute detail. He used a technique known as *spolvero* [dusting], to transfer the lines onto the wall. This was a technique usually reserved for figures, but it immediately reveals his passion for architecture, the disciplined organisation of the site and the desire to create a work that would excel.[10]

This is the setting surrounding the philosophers, a setting that, by definition, already affirmed the strength and harmony that can be achieved by human thought through artistic expression. The philosophers are engaged in calm discussion and once again organised around the psychological links that were Raphael's creative forte. Plato and Aristotle stand framed at the centre of the arch, with the horizon behind them. They are dressed in ancient fashion and their cloaks, one reddish and the other pale blue, also provide the largest splashes of colour in the painting and therefore immediately draw the viewer's attention. Plato points calmly to the sky, while Aristotle's hand makes a gesture that symbolises the dominion of reality. Around them, gathered in that lucid atmosphere, other recognisable figures celebrate the acumen of classical thought.

Anyone with the necessary knowledge would have seen this painting as an explicit reference to a scene that, while it could never have actually occurred, was at least evoked in a famous classical philosophical text. The philologists at the curia could congratulate themselves on such a refined literary image. But, to other viewers, the solemnity of the poses and the citations from treatises made it equally clear that the setting represented an ideal philosophical discussion in which all the leading proponents of classical thought were miraculously brought together in one place.

There was also another level at which the painting could be understood, one that certainly increased the pleasure of the pope and his court. Many of the individual figures from the curia could be recognised

in the portraits of the philosophers, so an observer would inevitably be prompted to identify the papal court as a modern reincarnation of ancient knowledge.

From a strictly artistic viewpoint, the key innovations lay in the graceful attention paid to every gesture and every figure, in the wonderful human expression on each face and, above all, in the golden atmosphere that appeared to transpire from the wall. Raphael had decisively left behind the coldly contrasting colours characteristic of his Umbrian work, which had still dominated the previous painting, *The Disputation of the Holy Sacrament*. In that painting the pigments were used with a brutality still reminiscent of the Quattrocento. The whiteness of Christ's cloak, of the clouds and of the other garments was almost pure, set beside the deep lapis lazuli blue of the other cloaks and the yellow and gold of the sacred paraments and decorative flourishes. The contrasting colours are embedded, like a metallic enamel in which each has its own clearly delimited border. The linear design emphasises the isolation of each figure, each anatomical detail and each expression. Looking at the steps, on which many of the figures are kneeling, they appear to be lit by a cold spring light. The brushstrokes used to create the figures are short and brisk, like those used on a panel painting, making extensive use of black to outline the hair and other details.

On the contrary, in *The School of Athens* and from there on, the light becomes that of a summer afternoon in Rome, which Raphael had now finally experienced in person. The gradual shift of chromatic tones was now also imbued with a feeling of aerial spaciousness. Each colour was blended, rather than being used in simple form. White becomes ivory and blue grows paler under a veil of indigo, although the passage of time has certainly contributed. The shadows are no longer in sharp contrast but become iridescent, fading into evanescent tones that draw the gaze towards elusive details. The drawing can hardly be discerned, and the overall effect is exquisitely blended into that golden haze that prompts a pleasant sense of abandonment in the viewer and a smile of complete satisfaction as one looks at the scene. Here, too, the figures closest to the viewer are grouped on the steps, but they have lost their hard edges and sharp, cold shadows. Raphael had truly arrived in Rome, where the light softens everything, turning this meeting of famous men into a solemn but joyful occasion as they move around with composure,

although devoured by their longing for knowledge. No one who looks up at this scene could be unaffected by this reassuring vision of the greatness of ancient knowledge as it finally blended into the knowledge of the church of Rome.

At first glance, such beauty and artistic expertise seem the work of a single artist. This is partly true, because Raphael certainly dedicated much of his time to this painting. But it was also the outcome of the technical organisation of the work, which was the culmination of, and a mark of the success of, the new structure of the workshop and of its transformation into a school. This would be true of many of the scenes painted in the years to come, when Raphael committed himself to too many projects and was unable to paint them all alone.

By good fortune the key to understanding this project has survived intact: it is the preparatory cartoon for the lower part of the painting, now housed in the Pinacoteca Ambrosiana in Milan. The preparatory cartoon was used to establish the final drawing on the same scale as the painting. Other, more restricted drawings were then made, all based on this cartoon, and they were laid on the fresh plaster onto which the drawing was reproduced through a variety of methods. The cartoon preserved in Milan is the original or primary cartoon from which all the others were subsequently taken, and it is undoubtedly made by Raphael himself.

After a series of complex preparatory studies, the final drawing for the painting was executed on an enormous sheet of paper, made by patiently gluing together the smaller sheets purchased from the paper-makers' presses – above all those in Romagna and in the Marches, places abundant in water resources, wherefrom came the finest quality products. For *The School of Athens* Raphael had to glue dozens and dozens of sheets together. Once it had been transferred onto this huge sheet of paper, holes were made in the drawing by using a pin to prick through the outlines. A copy of the main drawing was then transferred as a line of dots onto the sheet below. In order to obtain a true replica of the original cartoon, all that had to be done was to join up the dots with a pencil or brush. Then, to transfer the drawings onto the plaster, a pouncing bag filled with black chalk dust was lightly pummelled around the pricked outlines, so that the chalk passed through the holes onto the wall, to reproduce the design. The second cartoon, which was rested on

the plaster, could be cut into pieces or could in turn be roughly copied onto other pieces edged into place on the plaster. Contact with the plaster spoiled the paper, which explains why very few of the cartoons used to transfer the drawings have survived. For smaller projects, or when the artist carried out the work alone, only one cartoon was prepared. But when the work was complex and, above all, when several painters were involved, the cartoon was the only means whereby the principal artist could control the work done by his collaborators.

The perfection and the complexity of the preparatory cartoon for *The School of Athens* say a great deal about the degree of control that Raphael managed to exercise over his collaborators through the drawing, the instrument that had always been the mainstay of his work. The cartoon in the Pinacoteca Ambrosiana is so finished that it forms a complete and fully expressive work of art in its own right. Raphael had undoubtedly learned from Leonardo how to capture an idea on paper in such a definitive form. Like everyone in Florence at the time, he had been amazed by the cartoon for *Sant'Anna*, the only one comparable to *The School of Athens*. A closer look at Raphael's cartoon shows the extraordinary detail of the drawing that was transferred onto the replica and then onto the plaster: pinpricks were made not only along the main lines of the drawing and along the outlines of the drapes, but even round the shadows and shading, in order to provide a foretaste of the pictorial effect of the colour. Then, when one compares the cartoon of *The School of Athens* with the wall painting, it is apparent that, in addition to the details of the drawing, the painting reproduces the psychological expressions and the surroundings that were already clearly evident in the original. For example, the minute changes made to the figure of Aristotle, who looks younger and gentler in the painting, have not altered his dignified expression of satisfaction. The same is true of the background figures, sketched in through a few pencil lines in the cartoon and through minimal brushstrokes in the painting, but always in keeping with the psychology of the individual. It was this that Raphael aimed to achieve with his masterpiece.

A comparison between the cartoon for *The School of Athens* and other contemporary examples, like the cartoons of Ghirlandaio or of Raphael himself (say, the 'cartonetto' for the *Vision of a Knight*), shows how infinitely more detailed the former is. This enabled the

artist to achieve two important aims: he could give his collaborators an extremely precise idea of what the final painting would look like, including the expressions and nuances he wanted to obtain, and at the same time he offered them a complete replica of the work. The more finished the preparatory cartoon, the fewer the errors that could be made by the pupils.

Such detailed and complex cartoons were also a legacy from northern Europe. The Netherlandish masters used to draw painstakingly detailed preparatory drawings, as can be seen in Hugo van der Goes' painting (*c.* 1472) now in the Metropolitan Museum, New York, in which paint was peeled back to reveal an underdrawing of comparable quality and detail to the Ambrosiana cartoon. But Raphael also started to do something more with his collaborators. He began to use them in creating the actual model, not just the mechanics through which it was transposed. His pupils gradually became more involved in the development of the initial design, and they were trusted to draw and study details. These might be details such as the different varieties of fruit and birds that Giovanni da Udine studied and invented for later compositions. But they might also be positions of hands, bodies and expressions that Raphael's most gifted pupils started to try out under his watchful eye, either in the workshop or in Raphael's own house. This collaboration soon turned into a shared creative life, which was fuelled by, and in turn revitalised, the day-to-day events and experience of life in the extraordinary theatre that Rome was becoming under Julius II's innovative imperus.

The Stanza della Segnatura, like no other place, marks the rapid transition from the bourgeois painting of the Quattrocento, developed primarily in Florence, to the grand, ideal painting characteristic of the burgeoning High Renaissance in Rome. At the same time it reveals the prodigious versatility of a young artist who, within the space of a couple of years or so, completely transformed both himself and his narrative language. While beautifully laid out, the setting of the *Disputation* is still a fifteenth-century scene in terms of the scant spatial relief given to the figures, of the lack of air circulating between them and of the display of virtuoso skill used to depict superfluous detail. Raphael's progress towards a classical dimension in *The School of Athens* is achieved through the simplification of the image to be represented and the selection of

its focus, which is capable of offering the viewer everything required to make the image exciting. It was this process of subtraction that brought Raphael to the highest expression of classicism, with which he will always be identified.

Immediate confirmation of this comes from his treatment of drapery. In the *Disputation* the fabrics are twisted into labyrinthine folds and flashes of light; in *The School of Athens* they are simplified to a bare minimum, ceasing to interfere with and, indeed, emphasising the composure of the bodies. In both paintings Raphael frequently uses the same postures and sumptuous robes that had been used for decades by Italian painters, drawing on the notebooks and images that were circulated and reproduced in various ways. However, in the interval between painting the two works, Raphael had taken time to visit Rome in depth, to scrutinise Trajan's Column, the Arch of Constantine and other sculptural reliefs, and to learn the 'measure' of the poses and the essential qualities, not only of the gestures, but also of the drapery. He simplified his pictorial language until he had perfectly captured its evocative crux. The journey that Raphael made in two years through his detailed scrutiny of Roman sculpture can be retraced by us today if we walk the short distance in the Stanza della Segnatura separating the fresco of the *Disputation* from *The School of Athens*; the same trajectory is borne out with even greater clarity in the lunette representing the allegories of Fortitude, Prudence and Temperance. This was probably the last painting in the room to be finished, and in it the monumentality of the female figure is combined with a gracefulness never previously seen in Rome or anywhere else.

THE POPE AND HIS BANKER

1 THE POPE'S BEARD

There were good reasons why Julius II could enjoy the triumph that Raphael offered him in the decorations for his new rooms in 1510. In the spring of 1508 the pope's nephew, Francesco Maria, had inherited the duchy of Urbino from Guidobaldo da Montefeltro. This conveniently excused the pope from debasing himself through an excessively compromising use of nepotism, of the kind that had ruined his predecessor Alexander VI. It gave the della Rovere family a power base; and, for carnival 1510, Rome laid on a magnificent welcome for the young duke and his wife. That spring the festivities marked the high point of della Rovere's glorification in Italy. The carnival was one of the best ever staged in Rome. It included a number of races from Campo de' Fiori to St Peter's for buffalo, donkeys, Berber horses and, lastly, Jews, obliged to submit each year to the tyranny of Christian taunts. Even the local barons fell into line, and a new golden age seemed to have dawned on the banks of the Tiber.

But the rest of Italy stubbornly refused to comply with the pope's wishes. Alfonso d'Este, duke of Ferrara, became a thorn in the pope's side: not only did he unlawfully rule over a city that belonged to the church, but he continued to sell the salt extracted from his saltpans in

the Comacchio. Alfonso's obstinacy was detrimental to the church's monopoly of the salt market, and in particular to the interests of Agostino Chigi, a Sienese banker and a close advisor on matters of papal finance, as well as the sole intermediary who handled all sales of salt and alum on behalf of the church. Moreover, in Julius II's eyes Alfonso had made an error in marrying Cesare Borgia's sister, Lucrezia, although she proved to be an excellent and irreproachable governor at her husband's side. Following this marriage, the annual tribute paid by Alfonso to the pope, his feudal overlord, had been reduced from 4,000 to just 100 ducats. Julius II regarded this generous subsidy as one of the worst examples of the nepotism exercised by the Borgia, and in July 1510 he insisted that Alfonso should pay the arrears. The sum amounted to 35,000 ducats, to which, in a provocative move, Julius added a further 100,000 for the repayment of the military expenses that he had been forced to incur on account of Duke Alfonso, a dogged and excellent *condottiere*.

War on Ferrara was declared in the summer of 1510. Julius, mindful of the previous military campaign, which had been transformed without too much effort into a triumphal march, decided to follow his army once again, after having entered into a league against Ferrara and France with his old enemy, Venice. But on this occasion things did not seem to go quite as smoothly. Even the weather was against that warrior pope, who had already scandalised Europe by declaring war on a Christian prince, the Catholic King Louis XII of France. The pope and his army struggled through torrential rain as they travelled from Rimini to Bologna in September. Some prelates even died from exposure, and the appearance of the struggling papal cortege caused hilarity among the peasants. The pope stubbornly continued to Bologna, where he began to organise the final expedition against Ferrara despite intermittent attacks of fever, which counselled greater regard for his age and health.

The capture of Ferrara was becoming an increasingly distant mirage. The troops were encamped around the fortress of Mirandola and Julius visited them in person, in the belief that his presence might encourage the somewhat sluggish generals to finish off the siege. At the start of January, icy temperatures froze the rivers around the fortress and the surrounding countryside, and the trees and houses, and even the armies themselves were buried under snow. Showing unfailing determination,

Julius arrived on the battlefield. Having grown his beard, he took a penitential oath not to shave until Ferrara was captured and the French were chased out of Italy. His beard frightened everyone; it was tangible evidence of his inner rage, now manifestly disfiguring his face: as Julius stood shaking his arms to warm them in the blizzard, one contemporary commented that his 'beard made him look like a bear'. Unconcerned by the watching diplomats, Julius swore against Ferrara and called the countess of Mirandola a 'whore' for daring to resist him. Above all, his wrath fell on his nephew, Francesco Maria della Rovere, commander of the papal forces, who 'in all this time had failed to defeat a cheating whore with twenty thousand men'.[1]

In his exasperation, Julius used his very image as a political message: his eastern-looking beard had an impressive effect on the court and on all commentators. In their dispatches, ambassadors hastened to describe the pope's extraordinary behaviour: 'this morning, the pope was on the field, seated in a chair and covered with snow, which fills the whole countryside; he himself started to muster the soldiers, therefore he deceived them'.[2] Carried away by the force of his own imagination, Julius II saw himself in the guise of Julius Caesar. But his military endeavours were not as successful as those of his famous namesake. Having barely survived the rigours of the frontline, where he was obliged to use a stable as his lodgings, like the lowest of his servants, the pope was forced to withdraw slowly to Rome, hounded by gradual but unrelenting military defeat and by the flood of criticism that his un-Christian conduct prompted from all over Europe.

On 22 May Bologna fell back into the hands of the pope's enemies, who, well aware of the value he had always placed on symbols and images, subjected him to the worst possible mockery. On 30 December 1511 Bologna's citizens fastened long ropes to the bronze statue that Michelangelo had cast of Julius three years earlier, which had been placed on the façade of San Petronio, to remind the city's inhabitants of their true overlord. Below it they had prepared a deep bed of manure and, when the statue fell into it, it shattered in an explosion of metal and muck. But even worse humiliation was to come from Alfonso d'Este, who used the metal from the statue to cast a new and deadly bombard, christened 'La Giulia', which soon won a reputation throughout Europe for being invincible. It was the memory of this outrage that

hindered any dialogue between the two men when the pope was forced, for political reasons, to come to terms with the duke of Ferrara.

When Julius returned to Rome, his beard was longer than ever, but the fresh military defeats of his army and the need to defend himself against an unprecedented assault on the papal states proved a far greater burden. The French had called a schismatic council in Pisa with the support of their allies, the Florentines. This attack now threatened to undermine the pope's moral and religious authority. Should the outcome of the council be successful, the pope ran the risk of being ousted from his role and promptly ditched by those allies who were still loyal to him. His re-entry into Rome, once again under the torrential rainstorms that had accompanied his departure a year earlier, felt very much like a defeat. Julius had to pull off a difficult political recovery in order to get out of the tight corner into which he had been boxed by his own obstinacy.

Julius' attackers, who accused him of lacking spirituality and of showing excessive interest in temporal affairs, were now joined by none other than Erasmus of Rotterdam. This outstanding intellectual, whose views were certainly unbiased, had travelled to Rome, where the belligerent atmosphere at the papal court had shocked him. In his *Praise of Folly* Erasmus is undoubtedly attacking the excessive secularisation of the pope and of the curia in Rome. Other libels, including *Julius exclusus de coelis* (*Julius Excluded from Heaven*), were printed and circulated throughout Europe at the time, their barbed criticisms being inevitably aimed at the warrior pope.

Once again, propaganda was the main instrument used by Julius to achieve political recovery; and, once again, Raphael could be identified as his best ally. In the second chamber of the pope's new apartments, which has come to be known as the Stanza of Heliodorus, the artist and the Roman curia created the best response to the accusations levied against the pope from all sides. It was a response destined to change the interpretation of the actual events themselves. But, before he even started painting on the walls a celebratory version of the pope's rash exploits, Raphael turned to Julius' personal image. The resulting portrait was intended to contrast with the hostile propaganda, which was diffusing prints that showed the pope in full armour, wielding a sword on the battlefield.

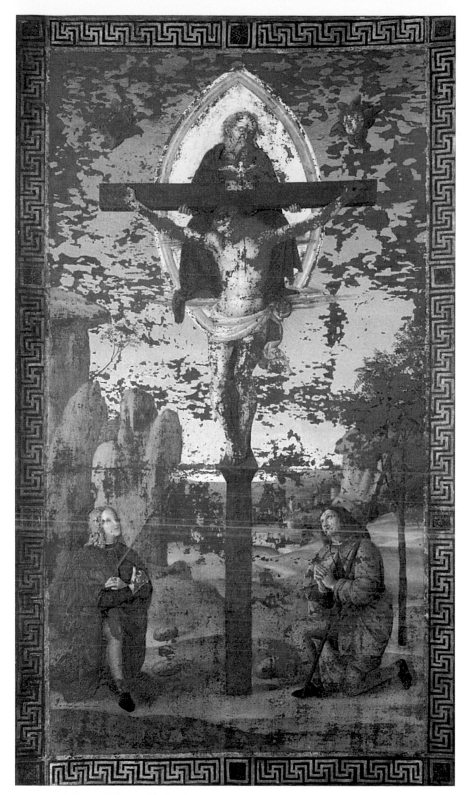

Plate 1 *Trinity with Saints Sebastian and Roch*. Pinacoteca Comunale, Città di Castello

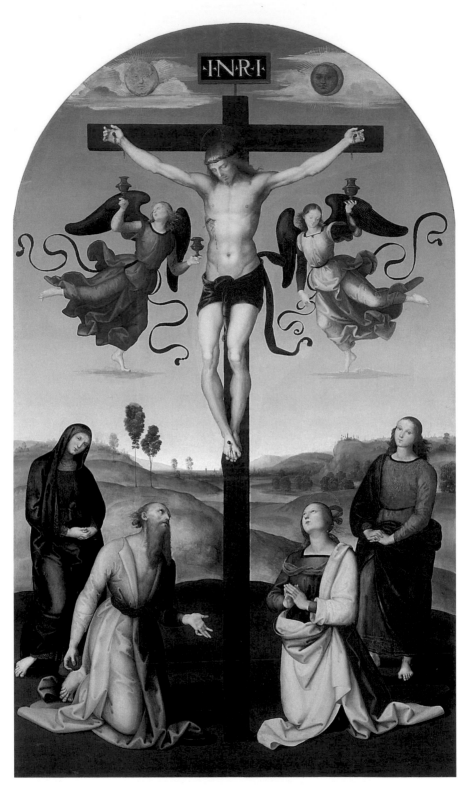

Plate 2 *The Crucified Christ with the Virgin Mary, Saints and Angels*
(The Mond Crucifixion)

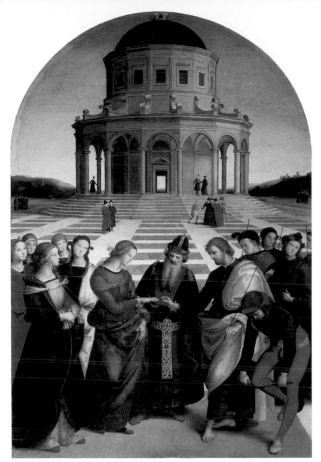

Plate 3
The Betrothal of the Virgin
('Sposalizio').
Milan, Pinacoteca di Brera

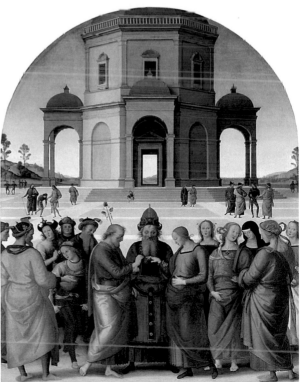

Plate 4
Pietro Perugino,
The Betrothal of the Virgin

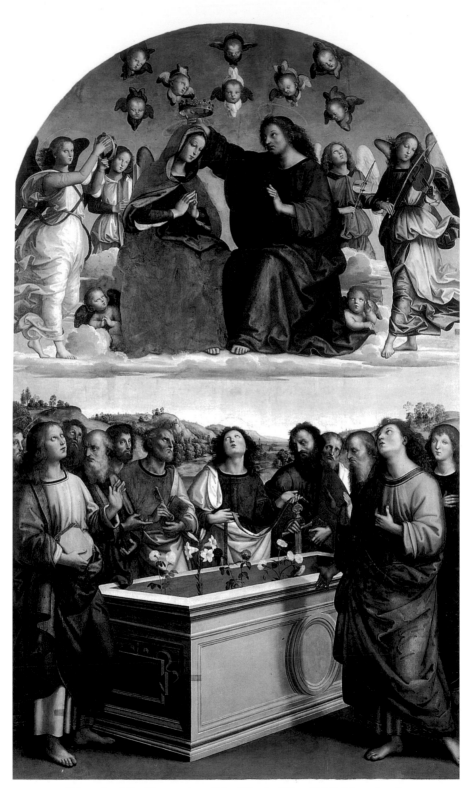

Plate 5 *The Coronation of the Virgin* (The Oddi Altarpiece).
Vatican City, Vatican Museums

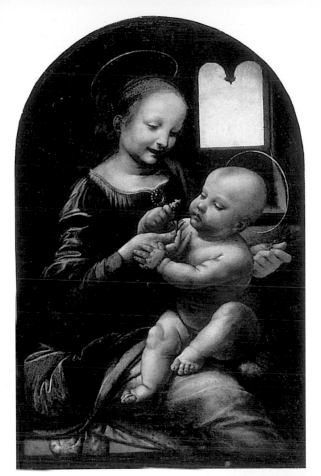

Plate 6
Leonardo da Vinci,
The Benois Madonna.
Petersburg, Hermitage

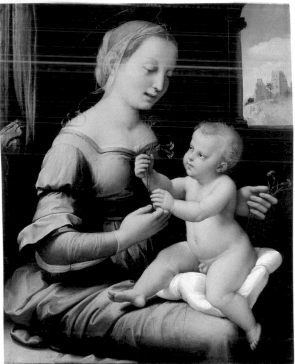

Plate 7
Madonna of the Pinks
(Madonna dei Garofani)

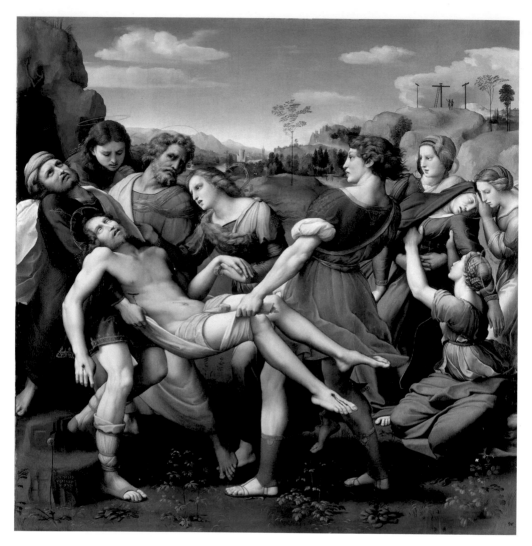

Plate 8 *The Baglioni Entombment.*
Rome, Galleria Borghese

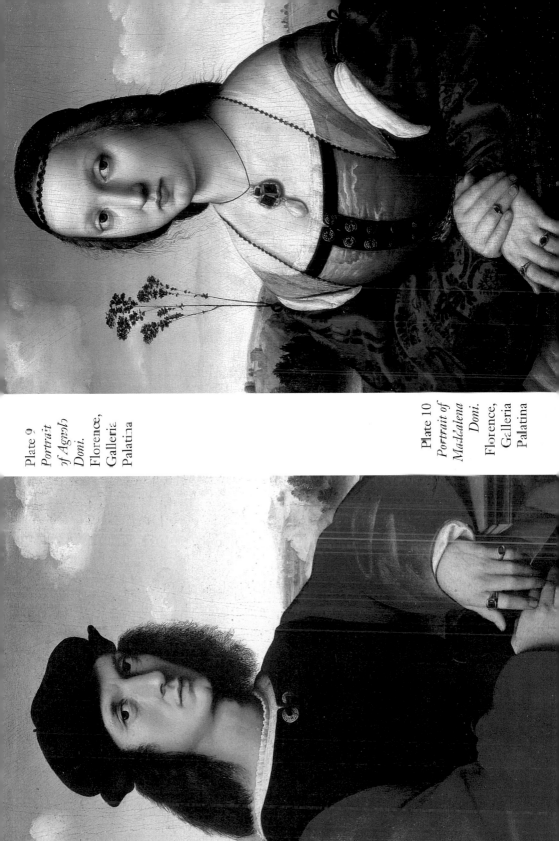

Plate 9
Portrait of Agnolo Doni.
Florence, Galleria Palatina

Plate 10
Portrait of Maddalena Doni.
Florence, Galleria Palatina

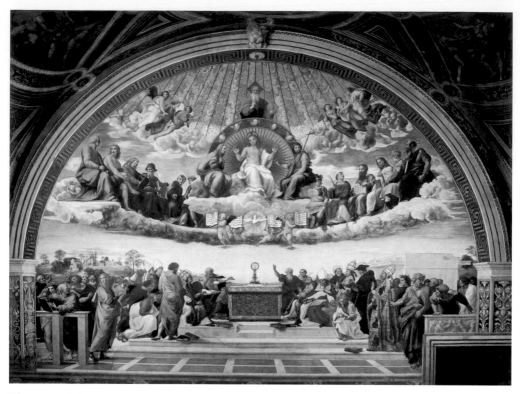

Plate 11 *The Disputation of the Holy Sacrament.*
Vatican City, Vatican Palace

Plate 12 *The School of Athens.*
Vatican City, Vatican Palace

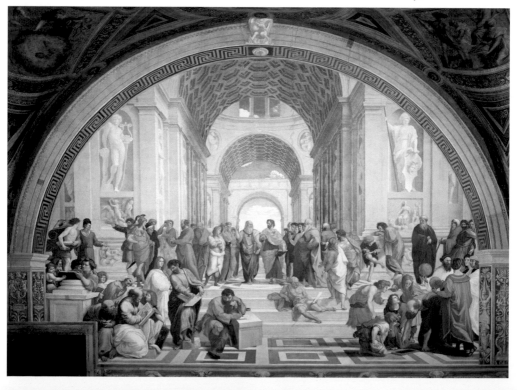

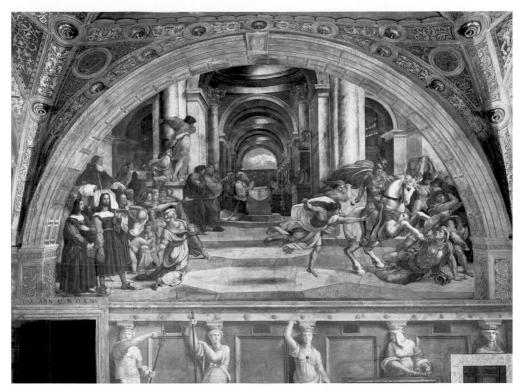

Plate 13 *The Expulsion of Heliodorus from the Temple.*
Vatican City, Vatican Palace

Plate 14 *The Liberation of Saint Peter.*
Vatican City, Vatican Palace

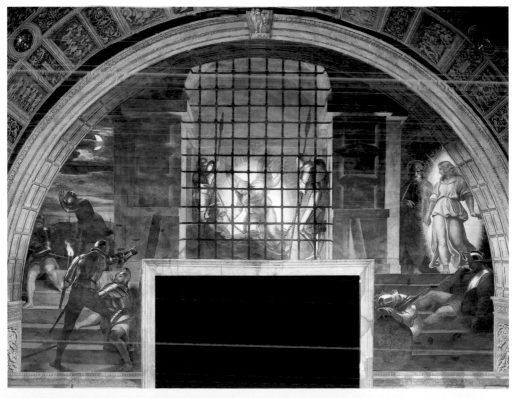

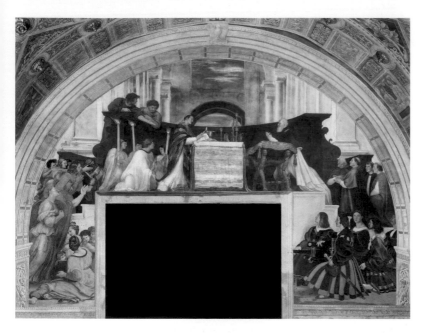

Plate 15
The Miracle of the Mass at Bolsena.
Vatican City,
Vatican Palace

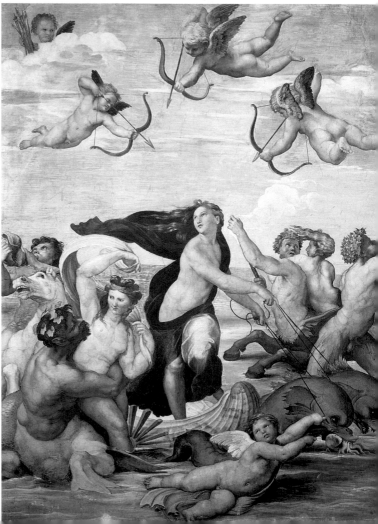

Plate 16
Galatea.
Rome,
Villa Farnesina

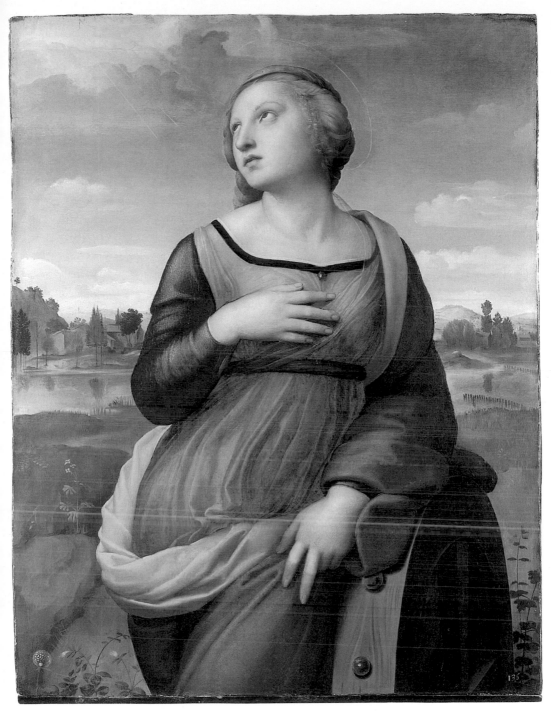

Plate 17 *Saint Catherine of Alexandria*

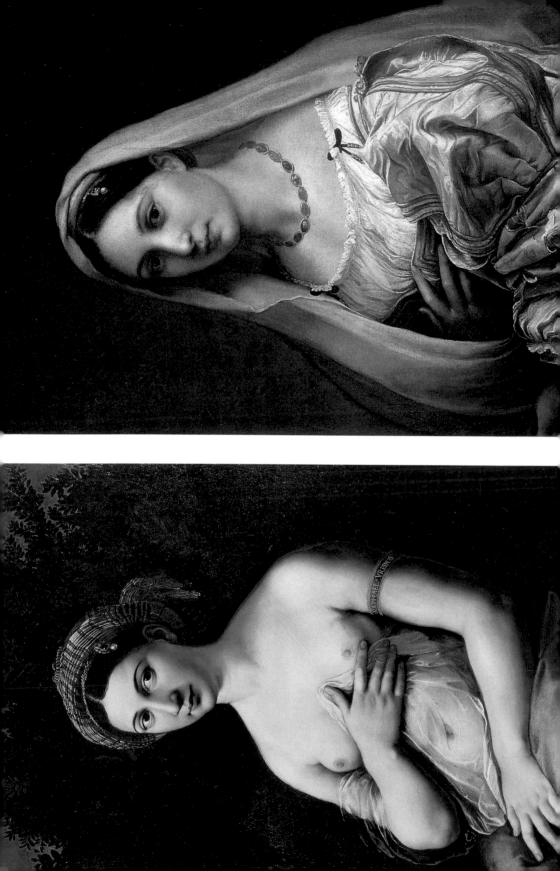

(opposite) Plate 18
Portrait of a Lady ('La Velata').
Florence, Galleria Palatina

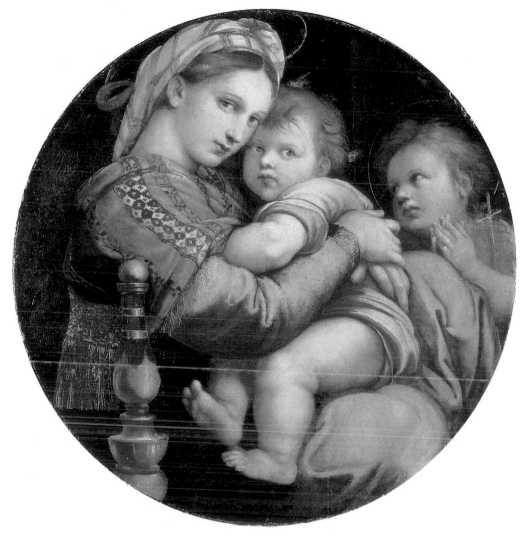

Plate 20 *Madonna della Seggiola*.
Florence, Galleria Palatina

(opposite) Plate 19
La Fornarina.
Rome, Palazzo Barberini

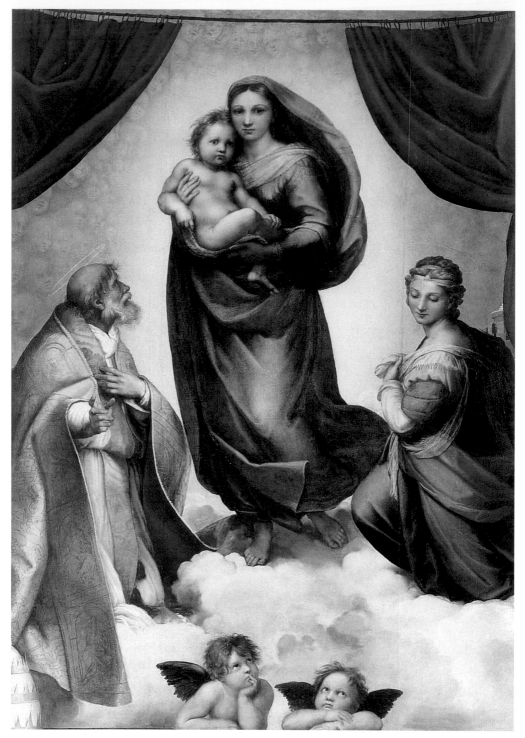

Plate 21 *The Sistine Madonna*

(opposite, top) Plate 22 *Portrait of Lorenzo de' Medici*. New York, Ira Spanierman
Collection

(opposite, bottom) Plate 23 *Portrait of Pope Leo X with Cardinals Giulio de' Medici and
Luigi de' Rossi*. Florence, Galleria degli Uffizi

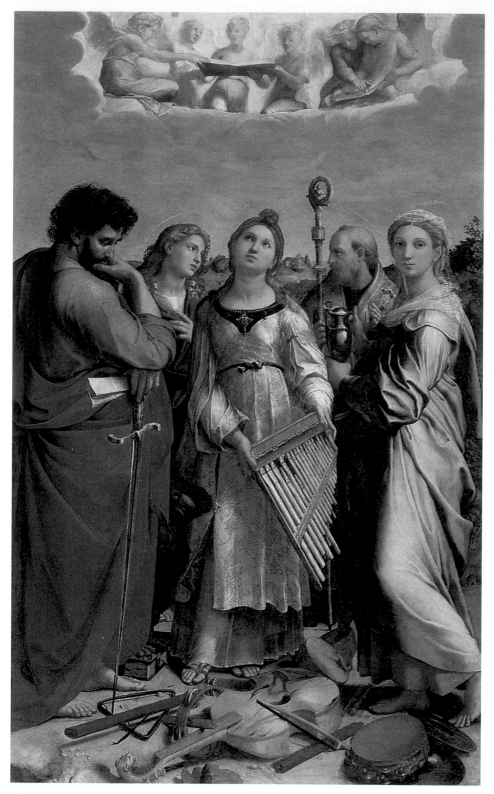

Plate 24 *Saint Cecilia between Saints Paul, John the Evangelist, Augustine and Mary Magdalene* (Dell'Olio altarpiece)

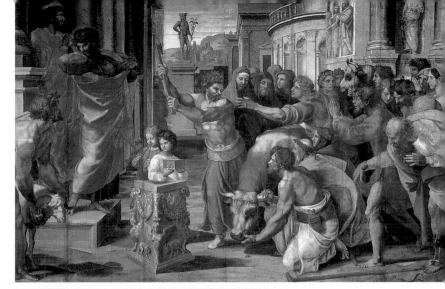

Plate 25
The Sacrifice at Lystra.
Bodycolour over charcoal underdrawing on paper mounted on canvas.
London, Victoria and Albert Museum

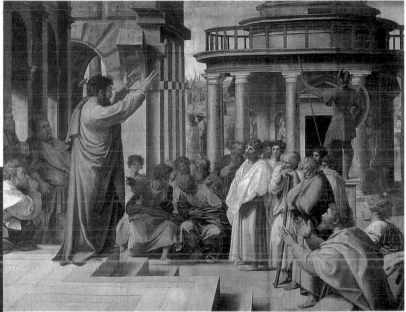

Plate 26
Paul Preaching at Athens.
Bodycolour over charcoal underdrawing on paper mounted on canvas.
London, Victoria and Albert Museum

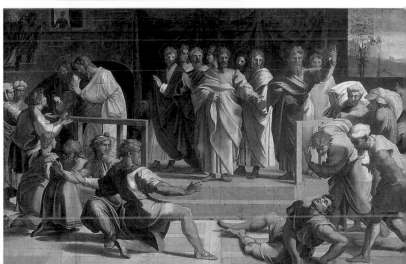

Plate 27
The Death of Ananias.
Bodycolour over charcoal underdrawing on paper mounted on canvas.
London, Victoria and Albert Museum

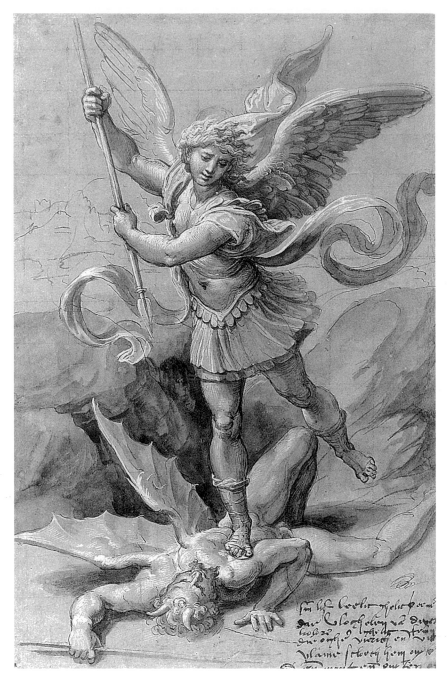

Plate 36 *Saint Michael*.
Pen and brown wash. Paris, Musée du Louvre

(opposite) Plate 37
Saint Michael Defeats Satan.
Paris, Musée du Louvre

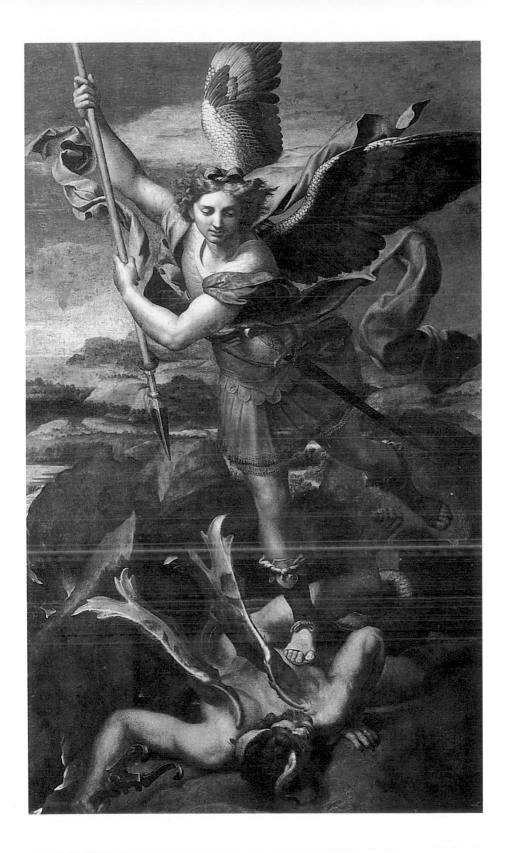

Plate 38 Loggia of Psyche (spandrel with Venus, Ceres and Juno).
Rome, Villa Farnesina

Plate 39 Loggia of Psyche (spandrel of Cupid with the Three Graces).
Rome, Villa Farnesina

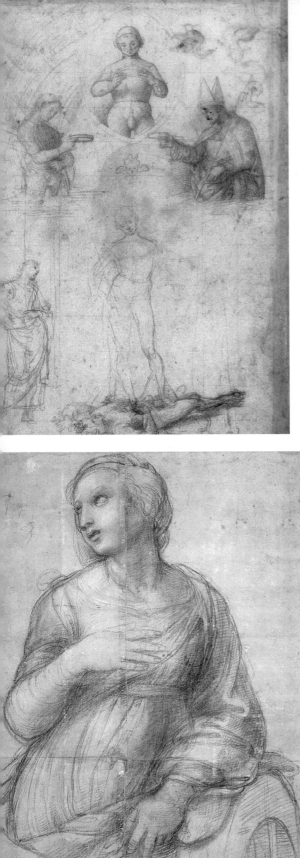

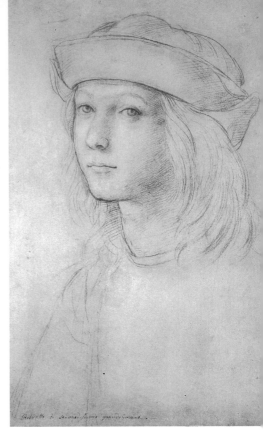

(top left) Plate 40 *Study for the Coronation of Saint Nicholas of Tolentino.*

(top right) Plate 41 *Self Portrait.* The Ashmolean Museum, Oxford. P II 515

Plate 42
Cartoon for *Saint Catherine.*
Paris, Musée du Louvre

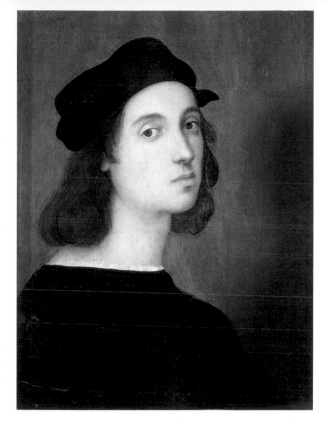

Plate 43
Self Portrait.
Florence,
Galleria degli Uffizi

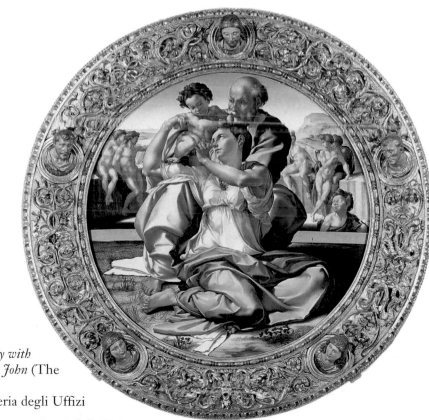

Plate 44
Michelangelo
*The Holy Family with
the Infant Saint John* (The
Doni Tondo).
Florence, Galleria degli Uffizi

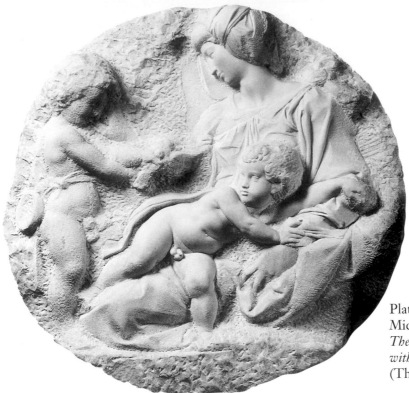

Plate 45
Michelangelo,
*The Virgin and Child
with Saint John*
(The Taddei Tondo)

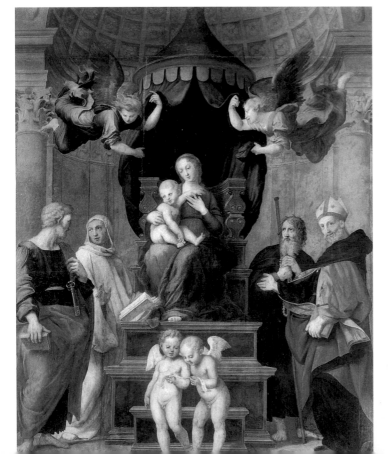

Plate 46
*The Virgin and Child,
Four Saints and Two
Angels* [Madonna del
Baldacchino: The Dei
Altarpiece].
Florence, Galleria
Palatina

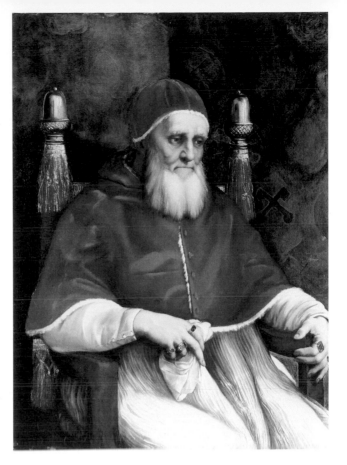

Plate 47
Portrait of Pope Julius II

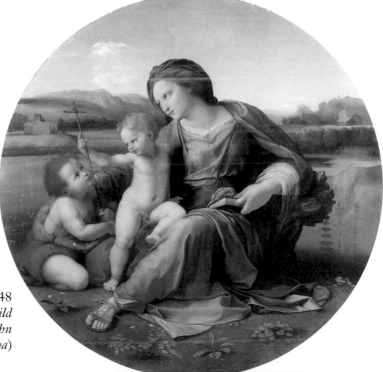

Plate 48
*The Virgin and Child
with Saint John
(Madonna d'Alba)*

Plate 49 St Peter's Basilica.
Façade elevation.
London, Kaufman sketchbook, fol. 139

(opposite, top) Plate 52
Giulio Romano and Giovanni da Udine
to Raphael's designs: vault of the loggia
at Villa Madama, Rome (1520–4). Detail
of the stucco decorations

(opposite, bottom) Plate 53
Portrait of Cardinal Bibbiena

Plate 50 *Stufetta* for Cardinal
Bibbiena. Vatican City, Vatican Palace.
Courtesy of the Vatican Museums

Pate 51 Loggias of San Damaso
[Logge di San Damaso].
Vatican City, Vatican Palace

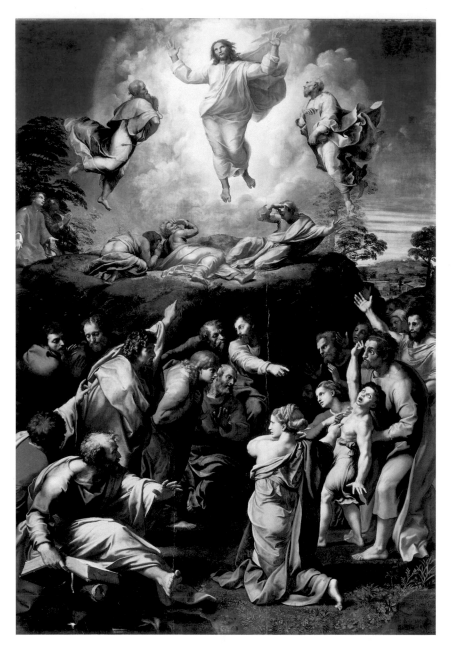

Plate 54 *The Transfiguration.*
Vatican City, Vatican Pinacoteca

The man whom Raphael portrayed for the admiration of all Christendom was as different from a warring monarch as one could possibly be (Plate 47). Dressed with a simplicity that, in a Roman Catholic pontiff, almost verged on the indecorous, Julius is shown seated in a chair whose high back is topped by two golden acorns – his heraldic symbol. The background, a green curtain bearing the church's insignia, reflects the light that shines down on him from the top right-hand corner. His hands are well manicured and still full of energy: he wears several ornate rings and a large ruby on his left index finger. In his right hand he grasps a white handkerchief, which he seems to have just used to wipe away his tears; with his left he clasps the chair arm, almost as if he needs to support himself. The light in his deep-set eyes, hidden below his broad forehead, which frowns slightly in response to a melancholic thought, is very moving, and a white flash enlivens the black pupils. He looks down, lost in thought; he no longer poses a challenge, or least not to anyone in this world. His tightly pressed lips appear to be holding back the vitality of his cheeks, which sag under the weight of the years; but his features are still handsome and even, including the broad bridge of his leonine nose. The silvery beard hangs softly, more softly than the coarse fur of the bear to which he was likened by contemporaries, and more softly than the (more lifelike) one carved by Michelangelo in the figure in San Pietro in Vincoli. In his portrait of Julius II, Raphael expertly 'adjusted' the pope's physical and expressive details, cleverly parrying the criticisms and the censure directed at his bellicose character. Above all, it is precisely the pope's beard, submissively painted in featherlike brushstrokes of silvery grey, that becomes a crown of light, and convincing proof of Julius' docile spirit.

When one looks at Raphael's portrait, everything that the documents tell us about Julius II acquires an air of wicked propaganda. He could not appear further removed from earthly matters; the red and the white of his robes allow no room for distraction, focusing his entire personality in a melancholic and reflective gaze. Julius looks like the true father of every devout believer, the reliable head of a government founded on the spirit and on justice.

The portrait was displayed in public in Santa Maria del Popolo and was an instant success. Those of the faithful who were able to approach the pope in Raphael's version were certainly more numerous than those

able to see him in person. The softness with which the artist painted the velvet of his cape and the *camauro*,* the folds that broke up the light on the linen undershirt, all conferred to the figure such a tangible materiality that the viewer felt he or she was almost in his presence, having encountered him in one of his most intimate and authentic moments. Anyone looking at the painting could not fail to believe that the real pope looked as he did here rather than as portrayed in the foreign propaganda.

2 THE STANZA OF HELIODORUS

From 1512 onwards Raphael started work on the second of the new Vatican rooms, which would later become known as the Stanza of Heliodorus.[3] We do not know how much of the decorative programme for this chamber may have been decided beforehand, but the close link to Julius II's severe recent setbacks are so evident that it seems certain that the programme was conceived, or at least adapted, by late 1511 in response to the pontiff's new problems – the obsessive focus of almost every fresco.

The main scene, after which the room was named – *The Expulsion of Heliodorus from the Temple* (Plate 13) – was, without doubt, closely linked to the schismatic council held by the French cardinals. The Bible story tells us how the soldier Heliodorus made his way into the sacred temple of Jerusalem in order to claim the treasure belonging to the widows and children. The high priest prayed for divine aid, which arrived in the form of three heavenly messengers sent to chase away the robber. In other words the holy see would never lack divine assistance, nor would aid be denied to anyone who invoked it with a pure heart. In this case it was Julius II who appeared in person in the fresco, to summon God's aid against the French and against the enemies of the church, who had planned to meet in Pisa to oust him from power. As an added insult, the French king had also given orders to withhold the *decima* [tithe], thereby appropriating the church's treasure, as Heliodorus had done.

* The *camauro* is a red velvet cap bordered with ermine, worn by the pope. (Translator's note)

THE POPE AND HIS BANKER

The scene was so carefully staged that it could well have depicted a play, and its dynamic character gave the painting an extraordinarily emotive impact. Raphael captured the angel in mid-air, whip held high, as if in a photo finish. This immediately serves to highlight the divine nature of the apparition, since, if the angel's foot had touched the ground, the scene would have simply become an ordinary fight. But the angel hangs in the air, his mantle billowing with the fury that spurs him to overcome the godless: the same fury that had driven Julius onto the snow-covered fields around Mirandola when he, too, would have liked to fly up and chase the enemy out of the fortress.

Like the angel, the pope is shown here at a different level from that of the other players, except that he is raised above the ground, on a sedan chair carried by elegant bearers who gaze straight at us viewers, drawing us into the painting. The scene is very cleverly constructed. The interior of the temple extends up to the sky and the golden domes reflect a spiritual light that slowly dissolves the tension towards the open backdrop of the temple. On the right, having been knocked to the ground, the soldier Heliodorus drops the gilded vase, spilling the coins onto the temple floor. This powerful man is depicted in an extraordinary foreshortening; he is terrorised by the white horse, who is about to trample on him. The presence of the horse in such a sacred setting also adds to the sense of unease created by the image and to the breathcatching suspense in anticipation of the terrible consequences. The centre of the scene is left empty, so that the viewer can see right to the back of the temple, where the high priest kneels in prayer.

The soldier on horseback, an angel without wings, wears a breastplate and a military helmet, both of which are painted in painstaking detail. He embodies the pope's central, but most disputed, conviction that not even divine justice could triumph without recourse to arms and military valour. In this way Julius was using his painter to respond to critics from various sides who accused him of devastating Italy through war. This angel–soldier figure, in full armour, emerged from the earliest origins of Christianity, to confirm God's will that it was more than legitimate for the church to resort to force when it was attacked by enemies of the faith.

Raphael introduced this powerful composition into the refined programme developed by the papal court, therefore reinforcing its

message. Against the symmetrical and solemn space of the temple, the three celestial messengers summoned to drive out Heliodorus are painted in yellow and white, like a ray of divine light. They arrive so fast that the cloak of the emissary, caught in mid-flight, billows out behind him. Like Aeolus' cloak, his swells too, to form a curve that is echoed and amplified by the horse's muscular rump and neck, like a wave that rises into a crest and appears to hang motionless before crashing onto Heliodorus, who is cornered and unable to escape. The angels and the horse express the strength of the divine anger without showing any atrocity attributable to human intervention.

On the left-hand side of the scene the arched back of a woman, also dressed in yellow and white, tries to stem the terrible force that is about to destroy Heliodorus. The woman's back serves to balance the tensions of the scene and the chromatic values by drawing attention to what is happening on her left, namely Julius' arrival on his sedan chair. Indeed the pope's white robe forms another climax of the action. In this complex and dynamic composition Raphael showed how well he had learnt the lesson taught by Michelangelo on the Sistine Chapel ceiling – seen for the first time at about the same time – where the artist had used the dynamic energy of the bodies as the source of action. But the more restrained balance of the action here also shows the different focus of Raphael's maturity: he avoids provoking any emotive involvement in the viewer by barely hinting at the drama. The play of forces on the stage framed by the large lunette is reabsorbed by the marble columns of the temple; they fade into, and are placated by, golden domes, before merging into the golden light and being carried through the open window into the pale sky. Once again, the end result is a classical equilibrium between forces, colours and emotional tension.

The other painting in the room, the one showing *The Liberation of Saint Peter* (Plate 14), provides an even clearer defence of the legitimacy of the pope's military campaigns. The basilica of San Pietro in Vincoli had formerly been Julius' titular cardinalate church, and the young cardinal had expressed particular reverence for the chains with which Peter had been imprisoned on arrival in Rome. In order to celebrate his election as cardinal, Julius had even struck a medal whose reverse showed the chains preserved in the basilica. There could have been no better image than Saint Peter freed from his chains to illustrate the

legitimacy of his military campaigns. For years, papal propaganda reiterated that Julius had liberated Italy from the chains of its subjection to the foreign powers. The spiritual nature of this struggle must have been clear to Raphael, who by then had acquired a fuller understanding of the pope and of his court. Indeed the artist's intuition in this scene marked a revolution just by itself.

Starting with the difficulties presented by the wall itself, which was interrupted by a communicating door placed right in the centre, the artist divided the scene into three different moments separated by the prison walls; this gives a sense of continuity to the narrative without introducing breaks in space or time. The action takes place at night: this is one of the first nocturnes in the history of Western art, and certainly the most successful. On the left, a soldier standing with his back to the viewer points out the prison to three comrades-in-arms, indicating the blinding light that shines out of it. The soldiers' metal armour evocatively reflects the light from the moon; the moon itself is half-hidden by low-lying clouds, through which the golden light of dawn is just starting to appear on the horizon. On the other side of the prison wall, in a narrow cell painted above the door, barred by a metal grid that separates the viewer from the scene inside with the help of an astonishing *trompe l'oeil* effect, a dazzling angel, wearing rose-coloured garments, leans over Saint Peter (who is still in chains) and indicates the way out. The chains binding the saint are in the foreground and stand out clearly against the light. On either side, having fallen into a miraculous sleep, the guards rest helplessly on their lances, while the dazzling light of the angel makes their armour gleam like mirrors. On the far side of the prison walls, in the third scene, the light is softer, contracting into a pale aura around the angel. The light emphasises the grace with which the young man holds the hand of Saint Peter, still dazed with sleep, as he passes the slumbering guards on the steps.

The nocturnal effect of the painting as a whole is extremely evocative and the figures emerge in outline from the darkness. The focal point of the action is the miraculous light manifested by the divine presence, which makes the armours, the swords, the lances and the steel plates worn by soldiers useless and defenceless. Once again, Julius was conveying an explicit message to his enemies: no army could halt God's wishes, embodied as they are by Peter and by his legitimate successors.

The nocturnal scene only served to exalt the supernatural dimension of the event.

On 11 April 1512 the French army won an overwhelming victory over the papal and allied forces at the battle of Ravenna. For Julius, this must have seemed like the end. In his despair, he was ready to sell even the fabulous jewels from his tiara. But, just when it seemed inevitable that the warrior pope would have to capitulate and when Cardinal Sanseverino, France's ally, had started to march towards Rome to depose him for good, events took an unexpected turn. The valiant French commander, Gaston de Foix, had been killed at Ravenna and the troops started to disband, while at the same time France's northern borders were threatened by outsiders. It may well have seemed miraculous – a fitting term for a situation involving Christ's vicar on earth – when the demoralised French army started to head north and left Italy. The looming spectre of military defeat was momentarily warded off, also because the Swiss mercenaries, in whom the pope had placed all his hopes, were now crossing the Alps and rushing to his defence. If need be, they would have been paid from the sale of the gems in the papal tiara, which had been pawned to Agostino Chigi's bank.

However, another, equally terrifying spectre remained: that of a schismatic council that might depose Julius II from his Vatican see. The pope now concentrated all his efforts on forestalling this threat and on reaffirming the orthodoxy of the church of Rome: it was a field in which he was sure he could claim undisputed supremacy. On 3 May 1512 the pope opened a universal council in the basilica of San Giovanni in Laterano; it was attended by 16 cardinals, 70 bishops, 12 patriarchs and 3 generals of monastic orders. Egidio da Viterbo, Julius' supreme advisor on matters of doctrine and propaganda, delivered a compelling sermon among the columns plundered from the Romans and the golden mosaics: 'From now on God's people must only resort to the arms of piety and prayer. Faith must be their armour and divine revelation their sword.'[4] Returning to the Vatican, Egidio passed the baton to Raphael and his assistants, with their vair brushes, their cartoons and their mixing bowls full of the finest colours. Now it was the artist's turn to work the political propaganda machine as effectively as possible by painting the most popular of the medieval miracles used for strengthening the church of Rome against heresy.

In 1263, in Bolsena, a cleric who had doubted the true nature of the divine substance of communion had watched terrified as the consecrated host had started to bleed when it was lifted up for exposition. Taking advantage of the peculiar layout of the wall, which had a door in the centre, Raphael depicted the miracle by placing it at the apex of a pyramid, with the celebrant on one side, dressed in splendid vestments, and Pope Julius II on the other, kneeling but with the stiffly upright posture of a general and dressed in a short cape of garnet red velvet with a splendid white train, which flowed like a river of light down the steps below him (Plate 15). By overstating the naturalism, whose use here seems out of character with Renaissance painting, Raphael used that immense train to accentuate the spirituality of the papal figure.

Standing behind the pope is his retinue, and in particular the cardinals who were closest to him, including his nephew Raffaele Riario. Indeed, following the custom of the time, a narrative work of this kind offered an excellent pretext for a family portrait. In order to exalt Julius' new-found religiosity, announced by Egidio's public sermon at the Lateran Council, Raphael used a highly effective device: he painted choir stalls made from dark wood, which enclosed and at the same time isolated the pope and the celebrant in an intimate dialogue, from which all the other figures are excluded. This gives even greater weight to the centrality of the revelation embodied in the lifted host. By using this architectural expedient, Raphael separated the royal pomp of the scene from this intimate and spiritual core, in which the pope is enveloped and protected by his own faith.

A little lower, below the steps, the group of noblemen who have accompanied the pope kneel on a small stage and jealously guard his sedan chair. The prominence given to these figures is deliberate, since it allows Raphael to include real portraits of a quality that might easily have been found in standalone paintings. The nobles are dressed with royal elegance, in brocade doublets trimmed with gold braid and in crimson velvet sleeves that reflect the light with glints of metal, and their expressions reveal an awareness of their own royalty and power. They are the Roman nobles who had the privilege of carrying the pope on ceremonial occasions. A description of the procession for the coronation of Pope Leo X, a year or so later, gives a clear idea of the magnificence of this special 'guard of honour': '9 hackneys [chinee],

3 papal mules, with drapes, all led by hand by servants dressed in gowns [*saioni*] of black velvet and doublets [*zuponi*] of crimson satin and scarlet berets'.[5]

These Roman nobles are so majestic that they seem the real protagonists of the *Mass at Bolsena* (Plate 15). Indeed, the homage paid to them by the pope through his artist was particularly significant at the time. In August 1511 a group of noblemen, led by Cardinal Pompeo Colonna, had taken advantage of the pope's illness and of the awkward political situation to rebel against him, demanding that he reinstate the ancient privileges of the *conservatori*. 'While unexpected, the pope's recovery only partly reversed the clash: all the *motu proprio* [documents] issued on 28 March 1512 granted most of the requests put forward by the Roman people.'[6] The political relevance of this change would become known as the *Pax Romana* of 1511, and these marvellous portraits kneeling below the pope in Raphael's fresco can be interpreted as the seal of public approval.

Even while celebrating theological orthodoxy, the pope never abandoned these practical political tools. This was his real court and the company he loved most, together with that of the artists, with whom he dined and drank whenever possible. The shades of green and red in the clothing and the contrasting white highlights of the shirts were marks of unparalleled elegance in the proud bearing of these nobles, who asked not to be set aside.

Julius must have been very satisfied with the celebratory programme drawn up by Raphael at the heart of the church's temporal bureaucracy. The same programme, a fervid obsession in the pope's mind, would be revived in what can be regarded as the last propagandistic gesture of the della Rovere pontificate: the *trionfi* used in the next year's carnival, when the streets of Rome witnesses a procession of animated floats in which Raphael's ideas became living tableaux.

3 THROUGH THE STREETS OF ROME

'[. . .] with the pope, who is in bed and has no appetite, he only eats two eggs a day, and he takes no relish in anything.'[7] This is how the Venetian ambassador reported on the pope's progressive deterioration in January 1513. Stubborn to the end, Julius received ambassadors and

cardinals in his bedchamber and continued to refuse the treatments suggested by his doctors: 'he has no fever nor will he let anyone take his pulse'.[8] Instead he was pondering how to transform even his death into a political triumph, and he gave detailed instructions to the palace secretary on how he was to be dressed for his funeral. Meanwhile he was also ensuring that his successor would not be elected by simony.

Outside the Vatican the carnival was in full swing, despite the icy winds, which brought an exceptionally heavy snowfall to the Venetian lagoon. In Rome there were bull races and the 'palio of the Jews', but the real showstoppers were the triumphal floats [carri trionfali]. Descriptions and commentaries were circulated to all the Italian courts, exactly as the curia had hoped:

> and on this float was a woman dressed as a queen, but she was vanquished with her hands bound behind her back, and on the ground at her feet were many spoils, namely armour and weapons that are usually used as trophies: the woman represented Italy, oppressed and bound by the violence of the French [. . .] and in the frame above were the words: Italy Liberated, with a bundle of palm fronds [. . .] *Julio II Pontifici Maximo Italiae Liberatori et Scismatis Extinctori* [To Julius II, Pontifex Maximus, Italy's Liberator and Extinguisher of the Conflict] [. . .] [and] a hydra above which was an angel with a sword and shield who struck at its head.[9]

The sophisticated papal propaganda conveyed by Raphael through the works of art admired by the cultured visitors and ambassadors admitted to the Vatican rooms was now adapted to the street and to the coarse taste of the popular pageant. However, it continued to hammer out the same message: Julius has freed the church and Italy from the chains of the barbarians, and all that he has done was necessary.

The floats and the crowds following them made their way through a city in turmoil. Rome was undergoing massive urban transformations: new streets were built around the Vatican, to rationalise and increase the visibility of papal control over the wealthiest and most dynamic area of the city, and affluent new houses did not take long to appear. The long 'corridor' of the Belvedere, simultaneously theatre and imperial gallery, continued to expand with its triple order of pilasters. Together

with the new basilica of St Peter's, it was the principal new work constructed in early modern Rome.

This subtle and deliberate transformation was changing the city's appearance day by day. An appreciation of the classical world, of its forms and symbols, had become the vogue: everyone had to imitate this language in order to be in tune with it – and even in order to be a political participant in that great restoration dream that Julius II had sought to realise through every means at his disposal. The court dignitaries and the rich Roman citizens were obliged to follow this trend with whatever resources they had. The pope's architects and artists were overwhelmed with requests from wealthy patrons who wanted their stake in the papal magnificence by sharing the artists, at least in part. Michelangelo was off limits because of the complexity of the task he had undertaken: the decoration of the ceiling in the Sistine Chapel was an extraordinarily difficult enterprise, made even more arduous by his moody character, which had soon isolated him from Rome's artistic community. Raphael, on the other hand, found a way to satisfy the requests that came flooding in from leading curial figures. His arrival in Rome had been heralded by the renown of his Madonnas and of his Holy Families, and many now wanted one of his works.

Raphael painted a Virgin and Child with the infant Saint John for one powerful dignitary, who remains anonymous. The painting, now known as the *Alba Madonna* (Plate 48), reveals the new confidence he had acquired after working on the Vatican rooms. Returning to the tondo format characteristic of Florentine devotional paintings, Raphael placed the group in a tranquil, open landscape, which alone appears to anticipate the *vedutismo* of the seventeenth century.* The meadow is perfectly depicted with its grasses and flowers, rich in symbolism, while the sky reveals clouds whose brilliant vaporous trails at long last look credible. The Virgin is seated in a pose that emphasises the supreme skill attained by the artist in portraying the most audacious positions of the body. She kneels with her left leg propped up to accommodate the two infants on her right. The overall coldness of the painting, declined in shades of blue and green, is warmed up by the geranium-pink of the

* *Vedutismo* is a style of landscape painting that came into vogue after the turn of the seventeenth century. (Translator's note)

young woman's blouse at the centre. The stereotypical features of the
Florentine Madonnas are replaced here by the singular physiognomy of
a girl of extraordinary beauty, with whom Raphael was infatuated for a
number of years, and not solely in his art.

With her high forehead and her intense dark eyes, this girl had
already lent her features to one of the allegories of the Virtues adorning
Julius II's library in the Vatican. There, too, in anticipation of the *Alba
Madonna*, she is seated with her right knee lifted, gracefully turning in
the opposite direction while she holds the yoke that identifies her as
an image of temperance. With her black hair and with eyebrows that
arch perfectly above her wide, dark eyes, she is visibly different from
the other stereotyped female figures beside her. Large dark eyes with
a frank, open gaze are typical of the wonderful women that Raphael
started to paint in many of his works from 1510 onwards: through these
openly sensual features, Raphael started to loosen the rigid female
model that he himself had imposed and implemented to an exceptional
degree in the Florentine altarpieces. The lesson learnt from the most
transgressive and free artistic spirit of the period had started to give
fruit: that figure was Leonardo da Vinci, who had allowed a disturb-
ingly ironic smile to play on the lips of his women, even when they were
posing as the Virgin or as Saint Anne. This smile would never again be
absent from the panorama of Italian iconography: it staked a claim for
attention and, although it had always been obsessively sought and cel-
ebrated by men outside the public arena, until then it had not won such
freedom of visible representation, at least not in the upper echelons of
Italian painting.

Renaissance women were regarded exclusively as pawns in the acqui-
sition of male power and were relegated to representing the seal of
alliances or the vehicle of dynastic integrity, but almost never treated
as active protagonists in public life. Many were catapulted there by
accident, or when their husbands or fathers were taken prisoner or
died. Isabella d'Este had acted as regent over the marquisate of Mantua
during her husband's imprisonment. The countess of Mirandola,
whom the pope scornfully condemned as a 'cheating whore' [*Putana
fotuda*], had defended her fortress with an energy that few men could
have rivalled. The convivial gathering at Urbino around Elisabetta
Gonzaga and Emilia Pia used their intellectual wit to demolish the

prejudices that undeservedly barred women from performing a fuller social role. They did so by referring to the classical world – now that women, too, had access to ancient history and could completely supersede the Catholic tradition, which tended to depress and mortify women's role. But these new conquests, which were only acknowledged within a narrow intellectual elite, would take years to spread to wider society; and they were not helped by the regression that lay ahead in the Reformation and Counter-Reformation. Baldassarre Castiglione was a friend of Raphael's, and a decade later, in *The Courtier*, he helped to spread awareness about the fruits of female intelligence. But Raphael was close enough to that court and to that elite to anticipate the appearance of new women on the social scene, women who moved away from the devout, maternal role assigned to them for centuries by the Catholic iconography.[10]

For a start, Raphael began to understand and portray this new sentiment of eros and of female sensuality, by which he was completely enthralled, living as he did in the free and liberal society of Rome at the age of nearly 30, at the peak of his virility. Raphael's face, made older and stronger by a new awareness of the world, can no longer constrain the pressing need to love, and he devoured the beauty around him only to reinstate it, cleansed of any sense of vulgarity. That full, sensual mouth had transformed the decidedly green youth of the early self-portraits into a man of irresistible charm who looks out, at last secure of his own position, from the self-portrait in the Stanza of Heliodorus, where he painted himself alongside Marcantonio Raimondi as an apostolic abbreviator, below the papal sedan chair, to show off the title he had received a short time before. The perfectly even black eyebrows frame very slightly prominent dark eyes. The full mouth is enhanced by the beard, which shortens that fragile, excessively elongated neck. The pale complexion and the shoulders strengthened by manual tasks give him the bearing of a soldier. Also, his clothes are the height of elegance, because black was allowed for the rich bourgeoisie, even if it was declined in the infinite nuances of embroidered brocades, satiny velvets and gleaming silk, and interspersed and enhanced by glimpses of pure white linen from Flanders folded into the fineness of pleats.

Raphael was now a courtier who could even enjoy the lifestyle of a prelate like Cardinal Marco Cornaro, who, after watching the proces-

sions of floats in honour of the pope, attended elegant dinners in the
company of beautiful Albinia, a Roman courtesan willing to indulge,
without a second thought, in orgies of food and sex together with
dignitaries from the papal court. In his own way, Raphael had also
become a Roman prince, and the eroticism of that gilded yoke painted
in the hands of the beautiful figure of Temperance in the Stanza della
Segnatura became a compelling obsession. Indeed we find the trace of
a poem in the margin of a drawing that can be dated, without doubt, to
the happy months that followed 1511:

Love, you enticed me with your two lights,
two lovely eyes, in which I melt, and with a countenance
of white snow and fresh roses,
with noble speaking of a maidenly nature.

Such that I burn so much, that neither sea nor rivers
could quench that fire; but it is not unpleasant,
for my ardour makes me feel so good
that burning I am consumed by brighter and brighter fire.

How sweet was the game and the necklace
your white arms entwined around my neck
that, releasing myself, I feel deadly pain.[11]

The shy young man from the self-portrait in the *School of Athens* – a
newcomer to the constant entertainment of Rome, his face still veiled
with concern – was now ready to embrace this new universe, confidently
and without fear or hesitation, ready to burn with even greater intensity
than the fire he seems to have discovered here for the first time. His
passion was entirely carnal: passion for eyes that shone as brightly as
moons, for pale arms and for rose-pink cheeks. From this moment on,
driven by a love that immediately gave new energy to his art, he started
to explore his own sensuality to the full, and to explore it by using all
his talent. Above all, however, he was able to benefit from the more lib-
eral lifestyle granted at the time to princes in particular, but also to the
prince of artists, as Raphael was now known in that invented city where
spectacle was, increasingly often, an important part of everyday life.

But on this symbolic and existential journey Raphael could not travel
alone. Nor could he travel in the company of Julius II, although he
undoubtedly loved wine, war and women, and – if the palace gossip
were to be believed – men, too, especially if they were young and hand-
some: after all, Julius was the pope and, moreover, he had reached
an age when even the most debonair spirits set aside the torments of
love and eros. Raphael needed to find a new figure, one that was being
invented before his own eyes: he needed a lay patron, someone who
was unconstrained by political and religious obsessions, a man who had
received an education inspired by fifteenth-century humanist culture,
but above all one who was richer than a prince, who could afford to
secure the services of an artist like Raphael – while the latter, from his
first appearance in Rome, seemed destined to serve the pope alone.
Such an exceptional figure first appeared in the Rome of Julius II and
Raphael; and he would be responsible for another facet of the artistic
creativity of the Renaissance, one that would see extensive develop-
ments in the coming centuries. His name was Agostino and he came
from Siena, but his role in Rome was to attract business for his family
bank, the Chigi.

4 THE POPE'S BANKER

In addition to the countless festivities that enlivened the city, the carni-
val of 1510 provided the backdrop for a fabulous spectacle: a superbly
elegant group of persons rode through the streets, in a procession of
500 horses, to attend the mock battles staged in Piazza Navona and the
bull hunts held both in the Vatican, in the Belvedere courtyard, and in
the popular neighbourhood of Testaccio, on the banks of the Tiber.
The pope had managed even to adapt the centuries-old popular tradi-
tions to his own need for propaganda, and he did not miss the chance
to celebrate his victory over Venice by staging, in Piazza Navona, his
personal battle against Venice and the release of the cities in Romagna
instead of the usual celebrations of the ancient Roman battles. But his
personal triumph was consecrated by the magnificence and pomp of the
mounted company that was riding around Rome, which became itself
an amazing sight. At the head was the young and beautiful Eleonora
Gonzaga, married to Francesco Maria della Rovere who was the pope's

nephew and Duke of Urbino, as well as Raphael's 'beard', as patrons were known at the time.

The couple had come to Rome to sanctify their marriage and to celebrate the glory of the pope's family, of which the whole of the city was in awe. On Shrove Tuesday the party went to the Vatican, to watch the bull hunts in the Belvedere and then the Berber horse races, which were luckily won by a horse owned by the duke's father-in-law. In the afternoon the party rode across the river, close to the Porta Settimiana, just under the Gianicolo Hill, which was covered in woods. The late spring frosts meant that the branches of the plane trees and poplars were still bare, while the bright green leaves of the huge oak trees, which had resisted the winter together with the ilex, offered their own tribute to the glory of the della Rovere family. The scent of the cherry laurels drifted as far as the doors of a magnificent palace overlooking the Tiber: a palace surrounded by gardens fashionably planted with oranges and citrons aligned against the fast-flowing, threatening river. Fifteen-year-old Eleonora, with her green eyes and pale skin, had been dressed royally for the entire visit, although clearly her wardrobe was not completely to her liking, because she ordered a new robe in gold cloth, which had to be hurriedly made up in Rome. It was made by melting 900 ducats, which were then beaten by an expert goldsmith into wafer-thin bands and crimped foils, then appliquéd and bound into the black velvet. Unfortunately the goldsmith had not understood exactly how to cut the gold leaf, which the duchess wanted 'to look like a veil that would balloon out'. Perhaps it was made in haste or the instructions were not precise, but the young bride was disappointed with the outcome. However, she did not waste the coins, which she had drawn from the dowry given to her by the pope: the gold could simply be melted down again, ready for new dresses to be made.

Eager to spread their gossip to chancelleries all over Italy, the chroniclers wrote that Eleonora outshone all the other women present at the festivities in the sumptuous palace. The conduct of her husband was less elegant. Having been bored by the plays performed in their honour on previous evenings at the house of Cardinal di Sanseverino and in the Apostolic Palace, he insisted on retiring after dinner, without waiting to watch the comedy. Other pleasures were more pressing, much to the affectionate amusement and envy of the guests present. But Francesco

Maria was mistaken, because the comedy performed in the palace on the Tiber was so good and so well acted that someone wrote a letter to Isabella d'Este – the bride's mother, who had been obliged to remain in Mantua – describing it in enthusiastic terms and promising to send the text as soon as he could.[12]

That it was an exceptional performance was hardly surprising: the host and organiser of the evening was Agostino Chigi, the man who had built this *palazzo all'antica*, which had no match even among Europe's most powerful princes, with the intention of equalling and surpassing the civilisation and indolence of ancient Rome. Born in Siena on 1 December 1466 into a family of bankers, Agostino had been the recipient of extraordinarily favourable horoscopes, filled with as many good auguries as money could buy; but his good fortune had even outstripped the astrologers' desire to please him. His birth chart was so precise that, four centuries later, with the help of an astrologer, the art historian Fritz Saxl succeeded in fixing his date of birth simply by describing the paintings that depicted it, well before a document was found in the Siena archives giving definitive proof.

Described by Marino Sanuto as 'an exceptionally wealthy man', Chigi was indeed the richest man of his time, and he achieved a position and a political stability never again held by other people in that century.[13] As the guests entered his palace, which overlooked the Tiber, they were forced to stand and look up, in admiration, at his Winter Loggia, which Baldassarre Peruzzi, an artist who had come from Siena too, had decorated with figures that convey the propitious horoscope drawn up for Agostino Chigi on the basis of the position of the stars in the sky at the moment of his birth. Jupiter was in Aries, the Moon in Virgo, Mercury in Scorpio, and the Sun in Sagittarius – an ideal position for benefitting commerce, good fortune, generosity and liberality – together, of course, with an irrepressible sensuality, guaranteed by Venus in the sign of Aquarius. Indeed, the latter appeared completely naked, on a chariot pulled by two slender white doves (this same image had also appeared in the ceiling of the Piccolomini Library in Siena cathedral, where it had been carefully studied by Peruzzi).[14] The whole was a discreet celebration of a triumph that had no precedent, not even in iconographical terms. As a bourgeois and a merchant, Agostino could not follow the example of the popes, who showed no constraint in

plundering the sacred symbols in order to celebrate their own fortune and family. He drew instead on a much earlier tradition: he borrowed the science of astrology and the preference, deeply rooted in antiquity, for showing the signs of the zodiac in illustrated form.

Agostino had an infallible intuition, combined with an uncommonly strong control over his own passions – qualities that had enabled him to pass, indiscriminately, from serving the Borgia pope to being a close confidant of his greatest rival, Giuliano della Rovere. He had financed the disastrous campaigns of Piero de' Medici, who, in exchange for such loans, had personally pawned his family's glory – Flemish tapestries and antique cameos, hauled out of the jute sacks in which they had been stored in the Orsini Castle that overlooks Lake Bracciano. In May, while the shores of the lake were in full bloom, Agostino had held in his hands 'a large tapestry cloth embroidered with the story of Moses [. . .] a silver plate with five cameos, including an emperor's head in the centre and four other enchanting heads',[15] and countless other marvels collected by Cosimo il Vecchio and Lorenzo il Magnifico before falling into the hands of their vacillating and unrealistic heir.

Among others, Agostino had also lent money to Giudobaldo da Montefeltro, the adoptive father of the same Francesco Maria – who, that evening, had barely tasted the rare fruit, the meat served at table in the form of cooked animals dressed in their own skin, and the game birds and venison marinaded in vinegar and cinnamon, only to leave the brilliantly torch-lit chamber, without any concern for the disappointment of his guests. On 22 November 1497 Duke Guidobaldo, too, had called on Chigi to open his coffers in return for his family silver, which he pledged as collateral. On that occasion Chigi had weighed the silver plates, the sweetmeat dishes and the golden lids piled up among the gems, pearls and balas-rubies. Perhaps it was then that he understood the miseries that political ambition could bring, and he decided to keep his power safely shielded from this delirious desire to rule, subordinating all his actions to the protection of his economic interests, the real source of lasting prestige. He understood that, for a man of his character, it was much easier to persuade governments to protect his own interests than to put these interests at stake for the sake of an obsessive need to govern. Agostino Chigi had become such an intimate advisor to the pope that he had even been accepted into the papal family and

granted the use of a chapel in Santa Maria del Popolo, where he buried his closest relatives.

The feast that Agostino held for the della Rovere and their guests on that carnival evening in 1510 was his way of paying homage to Pope Julius II; but it was also the affirmation of a familiarity that endowed his immense wealth with a particular dignity. His house, with its gem-studded bathrooms that sparkled in the evening light, joined the ranks of the most elegant venues of the era, way ahead of those of the cardinals, let alone the small and miserable courts of numerous princes. With his unique style, Agostino had done his utmost to surpass them; but now, in order to win the competition outright, he needed the work of an excellent artist, one who could capture and portray the novelties of the horizons being opened up day after day in the city that was once more at the centre of the world.

In 1510 that artist had recently arrived in Rome. He was young and elegant and he shared many of the qualities of Agostino's temperament; his name was, of course, Raphael. But the banker could not steal Julius II's protégé. Neither the banker nor the artist could survive without papal protection. So Agostino embarked on a long process of seduction: he gradually involved Raphael in increasingly grandiose projects, waiting for the right moment to detract him, temporarily at least, from the pope's service.

On 10 November 1510 Agostino Chigi's name appears beside that of Raphael in a contract for casting two bronze tondi designed by the artist. We do not know whether the work was ever carried out. Raphael's first known commission for the banker were the paintings undertaken in 1511 for the Chigi family chapel in Santa Maria della Pace.[16] In this instance Raphael was responsible mainly for designing the decorated wall, given that the paintings themselves only measured a few square metres and would therefore have required little time. In the space between a marble arch and an elegant marble frieze decorated with palm leaves and with the Chigi coat of arms in the centre, Raphael painted a group of Sibyls against the dark red background of a curtain hanging from fake metal rings. The artist used the same foreshortening technique as he had for the Virtues in the Stanza della Segnatura, but the strong figures and, above all, the presence of the ancient Sibyl of Cumae, who was seated in an evocative pose on the right and wearing disturbingly archaic robes,

contained echoes of Michelangelo's work in the Sistine Chapel, which had recently been made partly visible from below.

While absorbing the dominant impression of the powerful foreshortening and dynamic movement that came in abundance from the Sistine ceiling, Raphael received these novelties with great wisdom and modelled them, as always, so as to suit his own personal language. His sibyls are not disturbing and, unlike Michelangelo's, they do not resemble wrestling men. Instead they are as graceful and gentle as Muses, soft and charming, with lithe but never muscular arms. The faces of these Sibyls were hazy with the seductive light radiated by all of Raphael's female portraits, which seemingly enjoy the viewer's admiration without provoking him or her with their disturbing and elusive existence, as Michelangelo's sibyls did. The masterly nature of the narrative is highlighted by the drapes, all painted in tones of golden yellow and pink, in not unpleasant contrast to the dark red of the curtain behind. As in the *School of Athens*, where the air acquires that golden tinge of afternoon light, so the atmosphere around the Sibyls in Santa Maria della Pace is coloured red, absorbing the robes and flesh like a filter and evoking the hot darkness of the caves where these prophetesses were said to have lived.

A unique detail highlights the particular role of this painting in the process of giving a veneer of antiquity to the Christian tradition – or, to put it another way, in the christianisation of the pagan tradition. The Sibyls are surrounded by angels who hold their sacred books, as well as by naked putti like those that Michelangelo had painted behind his Sibyls on the ceiling of the Sistine Chapel. Paradoxically, one could say that morality and tradition were a greater focus of attention in the chapel of a private citizen than they were in the main chapel of the Vatican Palace, where the Sibyls and the garland-holding genii, and even the angels, had lost the characteristics used for millennia in Christian representation. Agostino, it is worth adding, knew how to uphold convention, at least in public.

5 *AMOR VINCIT OMNIA*

In 1511 Agostino followed the pope on his ill-fated campaign against Ferrara. He then travelled to Venice, where he had to collect some major debts and to act on the pope's behalf in some affairs in which

they shared an interest. During these months the banker, whose first marriage had been to a Sienese woman of excellent family, started negotiations to marry a noblewoman who would have added lustre to his already considerable wealth. Margherita was an illegitimate daughter of Francesco Gonzaga and had grown up at the refined court of Urbino. Agostino met her at the festivities he had organised for the pope's nephew in 1510, and she seemed the right woman for his designs. His letters of negotiation remain an unparalleled example of bourgeois intelligence and measure. However, in Venice he fell in love with a beautiful young girl called Francesca Ordeaschi. Having grown accustomed to the graces of Imperia, Rome's most celebrated courtesan, whom he shared with princes and cardinals, Agostino was appreciative of such a young lover and, with his usual self-assurance, he moved her to Rome and arranged for her to stay in a convent; there, in return for a considerable enticement, the nuns agreed to guarantee him exclusive access to such adolescent delight. But Agostino, now a middle-aged banker, was more in love than he realised. Although in December 1511 he continued to feign interest in the negotiations for Margherita Gonzaga's conceited hand, his heart had been captivated by this Venetian nymph and, six months later, in July 1512, the girl had moved into the 'palace of love', as the Chigi called the Farnesina. She gave him five children in seven years; but the outcome of this overpowering love story was unprecedented in Italian history. In August 1519 Agostino married Francesca under the admiring gaze of the entire papal court and watched by the propitious gods painted by Raphael in the ceiling of the main loggia. The couple were married by Pope Leo X himself, who oversaw the exchange of rings, naturally of the most precious sort (*certum annulum aureum cum gemma annulo inclusa*, 'a ring of solid gold with a precious stone encased in the ring').[17] It was impossible to imagine a greater triumph for love. It was a revolutionary moment, a miracle that would mark the start of a new social era. A girl who had been destined to work as a prostitute, albeit of the most elegant sort, had risen to the greatest social honour, being wed by the pope himself in full view of the leading representatives of European nobility, and all thanks to the power of love, renewed in Italy, and to its culminating victory over everything and everyone. Raphael had played an important part in this fairy story, because he gave it form and made it seductive

and therefore credible. He also helped, in his own way, to achieve this social revolution. Moreover, the more he devoted his life to the adoration of beautiful women, the more he felt involved in this fairy tale.

To plead his marriage to Margherita, Agostino had written letters to the marquis of Mantua that humbly confessed his status, in full awareness that wealth, however immense, could not compete with blue blood. Or – at least – not yet. As was customary at the time, the banker, who was particularly able in this respect, treated that marriage with the cautious prudence of an economic transaction. 'And I am well aware', he wrote, 'that the magnificence of your spirit has compensated for any defect regarding my low condition as caused by fortune.'[18] Immediately after this he cleverly alluded to his readiness to provide the marquis with particularly attractive loans, knowing well that, when it came to money, even marquises viewed family ties with favour. A comparison between these letters and the final outcome of the matter confirms the unstoppable force of love, which, like a cataclysm, swept this mature and sensible 50-year-old off his feet before this beautiful but low-born girl. Strengthened by such passion, Agostino tired of having to struggle for a respectability that perhaps he no longer needed, or that he could achieve by other means, and he rebelled against the social conventions of his time. His relationship with the beautiful Venetian girl turned into a magic fairy tale the following spring, when showers of white petals fell from the apple trees in his garden. Agostino decided to abandon himself completely, following the example of popes and cardinals, who had never seen the illegitimacy of sentimental attachments as a hindrance. Moreover, Agostino enjoyed the unconditional support of Julius II, with whom, after a brief argument, he restored very close relations, and indeed, after having accompanied the pope to the opening of the Lateran Council on 11 May 1512, he and a very small group of relatives dined with the pope in the monastery of San Gregorio al Celio.

Agostino's position could not have been more secure by that date. This may have explained why he convinced himself that the time had come to abandon himself to that love he heard praised and declaimed on all sides, which was acquiring a new visibility in Italy's social scene. Family and dynastic virtue appeared to have lost their charm in painting and poetry, finally giving way to the sensuality of carnal love. It had been praised by Ovid, whose fame among the humanists almost

equalled that of a church father. And now it was celebrated by Ludovico Ariosto in poems that enchanted all Italy. Even painters were starting to paint it, and Agostino felt that his preference for evocative imagery opened up a unique opportunity. From Julius II he had learnt that the power of the image could achieve far more than a noble coat of arms or a prestigious position at one of the more renowned European courts.

Agostino had commissioned Baldassarre Peruzzi to decorate the ceiling of his new palace with images taken from Ovid's *Metamorphoses*, and in January 1512 a book printed in Rome by the poet and philosopher Blosio Palladio was among the first to extol that building and its paintings as representing the most avant-garde elegance. The decoration in ancient classical style was continued by Sebastiano del Piombo, the painter summoned from Venice, who started to paint the lunettes below Peruzzi's 'astrological' ceiling and to fill them with representations of Ovid's stories linked to the myths related to air. In the panels below Agostino gave instructions also for the execution of paintings of love scenes inspired by the myths related to water, and Sebastiano had already been commissioned to paint a Polyphemus in whom Chigi would have easily recognised himself, in this learned play of mythological references.

Now it was Raphael's turn to transform the banker's house into a house of Love, with a painting that was destined to set its seal on subsequent figurative art through its capacity to bring classical antiquity to life – not merely as an evocative portrayal of it, but also as the expression of a living and profound rapport with nature, happiness and the universe. The entire palace, which Agostino had commissioned from Peruzzi as early as 1505, had been conceived of as a celebration of pagan sensuality. The architecture drew inspiration from the works of Vitruvius and from the ruins of classical architecture. Ovid, who was celebrated even in the Vatican, provided the source for the artistic programme – although within a generation his works would be among those censored by the Counter-Reformation and by the curia, where he was previously exalted. Agostino's intention was to build a house designed for leisure, and only he could afford one that was dedicated, so entirely and in such detail, to the cultivated magnificence he so loved. Only he could hold princely banquets at which dishes were served on gold plates and prepared as a feast for the eyes.

Moreover, he had designed a garden that aimed to recreate something very close to earthly paradise. The amount of gold he had used to decorate the rooms had only been seen in Rome's greatest churches. It was here, against this background, that the new goddess of love arrived, poised on a shell of mother-of-pearl; she was pulled by two sprightly dolphins and destined to outshine every female figure that had appeared in Rome in the previous two millennia. This was Galatea (Plate 16).

6 VENUS EMERGES FROM WATER

In the autumn of 1511 Raphael was finishing the Stanza della Segnatura. On the wall where he painted the approval of the Decretals he was making the last touches to a Julius II, shown with the beard that he had grown as a sign of mourning during his ill-fated military campaign. During the winter of 1512 the papal court was working on the programme for the second *stanza*, that of Heliodorus, where the scaffolding had already been assembled and the walls had been rubbed down in order to receive the *arriccio** and the preparatory drawings for the new paintings. Raphael's entire workshop worked on the cartoons. This meant that the artist was free for a while from his commitments for the pope – who, being again on good terms with Agostino Chigi, certainly did not want to refuse him access to his preferred artist for a few days.

So Raphael was given access to the Villa della Farnesina, which was awaiting only his brush and his joy for its consecration to Love to be complete. The wall he chose was in the Winter Loggia, open to the Tiber, where Peruzzi had already painted the banker's lucky horoscope in symbolic form. On the wall below it, below the lunettes where Sebastiano del Piombo had interpreted Ovid's *Metamorphoses* in human figures, Agostino probably wanted scenes linked to the marine world, or just simply love scenes. The available panels were rectangular and square, framed by pilasters ornamented with grotesques that supported the ceiling corbels.

In the square above the entrance door, the first panel in the

* The *arriccio* was the first coat of plaster in fresco painting. (Translator's note)

south-western corner of the room, Sebastiano had painted a Polyphemus seated by a tree and staring at the sea in the distance. In Ovid's story the cyclops had fallen in love with the beautiful nymph Galatea, who surfed the waves with her retinue of sea creatures: a triumph of beauty and sensuality. However, she spurned Polyphemus' offers of love and mocked him in song. It was not difficult to recognise the middle-aged Agostino Chigi in the image of the gentle cyclops who was holding the syrinx* tightly in his hands to comfort him in his lovesickness. Given that Agostino had openly surrendered to his love, scandalising the cynical world of the papal court, his friend Raphael had now to explain to the world and legitimise the unstoppable force of that sentiment. Beside the portrait of the melancholic Polyphemus, Raphael painted his Galatea, who was standing on a shell pulled by two dolphins, surrounded by sea creatures and placed beneath a pale blue sky in which winged putti were drawing their bows, ready to shoot love's arrows at the triumphal procession.

The fresco consists of fewer than ten *giornate* and was executed with as much care as an oil painting. The pale blue spring sky covers half the painting, while a light breeze lifts the nymph's wine-coloured mantle and the hair of the other female creatures. The breeze also stirs the calm green sea, which fills the lower half of the square panel and adds to the overall impression of squareness of the scene (although in practice it measures 295×225 cm). In the centre, Galatea is naked, but her pubis is covered by the draped mantle and her breasts are hidden by her right arm, which stretches forward to hold the reins of the two dolphins pulling the shell. She is turning back, twisting her body, exposing it to the light and highlighting its adolescent form. She is looking up, towards the light, and Raphael does not hesitate to use the same ecstatic expression that he had painted on the face of Saint Catherine a few years earlier (Plate 17). Ecstasy, whether spiritual or erotic, has the power to transport men and women to the higher realms of emotion. Her twisted bust, which is completely realistic, ends in the graceful position of her hands holding the crossed reins that lead through the mouths of the two dolphins. The black cords that control the two marine mammals

* The syrinx was a 'pastoral' ancient Greek musical instrument of great antiquity, made of reed and akin to the whistle, the flute and the pipe. (Translator's note)

are inexplicably reversed: this may be an irrelevant detail, or perhaps an expression of the painful path of love.

The giant shell reveals a hydraulic wheel reminiscent of the paddle riverboats of the north, but also of the scenic devices used on particularly important occasions for boats in the lagoon of Venice, Francesca's native city.[19] The nymph preserves a virginal purity and isolation, and the contrast between her luminescent flesh and the dark red mantle evokes an edible shellfish, with its twisted valve open to view. The figures around her embody and express the charged senses of the most carnal eros. In the foreground, on Galatea's right, a muscular and bronzed sea triton embraces the ivory pale body of a blonde nymph who offers the breasts of an adolescent completely indifferent to the scandal they might provoke in the mind of the viewer. This nymph's hair is lifted by a band placed on her forehead, like St Barbara in the Sistine altarpiece. Raphael shows extreme confidence in using this feature of female beauty, which he found seductive, to express both erotic and religious devotion. On the left, another naked triton stretches up to play a wind instrument. His body is both athletic and sensual, barely disguising his intimate parts under the capricious seaweed frill sprouting from his thighs. Behind him a third triton, half-man half-seahorse, carries a nude nymph, seen from behind, while on the opposite side a fourth male nude blows into a seashell while riding a white colt. In the lowest part of the fresco, almost outside the square composition, a putto hangs onto one of the dolphins and is dragged through the water. His beautiful face and body echo Galatea's pose and expression – a device that Raphael had used for the past five years at least, as a means of amplifying seductiveness.

This representation of aquatic life combines animals and humans in a fantastic but sufficiently credible manner, reviving an imaginary world without descending into grotesque. Iconographical precedents can be traced back to Roman paintings and to ancient marble reliefs, but Raphael's painting adds graceful anatomic drawing and the compactness of the flesh, carefully differentiated by species and age. Galatea's golden flesh is highlighted by the red cloak wrapped around her: this colour was something of an obsession for Raphael at the time, and it would appear in *The Miracle of the Mass of Bolsena* and again in *The Meeting between Leo the Great and Attila* in the Vatican paintings

between late 1512 and mid-1513. The bright light on Galatea's face softens her gaze and her smile. The nymph held in the muscular arms of the triton crowned with ivy is much paler, and this highlights the contrast between her softly female body and the bronzed muscles of the man embracing her. The putto holding onto the dolphins, a master-piece of childlike sweetness, recalls the twisting body of the putto who wriggles out of the Virgin's grasp in Michelangelo's Taddei Tondo, but here his sun-kissed cheeks turn the muscular tension to softness. Above the group, three winged *amorini* – their different positions execute a full turn of the body – are poised to shoot their arrows at Galatea and her retinue, while a fourth putto pokes his head out of the cloud in the upper left-hand corner, holding a good bunch of spare arrows.

Set in that loggia, which is already filled with mythical figures and amorous symbols of all kinds, the scene conveys a joyful satisfaction of the senses and brings order and composure to the entire room. Liberated from any archaeological remoteness, young Galatea is a brand new figure in Renaissance Rome. This appearance marks her debut; over the coming years she became an iconic figure in a new and rapidly expanding cult of Love. Her innocence and purity hold back the manifest sensual excesses in which her retinue clearly indulged, but at the same time they do not preclude the evocation of a form of love that, for the first time, celebrated sexual pleasure knowingly and joyfully, unconstrained by the social formalities of marriage.

In Raphael's fresco female beauty is openly acknowledged as the central theme, without having to hide behind allegorical or spiritual meanings; and it demonstrates that the most ardent instincts can be curbed but never completely denied. Nature made its way back into the villa on the Tiber, filling the loggia with the scent of apple and orange blossom, while the sight of the river flowing past brought life's continually changing cycle right into the palace. The golden-haired nymph had been given renewed life: no longer in the shadow of those ancient Venuses that gathered dust in papal and princely collections, but as an independent newcomer to the panorama of Rome. Turning back, she looked towards Polyphemus, or to the sky where the god of carnal love resided. But also to Olympus, where other gods were waiting to return to the city after centuries of exile. Rome had reopened its doors to them. Agostino Chigi and Raphael would soon invite them into the

very same house. However short-lived it would prove to be, the cult of
Venus had been revived.

7 THE DEATH OF A WARRIOR POPE

Drained by illness, Julius II lay in bed, apparently unafraid and waiting
to die. Despite the accusations that rained down on him from all over
Europe, he believed he had been a good pope, and he consoled himself
with a faith that, in his own way, he had sincerely cultivated throughout
his life. His last concerns were for his family and for papacy itself, since
he wanted to assure its continuity without the interference of simony –
a practice to which he, too, had resorted. From his deathbed, he issued
a bull that mandatorily called for his successor to be elected without the
usual horse-trading for money and offices.

Nor did he have any second thoughts about his obsession with
propaganda. Using his last reserves of energy, he summoned Paris de'
Grassis, the faithful master of ceremonies, on Saturday, 19 February
1513, and dictated his last wishes for the burial rites. After all he had
done and all he had risked for 'his' papacy, he did not want to tarnish
his glory in this last stage of the journey. He asked to be displayed
in a golden gown, worth an extraordinary 2,000 ducats, and wearing
precious jewels, and he sealed his secretary's promise with a glass of
Malmsey wine raised above the white sheets embroidered in Flanders.
Isabella d'Este's shrewd ambassador estimated the cost with a single
glance: 'The letter G is two rings worth 1,200'.[20] Less cynical, the
people would appreciate other qualities, and their tribute to him far
outweighed the opinion of politicians during the coming centuries.

On the morning of Sunday, 20 February, news that the pope was at
death's door spread throughout the city. It crept through the damp pas-
sages on the banks of the Tiber up to the bakeries and butchers' shops;
it climbed up, with the women, onto terraces where the cold froze the
laundry hung out to dry; with a shout, it leapt across the narrow streets
and squares, reaching the countryside, and from there it spread to cities
throughout the peninsula and further, on the back of fast post-horses.
The crowds started to increase the stream of pilgrims who were cross-
ing the city, heading for St Peter's. The *borgo* and the square soon filled
with black dots who were milling around and looking anxiously up at

the Vatican Palace, almost as if a sign might suddenly appear in the cobalt blue sky to relieve the tension that was now palpable in the silent city. Even the merchants in the banks and rich households of Via Giulia looked out across the Tiber before going about their business. But a cold wind from the direction of the basilica made them draw back hastily, pulling their fur-lined velvet gowns more tightly round their waists.

The bridge of Sant'Angelo was already bustling with foreign representatives and their servants, all of them waiting for news to dispatch to their princes. The death and the election of a pope were unique moments, when Rome truly became the centre of the world. Like the *popolo minuto*,* they, too, looked towards the palaces that suddenly felt empty, abandoned by the life that was dying in the breast of the great warrior pope. Those palaces, which Julius had so forcefully desired, now seemed to dishonour his memory; their grandiose splendour revealed the human frailty even of powerful people such as him. But the foreign representatives and the ambassadors had already moved on beyond his death. Some expressing concern, others delight, all were talking about the possible successors and starting to lay bets on the candidates for the papal throne.

People from every background wandered in the square as if they were about to lose their father. Julius had been a father figure as well as a prince: a man who knew how to shelter them from a turbulent world, from the threats of small and great tyrants, from the Turks amassing on the boundaries of the Western world and poised to occupy it. Both pilgrims and the city's inhabitants were saddened by this imminent loss, which hung over the piazza like an invisible, yet very real threat. They entered the basilica and knelt in front of Michelangelo's *Pietà*, where, instead of displaying the usual admiring enthusiasm, they now cried apparently without cause. They queued to kiss the bronze foot of Apostle Peter, wetting the metal with their tears, as they had dreamt of doing for years, before they arrived in Rome.

Hours passed, and the death throes of Julius, the pope who had saved the church from ruin, became the death throes of the whole city. A pall of silence fell over its hostelries and over its lawful and illegal traffick-

* The *popolo minuto* consisted of those excluded from participation in civic life – e.g. the lowest ranking workers and craftsmen. (Translator's note)

ing, which were as eternal as its stones. Finally, to a general sigh of relief that was immediately accompanied by outbursts of tears, a peal of bells, first faint, then thunderous, chimed on the night between Sunday, 20 and Monday, 21 February. The wave of sound started like a slight ripple from St Peter's and then broke like an oceanic roller against the old walls of Porta San Sebastiano. No church, no matter how large or small, would have abstained from that mournful roll; nor would it have failed to add the lament of small bells hanging from wooden frames to the terrifying clamour of those cast on the other side of the world and walled into the bell towers of Rome's ancient basilicas. The bells of Santa Maria Maggiore, San Giovanni in Laterano and San Paolo fuori le mura would have been sufficient to deafen the entire city. A dry, drawn out sound, without modulation, started to vibrate through the walls of the fortified palaces and through the run-down houses wedged in-between the old churches. It spread through the alleyways and across the vast squares, waking the city, which, for days now, had been waiting for this signal. The incessant tolling proclaimed to all that Julius was dead and that Rome and Italy were again at the mercy of princes. That the world was again in danger. Paris de' Grassis wrote:

> Throughout the forty years that I have lived in this city, I have never seen such an extraordinary crowd at a pope's funeral. Great and small, old and young, all wished to kiss the feet of the corpse, even though the guards tried to fend them off. Overcome by tears they prayed for the redemption of his soul, and for the man who had been a true pope and Christ's vicar, a shield of justice, who had expanded the Apostolic Church and had persecuted and overcome tyrants.[21]

One of those men and women drying their eyes was undoubtedly a young man dressed in black, with shoulder-length hair: Raphael, son of Giovanni Santi.

6

THE YEARS OF TRIUMPH

1 A NEW ERA

On 11 March 1513 the bells of Prato rang out the good news, but the women of the city were once again reduced to tears, if they still had any to shed. They had cried for violations perpetrated on their boys that no amount of ointment would heal; they had cried when their daughters' abdomens started to swell; they had cried when they realised that something was stirring in their own bellies and would soon come into this world. Through their tears, they looked at the empty beds left by their husbands and at their sons who would never return. Killed, butchered and strung up on the gallows by their testicles, they had then been thrown into pits from which 6,000 corpses were extracted, one by one, after the sack was over.

The memory of these deaths was still fresh when the bells announced that the new pope elected in Rome was the very man who had led that massacre. Under the indifferent gaze of the Old Testament figures brought back to life by Michelangelo on the vault of the Sistine Chapel, Cardinal Giovanni de' Medici had been elected as St Peter's successor and had taken the name of Leo X. When the French had withdrawn from Italy the previous spring, Julius II had decided to punish the Florentine Republic, once and for all, for having sided with the foreign-

ers and, with a good measure of cynicism, he had selected the Medici cardinal to carry out that task. Indeed, Giovanni de' Medici had staked his claim to the Signoria of Florence, the city from which his family had been exiled 20 years earlier: it was he who would lead the papal army in order to crush the republic.

On 30 August 1512 the army had reached the gates of Prato. The summer was about to fade into autumn, and the weather was so balmy that it was almost impossible to imagine the torment that was about to start. Giovanni halted beneath the walls and ordered the bombardment to begin. Once a breach had been opened, the soldiers poured into the city, whose wealth they had been promised. The havoc was unimaginable. Indeed one of Giovanni's first acts, after making his triumphal entrance into Florence in mid-September as the victorious *condottiere*, was to ban everyone from talking about what had happened in Prato. He was wholly indifferent to the massacre. While still in his quarters in the ransacked city, he had asked his brother Giuliano to write a letter to Isabella d'Este announcing the family's imminent return to Florence, as if that had been accomplished through the grace of the Holy Spirit rather than through the blood that flowed beneath his windows.

In a letter to the pope that informed him of Prato's capitulation, Giovanni referred dryly to the tragic human cost of the sack:

> Today, the Spanish assaulted the walls of Prato with immense valour and they succeeded in entering the city through the breach in the walls, and by the steps, at around sixteen hours [midday]. They sacked the whole district, not without a few instances of cruel killing, which would have been impossible to avoid.[1]

In the cardinal's words, the slaughter of 6,000 of Prato's inhabitants was reduced to 'a few instances of cruel killing', an inevitable price to pay for that glorious achievement. In any case, Giovanni had been so eager to repossess Florence that he had even promised to pay the pope 50,000 ducats in order to do so.[2]

As if such heavy losses were not enough, Prato had then suffered from famine. A year later, as Pope Leo X prepared for his coronation, these festivities proved to be the final insult, as the city was expected to show its happiness for the good fortune of its persecutor. After

the pealing bells had stopped, there was even a display of fireworks designed to raise the morale of the surviving inhabitants and to give them renewed hope, as if the infants born to women of all ages who had been raped by the soldiers would not be a lifelong reminder of the slaughter that occurred during the papal sack.

In Rome Leo was confident that he could soon dispel the shadows that darkened the months leading up to his election. The papal master of ceremonies, Paride de' Grassis, was immediately struck by the new pope's heavy physique, remarking that he was fat and constantly sweating. Other members of the court were impressed by the joviality with which he announced his intention to enjoy his papacy as a marvellous gift of providence. His superstitious nature prompted him to alter the date for the coronation, because his astrologers had predicted an unfavourable moon. Leo's delight in worldly pleasures immediately became clear: the cavalcade for his coronation, which was finally held on 11 April 1513 and processed from the Vatican to the church of San Giovanni in Laterano, cost the extortionate sum of 150,000 ducats.

To mark the event, the city was transformed into a stage worthy of imperial Rome. Along the route triumphal arches made from papier mâché were assembled from which youths, dressed in classical costumes, declaimed verses eulogising their new victor. The most spectacular arch was erected by Agostino Chigi in front of his house in Banchi, immediately opposite the Sant'Angelo bridge. It was decorated with statues, while youths recited poetry and threw money to the crowds. Leo was delighted by this dramatic tribute, but he was even more appreciative of the loan of 75,000 ducats that Agostino had granted him that spring in return for the confirmation of his monopoly on the alum mine in Tolfa, the small town in the papal states where the precious mineral had been discovered some years earlier.

For a member of the Medici family, the choice of the procession as the highlight of the coronation was ideal. Leo's father and great-grandfather, Lorenzo and Cosimo de' Medici, had consolidated their power in Florence by using the legendary mounted processions of the Magi, and during these sacred enactments they had flaunted the magnificence that Benozzo Gozzoli had portrayed on the chapel walls of the palace in Via Larga. Here in Rome, Leo could use the most spectacular theatrical backdrop in the world as the setting for a cavalcade that would

have delighted them. The procession started across Ponte Sant'Angelo, which was closed for the occasion from 'one end to the other and lined, on both sides, with floral columns between which large tapestries were hung, while the passageway remained uncovered'.[3] Tapestries and garlands hanging from the columns created a backcloth that would have looked magnificent against the huge outline of the castle and rising above the green water of the Tiber, swollen as it was by the spring rain. Leading the way through the shower of flowers thrown from the windows and through the coloured hangings displayed on every house was the 50-strong troop of mounted crossbowmen commanded by Giulio Orsini, followed by the fierce Albanian soldiers dressed in papal livery and riding 100 horses. On their breastplates was emblazoned a large diamond inscribed with the word *Semper* ['Always'], while on their backs, instead of St Peter, there appeared the figure of Jupiter and the word *Suave* ['Agreeable'].

This advance guard was followed by 24 cardinals in full scarlet and gold capes, bishops in white mitres, and finally the other horsemen, all dressed in brocade and velvet and displaying insignia of all kinds. But the most elegant component of the procession, riding right in the centre, was the pope's own household, which seemed to have been preparing for this triumphal moment for the past century or more. The Medici had conquered Italy, and now 150 of their closest members were processing, 'all dressed pink and scarlet'. In comparison, the 200 Roman barons and their accompanying grooms were barely noticeable, while the court officials and members of the nobility who had flocked to Rome from all over Europe merged into an indistinct mass of brocade and velvet.

All except for two men who, for different reasons, stood out against that glittering blaze of fabrics and jewellery: the duke of Urbino and the duke of Ferrara. The former rode at the head of a group of 25 men dressed entirely in black velvet, as a sign of mourning for his late uncle, Pope Julius II. The latter was dressed with dazzling elegance, since he could celebrate Julius' death as the first step towards ending any papal claims to the state of Ferrara. To the thousands of Romans crowding the streets, Duke Alfonso d'Este's Herculean physique made him look like the god Mars and reflected his aggressive, brash temperament. He wore an ermine-lined cloak and a black velvet beret on which shone a

single diamond, said to have cost as much as a palace, and a pearl whose lustre left the other nobles speechless.

This triumphal cavalcade announced the opening of a new era, the end of the wars and the start of a new period of hedonistic peace, which within the space of a few years would endanger the stability achieved by Pope Julius II, albeit at the price of so many lives that were lost. Once he had settled in the Vatican, Leo immediately demanded a place in the pictorial celebrations that Raphael was still working on for the Vatican rooms [*stanze*]. In the fresco for the Stanza of Heliodorus, which was to represent the *Meeting between Attila and Leo the Great*, the new Medici pope's ruddy and heavily jowled face soon replaced the della Rovere pope's strong face, which was marked by suffering. A new age had begun and Raphael used his talent to give solemnity to that ungainly, paunchy figure of a man, whose face was always filmed in sweat and who had been raised in princely comfort at a wealthy court that had buried itself in its own luxuries.

In Raphael's fresco the figure of Leo the Great is swathed in a purple mantle that merges with the drape, which in turn covers practically all of his mule. His face is almost expressionless, although there is a sense that he is struggling to maintain a semblance of decorum. Raphael did not know the Medici pope well enough at this stage to portray and reveal his character, as he did later. But the entire decoration of the *stanze* was losing the central importance it had had in Julius II's politics, and Raphael would soon delegate the completion of the works to his workshop, limiting his contribution to the preparatory drawings. Not, however, before he had painted an exceptionally tall painting, *The Fire in the Borgo*, in the third *stanza*, which points to his new interest in architecture.

In keeping with the new era of the Medici papacy, Raphael was given broader responsibilities, which were tantamount to being in charge of everything that was happening on the artistic scene in Rome. The animosity that had persisted for two decades between the Medici family and the other leading artist in Rome, Michelangelo Buonarroti, ruled out any possible competition. Rome was Raphael's. His elegance and his knowledge were instrumental to a policy focused on celebration and founded on luxury and refinement of every kind. Within a few months the clash of sabres was replaced by hunts, banquets and theatrical

performances. Castel Sant'Angelo fired round after round of artillery salutes to mark the coronation of the new pope. It would go on doing so for years, during endless festivities, until the abrupt wake-up call of 1527 – a rout at which neither this Medici pope nor his artist would be present.

2 ONE LONG PARTY

'Now that God has given us the papacy, let us enjoy it.' This is what Giovanni de' Medici reputedly told his friends and family after his election: it was a message that was taken to heart by the entire court and city. On 27 April 1513, after barely six weeks as pope, Leo visited Agostino Chigi's palace on the Lungara. It had become the most fashionable destination in the whole of Italy, and those who were not fortunate enough to have visited it had to make do with the elegiac descriptions printed by Egidio Gallo in 1511 and by Blosio Palladio in 1512.

On that day, however, Leo had the honour of dining in a room perfumed by the slightly cloying scent of blossom from the expertly grafted pear and apple trees, and of delighting in the sight of the brilliant yellow lemons gleaming among the dark leaves that reflected the water of the nearby Tiber. The banquet lived up to Chigi's reputation for magnificence, yet in the gossipy dispatches written by various ambassadors it was soon outclassed by the astonishing ostentatiousness of the banquets given by the Roman senate for the Medici family on 13 and 14 September that year, when the pope's brother Giuliano de' Medici and his nephew Lorenzo were honoured with Roman citizenship.[4] Preparations for those banquets started as soon as the worst of the summer heat had passed, ripening to bursting point the pomegranates and figs that grew wild on the Capitoline Hill, their roots sinking deep into the brickwork. A team of carpenters began work on the project in order to build a temporary wooden theatre, capable of seating 3,000 spectators, on the Piazza del Campidoglio, where the temple to Jupiter once stood and now the decrepit Palazzi dei Conservatori highlighted the impotency of the city's lay institutions. The projected theatre was designed in accordance with Vitruvius' rules, although this was the first time they had been tested so strictly in a building that was not meant to last. Every artist in the city was summoned to help: apart from building

the structure, they painted fake marble reliefs designed to make the façade look like a triumphal arch and panels intended to celebrate the presence of the Medici in Rome.

Once the Medici procession, headed on this occasion by Giuliano and his retinue because Lorenzo was not in Rome, had reached the theatre, first a mass was sung and then an oration was given by Lorenzo Vallati. The mass setting was then quickly changed into a banquet one and a *credenza* [dresser] appeared, with 12 large shelves 'well stocked with gold and silver'. The air was filled with the scent of the perfumed water carried around in ewers to wash the guests' hands between one course and the next.

The guests were surprised to find that the fantastic shapes of the folded Rheims linen napkins contained live songbirds, which then flew around the room, adding their chorus of birdsong to the general buzz of excitement. The meal started with antipasti made from marzipan, which were served with Malmsey wine. The 25 courses that followed excelled one another for the dramatic effect they created:

> VIII gilded shells containing VIII roast kids coated with thick white sauce [*savor bianco*] and stuffed with roasted birds; these kids stood upright, one in each shell [. . .] VIII plates with dough baskets, expertly crafted and gilded, and filled with many good things [. . .]. A huge vase containing a high mountain filled with men and various animals, made from scented ingredients. From all four sides trickled sweetly scented waters, and incense burnt in four places. It was crowned by a golden ball.[5]

The political significance of the ceremony lay in stressing the alliance between the Medici and Rome and the non-belligerency pact between papacy and senate. Image was always important, even that of the courses served at table, and nothing could be left to chance. Therefore even the sweetmeats and the *confetture*, the flatbreads and the roast pheasants were adapted to the needs of political propaganda.[6] Snow and ice were carried in, to cool the increasingly stuffy room, while jesters entertained the crowds with tricks of all kinds. The atmosphere became so elated that the guests started to throw pieces of roast chicken and kid towards the populace, which had stayed to admire the spectacle.

Once the banquet was over, Giuliano and the other guests were invited to take their places in the theatre. The tables and the *credenza* laden with gold plates were swiftly cleared, to make way for the musicians and for the procession of actors impersonating allegories and reciting verses. Their performance re-evoked the pagan tradition, as if Christianity should be content with the mass that had inaugurated the banquet. The first actor to appear was a personification of Rome crowned with gold; this was followed by two nymphs sprinkling perfume, while the sound of fifes and drums filled the room. There followed a series of other allegorical scenes. But the celebration of the Medici reached its climax on the second day, when a richly decorated float appeared on the stage, bearing an open-winged pelican who fed its young with its own blood. It, too, symbolised Rome. Round its neck was a yoke, and beside it was the she-wolf suckling Romulus and Remus; the whole scene was placed under a laurel tree, on which hung the golden Medici balls and golden yokes studded with diamonds.

Leaning against the laurel was an allegory of Lorenzo the Magnificent's wife, Clarice Orsini, who was mother both to the new pope and to Giuliano. The Orsini were one of Rome's oldest noble families, and in the circumstances it was Clarice who could claim to have united the two cities, Rome and Florence, in the glory of the new pontificate.

> In her right hand she held a laurel branch, in her left a golden ball topped by a gilded lion. On her left shoulder hung a shield emblazoned with a snake. On her right lay the river god Tiberinus, and on her left Arno, both with white beards and wavy hair, and completely naked except for a cloth that covered certain parts of their bodies.[7]

After getting off to such a spectacular start, Leo X's pontificate inevitably raised very high expectations. But the Medici pope managed to exceed them – so much so that Pietro Aretino, who enthusiastically attended Leo's festivities and even organised a few for his protector, Agostino Chigi, described him as the pope who had shown the world the 'greatness of the popes'. A quick look at Pope Leo X's household accounts reveals the high tenor of the life he provided for his court. The loans that Chigi was all too ready to grant – knowing this time

that the money would not be wasted on foolhardy military adventures, as it had been in the case of the pope's brother Piero – were now spent on buffoons, banquets, comedies and, above all, on hunting. This was the pope's favourite sport and his hunts soon became legendary – for example the one that took place in January 1515 at the papal villa at La Magliana, where the bag included 30 deer and 9 boar. Throughout his pontificate, the artillery at Castel Sant'Angelo was used more often for firework displays than for military battles. These were Rome's most carefree years.

3 SERVING THE DREAM

Raphael had been sincerely saddened by Julius II's death. During the period of mourning that followed, the artist continued to work on the frescos for the Vatican *stanze*, but also on the portrait of the young Federico Gonzaga, whom Julius had held in Rome since 1510, as a hostage for the loyalty of his father Francesco, marchese of Mantua. The boy, who was extraordinarily good-looking and very affable, had become one of the most brilliant members of Julius' court. Raphael had even asked to borrow Federico's gown, which was made of golden cloth and purple satin, and he had taken it home to analyse the iridescent effects of the precious cloth. He wanted to compose the painting, thus minimising the time the model would have to sit. However, during the days immediately after the pope's death, Raphael did not feel like working. As the Mantuan ambassador wrote to Isabella d'Este, the boy's mother, 'at present it is not possible for him to keep his mind on the portrait'.[8]

Over the months that followed Raphael continued to work for the new pope by completing what he had started for his predecessor. In the *Meeting between Attila and Leo the Great* – the fresco in the second *stanza*, which was already at a very advanced stage – Raphael managed to include a portrait of Leo X. Relations between the two men continued to improve and Leo's attitude towards the artist was, if anything, even warmer than that shown by Julius. Leo immediately expressed his intention to surpass the dream of reinstating the golden age started by his predecessor by including the entire city and its ever more refined court in this dream. Once again, fortune was on Raphael's side. On 12

March 1514 Donato Bramante died: this ingenious architect had been in charge of all the main papal building projects under Julius II and Leo had reconfirmed him in the post, appointing Giovanni Giocondo of Verona as his assistant in the difficult process of building the new St Peter's. After the death of the man who had been Raphael's mentor and friend, as well as his teacher in matters of architecture, Leo decided, not without causing some surprise, to nominate as his successor the young artist who, at the age of nearly 30, had only completed two architectural commissions for Agostino Chigi: the rebuilding of the chapel granted to him by Julius II in Santa Maria del Popolo and the construction of his 'stables' in the garden of the palace on the Via Lungara.

Raphael accepted the position enthusiastically, but also with surprising humility, aware as always of his own limitations. He realised that he could learn important rules of classical architecture from the elderly Fra Giocondo, and he set about the task with the zeal of a newly graduated student.[9] He started by planning the work in minute detail together with his collaborators, who now formed a tightly knit creative group, as they were capable of bringing their respective specialisations to bear on any problem arising in practice. Giulio Romano, Giovanni da Udine, Giovan Francesco Penni and many others could no longer be regarded as apprentices or simply assistants, but rather as artists who were now at the height of their careers. They worked together to assist Raphael with the drawings and plans, and they were flanked by specialists in relief drawings who were dispatched as far afield as Greece, to measure and study the most significant examples of classical architecture.

Another facet of this systematic study of the ancient world was the Italian translation of Vitruvius' *De architectura*, which Raphael commissioned from the renowned humanist Fabio Calvo of Ravenna. By translating this text, fundamental for the rules of classical architecture, and then by verifying it through the systematic mapping of the monuments, which had been measured with scientific precision, Raphael was drawing closer to the final goal of that quest for linguistic and stylistic integrity that had attracted Italian artists for the past century.

Once again, he understood that the opportunities offered to him by the pope and by Rome, at that moment in time, were unique and had never been offered to anyone before him. It was a conjuncture of

events that gave him a unique advantage: his potential rivals were put out of the game by a variety of circumstances. Leonardo da Vinci, who had also been summoned to Rome by Leo X, shut himself up in the Vatican, beleaguered by age and by his own obsessions. Leonardo's scientific research was too unwieldy and wide-ranging to produce a synthesis that could be used by that world, which was feverishly hunting for new and, above all, self-celebratory images. Michelangelo Buonarroti, who was busy designing the tomb for Julius II, isolated himself in his modest workshop in Macello dei Corvi, a prisoner to his own tormented nature, to his enmity with the Medici and, most importantly, to his existence as a perennial exile, which had prompted him to move to Rome and to build the factor of distance into his exasperated relations with Florence and with his pretentious family of birth. This meant that Raphael could dominate the stage – with a freedom and wisdom worthy of a great philosopher, as well as with his exceptional talent.

Even in his family relations, Raphael showed an ability to block any requests that might have hindered the construction of his prodigious career. In a letter written to his uncle Simone Ciarla on 1 July 1514, he reveals the foresight of his approach to art, and especially the intelligence of his approach to life. Like most relatives who become the guardians of children of whom they are very fond, Raphael's uncle insisted that his nephew should marry, now that he had, at last, reached the city regarded by all as the only place where a man could work to his best advantage and, of course, provide for his own descendants – a task seen as a top priority in the fragile society of the early sixteenth century. Underlying this preoccupation were the rumours, which Raphael's uncle would almost certainly have heard, regarding his nephew's exuberant love life. Giorgio Vasari, who had been reliably informed by the artist's pupil and heir Giulio Romano, elegantly described Raphael as a 'very amorous man who was fond of women, and he was always quick to serve them'.

With a nonchalance verging on cynicism, Raphael explained to his aged uncle that his earlier resistance to marriage had been providential: his social standing had risen so rapidly that it would have been foolish to marry earlier and be content with a modest dowry when now he could command quite a different sort of alliance:

[O]n the subject of taking a wife, I tell you that, with regard to the woman you wanted to give me earlier, I am very happy, and constantly thank God, that I have taken neither her nor another, and in that I have been more prudent than you, who wished to give her to me. I am sure that you too now realise that I would not be where I am now, since at the present time I have property in Rome worth three thousand gold ducats, and an income of fifty gold scudi, because His Holiness has given me a retainer of three hundred gold ducats for overseeing the fabric of St Peter's, which will continue as long as I live, and I am certain that more will be forthcoming.[10]

He was, of course, referring to more money and to the increasingly promising future that, with enthusiasm, he saw ahead. The city was at his feet and, in the years to come, Raphael would ensure that his dominance would be even more complete.

The cardinal of Santa Maria in Portico, Bernardo Dovizi da Bibbiena, one of the most powerful men at the papal court ('Mr Everything', as he was aptly described by the Venetian ambassador in Rome), had promised to give Raphael the hand of one of his nieces in marriage. Without doubt, this would have given Raphael a definitive entrée into Italy's most influential circles and, for the first time, it would have broken down the social barriers that, for 2,000 years, had excluded even the most famous Western artists. However, even if this plan did not come off, Raphael knew where in Rome to find 'a beautiful violet, whom I understand has an excellent reputation, and her relatives want to give me three thousand golden *scudi* as a dowry'.

Beauty was a quality he could not live without, nor was there any reason to rush into just any marriage. His young heart was filled with an ardent passion that only painting could appease. The two portraits that date from this period and undoubtedly feature his lovers are charged with such sensuality that they betray themselves to be a remedy for his unrestrained feelings. Through the silken touch of the brushes, which left no trace on the canvas, Raphael stole his lovers' beauty and transferred it into paint, possessing it for ever: it was a privilege that not even a prince could boast, even if he were pope – or indeed a man of fabulous wealth, like Agostino Chigi.

4 RAVEN BLACK HAIR AND EYES

He painted the portrait of Beatrice Ferrarese and other women, and especially his own [woman], and infinite others. Raphael was a very amorous man who was fond of women, and he was always quick to serve them. This was the reason why, as he continued to pursue his carnal delights, he was treated with consideration by his closest friends who regarded him as a very confident person.[11]

But Raphael's love of women and of sex knew no bounds, and it became such a central trait of his life and personality that even Vasari, usually measured in tone and far removed from this type of personality and its sensibilities, could not fail to hint at this side of Raphael's nature in his biography of the artist. Moreover, Vasari's information on Raphael came from Giulio Romano's first-hand experience not only as the artist's friend, but also as his best pupil, who shared the most ardent phase of his short life. Indeed Giulio himself, who continued to enjoy the freedom that characterised the circle of Raphael's friends and carried it further still, was later at the centre of a scandal in which the whole papal court got eventually involved. Immediately after 1520 Giulio drew a series of erotic drawings that showed sixteen different positions for making love. The classicising style of these explicit images of ingenious coupling, which made no attempt to conceal the protagonists' genitals, fully engaged in lovemaking, barely distinguished them from the crudest pornography. The project would have been tolerated without a second thought in the liberal and easy-going climate of Rome under Clement VII, Leo X's cousin, if the authors had not produced prints of those drawings; and the prints were engraved by Marcantonio Raimondi, another of Raphael's close friends. In this way a much wider – in theory unlimited – audience obtained access to the erotic material, spreading a culture that, once released outside its own, more refined circles, ended by discrediting the entire court of Rome. Through the intervention of Gian Matteo Giberti,* the engraver was imprisoned; but, thanks to pressure from influential friends like Cardinal Ippolito d'Este and Pietro Aretino – who immediately wrote a series of bawdy

* A prominent figure in the papal curia and a leading reformer. (Translator's note)

sonnets to accompany Raimondi's engravings in a secret or limited edition – the poor man was released from jail.

Giulio Romano was therefore, by all reports, a reliable witness of Raphael's erotic and sentimental life, and he was unquestionably an accomplice and confidant during the years leading up to his death, which Romano blamed – as did many other contemporary witnesses[12] – on the artist's amorous excesses. Raphael's last self-portrait captures the intense, dewy-eyed gaze, filled with a sensuality that was both irrepressible and unrestrained and that lit up and gave profound virility to his dark eyes and full mouth. Even the pose in which he painted himself, with his hand resting gently on the shoulder of his handsome friend – certainly a companion in gallant adventures – conveys a profound sensuality, a carnal existence that, even in friendship, cannot manage without physical and loving contact. From this point of view, there is no other Renaissance painting that is more disturbing. No other two men are linked by such an intimate and affectionate relationship as Raphael and his friend.

Clearer signs of Raphael's passion for women and for 'their services' can mainly be found in his unparalleled ability to portray female beauty through painting: a beauty that was freed from all religious overtones and elevated to being an object of cult and devotion in its own right. The Galatea he painted for Agostino Chigi is the best Renaissance portrayal of the goddess of love. The women he painted in the adjoining Loggia of Psyche, dating from around 1519, also stand out for their seductive charm. It is hard to imagine the works of Titian, the supreme painter of female beauty, without the precedent set by Raphael.

However, there are two outstanding paintings of women that embody Raphael's eros: the *Portrait of a Lady*, usually known as *La donna velata* (Plate 18), now in the Galleria Palatina in Florence, and the renowned *Fornarina* (Plate 19), in the Galleria Nazionale di Palazzo Barberini in Rome. For 400 years these two paintings have given rise to endless speculation regarding the identity of Raphael's lovers without any definite results being reached, and indeed the interpretation of these paintings has been blurred by changes in the standards and customs linked to the morality and liberality of various societies and periods. During the nineteenth century critics even questioned the authorship of the Barberini portrait, because its blatant eroticism

did not square with a Raphael whose morality was felt to be closer to Platonic rather than carnal love.[13] Similarly *La Velata*, with her iconographical ambiguity, has been variously interpreted as an honourable and noble bride or as a courtesan – perhaps the lover of Lorenzo de' Medici, who was also famous for the extravagance of his love affairs, so much so that his uncle, Pope Leo X, had to recall him to Rome in 1515 to put an end to the scandals he had caused in the straighter-laced atmosphere of Florence. In order to reinstate the documentary value of these two paintings, however, it is important to separate them from the legend and to return to a reading that is as free from prejudice as possible.

The first mention of *La Velata* appears in Vasari:

> Marco Antonio afterwards made for Raphael a number of other engravings, which Raphael finally gave to Baviera, his assistant, who had charge of a mistress whom Raphael loved to the day of his death. Of her he made a very beautiful portrait, wherein she seemed wholly alive: and this is now in Florence, in the possession of that most gentle of men, Matteo Botti, a Florentine merchant.

The woman in the painting was probably not Raphael's last lover, who is more plausibly identified with the model for the painting now in Palazzo Barberini, Rome, known as *La Fornarina*. Vasari's words illuminate, with the imperfection of a flash of lightning, the most human aspect of the artist's life, which was later disguised and manipulated by legend. Like great princes and cardinals, Raphael asked his loyal assistant and pupil to look after the woman who was his current lover, his mistress, the courtesan, the classy prostitute. Having acquired this status, the woman could in turn display the social advantages of affluence and call for whatever services she needed. To seal her social standing as a refined lover, Raphael offered to paint her portrait, as if she were a noblewoman. What other women acquired through noble birth or through hard cash was given to her through the love of a great artist, and through the revolution that he brought about with his talent.[14]

At the time, this was not at all scandalous. Several great figures of the Renaissance were the product of extramarital affairs: first and foremost, Giulio de' Medici himself, who later became Pope Clement VII. Indeed

one of the first acts undertaken by Giulio's cousin Giovanni after he was elected pope was to order a fake marriage certificate sanctioning the legitimacy of the relations between Giulio's mother, Fiammetta, and his father Giuliano, Lorenzo the Magnificent's brother. These illegitimate children were often raised in the paternal household, and their mothers were reintegrated into society by being married off, especially if they had had the good sense to conduct an affair with someone of influence and power. In the Renaissance the prostitute enjoyed an honourable status, legitimacy and respect in proportion to the status, respect and legitimacy of her clients. One example alone serves to illustrate this: that of the renowned courtesan Imperia, lover of princes and cardinals and, of course, of Agostino Chigi, who managed to have her buried in the portico of the church of San Gregorio al Celio – a mausoleum worthy of a cardinal – until the tomb was removed as a result of much stricter social mores.

Before the Council of Trent slipped a tighter noose around family inheritance, enforcing exclusive dynastic continuity, the inhabitants of a city like Rome enjoyed a degree of sexual freedom that is difficult to understand, even today. Marriage was unanimously regarded as a dynastic and economic matter and its parameters hardly ever conceded any space for those passions, exalted thanks to the rediscovery of classical literature from the mid-fifteenth century onwards, that might result in a much more complex relationship between the spouses, one that went further than the purely reproductive function. Between the late fourteenth and the early fifteenth century, it was indeed the figure of the courtesan that fuelled men's dreams of refined sensuality. Certainly, women of rank could not be asked to act as elegant seductresses or to host brilliant society events and festivities. This role was played instead by courtesans, some of whom acquired extraordinary reputations, like Imperia or Cardinal Cornaro's lover, Albinia, who attended the parties at his palace together with Bibbiena; or, again, like Beatrice Ferrarese, who, according to Vasari, was painted by Raphael and may perhaps have been portrayed in *La donna velata* (according to Renaissance custom, prostitutes and courtesans were not referred to by their family names, but by their native city). But the search for the precise identity of the woman with whom Raphael was in love is much less important than the story told by the painting itself.

The model, a young woman of ravishing beauty, sits in a three-quarters pose, against an olive green background. The dark outline of her right-hand profile and the mellowness of her complexion, lightly veiled through a *sfumatura* that hollows her features and surrounds her gown, date from the period before Raphael's portrait of Bibbiena.[15] The woman is dressed in a grey silk gown worn over a paler undergown [*camicia*] of gauzy linen, which is minutely pleated and gathered into a low frill around the neckline. Her head is partly covered by an ivory-coloured veil that hangs down over her shoulders. The veil reveals part of a golden headband onto which a precious pendant is attached, consisting of a ruby above a dark gemstone, both set into a narrow gold band below which hangs a single seed-pearl. On her left wrist is a gold bracelet set with precious stones, while the curve of her neck is enhanced by a simple necklace of oval amber beads, as large as almonds and slightly differing in colour.

The woman's gaze is perfectly composed, and her dark eyes, framed by arched but not emphatic brows, are slightly cast down, looking into the distance and seemingly lost in thought. It is an expression that suggests a vague sense of fear, or someone who is thinking about the future, but without much certainty or enthusiasm. She is looking elsewhere elusively, in a way that would be unbecoming for a marriage portrait – which is what some researchers have suggested the painting is; but then neither is she wearing a ring, as was usual in portraits of that type.

Her right hand rests on her breast, partly hidden by the veil, and her index finger points to the opening of her gown, as if indicating her heart or holding up the gown, which seems to have slipped slightly. The suggestion that the gown may have been loosened is also borne out by the emphatic disorder of the silken sleeve trimmed with gold braid, which fills the lower part of the painting with such movement that its volume seems to thrust above the surface and brim over the frame. The silk and gold sleeve is painted with a tactile quality that differs from that of the other fabrics, particularly the veil – which appears to draw back, its vague folds melding into a single surface. The viewer's attention is immediately caught by the billows created by the 'cut' sleeve – as the practice of slashing the fabric in the sleeve was known at the time – thereby revealing the contrasting fabric beneath and producing a strikingly luxurious effect.

Much of the painting's fascination undoubtedly lies precisely in this sleeve and in the way it juts forward and is used by Raphael to embody the sensuality of the feminine world. Its deeply sinuous folds are exaggerated through brilliantly gleaming highlights and cavernous depths, especially in the wide opening edged with gold, which clearly recalls the female sex. Even without wanting to suggest any explicit allusion to the shell-like pudendum (which is quite possible, in view of the similarly licentious images included in the festoons of fruit and vegetables painted by Raphael and his collaborators at the Farnesina), there is no doubt that the woman's sleeve emits a sense of overpowering femininity, softly penetrable, in a joyous promise of carnal intimacy. The way in which the gold braid on the sleeve is folded back to reveal the gauzy undergown, and the way in which the reflection of the golden lining draws attention with the help of one of the brightest tones in the painting, are certainly the result of careful thought. Furthermore, x-rays of the painting made at the time of the last restoration revealed *pentimenti* confirming that the final outline was 'thought out' directly onto the canvas rather than being transposed from a finished cartoon.[16]

The sexual symbolism returns in the almond-shaped amber beads of the necklace and in the open edge of the gown, to which the woman's forefinger is pointing. Even the sense of precariousness conveyed by the portrait is a projection of male erotic fantasy: the veil is slipping off her head, her sleeve drops down her shoulder, the gown is unbuttoned, while her full and slightly unwilling mouth rebuffs any intrusive looks. Raphael brings us inside the bedroom of a woman who is in the process of undressing, and he captures the magic of the intimacy that is about to take place. While Maddalena Doni's bodice is laced around her bust with decorum, the veiled woman's bodice is loosened, almost revealing her breast beneath the already dishevelled undergown.

It is these elements that make the portrait distinctive, rather than the woman's identity. That this is a portrait and not some allegorical ideal is emphasised by the extremely natural appearance of her attached left ear lobe, which invalidates the repeated attempts to identify this woman with the sitter known as *La Fornarina*, whose ear lobe is clearly detached. This detail appears to have escaped the attention of nearly all the critics; they have focused instead on an idealistic and allegorical interpretation of Raphael's work and love affairs.

The need for a moralising stance has also influenced the most recent generation of scholars, to the extent that many have seen this painting as a wedding portrait, because the veil was reserved for married women. But this simplistic classification of sixteenth-century fashion codes appears to reflect the requirements of academics and overlooks the real world, of which a sharp observer of the period notes: 'I think it is hard to distinguish a woman of good reputation from a courtesan in Rome; the latter still wear that straight veil worn by honest Roman women, and I have seen plenty in every area of Rome.'[17] To sum up, *La Velata* is Raphael's fascinated tribute to his lover and to female beauty, captured in an extremely modern sense, which reveals the artist's close intellectual – and not merely artistic – scrutiny of the portrait's psychological and sentimental facets.

Raphael's next step, which resulted in the Barberini portrait universally known as *La Fornarina*, drew him even further inside this disturbing and elusive female world. The painting shows the woman who, according to Vasari, Raphael insisted should come and stay with him while he worked on the Chigi Loggia, probably in order to steal her charms and transpose them onto the wall rather than because he could not be separated from her for a few hours, as the legend goes. The origin of this untitled painting is even more mysterious than that of *La Velata*. It is mentioned for the first time in Rome in the late sixteenth century, when it was unquestionably attributed to Raphael. The model is a young woman seated against a background of a myrtle bush, now darkened by time, but, even in the original, lit by the last rays of the evening sun. The young woman, almost adolescent, is semi-naked to the waist, except for a transparent veil artfully draped over her upper body, which enhances rather than hides her nudity. A red cape covers her legs. She wears a silk Roman-style turban around her head; this is fastened by a golden band, to which is fastened a very similar jewel to the one in *La Velata*. On her right arm, just below her armpit, is a golden armband inscribed with the words *Raphael Urbinas* – a token of the woman's ownership rather than of the painting's authorship. The lower part of the painting is unfinished, as is shown by the chiaroscuro on the right hand and arm, which is much less incisive than that on the left hand. As can be seen from Raphael's other unfinished work, the Dei altarpiece in Florence, the artist worked by gradually adding

to the details and structure of the painting. Once he had brought the chiaroscuro of the entire figure to a certain level of finish, he started to add depth by using progressively more substantial glazes. The edge of the veil covering the right arm was also left at an intermediate stage of finishing: x-rays of the bottom part show clear traces of the under-drawing. This means that the painting was still in the process of being completed when Raphael died. Moreover, it was found in his house and was therefore an intensely private work.

The dark background of the myrtle bush highlights the candour of the young woman's skin as, with disturbing naturalism, she uncov-ers her breasts with their delicate nipples and faintly purplish areolae. Again, the sitter manages to evade the viewer's gaze, but not through shyness. A slight smile plays on her lips and she is ostentatiously aware of her own attractiveness and perfect beauty. The dark irises are lit by a flash of light, while the eyeballs retain the bluish tinge of child-hood. Her huge eyes are framed by perfectly arched dark eyebrows, painted by Raphael in minute detail. The whole painting seems to be constructed on the curve that starts from the tightly pleated turban, descends through the eyebrows and eyes, then through the lower lip that rises in a smile, and ends at the breasts and nipples.

The darkness of the sky enhances the white shoulders and breasts, which are slightly paler than the face – lightly bronzed, as this is, by the Roman sun – and are offered like secret and delicate fruits, with the promise of ecstasy to the fortunate viewer. This difference in colour between face and bust is proof that the portrait was drawn from life rather than being an allegory of Venus or marriage, as many have tried in vain to assert, in an attempt to move the painting away from the heat of passion to the more presentable genre of philosophical culture. The woman herself, Raphael's last and most desired lover, was perhaps made to pose on the house terrace, submissive and compliant, given confidence by the artist's admiration, which is clearly evident in this work. The alignment of the face is a product of the rules of composition always used by Raphael, a common thread that runs through all of his portraits, whether of friends, cardinals or courtesans. The artist's selec-tive eye traces onto canvas the key traits of his sitters, whether men or women, adapting them to an ideal construction that prevents the image from lapsing into naturalism while it also gives it the fascination of a

universal vision. Again, Raphael lets life flow through this ideal type, as if it were being embodied before our eyes. The complexion looks as if ivory were blended with pearls, and it is covered with such transparent layers of pigment that no signs of the brushstrokes can be seen, let alone clots of colour.

The work was laborious and it probably continued for months, an amalgamation of Raphael's entire earlier experience of portrait painting. The play of light and shade on the face throws up every detail of the features without ever becoming calligraphic, and the essential qualities become a wonderful blend of warm flesh and clear light. A slight lightening of the flesh around the lips and on the eyelids creates a quiver of life, which affirms the woman's beauty and existence. The smile is accentuated more by the way the light falls on the right edge of her lips than by any real muscular contraction. Likewise, her gaze, which seems immobile, is enlivened by the constantly changing light of the eyes themselves, and of the skin around them. This is a small painting, but no part of it is flattened by some uniform block of colour. Even the dark hair, combed back and held by the headdress, is given movement by the small wisps falling onto her pale forehead. The shaded eyes are darkest at the corners, where the eyelids are slightly heavier. Even modern reproduction techniques fail to do justice to this painting: they alter its quality and make it essential to see the picture in real life.

Yet this vibrant construction is contained within a perfect drawing, which allows the artist to go well beyond mere pleasure and verisimilitude. His brush is quick to correct those details that nature almost always leaves uncertain. The outline of the mouth swells without hesitation, as does the dark line of the eyes around the eyebulb. The nostrils seem flared up because of the angle joining them to the cheeks, and the chiaroscuro is calibrated to reveal every detail without unveiling the mystery. Another astonishing detail in this regard is the shaded eye, which nonetheless appears to reflect light from the chest, achieving a depth and spatial quality that only Leonardo had succeeded in giving his figures, without relying on the calligraphic emphasis of the drawing.

The ambiguous use of light within the painting creates a bewitching effect: in the background the sunset is just turning into night, while the pale light, whose dying rays play on the body, is reflected in the golden gleam of the headdress. There is nothing to distract the viewer's eye

from the flesh, the breasts and the soft complexion reminiscent of the roses whose scent gently pervades the last light of the evening. The brighter colours are pushed to the edges of the composition, like the madder lake of the mantle covering the legs, the blue on the armlet and the gold around the head. The entire vision condenses on those breasts, which the woman seems to offer rather than to hide, with that grace for which Raphael had been searching all his life.

Such was this beauty that Raphael was compelled to paint it in order to temper the passion that devoured him. Only by composing it and recreating it on the panel, in the evening. after making love in his palace, could he entertain the illusion of controlling the fire that consumed him. The woman's sensuality is so evident, so irresistible that it goes without saying that the artist must have experienced such vertiginous sensations, fully and hopelessly, in order to be able to capture it in paint. The sixteenth-century copyists from Raphael's household and workshop would later experience it vicariously, in their attempts to recreate the magic by painting with their eyes what Raphael had painted with his heart. The results were so distant from the original that their banality and sloppiness is even offensive. The subject matter, the embodiment of erotic desire, is so simple, yet so extraordinary, that it could only be carried off by an artist for whom that desire represented his entire *raison d'être*.

5 STATE PORTRAITS

Julius II's pontificate had been hotly opposed by those who believed that a pope's main task was to act as the spiritual leader of the Catholic church, not as the military leader of a state army. Clandestine, scathing and often offensive satire, a constant companion of papal politics, received an enormous impetus from the spread of the printing press, especially in northern Europe, where reforming ideas were growing in popularity. Not only was the pope attacked in the anonymous notes placed on the statue of Pasquino behind Piazza Navona, but he became a target of short works and ironic verses whose authors were educated and often revealed inside knowledge. After his aggressive and destructive policy on homosexuality, this became the one area for which Julius was most often berated. One of the countless visitors to Rome during

Julius' papacy was Erasmus of Rotterdam, who was one of Europe's most brilliant intellectuals in the early sixteenth century. He was the author of a satirical work composed shortly after the pope's death, *Iulius exclusus e coelis* (*Julius Forbidden to enter the Gates of Heaven*), in which Saint Peter asks the recently deceased pope to account for the wars, the simony, the sodomy and other misdeeds associated with his papacy.[18]

Such radical and sharply argued criticism continued and became even more virulent under the pontificate of Leo X. Erasmus and the other intellectuals of northern Europe intensely disliked the luxury and ostentation of the court at Rome, with its artists, buffoons, bankers and actors. The petitions put forward by the reformers became radically conflictual during precisely these years. Finally, on a bitterly cold night in October 1517, while Leo's attention was fixed on his imminent acquisition of the state of Urbino for his nephew Lorenzo and both were attending a magnificent feast at Agostino Chigi's palace, a German Augustinian monk, Martin Luther, decided to challenge the pope openly by nailing 95 theses against simony and the church of Rome onto the cathedral door in Wittenberg. From then on there was a dramatic escalation of action on both sides, and this was a process in which images played a very important part. Those used by Luther and his propagandists showed the monk dressed in a simple habit and holding the gospel tightly in both hands, while above him hovered the dove of the Holy Spirit, protecting him and encircling his head like a crown. The images used by Leo and his family aimed instead to present the pope in royal solemnity, dazzling with gold and precious fabrics. Rome failed to grasp the dramatic implications of the conflict and continued to underestimate it. This was pointed out by the papal *nuncio* [envoy] Aleandro when he visited Worms in 1521, at the diet where Luther challenged the theologians from Rome, being already strengthened by political alliances that would deepen the conflict between northern and southern Europe: 'Those who come from Rome spread the word that everyone in Rome laughs about Luther and does not pay any attention to him or his affairs.'[19]

Six years later they would shed bitter tears in Rome when an army, driven by religious hate, would rape, torture and kill priests and nuns, destroying all the symbols of their power, and even damage Raphael's frescos. But Leo was untouched by anti-papal propaganda. He saw

himself as being different from Julius, the warrior pope, and he cast himself in the role of *pacificator* [peacemaker]. However, he was the target for other, even more infamous accusations, which were based on a situation that was soon impossible to disguise. To fund his luxurious lifestyle and dynastic ambitions, Leo was dissipating the church's finances, which had been rebuilt with considerable effort by his predecessor. In the satire that was circulated mainly in Italy, on the pope's death Saint Peter asked him why he obstinately continued to knock on the gates of paradise: 'Why did you not bring my keys with you to open the door yourself?' To this Leo replied without a qualm: 'Because I pawned them.' Saint Peter then accused him of bringing rack and ruin and of being 'a blind, perfidious, squandering thief'.[20] Even Saint Peter had learned that, while Julius had pawned the papal tiara to fund the wars, Leo had pawned his pectoral cross to pay for his feasting.

Another scurrilous poem that was composed and circulated after Leo's death was even more cruel, because it was true:

O musicians with your riddles
cry, or violin players
cry, cry you Florentine dupes
drum your plates, ladles and boxes. [. . .]
Cry you clergy of God, cry Saint Peter
cry all of you for your ills
because Leo the Tenth is dead
having been entertained by every buffoon
and every base person
as a dirty, dishonest and tainted tyrant.[21]

This was the other side of Leo's pontificate, one that could turn to his detriment and debase that very same image of grandiosity and splendour so obsessively constructed by him. Not even the Florentine historian Guicciardini could help expressing his severe judgement of Leo – of his ambitions and of his irresponsibility:

But the authority of the Apostolic See, used so licentiously by Leo, had been the cause of stirring up this heresy anew in Germany. [. . .] Since there was no precedent or truth of any sort in this procedure,

for it was notorious that these indulgences were being granted only to extort money from men who yielded more out of simplicity than out of wisdom, and since the practice was being impudently carried on [. . .] [it had] stirred up a great deal of scandal and indignation in many places; and especially in Germany where many of the Pope's ministers were seen selling at a cheap price, or gambling away in the taverns, the power of delivering the souls of the dead out of Purgatory.[22]

The most significant images created by the new papal propaganda, to which the Lutherans would respond by transforming luxury into simplicity and sovereignty into spirituality, were the family portraits that Leo commissioned from Raphael. The portrait of his nephew Lorenzo de' Medici (Plate 22), on whom the pope's dynastic ambitions rested, was commissioned to mark the former's marriage to the French princess Madeleine de la Tour d'Auvergne. It was hoped that the portrait would give an aura of majesty and legitimacy to a young man who had failed to show any promise whatsoever in real life; he even lacked ambition, although this was made up for by his mother, Alfonsina Orsini, who was never satisfied with the honours bestowed on her son. In the painting, Raphael focused on the royal quality of his clothes, which appear to be the real subject matter of the portrait. Lorenzo is shown standing, in an almost frontal pose. In his right hand he holds a golden coin, a sign of munificence that was appropriate in a ruler, while his left is behind his back, to display his sumptuous clothing as well as the handle of a sword hanging by his side – an allusion to his military valour. He is wearing a doublet of golden damask embroidered with floral patterns. The light falls on the breastbone, adding brilliance to the golden velvet pile. Over his shoulders he wears a red silk surcoat, trimmed around the collar and halfway down the sleeves in silver-wolf fur, which creates a halo of light around his face. Below his hips, the doublet widens into a gathered skirt with gold and white vertical stripes, fastened by a strip of leather that extends up the doublet. A blue silken cord is tied over the skirt in a tight knot, to hold the pleats and presumably a bag full of gold coins.

Lorenzo's face is framed by the minutely pleated linen that emerges above the doublet but stops short of the collarbones, to emphasise his powerful neck muscles. The trimmed red beard is sparse enough

to reveal the outline of the chin to great effect. The nose is large but straight, the low forehead is half-hidden by hair, which reaches down almost to the arched brows. An ancient cameo brooch, probably taken from great-great-grandfather Cosimo's renowned collection, gleams against the black hat. The dark eyes are large, slightly protruding; indeed their vacuous expression somewhat detracts from the majesty that Raphael had constructed with the help of the detailed texture of clothes.

In spite of such sartorial profusion, the portrait does not achieve the same psychological seductiveness that is evident in the artist's portraits of his humanist friends – all shown, almost with polemical zeal, in simple and modestly cut black clothes. The absence of any feeling for Lorenzo may be explained by the young man's political role, since he had snatched Urbino from those dukes who were still dear to Raphael and who in turn sincerely cared for him: Francesco Maria della Rovere and his adopted mother, Elisabetta Gonzaga, whose crying may have resounded in the artist's ears as he coated Lorenzo's surcoat with lake.

The other state portrait of this period, showing Pope Leo with two cardinals – his cousin Giulio de'Medici (who would become Clement VII) and Luigi de'Rossi – reveals a similar psychological uneasiness (Plate 23). This large oil painting on board (measuring 154×119 cm) was commissioned from Raphael in the winter of 1517, in anticipation of Lorenzo's marriage in Florence the following summer. The pope would not be present, except in effigy – thanks to Raphael's artistry. In those days, for being present at such events, rulers tended to rely on their portraits more than on physical apparitions, given that portraits could travel a lot more than their sitters and survive any natural threat that might endanger the well-being and dignity of princes and popes.

Perhaps it was the imminence of the deadline or the fact that Raphael had already undertaken too many commitments that winter, but the final outcome seems very detached from its celebratory purpose. Leo is shown in a three-quarter pose, seated at a table covered in a red cloth, on which are a gold and silver handbell, a magnifying glass and an illuminated codex; and the codex reveals images of Christ's Passion taken from the gospel of John, the Pope's baptismal name [Giovanni]. Together with the chair, which is crowned by a golden ball – the Medici emblem – and miraculously reflects the light from an open

window that remains outside our field of sight except for this reflection, these still life details are the most successful parts of the painting.

The portrait was probably composed by juxtaposing the three individual protagonists. This is the only plausible explanation for the awkwardness of Cardinal Giulio's position, on the pope's right, where he seems to be crushed against the pope's arm that rests on the table and pressing towards him like an insubstantial ghost; and his empty gaze and stiff features render him even more inexpressive, although here Raphael does reveal the beauty of Giuliano's son – a rare attribute in this family. Cardinal de' Rossi, too, who grasps the back of the chair with both hands, in an protective gesture, seems a distant, sad and frightened apparition instead of a dignified one, as he should have been. There are no psychological links between the three figures; they seem to have been cut out and positioned at different stages. The atmosphere is stern and the air is distinctly hazy, to the extent that all three faces seem to show signs of physical exhaustion. Leo wanted a majestic portrait, one that would do justice to his reputation as a humanist, which he certainly was, but Raphael could not curb the pope's overpowering and unhealthy physical presence. The livid colour and rigid features recall the words of Paris de' Grassis, the chamberlain who helped the pope even in the intimacy of his daily routine. Leo's left hand, which is insignificant and small, almost feminine, appears limp and far removed from the energy with which Julius II gripped the arm of his chair.

As in Lorenzo's portrait, the beauty of the painting seems to be embodied in the choice of vibrant reds. Vermilion with highlights of paler red is for the plain cloth that covers the table almost without a wrinkle; and standing out against it is the dark red silk ribbon of the bell and the identical one hanging from the book. There is red for the pope's velvet *mozzetta* [short cape] edged with ermine, and a darker shade, shot with purplish shadows, for the *camauro* [red velvet cap] he wears on his head. Vermilion is used again for the shiny satin cape worn by Cardinal Giulio, which slants back under the light reflected over the pope's shoulders. The same material is also used for Luigi de' Rossi's cape, which is visible behind the chair, but the tone is darker because of the shadow. Reds with deep areas of shade also appear on the chair back, on the chair cushion and on the robes worn by the cardinal.

Leo's watered silk cassock, of a weight suited for winter, is blindingly

white, embedded like a pearly prize in a giant shell. It rises up along the edges of the cape and along the torso, it encloses the neck and head and it isolates the absolute protagonist of the painting. Even the light strikes his face with a different intensity, rendering every crease clearly visible – especially those around his nose, those on his chin, where the swollen round lip protrudes, and those on his cheeks and eyelids. Leo appears lost in thought, seeking to concentrate in the shadows. He holds his breath, compelling the two cardinals to remain immobile, since they dare not disturb this suspended moment.

The technique used in the painting's execution is astonishing, to say the least. The depiction of the various fabrics is realistic to the point of virtuosity. The shadows playing on the pope's *mozzetta* never stall on an incongruous clot of colour, as in the case of almost every painter who ventures to paint velvet. By subtly varying the tones of red and white, almost by sleight of hand, Raphael avoids using any other shade and constructs the painting from the colours that represent Christ's Passion and are also highly symbolic of the church and the papacy. This might also seem to be his main aim; in order to achieve it he rejects even the use of a background colour – the olive green that framed Julius II's portrait. Here the background is so dark that it discreetly disappears, so as not to detract from the blooming red and white. Even the skin tones are enriched with pinkish shadows, as if the entire room had been tinged by a coloured mist.

All things considered, the portrait was a triumph, as was confirmed by Alfonsina Orsini's gratified comment. After the Roman celebrations in September 1513, the pope's sister-in-law had spent the next four years working tirelessly on her son's behalf, pushing him to take political risks and forcing Leo to embark on the reckless enterprise of Urbino. The celebration of Lorenzo's marriage to a French princess in the re-conquered city of Florence must have repaid this solicitous mother for the long years of disastrous military adventures with her husband Piero de' Medici, who had been drowned many years earlier, during the course of an ill-timed campaign. Alfonsina wanted her son's marriage to be remembered in the annals of Italian history, and one of the highlights would be the display of the portrait that Raphael was finishing in Rome.

However, as the date of the festivities drew closer, the portrait was

still not ready. In the end Raphael was forced to resort to an extremely complicated method of transport, and also to send two apprentices to escort the portrait and, if necessary, to retouch any damage caused during the journey. On 2 September 1518 a trusted retainer of the Medici, charged with organising the shipment of the painting from Rome, gave the final instructions to Goro Gheri, who would receive it in Florence:

> The bearer will be Luigi apprentice of Raphael of Vitale who will accompany the painting depicting His Holiness, and you will give the said Luigi twelve gold ducats [*duchati d'oro larghi*], which is what we have agreed. He will come with two mules and two apprentices in order to take turns and arrive; and the apprentices have promised that they will be there either Sunday evening or Monday morning during daylight and, if they arrive on time, they are to receive a pair of hose each, which I have promised them so that they take care to be there at that time. I may have been too generous, but I have done so that the reward will encourage them if they go slowly, and I do not think it desirable to save 4 ducats provided it is there on time.[23]

The arrival of the painting in Florence was greeted with more ceremony than that of an ambassador. The agony of the preparations, overseen by top officials in the Medicean secretariat, are in themselves indicative of the extraordinary political value of a portrait in Renaissance society, where images were as valuable as the outcome of a battle. Luckily the journey went well and the painting arrived safely. It was displayed at the table, in the position of honour, while the ambitious Alfonsina boasted to her heart's content, to anyone who would listen:

> [T]here were LXXV women in all, without counting our own, which was truly a beautiful sight. They got up from table at about XX hours [about 4 p.m.] and some retired to the small drawing-room [*camera della saletta*] and some to the room opposite, and others came upstairs to my room. Nearly all of them changed into the most beautiful clothes, and there were few other colours apart from kermes, and those were beautiful [. . .]. After the comedy had finished and they had rested in the room, all the young women from this morning went to table,

together with the Duchess; and after dinner we did not wish to dance because there were so many young women, in order not to create confusion. I heard tell that the Duke ordered the painting of His Holiness and the Most Reverend [Cardinals] de' Medici and Rossi to be placed over the table where the Duchess and the other gentlemen were eating and all were truly gladdened.[24]

Alfonsina may indeed have preferred the presence of this effigy to the actual presence of her powerful brother-in-law, who would have sweated profusely and created endless difficulties in all that festive confusion. Instead, hanging over the table, the pope could fulfil his royal function in full. Moreover, it was a lucky coincidence that, by choosing all those reds, Raphael had guessed the colour of the dresses worn by the young girls. The crimson red silks and velvets set off their gold jewellery and the brilliant white of their undergowns: exactly as Raphael had painted the pope.

THE DISCOVERY OF ARCHITECTURE

1 DEVOUT WOMEN

Not far from Florence, a pack of wolves attacked a hermit who was travelling through an area of dense forest. Fearing for his life, the man climbed a tall tree, from which he might well have fallen if a courageous girl had not shortly arrived on the scene and chased the wolves away. As well as being brave, the girl was very beautiful: she had chestnut hair and eyes the colour of hazelnuts, set in an oval face as pale as porcelain. She was the daughter of a cooper who lived on the edge of the forest. Having been saved by the girl's actions, the hermit predicted that both she and the oak tree, which had also played its part in the story, would become eternally famous.

Some years later, when the girl had become a mother of two children, a famous painter stopped at her father's house. Entranced by the tender love with which the mother held the youngest child in her arms, the painter succumbed to the irresistible urge to draw her in this delightfully intimate pose. Because he had neither a canvas nor a panel with him, he picked up one of the bases used to make barrels, which were piled in the yard. It was made from the same oak in which the old hermit had taken refuge from the wolves. Under the admiring gaze of those around him, the painter first sketched and then painted

the girl with her children, transforming her into a Madonna with the infant Jesus and Saint John. Over the course of time, the girl became the world's most famous Madonna, and the planks of oak were also immortalised, as the holy man had predicted.

This is the legend that grew up and survived, over the centuries, around Raphael's *Madonna della Seggiola* (Plate 20), a painting about which very little is known, since it is not even mentioned by Vasari. The first credible trace appears in a late sixteenth-century inventory that records the painting in the grand duke of Tuscany's *guardaroba* [personal belongings]. By the eighteenth century the painting had become so famous that hundreds of copies and engravings were made, and these were meticulously collected in an album held by the British Museum, until colour printing and photography made such reproductions so commonplace that the fame and circulation of the painting spiralled beyond control.

A masterpiece that is surrounded by a historical and documentary vacuum presents a difficult challenge for any admirer. The legend therefore furnishes those details that are essential for a more human enjoyment of the artwork, which has entered popular veneration as an expression of maternal love and as a tribute to the Virgin's divinity. Like all legends, however, the web of fantasy that has grown up around the *Madonna della Seggiola* does lay bare an essential reality of the painting: its spontaneity, the fact that it is the result of an impulsive gesture to draw a mother cuddling her infant in real life. Raphael's talent lay in his ability to simulate the creative processes used to gloss reality by adapting them to an ideal model, and in his ability to extract the most significant formal and emotive contents from every situation. However, the efforts he made to correct reality and to render it universal and ideal do not transpire from his work, a fact that makes this work seem the result of a natural gift, comparable to a beautiful singing voice or to the ability to run fast.

Attempts to explain the laws underlying the production of a masterpiece, and of this masterpiece in particular, have backfired even on the most sophisticated art critics, at least until an insightful essay by Ernst Gombrich loyally stated that the roots of Raphael's creativity lay in the deepest layers of his subconscious and that the desire to explain and interpret them led to an undignified intellectual impasse. In practice, all

we know about the painting is what the painting itself is willing to tell us: that is to say, everything except its mystery.

By its style, the portrait can be dated to 1514–15, therefore between the portrait of Julius II and those of Baldassarre Castiglione and of Raphael's other humanist friends, which can be dated with some certainty to a time around 1516–17.[1] The elusive quality of the flesh tones, the unaccentuated contrasts between light and shade, the *sfumato* outlines of the hands and the wide expanses of drapery, which are not yet defined with the tactile substance of the later portraits, all offer a *terminus ante quem* for the painting and, until new documents come to light, we must be satisfied with this.

The young woman is shown in profile, sitting on a chair whose ornate back, decorated with a gold fringe, can be seen vanishing into the shadow. She is embracing a large infant and holds him tight to her chest, with clasped hands. In order to stop him from falling, she has lifted her left knee, which is covered by her blue mantle, creating a comfortable support for his back. The embrace is made even more intimate and tender by the woman's bent neck, which is inclined just so that, without taking her melancholy gaze off the viewer, she rests her left temple on the child's forehead, and in doing so she placates him. Behind her lifted knee Raphael has painted Saint John, whose hands are joined in prayer with graceful but childish imprecision, both tender and clumsy.

The composition of these three interlocking figures, which creates a strong sense of physical and, above all, psychological contact, recalls Leonardo's Madonnas, paintings in which he explored a variety of intersections between bodies in space. Here the Virgin has her hair wrapped in a pale scarf that follows the slant of her neck, creating the fashionable turban *alla turchesca* (as they used to call it in those days) and revealing the hair above her forehead, which separates the pale linen scarf, interwoven with gold, from her youthful complexion, tinged with adolescent pink on her cheeks. The viewer is struck by her delicate features and by the composure of her gaze. There are only few instances of paintings in which the Virgin looks straight at the viewer. It was more usual for her to be enveloped by the psychological dialogue between mother and son, a dialogue that was almost always impenetrable. Instead of that, here the girl resting on the chair looks straight at

the viewer with those gentle eyes, asking us to share the melancholy and tenderness that make her hug the restless child tightly, while his eyes turn to the left-hand side of the tondo.

The spiral composition of the figures makes the best use of space within the tondo, which was the typical format used in Quattrocento Florentine representations of the Madonna (including the one by Michelangelo), however different the result. This points to a Florentine patron, probably someone very close to Pope Leo X, if not the pope himself. With its slightly rounded neck and shoulder and its raised knee, the Madonna's own body creates a circular shape; and, with the help of the frame, she isolates the Christ Child in her arms.

The group is also innovative in another way, which appears to be Raphael's own invention; moreover, it can only be accounted for by acknowledging the mature artist's unfathomable creative instinct, which made him renew the image and feelings by introducing details that become essential to the narrative – all this because he refused to repeat traditional models. The oriental-looking scarf that the Madonna wears wrapped around her shoulders immediately distances her from all the other Madonnas painted up until then and introduces a note of mystery, which makes her charm irresistible. That the scarf is from the East is shown by the white and red geometric pattern edged in black that runs down the strip covering her shoulder. To either side are a further two lines of dark, criss-crossing rectangles, which are less evident because they are not used to highlight the movement of the arm. The latter are reminiscent of the pattern, perhaps painted by Raphael himself, on the dress worn by Elisabetta Gonzaga, his beloved duchess of Urbino. The precious fabric alone would have cost as much as the entire dowry received by the cooper's daughter, even making due allowances for the legend. However, as the precious chair also underlines, this is a woman whose elegance and wealth are highlighted by her clothes and further confirmed by the gold fringe cascading down the chair.

Even if these oriental scarves were frequently found in the Renaissance wardrobe, what makes this one so original here is that Raphael uses it to express the spontaneity of the scene. He uses it not to wrap the woman's hair or to mask the neckline of her red gown, which is visible below the scarf, but to cover the the neck and chest, as

if she had grabbed the first thing she found in order to protect herself from a sudden chill. This sensation is confirmed by the child's left arm, which pushes under the green fabric, in search of warmth. This detail enhances the feeling of intimacy emanated by the scene. The extraordinary elegance of the curved shoulder highlights the Virgin's long neck and delicate ear, surrounding her face in iridescent reflections that become clearer until they culminate in the beam that highlights the chin, which is turned over the left shoulder and in contrast with it. The scarf creates a landscape of completely new forms and colours around her face, recalling its colours and preciousness and exalting her femininity. With this, Raphael had moved as far away as he could from the rigid devotion of earlier Madonnas. This glorification of femininity also becomes a glorification of natural maternity and, as such, was rightly recognised and appreciated in centuries to come by women all over the world.

The scarf wound casually round the Madonna's shoulders also creates the intimate effect of a scene that is ahead of its time: a woman wrapped up against a sudden chill, caught in an intimate moment of reflection, seated at home before a lit fire. All this gives the painting that miraculous feel of unexpected poetry – the poetry that Raphael, as legend would have it, chanced on in a cooper's yard, but that he recreated later in his workshop with inestimable genius, by getting a model to pose for him and by turning her into a perfect image of spontaneity. Raphael's painting constantly uses reality, whose banality is blunted by his gift for selective composition: it is a process that has been repeatedly attributed to the influence of Neoplatonic thought on the artist but that, in this intellectual formula, says nothing about his own creative processes. In this sense, it is more profitable to follow the influence of the oriental scarf, for example by trusting the evocative power it had upon the painting's greatest imitator, the French artist Jean-Auguste-Dominique Ingres, who created several versions of it, all equally splendid.

Apart from Raphael's paintings, the oriental scarf also appears in other contemporary works: it is almost always worn by women as a turban-like headdress, like the one that Isabella d'Este, that inexhaustible fashion icon, is alleged to have invented in order to stun the Italian courts. Worn around the shoulders or hips, the embroidered scarf, or

more appropriately the sash in this instance, also appears to have been a masculine accessory, more precisely one worn by eastern dignitaries in many sixteenth-century paintings.

As an exotic addition to the male wardrobe, the sash was therefore more likely to have been used by an artist like Raphael than by Roman noblewomen. It is not hard to imagine the artist asking the model to pose in his studio and then pulling a gold-embroidered Syrian scarf out of a cupboard and standing back to admire the effect. It is this instinctive gesture, which lacks any immediate iconographic or allegorical meaning, that has proved to be one of the most fascinating aspects of the painting destined to become the subject of a popular cult, one that is still very much alive across the world today.

Perhaps the same model, and certainly the same scarf, were used again by Raphael in 1514 to create another masterpiece of devotion: the *Sistine Madonna* (Plate 21). This painting was commissioned in the last months of Julius II's life as the result of a promise to the Benedictine church of San Sisto in Piacenza, which the della Rovere pope had helped to restore when he was still a cardinal. The possible reason for the commission can be traced a few years back, to 1512, when a delegation from Piacenza had arrived in Rome to announce the city's spontaneous accession to the papal states, and Julius may then have promised to donate the altarpiece that Raphael would later paint.

Here the Virgin is shown holding her child naked in her arms; he is supported by a golden cloth. She is barefoot, walking on a cloud between two kneeling saints, Saint Sisto (who was the patron saint of Julius' uncle, Pope Sixtus IV) and Saint Barbara. The figures are solemn and graceful, and their clothing is stirred by a light breeze that blows back the veil over the Madonna's head, although it is held in place at her waist. The golden background blurs into a cloud of cherubim who are faintly discernible against the pale blue halo.

Like the *Madonna della Seggiola*, this painting, too, contains an unusual detail that, over time, has gained in popularity. At the Madonna's feet, resting on a balustrade that remains invisible to the spectator, there are two winged putti who watch the scene with the natural curiosity and incredulity of two children drawn from life. The one on the left rests his cheek in his left hand, lifting his finger to his lips and raising his eyes in surprise. The one on the right looks up with an innocent

expression, as if to question the meaning of the scene before him. The inclusion of such a spontaneous and insignificant detail helps to deflate the drama of the scene and to bring such solemnity closer to the simple worship of the faithful gathered in prayer – whom Saint Sisto, dressed in a golden cope with a red lining, points out to the Madonna. Saint Barbara, on the other hand, looks down with majestic features to the men and women awaiting her protection. Separated from the rest of the painting, the two winged putti have taken on a life of their own in popular imagination and are now used to advertise any product that evokes tenderness or any tenderness that evokes love, even at a much less spiritual level than that celebrated by the Madonna, who shows the faithful her son destined to die for their redemption.

The contrast between the luminous background and the Madonna's dark robes gives her a stateliness that is completely new and different from the static solemnity achieved in the Quattrocento by the unmoving and imposing figures, with their marble thrones and clouds of cherubim. The *Sistine Madonna* lands on the cloud, after a flight that slightly ruffles her lightweight robes and golden scarf. Her expression is humble as she offers the child; and he seems so light as to be ethereal in substance. In spite of the mystical wind, her movement is completely natural and her left leg is bent, changing the light on the heavy purplish cloth. It is a pose that gives her a classical monumentality, in contrast with the more emotionally agitated monumentality of the saint who kneels below her. The fascination that Raphael felt for this dark-haired woman, who inspired *La Velata*, now helps him to exalt the feeling of devotion. The large black eyes, which hint at seduction in *La Velata*, here reveal understanding and look straight into the heart of all those who admire the painting. Once again, through Raphael's brushstrokes, female beauty passes with unfaltering self-assurance from the erotic register to the devotional.

Finally, a third painting completes this mature phase of Raphael's devotion: the altarpiece with Saint Cecilia between Saints Paul, John the Evangelist, Augustine and Mary Magdalene (Plate 24), which was commissioned by the Bolognese noblewoman Elena dall'Olio for the church of San Giovanni in Monte. This painting, too, soon formed part of the legend, after Giorgio Vasari published an account that alleged that, when the Bolognese artist Francesco Francia – who was reputed

to be one of the greatest local masters – saw the painting, he became so depressed at the sight of such perfection that he swore never to touch his brushes again and died in despair.

The painting was much appreciated by the patron, an extraordinary figure of the period and a witness to Raphael's immense professional versatility: he was employed in Rome to celebrate its mundane splendour and eroticism, but he was at the same time capable of creating images of sublime devotion. Like Saint Cecilia herself, Elena dall'Olio had taken a vow of chastity even though she was married; she lived her faith ecstatically and she experienced spiritual visions and episodes of swooning capable of sublimating and quashing any sexual yearnings, which she resisted with excruciating effort.

> She heard angels singing with her in praise of God and saw fire descend upon her, filling her with the desire for Holy Communion. Such communion is nothing else than the intimate unification of the heavenly bridegroom with the amorous soul, for whom he sacrificed himself and whom he renews to become a completely spiritual and angel-like being.[2]

The faith that Elena felt so ardently was being propagated, during this same period, in the most exclusive social circles and among those individuals who were beginning to feel the anxiety generated by the early stirrings of what would become the Protestant Reformation. It was from these circles that the Oratory of Divine Love would soon emerge, gathering together the most influential figures in Italy who felt the need for a spiritual renewal through the daily practices of worship and prayer. Raphael was therefore brought face to face with the demands of a deeply interiorised faith, which was nourished by the study of the scriptures and by a profoundly sentimental contact with the teaching these gospels contained. Yet in his response Raphael used the classical, almost archaeological language that underpinned his entire artistic output during the years around 1515.

Three quarters of the painting is filled by the figures of the five saints standing in a circle. At the centre, Saint Cecilia lifts her eyes to heaven while letting a small organ fall to the ground. Indeed the ground is littered with other musical instruments, manifestly broken or worn out by

time; they symbolise the vanity of worldly pleasure, in contrast to the divine music of an angelic choir that sings in heaven, its members holding books in their hands. Musical instruments had been condemned by the church fathers, who stated that only the simplicity of angelic voices was fit to extol God's glory. But in the painting each instrument is depicted with a care and precision worthy of a Netherlandish still life. Tradition has it that they were painted by Giovanni da Udine, who, with the meticulousness of a chronicler, included the viola and its bow, the cymbals, a tambourine, metal kettledrums and a fife. In contrast, on the pale blue sky above, which opens like a manuscript scroll, the group of singing angels is painted in perfunctory outline, the features and colours being made indistinct by the glaring light around them.

The posture of the saints is monumental; all expression is suppressed to the point of silence. Behind Saint Cecilia, only Saint John and Saint Augustine appear to exchange glances. The beauty of the figures is condensed in the solidity of their bodies, which appear to have been lifted straight from an ancient marble relief. On the left, Saint Paul stands in a three-quarter pose while he looks pensively down at the broken instruments, resting his elbow on the back of the hand that holds his long sword made of gleaming gold and steel. The red cloak that hangs down from his waist in simple and heavy folds adds strength to his appearance, like a bearded Hercules. The hand holding the sword also clasps a letter – perhaps the letter to the Corinthians in which Paul affirmed that even the clearest voice, if it speaks without charity, shall 'become as sounding brass or a tinkling cymbal'. Behind him is a marvellous portrayal of Saint John, as handsome as Apollo, whose golden, shoulder-length locks hang in gleaming ringlets. Saint John was the patron saint of the church for which the painting was commissioned, therefore his presence was obligatory; but, by focusing entirely on his beauty, Raphael has made him virtually unrecognisable, although beauty appears here as the true manifestation of the divine spirit. A flash of light, which gleams below the lower hem of Paul's curving mantle, highlights the profile of an eagle whose claws rest on a bound copy of the Gospel lying beside the broken instruments.

In the centre, facing forward, is Saint Cecilia herself, her eyes and heart lifted heavenwards in divine ecstasy, in a pose often taken by Elena dall'Olio herself. As she listens to the angels, she has no hesita-

tion about sacrificing the earthly joys of human music. She is dressed in a golden velvet tunic embroidered with black foliage, the height of elegant fashion for queens and other aristocratic women. The neckline, which is edged in black and adorned with a large gem, emphasises the luminosity of the tunic caught at the waist with a thin silk band. Beneath it the saint wears a gauzy full-length gown that almost covers her Roman sandals, a painstaking replica of those seen on ancient monuments. Raphael interprets Cecilia perfectly, as a nobly born Roman bride who has chosen to renounce her elevated status for the sake of her faith (as did the patron of the altarpiece, thus giving her another reason to see herself in the painting). Behind Saint Cecilia stands Saint Augustine, dressed in a golden cope and leaning on the staff that dominates the group. Lastly, the circle ends with a most beautiful Mary Magdalene, who is symmetrically opposite to Saint Paul. She turns to face the spectator, holding the jar of perfumed oil in which she anointed Christ's feet. With their poses, the four saints around Cecilia create an imaginary movement around the saint – one that rotates from Saint Paul's closed position to the openness of Mary Magdalene. Even though their poses are completely immobile, the viewer has the impression that this circular movement is happening while he or she watches.

The whole painting highlights the potential uses of classical language and iconography as a means of representing the spiritual requirements of a religion that had not even appeared on the historical stage when those forms – which Raphael was so keen to explore – were carved on monuments. Accustomed as we are to the hierarchical pyramid of fifteenth-century altarpieces representing sacred conversations, we are astounded by the solemn composure of these figures, aligned within such a tight space. Mary Magdalene in particular had always been close to lay noblewomen: in their anguished spirituality women like Elena regarded themselves as sinners on account of those temptations that they found it hard to resist, and in their anguished spirituality they saw in Mary Magdalene, the repentant prostitute, a sign that their own redemption was also possible. Even Magdalene's hairstyle has been copied from archaeological finds, as has the jar she is holding.

Like other contemporaries, Raphael believed that beauty was a direct manifestation of the divine spirit and that therefore the perfect beauty of the figures he painted would arouse devout admiration. The

relaxed, well-proportioned features of the faces of both Saint John and Mary Magdalene seem to have been copied from statues of Venus and Apollo, and they create a direct link between the viewer and the divinity that inspired them. Raphael held the keys to the world of beauty and, through this, he could control the world of emotions: all the emotions, ranging from Elena dall'Olio's spiritual ecstasy to the erotic and carnal desires of Agostino Chigi and Bernardino Bibbiena, for whom he continued to work during these months. We can imagine a row of such paintings lined up in his studio, intended for such very different patrons, yet all sharing a graceful sense of calm and a pervasive beauty that allowed each patron to realise the desires to which he or she aspired. Far from maintaining the craftsman-like tradition of fourteenth- and fifteenth-century artists, who narrated stories in keeping with the biblical tradition, Raphael was now creating cult objects that had the capacity to liberate spiritual feeling in humans, linking them to a higher world, which was increasingly characterised by a beauty that owed much to the ancient models being unearthed in Rome.

Elena dall'Olio welcomed the altarpiece as a miracle inspired directly by the God to whom she dedicated every spasm of her body, every moment of spiritual ecstasy. On the contrary, even if only part of Vasari's tale is to be believed, Francesco Francia realised that such irrepressible seduction sprang entirely from the artist's unique talent, a talent that Francia could never have hoped to achieve, even if he prayed for a thousand years to the God to whom Elena had dedicated her life.

2 STORMING THE FORTRESS

Around 1515, Pope Leo X decided to finish the decoration of the Sistine Chapel by commissioning Raphael to draw the cartoons for a set of tapestries that would be woven in Flanders. The first payment for the work is dated June 1515, when the artist was fully engaged in his archaeological studies and in reconstructing the plan of ancient Rome. The walls of the most important chapel in Christendom were already decorated with the stories of Jesus and Moses, founders of the Christian religion; on the ceiling, Michelangelo had painted the story of creation using a new but disturbing style. The monumental chapel was also a showcase for Italian painting, one in which all the artists

involved in the dramatic renewal of painting over the previous 50 years had left their mark. Now it was Raphael's turn to complete this cycle of decorative works by designing the *arazzi* [tapestries] to be hung along the bottom section, where the wall was currently decorated by fake hangings, at the height of the congregation that crowded into the chapel for ceremonies and worship.

Raphael and his assistants, themselves talented artists by then, were employed to decorate the last of the Vatican apartments, the *stanze* containing the wall frescos *Fire in the Borgo* and *The Battle of Ostia*. For both frescos Raphael's role was restricted to conceiving the overall design; his collaborators were left to undertake the material execution. But the work on the tapestries was more congenial, since it involved the use of tempera to copy drawings onto cartoons. This rapid, immediate technique played a major role in the creation of the designs: first because there was no time to indulge in the search for the vibrant colouring, to which viewers had grown accustomed after the introduction of oils, and second because it was essential to consider the difficulties that the Flemish weavers would encounter when re-creating the works. The stories were selected from the Gospels and narrated highlights from the lives of Saint Peter and Saint Paul, seen, respectively, as the pastor of the faithful and the expounder of Christian doctrine.

Once again, Raphael's choice reveals the narrow focus of his unity of language, which was necessary in order to maintain readability and clarity in such large-scale works. In terms of image and narrative, the cycle was intended to clarify the official language of the church of Rome; and Raphael had to develop an official rhetoric, which would assure the greatest possible dignity for the works. As in the past, his research ran parallel to that of the *letterati* gathered around the curia, who were also engaged in reinventing a courtly rhetoric equal to – or better than – that of classical Rome, in particular the Ciceronian model. Thanks in part to the simplifications imposed by the technique used, the models that Raphael drew on are clearly visible: the reliefs of Roman imperial monuments and their way of composing the narrative by using a hierarchical sequence and by placing the figures in order to give each passage its formal, spatial and iconographic autonomy, while also preserving the relationships between the characters.

In this cycle the simplest model to understand is the cartoon of *The*

Sacrifice at Lystra (Plate 25), which is almost a chromatic transposition of the Roman reliefs on the Arch of Constantine and Trajan at Benevento – and not only in terms of careful depiction of the accessories used in ritual and of the clothing of those present. The figures completely abandon the frontal poses still characteristic of the fifteenth-century narratives that adorn the walls of the Sistine Chapel. Here each figure is shown either in profile or in three quarters, sometimes even from the back, and this serves to gauge the size of the space into which the spectator is drawn, almost as if physically present. In one of the most successful cartoons, *Paul Preaching at Athens* (Plate 26), which also celebrates the union between Christian culture and the ancient philosophical tradition on which intellectuals had been working for years, Raphael actually chose Saint Paul's own viewpoint, showing him from behind, as he looks at the group of philosophers in front of him while they listen intently to his sermon. The dais on which the saint stands stretches out towards the viewer, emotively reaching out to envelop him or her within the scene.

The backdrops used as the settings for the narrative are always extremely effective archaeological reconstructions, almost three-dimensional projects that could be used as a direct guide for the rebuilding. As in Roman sculptural relief, the weighty musculature never exaggerates the gestures and calmness of the action. This calm solemnity is also emphasised by the orderliness of the drapery. In this sense the representation becomes heroic, as befitted a court that saw itself emulating those of the Roman emperors. The focal point of action is pushed back, as in the scene of *The Death of Ananias* (Plate 27) or of *The Conversion of the Proconsul* (Plate 28), or it is moved to the side, to create the symmetrical correspondence that gives complexity to the narrative. In *Christ's Charge to Peter* (Plate 29) Christ appears in a toga, looking like a Roman pontifex and standing opposite the group of the apostles, who appear petrified by the grace of his gesture. Behind him is a herd of white sheep, which he points out to Peter, so that he, too, can care for the faithful just as the shepherd tends his flock. The movements and expressions are gentle and barely hinted at, controlled by a natural propensity for dignity.

Even the most dramatic scenes, like *The Stoning of Stephen* and *The Conversion of Saul*, preserve a formal counterpoint that locks the

narrative into a concise, effective language, one that yields little to dec-
oration for its own sake. The symmetry is never geometric, as it was in
fifteenth-century narrative paintings, but instead is structured around
a few ordinative elements, often architectural features. The twisted
columns in *The Healing of the Lame Man*, gleaming with silver (Plate
30), are a splendid example: they were said to come from Solomon's
Temple, whence they would have been transported to the Chapel
of the Pietà in the old basilica of St Peter's. The columns frame the
central scene like two blades of light, and they block our view so that
completely different scenes can take place on either side: on the left, the
arrival of the women and children, who carry offerings to the temple
against a background that fades into the open countryside, and on
the right a crowd pushing forward for a glimpse of the miracle. In other
instances colour is used as the balancing element, adding solemnity to
the scene: this is the function of Saint Paul's red cloak in *The Sacrifice at
Lystra*, which envelopes Paul like a giant pod, protecting and defending
him from the angry surge of the crowd that has accompanied the bulls
to the sacrifice.

In *The Miraculous Draught of Fishes* (Plate 31), one of the gentlest
and most extraordinary creations of the century, Christ is shown wear-
ing a red cloak (now faded, yet still reflected in the water and brightly
coloured in the tapestry) and seated in a small boat. His immobility bal-
ances the agitated movements of the apostles and the fishermen, who
seem to be on the verge of upsetting the precarious equilibrium of the
boats teeming with fish. The calm surface of the lake, which reflects
the sunset, stretches into infinity, following the flight of birds as they
vanish into the distance. On the right bank, a small crowd of people
remains; they have heard the sermon given by Jesus, whose composure
now reassures Apostles Peter and Andrew. Here too, Raphael is care-
ful not to show the protagonists in frontal poses. Even Zebedee, the
father of James and John who stands opposite the viewer, is shown in
a twisted position, like a pagan river-god. This is because, as Raphael
had noted from his study of Roman reliefs, the presence of frontal poses
would stop the slow movement of the narrative, which makes it alive
and convincing.

Every scene comprises expressive attitudes that reveal the human
psyche: amazement, terror, admiration, even happiness (as in Saint

John's face in *Christ's Charge to Peter*) flicker across the faces and bodies of the figures, like a strong wind, bringing minuscule differences between one attitude and another in order to avoid introducing farce or vulgarity into the natural episode. The court of Urbino, where Raphael had been born, recommended, as a measure of elegance, the simulation of artifice, the control of the effort used to achieve an attitude – which had to seem natural at all costs. In Rome, such control matched the naturalness attained by ancient classical sculptors after centuries of research. Raphael's narrative remains solemn due to its composure, beauty and attention to detail, becoming a language that could be used by the pontificate in self-celebration. More so than in the *stanze*, which were too open to the wealth of the natural world, in the tapestries this language was refined and adapted to an official solemnity, almost as if the artist were rewriting the Gospels rather than simply depicting them, as his predecessors had done.

The cartoons left for Flanders and the tapestries returned to Italy before being dispersed after the Sack of Rome of 1527. But these movable works, which were ephemeral by nature, served to convey across Europe an awareness of Raphael and his style and, over time, they generated a language that was not only spiritual but historical. The measured rhetoric of the tapestries would be echoed by Pieter Paul Rubens and Nicolas Poussin, and also by Jacques-Louis David, Eugène Delacroix and all the other masters who would try later on to recreate Raphael's sense of proportion, which in this work became the perfect measure of a renewed classicism.

3 THE FLIGHT OF ICARUS

The continuous festivities that accompanied Leo X's pontificate had moments of unbridled pagan excess, above all at carnival, when Italy's aristocracy, attracted by the hunts, the bulls and the jousting tournaments, gathered in Rome to compete in the horse races, parading its pomp and skill. On several occasions Agostino Chigi had the satisfaction of seeing his horses triumph. He could afford the most expensive Arab horses, which he stabled and trained at enormous expense, often outdoing even the Gonzaga stables, which were famed for their luxury.

But, in parallel to the festive atmosphere that enveloped the city, a

more lasting and decisive project, one that would eventually change the face of Rome, continued without a break. In the area around the Vatican, palaces of amazing beauty were being built, continuously and to a rigorous design in the style of the ancients. Donato Bramante had started this renewal by designing Palazzo Caprini among many other buildings. This was a palace in the Borgo with paired semi-columns placed on the first storey in order to frame five windows with triangular tympana and to support an entablature divided into triglyphs and metopes. The shops on the ground floor – an essential feature in a district where renting was so lucrative – were disguised by a heavy *bugnato*, which in turn was divided by pilasters and arches whose lintels rose up to the smooth cornice separating the upper storey. The rigorous symmetry of the shops and of the windows above them, the protean softness of the columns standing on tall bases, the chiaroscuro rhythm of the entablature, which was high enough to end the vertical thrust in a perfect equilibrium of forces, were reminiscent of an ancient temple much more than of a modern palace. Anyone walking along the street would have read there, in new form, the entire classical alphabet, previously encountered in a fragmentary state, in monuments that were being constantly dug out of the ground. Here, on this façade, these columns, metopes, triglyphs and moulded pediments had been magically recomposed. In short, they had been 'reborn'.

Since Raphael soon became the arbiter of this renewal, he could only live in a palace of this kind. In 1517 he moved into the building designed by Bramante, his old master and protector (Figure 2), while he was waiting to have a new one built for him, one that would be even more beautiful and closer to ancient models. By settling in the Borgo, in close proximity to the pope and his court, Raphael was automatically entitled to join the city's wealthiest circle. A few years earlier, however, he had already been assigned a special task in the rebirth of that dream called Rome.

Bramante died in March 1514, but not before he had used his remaining energy to ensure that his young compatriot would succeed him in the work that everyone considered the most important project in the whole of Italy: the rebuilding of St Peter's basilica, the most revered church in the whole of Christendom. Raphael was not exactly an expert on architecture, but he was undoubtedly talented, and this,

together with his gift for management, seemed to the dying man the best guarantee for the success of the project. This succession was far from being a done deal, as later events confirmed. Ten years after that nomination, Raphael's pupils took the violently polemic decision to paint, on the plinth of the Sala di Costantino, a grisaille showing the laying of the first stone of Old St Peter's. In front of the pope an old and bearded man, probably Bramante himself, unrolls a long drawing, on which the plan of the building can be seen with unusual precision, and even today. In all probability it corresponds to the building designed by their old master Raphael, which was later altered beyond recognition after his death.

This project, and this commission, had been the subject of an extremely bitter battle for control of the artistic scene in Italy. By the time Julius II, who started its construction, died in February 1513, the pillars of the dome had reached the pendentives, 'while the wing of the choir had reached the imposts of the vaults, and the two main pillars in the central nave had risen about their foundations'.[3] Leo X, who succeeded him and was an irrepressible optimist as well as a lover of pomp and excess, asked Bramante to enlarge the project still further. Alongside him the pope placed Fra Giocondo, an architect from Verona with extensive experience, whose work also focused on classical architecture, and the Florentine Giuliano da Sangallo, an expert builder linked to the Medici family. Therefore, when Bramante died, it was far from certain that Raphael would have been asked to take over as supervisor, especially since he had little experience to prepare him for such a challenging project. Indeed, many probably regarded the decision as a gamble; but the artist rose to the challenge with great enthusiasm.

By the summer of 1514 Raphael had already started working on designs for the construction. His central idea was to build a large dome surrounded by four smaller ones, so that the light would be concentred in a single point, as he had already shown in the dramatic backdrop of *The Expulsion of Heliodorus from the Temple*. Unlike Bramante, Raphael had a very precise understanding of architectural forms, and he regarded the various parts of the building as being relatively autonomous; he created the connections between them by using formal references rather than rigid axiality and unchanging proportions. His project for the façade of St Peter's is a perfect example. At the level of

the central nave he imagined a separate body with four giant pilasters that had to support the triangular tympanum, which was in turn made up of horizontal bands: at the ground level was a colonnade topped by an elegantly moulded frieze, and at the top level was the Benediction Loggia, divided into four small bays of which the central one was crowned by a semi-circular tympanum. At the sides the colonnade and the loggia stretched out horizontally from the lesser bays, but they ended, completely autonomously, with a low, rounded trabeation that reached the imposts of the capitals on the giant pilasters (Plate 49).

The composition was therefore organised by using a hierarchy controlled by the dimensions and by the conspicuousness of the main framework: tall bases, giant pilasters and triangular tympanum. For a painter like Raphael, these highly visible elements would have appealed to his training and sentiments. The other elements were organised around and inside this framework, offering the possibility of an interpretation that grew increasingly complex but never lost the explicit yet solemn impact of the ordinative structure. Raphael even ensured that the proportions of the various elements were pleasant and balanced by using visual sensitivity as only he, a consummate artist, could. He used the same method to balance the interior with the exterior, dividing the longitudinal body into five bays, structured separately by groups of columns supporting triangular tympana, inside which were loggias whose curved central arches were later described as *serliane* [after the Bolognese architect Sebastiano Serlio].

Encouraged by Leo X's grandiose ambitions, Raphael drew up plans to include a gigantic ambulatory around the choir, with chapels and high niches in whose construction he got involved while he was still alive. His refined taste for detail, including the mouldings, the polychrome marbles and the sinuous capitals, made that ambulatory unique.

By express order of the pope, on 27 August 1515 Raphael was also appointed 'commissioner of antiquities'. He was given the dual task of making a systematic study of Rome's antiquities in order to draw up a plan of the ancient city, something that had been the aim of all educated Italians for centuries, and also of preserving its ruins, thereby deciding which materials could be used for the new St Peter's and which ones had to be left *in situ* instead. In a city like Rome, whose ruins had been used as a convenient open quarry for centuries, this was a position of

extraordinary power. Rome had destroyed many of its ancient treasures not in iconoclastic frenzies or as a result of religious hatred, but through laziness. Nymphs and satyrs, sea monsters and beautiful goddesses had all too often been carted to the kilns in Via delle Fornaci, right beside the Vatican walls. During the centuries of abandon, even to build a modest house, it was much easier to obtain lime by burning a newly excavated marble statue than to travel as far as Tivoli to quarry the brilliant white travertine limestone originally used to produce the lime mortar with which the ancient Romans had built the empire.

There was no better man than Raphael for the position of 'commissioner of antiquities', and the artist carried out his duties with modesty and dedication. Concerned by the weight of his responsibility, he wrote to Baldassarre Castiglione, one of his most respected friends: 'I long to find out more about the noble forms of ancient monuments, and I know not if my flight may not prove to be that of Icarus. Vitruvius has thrown much light on the subject, but has not shown me all that I want to know.'[4] To improve his knowledge of ancient architecture, Raphael did not limit himself to using scientific methods in his surveys – which he then described in minute detail to the pope himself, in order to demonstrate his rigorous approach to the task. Acting like a prince or wealthy patron rather than an artist, he hastened to commission a new translation of Vitruvius' *De architectura* from Fabio Calvo, a humanist who had recently arrived in Rome as tutor to Federico Gonzaga. This trustworthy intellectual completed the translation in March 1519 'in Rome in the house of Raphaello di Giovan di Sancte of Urbino, and at his insistence'.[5]

The dedication alone introduces one of the brightest moments in the Italian Renaissance. In Bramante's colonnaded palace, home to one of the greatest artists of the time, this key text on classical architecture was translated *ad instantia* [at the request] of Raphael Sanzio of Urbino: it represented a circle of creativity that would never be repeated in Italian history. On returning home from the Vatican, Raphael could work on his easel paintings or design new projects. The humanist working on the translation was also housed in the palace, and therefore, together, they could discuss columns, the proportions of modules, or how the Corinthian capital was born out of baskets of acanthus leaves. The two could also admire the reliefs presented day after day by Raphael's best

assistants, which revealed to the world the secrets of ancient architecture. No poet had ever have dreamed of anything as harmonious as Raphael's life at that moment.

The work produced extraordinary results, and it would have progressed even further if the young artist had not died so prematurely. In 1519, in a letter prepared for Leo X, Raphael demonstrated a perfect understanding of the specific nature of the various historical periods and of their architectural expression. Antiquity, which only a century earlier had been a vague magical land composed of widely varying forms, was for the first time being classified: 'And as for those from the period of the Emperors, they are not very difficult to recognise, for these buildings are the most excellent, built in the best style and with the greatest expense and artistry of all. It is only the latter that we intend to demonstrate.'[6]

Together with this understanding, a new awareness was growing of the value of these ancient testimonials. By finally condemning the destructive habits that had already eliminated so much vital evidence of the classical artistic heritage, Raphael laid the basis of the modern awareness of conservation:

> How many Pontiffs, Holy Father – men who held the same office as Your Holiness but who had neither your wisdom nor your qualities or magnanimity – how many of these Pontiffs, I say again, allowed ancient temples, statues, arches and other buildings – the glory of their founders to fall prey to ruin and spoliation? How many of them allowed the excavation of the foundations simply to get at some pozzolana, such that in a very short time those buildings collapsed? What quantity of mortar was made from the statues and other ornaments of the ancients? I would go so far as to say that this entirely new Rome that can be seen today – grand, beautiful and marvellously ornamented with palaces, churches and other buildings though it may be – is built using mortar made from ancient marbles.[7]

It could be said that these words marked the moment when Rome moved into the modern period, in a new role that it would retain, unchanged, to the present: the city became the fount of all civilisation, of all art and all knowledge.

Raphael had only to demonstrate that Rome could be the ideal setting for a renewal of artistic languages. This is precisely what he was trying to do in his designs for the new St Peter's, but here matters were not so straightforward. The huge costs were a problem, and the pope had started to siphon off funds to invest in the arms he needed for his ill-fated attempt to conquer the duchy of Urbino for his family. Leo even went as far as to declare a new plenary indulgence, whose only effect was to accelerate the European religious crisis and the Protestant Reformation. Moreover, there were also practical and technical problems to resolve, and Raphael was busy with countless other commissions, which he could not or would not postpone. Therefore the pope placed Antonio da Sangallo – Giuliano's nephew, who was the same age as Raphael – to work alongside the artist. Antonio represented that clique whose ambition was to control the whole enterprise: it was thanks entirely to Raphael's extraordinary ability that he was able to collaborate at all with a man who saw himself as his natural rival.

Antonio worked with Raphael as second Vatican architect from December 1516. Although he recognised the young man's enmity, Raphael could not do without his skill. Relying on the experience he had acquired in coordinating the work of many different and not always easy-going craftsmen, Raphael strove to ensure that theirs would be a constructive collaboration, aimed at the success of the project. Few others would have taken such a brave decision, but the results proved excellent. By the spring of 1519 the final project was complete. The foundations of the southern arm of the choir were laid, and the marble cladding was completed on the area that had once been the king of France's chapel.

But the agreement proved extremely superficial. Immediately after Raphael's death, the following year, Antonio attacked his superior's project and the work that had been done by drawing up a detailed memorandum to convince the pope of the mistakes made by his protégé. The resulting battle for control over the building works was won by Sangallo's cronies, who then retained the upper hand for the next 25 years, until they had to contest the works with another giant, one who had also been Raphael's enemy, but owed them no favours either: Michelangelo Buonarroti.

4 PRIVATE PLEASURES

Donato Bramante's death had also left another important architectural work unfinished: the construction of a triple loggia in front of the Vatican Palace overlooking the courtyard of San Damaso and the rest of the city. The elegant portico brought a note of rationality to the hotchpotch of façades that made up the palace, linking it on one side to the Benediction Loggia on the façade of the new St Peter's and, on the other, to the large Belvedere courtyard that was taking shape.[8] Building work had reached the level of the first loggia when Raphael was charged with its continuation, but initially the artist's influence appears to have been limited to the creation of the beautiful central cupola, which was decorated with caisson stuccowork in homage to the Pantheon, whose coffered dome had inspired the background of his last Florentine altarpiece for the Dei family.

Raphael had a much more radical influence on the design for the second loggia (Plate 51). The bays are divided internally by a series of polystyle pilasters that continue upwards, to form blind arches that give a sense of greater depth and plasticity. Each bay contains a marble niche that used to house an ancient statue. The identity of only two of these statues is known: one was of Mercury, the other of Diana. The vaults covering the bays are constructed using the *a schifo* technique, a cloister vault topped by a rectangular flat surface; they rest on a series of architraves that link the internal wall to the pillars of the loggia. By devising such a complex structure for the loggiato, Raphael created the conditions for a perfect balance between the rigorously classic architectural structure and the painted grottesque decorations that framed, in the flat areas, narrative scenes from the Old Testament. The ornamental stuccowork was completely new and made the structure very similar to that of the ancient models that had inspired it: Hadrian's Villa at Tivoli and the cryptoporticus of Nero's Domus Aurea on the Colle Oppio, close to the Colosseum. The inclusion of marble statues in the niches completed the decoration of the loggia, which now closely resembled Vitruvius' and Philostratus' descriptions of the galleries used to exhibit works of art.

However, this extraordinary blend of architecture, painting and sculpture had to come to terms with two much more serious

technological problems: how to ensure that wall paintings would withstand the ravages of time, and how to produce bas relief stucco decoration. Both questions must have been in the minds of Renaissance artists as they noted the different forms and consistencies in their architectural surveys. In particular, the stuccowork that was found – not only at Hadrian's Villa and at the Domus Aurea, but also at the temple of Fortuna Virile in the Foro Boario – intrigued architects because of its ability to imitate finely worked marble, and at a significantly lower cost. For 20 years or more, many had tried to reproduce this type of stucco. Baldassarre Peruzzi had tried around 1506, in the frieze with putti and garlands for the Farnesina. Similar efforts had been made by the architect who added the portico in ancient style to the atrium of the Farnese Palace, dated to the early part of the second decade of the century. However, both had used a mixture of *pozzolana* [volcanic ash used in mortar], supported, where necessary, in those areas that projected furthest, by the addition of *cocciopesto* [mortar containing crushed pottery or marble fragments], or even secured by wires anchored in the masonry. The mixture was applied by using a spatula and painted with slaked lime, which was designed to give it the colour of marble.

This technique was only a pale imitation of the refined examples seen in the ancient monuments, and an artist like Raphael could not be satisfied with such a rough copy. His painstaking study of Vitruvius' instructions eventually paid off; they were helped no doubt by direct observations of the classical buildings and by the possibility of experimenting with new materials, with the help of a team that included a number of other artists. Around 1515, when the loggias were being built, Raphael and his school perfected the formula for a new mixture for low-relief stucco, which could be worked with a spatula until it resembled carved marble perfectly. They had finally revived a technology that had almost disappeared since the Roman Empire. The formula called for a blend of well-slaked travertine or marble limestone paste and very finely mortar-ground travertine or marble, in a ratio of one part to two. Vasari attributes this invention to Giovanni da Udine, but Raphael was unquestionably responsible for the research: only he could have made the right deductions, on the basis of the instructions given in the sources (it is worth remembering that the work of translating

Vitruvius was taking place under his own roof) and on an analysis of the samples collected from various monuments.

The formula was jealously guarded by Raphael's workshop, and before long it gave him the possibility of producing work that was perfectly comparable to that of the ancients, but at a fraction of the cost. Ten years later, when he was working on the decorations for the library of San Lorenzo, even the proud Michelangelo would be obliged to ask a trusted friend from Rome to send him the 'formula for marble stucco' perfected in Raphael's workshop. This fact, over and above Vasari's account, confirms the real novelty and importance of the studies and experiments carried out by Raphael's workshop in the field of technology, as well as in that of form.[9]

The other aspect that helped the decoration of the loggias to resemble those imperial models, which Raphael deemed the most perfect ones and worthy of imitation, was the special 'lustrous fresco' covering the walls. The Romans achieved this brilliant yet solid effect, similar to that of marble inlay, by beating or compressing the plaster to be painted, which was gradually built up using a surface layer made from lime and increasingly finely ground marble powder (the same as for the stucco). The chemical bond created by the two elements, both of which are derived from calcium carbonate, guaranteed a rock-hard finish, which could be buffed to a shine. The fifteenth-century Tuscan school of frescos, even the best examples found in Florence or Siena, or in Perugia, did not contemplate this kind of beating or compression, and the joins between the various *giornate* remained clearly evident (indeed they are in Michelangelo's Sistine Chapel). What amazed contemporary observers and still astounds us today is the organisation of the artists working on the wall paintings in Rome, which was so perfect that the *giornate* are in no way distinguished from each other. In the late nineteenth century many thought that this gleaming finish and the absence of any joins between the *giornate* were due to the use of wax when painting *a secco* on the wall: if anyone attempted to reproduce this encaustic painting technique, the results proved disastrous. Raphael was the first to imitate successfully painted Roman murals, to the extent that, in the loggias, it is impossible to detect the joins in the plaster. In another respect, this is also conclusive proof that his workshop, although by then it included different painters, had achieved a sense of

understanding and a level of coordination that made it impossible to detect the individual hands.

This intense process of technological research produced a level of decoration that was unparalleled in other buildings of the time, even though the grotesque repertoire had already been in use for half a century. Onto this lustrous surface the artists painted intertwining leaves and fantastic animals, with an extraordinary sense of confidence and freshness of touch. There was no room for *pentimenti* [alterations] or subsequent retouching on such compact plaster, with its bright backgrounds. The brushstrokes had to be precise and swift. The curve of the festoons, like the anatomy of the small figures that thronged the walls, had to be line perfect – there was no question of a second chance here. The white background was without a single smudge. There were no drips, no faltering brushstrokes. Painting was again fast and natural, as it had been in Roman times. Only the scenes on the ceiling, those of the Bible, returned to the ways and compactness of the Renaissance, using a technique that gradually reconstructed the anatomies, the chiaroscuro and the shaded draperies in short, rather fidgety strokes.

The same was true of the *stuccatori* [plasterers] who miraculously attached onto the walls delicately jutting cornices ornamented with foliage, fantastic figures and exotic fruits and, at the imposts of the arches and along the edges of the pilasters, the typical mouldings of the architectural orders, which looked as if they were lacy marble frills. The effect was extraordinary, and it immediately became all the rage in every other project then being built in Rome. The white stucco, cleverly alternating with blocks of blood-red, violet and blue and with gold leaf on the highlights, created a sensuality that turned every head. Yet all this wealth of decoration was subdued by an architectural cornice that was perfectly and rigorously correct. Raphael achieved precisely the right balance between painted decorations that were not invasive and were free from any sense of vulgarity, and an architectural structure that was softened by precious mouldings but retained its geometric purity.

The first rumour of these extraordinary developments in the loggias hastened the arrival of the most influential figure at the papal court: Bernardo Dovizi, whom Leo X had appointed cardinal of Santa Maria in Portico but who was widely referred to as Bibbiena, the name of his

native town in Tuscany. Dovizi had been chancellor to the ill-fated Piero de' Medici before the family was driven out of Florence in 1494. He had shared all the Medici's troubles and hardships and, after Piero's death, had become Cardinal Giovanni's closest supporter. He had also played a crucial role in the political negotiations at the conclave leading to the cardinal's election as pope. Dovizi was also the author of the comedy *La Calandria*, written in Italian and staged with great pomp in February 1513 in the ducal palace in Urbino. Having grown up amid such festivities, Dovizi was rarely absent, even when he was entertained by Rome's most notorious courtesans or by buffoons who told the most risqué jokes. In the days immediately following Leo's election, the Venetian ambassador cuttingly described Dovizi as the 'be-all and end-all' of the court. It was an apt choice of words. Leo even wanted him to live inside the Vatican and assigned him the apartment immediately above his own, which had formerly belonged to Pope Julius II.

Having seen Raphael's work on the loggias, Bibbiena then asked the artist to redecorate his own apartment, making it more suited to his cultured but hedonistic persona, which was admired throughout the city. The artist decorated a small loggia for him, overlooking the Cortile del Maresciallo, and a small *stufa* [bathroom] (Plate 50) where the future cardinal could take reinvigorating steam baths. These were the first works that Raphael had undertaken in that part of the apostolic palace, but they were unquestionably also the most successful. On 25 April 1516 Bembo wrote to the cardinal: 'I shall be happy to bring you good news [. . .] that your Lordship's loggia, *stufetta*, rooms, and leather hangings are finished.'[10]

The *stufetta* was an indispensable and civilised accessory for anyone who enjoyed the pleasure-filled life of Rome under Leo X. The use of spas, which had been so important in ancient Rome, was reinstated during the Middle Ages as a medical practice that was extremely important to bodily health. But, since the late fifteenth century, elite culture had rediscovered the inevitable sensuality linked to a practice centred on the body and not short of opportunities for promiscuity, which evoked the freedom and joyful naturalness characteristic of the civilisation that this culture was determined to revive. This was the explicit, if brutal, meaning of a letter in which a Bolognese doctor, Floriano Delfo, described the delights of the spa at Porretta to Marchese Francesco

Gonzaga, who had left his wife in the ecstasy of her artistic collections in order to dedicate himself to the less elegant but more immediately satisfying quest of erotic collections:

> The water in the baths at Porreta [*sic*] [. . .] seems to me similar to that in the probatic pool described in Saint John's Gospel, instead this usually heals all infirmities [. . .] Truly, most Illustrious Prince, this is the only place in the whole of Christendom where love exists in that true liberty which resembles the first Golden Age when, without discretion and without knowing another's first name, every part was shared [. . .]. All reverence and modesty is foreign to the bathers, who are not ashamed to bugger, cack, belch and piss in public, often showing arses, pricks and tits without blushing [. . .] and because intercourse is said to be harmful to women who take the waters for the good of their wombs, these damsels are happy to consent to be swived from behind [. . .] men and women enter the baths together, naked, and here [. . .] husbands are not jealous of their wives, nor fathers of daughters or brothers of sisters, knowing that death here guards against corruption.[11]

This leaves little doubt that a pagan sense of the uninhibited physical enjoyment of the body had survived in this culture of baths and thermal therapies, and that these were the circles frequented by Bibbiena and his patron Leo X, both of whom had been guests of Francesco Gonzaga and his wife Isabella d'Este in Mantua. Agostino Chigi himself frequently visited the spa at San Casciano near Siena whenever he could; there the atmosphere differed little from that painted for the marchese of Mantua. As a supreme artist and consummate man of the world, Raphael was capable of expressing the quintessential idea of that natural freedom. For the cardinal's *stufetta* he devised a cycle of the Venus stories, taking his cue from a statue of the goddess that Bibbiena had been given and that he wanted to display here. The tiny bathroom (measuring just 3.20 x 2.50 metres) has niches framed in gilded stucco and a dark red dado with black squares decorated with winged cupids driving seashells pulled by dolphins, of the type that became famous later, after the discovery of the House of the Vettii in Pompeii; but Raphael must certainly have copied them from other examples he had seen in Roman ruins. The walls are painted using a fast, dry technique in which

the colours tend to stray over the lines: the scenes include the birth of Venus, Venus approached by Pan, and Venus and Cupid riding marine creatures that, in deference to the pope, have leonine features. The bright colours, geometric mouldings and minutely detailed decoration on the bright background give the room an authentic classical character, and certainly also have Platonic associations: the purification of the spirit and body through water and the celebration of these universal elements. However, alongside such complex meanings, the room lends itself to openly sensual enjoyment, being surrounded by the beauty of women's bodies and by elegant decorations.

5 BETWEEN THE TIBER AND MONTE MARIO

At the same time as he was working on the Vatican loggias, Raphael also designed a number of remarkable palaces: Palazzo Pandolfini in Florence) and Palazzo Alberini, Palazzo Branconio and Palazzo Jacopo da Brescia in Rome. In November 1514 Jacopo da Brescia, Pope Leo X's personal physician, had acquired a valuable plot of land in Borgo for 1,000 ducats, right beside the axis that was becoming the most important street leading to the basilica. Having sold the land to Jacopo, the pope expressed the wish that any building should bring honour to the city and to the papal court. Subsequently the physician also bought a house that had been being built by Giuliano da Sangallo when the latter returned to Florence in 1516. It fell to Raphael to restructure the entire complex by using an extremely effective and functional layout.

The façade is divided into three storeys. The horizontal *bugnato* of the basement is dominated by a decorative design that has cast aside the rustic feel of the powerful 'wall' still used by Bramante in Palazzo Caprini. The ground floor contains four shops divided by a simple entrance door. The *piano nobile* [first floor] has shallow pilasters, which are flanked by pairs of pilasters designed to give the façade a vibrant luminosity and which support a Doric entablature and a cornice that gives a strongly horizontal emphasis to the whole. In the five bays between the pilasters are windows, alternately topped by triangular and semi-circular tympana, following the model of the kiosks in Trajan's market. The real innovation, compared to Bramante's prototype, lies in the attic. In Palazzo Caprini Bramante had inserted the mezzanine

windows between the triglyphs on the Doric frieze, minimising their presence so as not to interrupt the rigidly classical design; Raphael, on the other hand, made the mezzanine fully visible, separating it from the *piano nobile* and opening lobed windows with a simple cornice, in correspondence with the shops and windows. In this way the functionality and the need for accommodation within the palace were not sacrificed, while the design remained strongly anchored to classical form. The attention to detail, the elegant moulding of the tympana and the linear nature of the *bugnato* guarantee the impeccable decorum of the building. On the narrowest side of the palace, at the north-western corner, the pilasters support a high, blind, semi-circular tympanum, which, owing to the span of the architrave, resembles a triumphal arch.

In this project Raphael once again confirmed his ability to conceive each storey as an independent form and to organise them using a unique layout that, by means of carefully controlled mouldings, was linked to an overall design. This same process of rational simplification of both ornament and function guided his designs for another palace, which he worked on at about the same time, not far from that for Jacopo da Brescia: Palazzo Alberini in Via dei Banchi. The street facing Castel Sant'Angelo could command some of the highest rents in the city and the Alberini, a family of ancient lineage, had owned houses there for hundreds of years. In 1515, when Giulio Alberini bought new plots of land adjoining the family property, he commissioned Raphael to enlarge the palace, with a view to boosting the income he could obtain from renting the ground-floor shops to the bankers who had concentrated their activities in the neighbourhood. The palace therefore appears to have been conceived as a profitable enterprise rather than as a residence for the family, and the design reflects these functional requirements. On the ground floor there were large shops, which represented the most lucrative part of the building. The *piano nobile* is almost the same size as the upper floor, and only the prominence of the pilasters identifies the more decorous nature of the first floor, by comparison to the second. Both are separated by cornices, although on the second floor this is reduced to a simple evocation of the order below. It is now difficult to make out what the cornices above the pilasters on the second floor may have looked like. The palace presents an ugly combination of stone and brick, but plans may have existed to finish it

in coloured stucco, and this would have given greater emphasis to the pilasters and to the levels behind. This finish would have eliminated the contrast between the stone and brick, transforming the entire façade into a brilliantly carved relief and giving the illusion of its being clad in polychrome panes [*specchiature*] in fake marble.

Raphael's pictorial awareness – difficult to sense in this work, which remained unfinished for so long – is instead immediately obvious in the third palace built for another rich patron: Palazzo Branconio dell'Aquila, also in Borgo. Giovan Battista Branconio dell'Aquila, a rich courtier to Leo X and a collector of ancient coins, started to build the palace in 1518, having commissioned Rome's most fashionable artist and his collaborators to work on its design. The palace was visible from the papal loggias and was intended to bolster Branconio's reputation as a numismatist. The results exceeded his expectations, and by 1520 the palace was being celebrated as 'the most joyous building that has ever been seen'.[12]

On the ground floor Raphael again positioned columns so that they framed elegantly moulded arches and supported a strongly jutting cornice that separated the *piano nobile*. He also included a highly innovative decorative device. On the floor above he opened deep niches aligned with the columns below, and they separate windows crowned by alternating triangular and semi-circular tympana, which are of sufficient size to acquire an independent expressive value. The space between the top of the tympana and the cornice of the upper floor contains stucco floral garlands that frame medals bearing the profiles of famous figures, a trope that recalls the patron's passion for ancient coins. The windows on the attic storey alternate with square frames that were originally decorated with polychrome paintings or, according to some scholars, stucco reliefs.

The self-assured use of the classical order reaches an unprecedented degree of virtuoso display in this palace. The ancient repertoire is reformulated with a richly exuberant taste for decoration, which is curbed by a painterly sensitivity capable of distributing columns, cornices, festoons and paintings without ever risking confusion or superfluity. The palace seemed to have materialised beside the Tiber from some fantasy world, or directly from the dream of rebuilding Rome as it had been, on the basis of studies that absorbed both architect and client during

these same years. Sculpture, painting and architecture were combined here in the difficult equilibrium of the façade, following a scheme that, as usual, gave autonomy to the different storeys but also united them through the expert use of proportion and through the confidence with which the individual classical features were extrapolated from the original syntax and repositioned; this reflected the new taste for evoking, but also revitalising, the past and for reintegrating it into the wealth of imagery to which the city's inhabitants had by now grown accustomed. Just as Raphael had begun by conjuring up all the complex richness of classical architecture in his paintings, during this phase of his career his experience as an architect matured to such a degree that he could transform a three-dimensional building into an unparalleled artistic vision, capable of maximising the expressive potential of all three arts – architecture, painting and sculpture – in order to capture the language of Roman antiquity.

8

A NEW ARTIST

1 THE INACCESSIBLE PALACE

During the early months of 1515 Raphael dominated the artistic scene in Rome and Italy as no other artist had done before. This high point of his success is also confirmed by the pressing requests he received from two of the greatest collectors in Italy at the time: Isabella d'Este, marchesa of Mantua, and her brother Alfonso, duke of Ferrara. Both had already amassed works by the leading artists of the time, but they now regarded their collections as incomplete without a painting by Raphael.

Isabella passed on her request to Agostino Gonzaga, but on arriving in Rome in early June 1515 the latter immediately informed her that the artist was extraordinarily busy, although he had indicated his willingness to comply with her wishes:

> I spoke to Raphael of Urbino about the small painting that your Excellency wishes to commission from him. I persuaded him to oblige, and he will do so and, although he has plenty to do at the moment, in order to demonstrate his desire to serve your Excellency as best he may, he has resolved to paint it in any case.[1]

Isabella was indefatigable in her pursuit of fashionable artists; yet, in the case of Raphael, her requests were ignored for months, even years. In a vain attempt to attain her wishes, she called on her loyal supporter Baldassarre Castiglione, a talented nobleman who, in view of the marchesa's insistence, constrained Raphael to paint in his presence, knowing full well that the artist would set the work aside as soon as he himself left the house. Indeed, the painting was never finished.

Alfonso d'Este was even more demanding: as early as December 1514 he charged his brother, Cardinal Ippolito, to commission a painting from Raphael for his personal study. Here too, Raphael's promises never came to anything as weeks stretched into months, then into years. The last promise was made only a few days prior to the artist's death, which robbed Alfonso of his desired work. The emissaries from Mantua kept up a steady flow of letters voicing Alfonso's determined and insistent demands, and this correspondence provides a detailed account of the artist's last years, his habits, his activities and his attempts to satisfy the requests of an entire nation hungry for his services.

Although a keen patron of art, Alfonso was, first and foremost, a military leader. He had withstood Pope Julius II's attacks thanks to the artillery whose casting he had personally ordered, and he was respected as one of Italy's greatest princes. Indeed, although he instructed his ambassadors to write dozens of letters to solicit the painting, he never wrote directly to Raphael, even though his envoys suggested it. For a prince of his rank, the idea of addressing an artist would have seemed humiliating:

> We do not consider writing to Raphael of Urbino as you suggest, but we wish you to find him and tell him that you have received letters from us in which we write that three years have now passed since he gave us his word; and that this is no way to treat men of our rank. If he does not keep his promise, we will take steps to show him that he should not have misled us. And then, in your own words, you can tell him that he should be careful not to provoke our hatred instead of the love we have had for him; and that by maintaining our trust he can hope for our support, but on the contrary if he fails he can expect one day to receive things he will regret.[2]

Alfonso showed no qualms about threatening Raphael; but he was too distant from the Rome of Leo X to understand the social pre-eminence of an artist of Raphael's status. He was too distant to understand that some artists considered themselves to be more important even than cardinals – so much so that, for a number of years, Raphael himself expected to be nominated a prince of the church in view of the goodwill and favours he had accumulated with the pope. Indeed, it is precisely this difference in Alfonso d'Este's perception – the perception of a man who nonetheless embodied the highest level of court culture in Italy – that shows how far Raphael had ventured in exploring new intellectual territories linked to the image and understanding of the world. Alfonso's protracted negotiations with Raphael over the painting of a Bacchanal continued for six years. At least 77 related documents have survived, including 14 letters written directly by Alfonso to his ambassadors and urging them to chase up the painting. Even in Paris, where he travelled to ask for François I's military support in the reconquest of Modena, the warrior duke's mind never strayed far from that painting, which had become by then something of an obsession: 'Will you write to Monsignor De Adria in Rome and tell him to solicit our painting by Raphael of Urbino.'[3] The last letter is dated 21 March 1520, just within weeks of the artist's death.

Alone, Raphael's many commitments with the papal court during this period are not enough to account for his refusal to work on this particular commission. The same years saw him finding the time to dedicate himself to other private works, for instance the portraits of his lovers or his friends. Moreover, he could have relied on the assistance of his pupils, now fully fledged painters themselves. Rather it would appear that he was not interested in the type of work that Alfonso had requested. Painting a mythological scene was perhaps a stylistic exercise that no longer attracted him. This intolerance is borne out by his attitude to the realisation of the Loggia of Psyche for his protector and patron, Agostino Chigi. He painstakingly devoted himself to designing the decorative cycle, and also to organising the work of his collaborators. But Raphael's autograph work in these paintings is limited to the bare minimum required to satisfy his friend. His own interventions can be identified in a few of the spandrels, which display a row of the best female nudes of the entire sixteenth century. The main ceiling panel

and the other spandrels and pendentives are clearly the work of his pupils.

During these years Raphael's interests lay elsewhere: Rome was bubbling with intellectual energy focused on goals that looked far beyond the search for formal perfection, which in any case had already been attained in the second of the Vatican rooms and in the devotional paintings dating from 1515 – for example the Saint Cecilia altarpiece. Leonardo da Vinci had been in Rome since 1514, under the protection of Giuliano de' Medici, and he was housed in the Belvedere apartments of the Vatican. Leonardo continued his anatomical studies: he had a particular interest in reproduction and was actively involved in the dissection of women who had died in pregnancy. His insight and intellectual voracity drew him dangerously close to questions that were distinctly awkward from a theological and a philosophical point of view. Indeed his latest work touched on a topic that was tormenting intellectuals at the curia: the soul's formation and immortality. The subject generated the first real split between Renaissance theologians and philosophers, and the different camps of opinion were never reconciled. In December 1513 Pope Leo X, who did not spend his time solely organising sumptuous festivities, had promulgated the papal bull *Apostolici regiminis*, which condemned outright those philosophers who supported the thesis of the mortality of the intellectual soul. The most illustrious victim of this stricture was the well-known humanist Pietro Pomponazzi, who in 1516 published a treatise titled *De immortalitate animae* [*On the Soul's Immortality*], which was immediately condemned and burned after Leo X's personal intervention.

Leonardo's studies were coming dangerously close to this territory, and it was not long before the great old man, although adored by the ruling house, started to attract torrents of criticism and slander, which turned into acts of informing on him. A hint at this ambiguous period of Leonardo's life appears in a passage from the first edition of Vasari's *Lives*, which was published in 1550: 'Because [Leonardo] transformed soul into a concept so heretical that it did not suit any religion whatsoever, perhaps he valued being a philosopher much more than being a Christian.' These words were prudently eliminated from the second edition of the *Lives* published 18 years later, at the height of the Counter-Reformation.

Being a philosopher was undoubtedly Leonardo's ambition, notwithstanding the possible consequences. He perceived philosophy to be the study and intellectual understanding of the world, and in those years such understanding also included the study of antiquity – certainly not as a marginal subject. This is demonstrated by a passage in which Marco Antonio Altieri described the overlapping interests of the philosophers and archaeologists who mingled in Rome during Leo X's pontificate, men 'dedicated to contemplative studies of nature and curious observers of Roman antiquities'.[4] This immediately highlights how close Raphael was to Leonardo and to the intellectual ferment at the forefront of philosophical discussion at the time. Raphael's spring excursions to the ancient sites are testimonials to this involvement, since they were made not in the company of architects and draughtsmen but rather of philosophers, as Pietro Bembo wrote in a letter to Cardinal Bibbiena: 'Tomorrow, after twenty-seven years, I shall again see Tivoli, with Navagero, Beazzano, Castiglione and Raphael.'[5]

In short, Leonardo's presence in the Vatican probably gave a greater sense of 'intellectualisation' to Raphael's art and life, and this hypnotic influence was again evident in his painted work from this period. Leonardo's experience immediately became the centre of a broader interest when Raphael started to reconstruct the plan of ancient Rome, an undertaking that excited philosophers much more than it did architects. The enthusiasm with which a philosopher of great renown such as Celio Calcagnini described this endeavour to a fellow philosopher, Jacob Ziegler, in 1519 leaves little room for doubt. In his account Calcagnini also described Fabio Calvo of Ravenna as a philosopher worthy of sainthood, who spent his days eating vegetables and lettuce, like an old Pythagorean,* and who was lovingly cared for during his illness by Raphael, in whose house he was translating Vitruvius.

This intellectualisation of Raphael's research could hardly not have affected his painting. By this stage he had almost lost interest in stories and in how he could tell them; during his most fertile years, his creative vitality was focused entirely on portraits, which attained a level of perfection that was never again reached by any other artist. He

* This term was used in the Renaissance to describe someone whom we would now call a vegetarian. (Translator's note)

preferred to paint people, whether friends or lovers, whom he could study in greater psychological detail. In the portraits of Julius II and Fedra Inghirami, both dating from 1511–12, he had already shown an extraordinary capacity for psychological analysis and realism. But if one compares these portraits with those painted after 1515, starting with the portrait of Cardinal Bibbiena, which is now in the Galleria Palatina of Florence (Plate 53), the difference is striking.

In the cardinal's portrait, the fabrics and flesh tones acquire a corporeal quality that is lacking from the earlier works. Abandoning the impalpable *sfumato* with its chiaroscuro transitions, Raphael concentrated the lights and shades so as to produce dramatic contrasts. The details are rendered with minute Netherlandish precision, but they stop short of a purely naturalistic reproduction. The light deep in the iris of Bibbiena's eyes provides an extraordinary flash of vitality. Gone is any haziness in the definition of his hands, and the perfect foreshortening freezes the movement like a snapshot. His garments acquire luminosity and the consistency of the materials is rendered with scientific precision. The weight and cost of the rings can be gauged, to the extent that those worn by Julius and Inghirami look like fake gold. The cardinal, a man used to constant action, fidgets and struggles to sit still in his chair. Along his left arm the cope rises from the pleated linen, creating a shaded area that makes the viewer want to look inside it. Here the edges are sharp, highlighted by a barely noticeable pale line that replaces the dark *sfumatura* used in the earlier portraits. To find another man captured with such vitality on canvas – someone whose judgement is so piercing that it embarrasses the viewer – one would have to go back to Antonello da Messina and his portraits of impudent sailors.

It is a change that reflects protracted and acute observations on light and on perception through the optic nerve. Even the intensity of colour helps to give a new focus to the figure. The red *mozzetta* with its cold tones of alizarin-red differs from the *biretta* [peaked square cap] and from the edge of the fire-red cassock, which is visible below the white shirt. Even the portrayal of Julius II seems distant. Bibbiena's portrait inaugurated a new stylistic season, one fostered by Leonardo and by the desire to give a tactile sense of the figure in space. The hazy technique of *sfumato*, which blurred the details of the figures in the *Madonna della Seggiola* like a slightly cloudy glass held between the painting and the

viewer, now gave way to a luminescent contrast that animates the flesh, making it look as if the sitter were about to stir.

All these new features reappear, with even greater mastery, in the *Double Portrait of Agostino Beazzano and Andrea Navagero* (Plate 32), in the portrait of *Baldassarre Castiglione* (Plate 33), and in the *Double Portrait* – a self-portrait with a friend (Plate 34) – which are some of Raphael's most perfect works after 1516. The chromatic scale of Castiglione's portrait plays a key role in creating the psychological atmosphere of the painting. The robe forms a single play on black, layered with green and lightened by the hazy reflections on the sleeves before being banished in the centre by the brilliant white of the shirt. The neutral, unreal background offers no relief for the eye and increases the isolation of the figure, which is transformed into an apparition. This loosening of all realistic references to time and recognisable space provokes a disturbing sensation, but one that involves the viewer emotionally. (Three centuries later Manet would faithfully use the same formula in portraits of his beloved Berthe Morisot, an incontestable celebration of Raphael's greatness.) Over the black velvet doublet, the man is wrapped in fur whose silvery reflections create an intense focus of light on the white shirt jutting forwards below his beard. What is immediately apparent are the writer's blue eyes, shining out from the dark silhouette, and the contrast between the luminous forehead and the large hat, which seems flattened against the half-lit background. It is as if the clothes and their realistic presence draw back to make room for that gaze, which is the real protagonist of an image that bears no relation to earlier models.

In the two double portraits, Raphael shows even less concern for the credibility of the physical setting: he draws the figures closer, without overly worrying about the laws of perspective, and he darkens the background so that the faces emerge from the half-light to become a source of light, which is then dispersed through the painting. Until this point in time portraiture was above all concerned with representing the sitter's material and social context. Raphael moved it into another dimension, one where the psychological tension is so strong that, freed from all incidental detail, it proves hypnotic. The only precedent for the psychological portrait – apart from those made by Leonardo, which, not by chance, Raphael would have been able to study every

time he visited the grand old man in the Belvedere – are the portraits of illustrious men painted by Berruguete for Federico da Montefeltro's *studiolo* [little study] in Urbino. But, since these were an abstract evocation of men no longer alive, they lack that imposition of vital energy that emerges from Raphael's late portraits.

The process of selection and psychological analysis was the first step towards this end. Raphael studied his friends (and himself) until he could identify the flash that encapsulated the profound truth of the soul. It was this flash – this intense, fleeting and dazzling light – that he succeeded in revealing on canvas. That Pietro Bembo realised this is clear from his letter to Bibbiena, where it is couched in the lucidity and incomparable elegance of his prose: 'Raphael, whom I reverently commend to you, has painted such a life-like portrait of our Thebaldeo that the painting looks more like him than he does himself.'[6] A superb way of saying that art has exceeded nature!

But this procedure was far from being instinctual or improvised: Raphael constructed each portrait starting from an 'ideal', and even from a stereotyped image of the man or woman in question. Raphael's finished portraits all have in common a number of features typical of the artist rather than of the sitter: the eyebrows that curve in a perfect arc, as if drawn with a compass; the almond-shaped eyes; the finely proportioned oval-shaped face, with a small chin. These traits reappear in all his figures and have often prompted critics to identify very different women as the same person: for example, the model for *La Velata* and *La Fornarina*. Not to mention identifying the sitter in *La donna con il liocorno* [*Lady with a Unicorn*) as the one in *Maddalena Doni*, which is wholly untenable. But the starting point was always Raphael's 'ideal', and this served as a valuable frame in which he could then embed elusive fragments of matter and spirit. By resorting to an ideal stylistic matrix and then combining it with his own ability to match it to the sitters' physiognomies, Raphael found a way to paint people so that their portraits looked more like them than they did in real life, as Pietro Bembo had noted. His artistic creation was not hampered by reality; instead, with perfect control, he dismantled and then reassembled it, using restraint. And, above all, light, which he stole from Leonardo, was used to embellish and purify the complexion – even in the case of older men like Castiglione, whose beard is turning grey, or in the case of men whose

features are hardly attractive, like Andrea Navagero with his prominent eyes and double chin. Raphael curbs these natural disfigurements by setting them in an ideal structure that, alone, was enough to guarantee the fascination of the portrait.

In this way matter is expressed through the emergence of light and colour, which are governed by a design that dispels any vulgarity from the features. It was precisely in his portraits of friends that Raphael was most able to advance this creative process, when he was free from the formal constraints of social etiquette that hampered his official portraits. In his portrait of Lorenzo de' Medici, for example, the artist's talent is smothered by an irritating narrative of material wealth: velvet, gold, fur and silk had to be included in the painting, in keeping with social decorum. Likewise, the features of the aspiring prince had to be portrayed in detail, together with the coin held in his hand as a symbol of munificence and with the sword worn at his side – a symbol of military valour that was not matched by his real life story. This portrait shows, unfortunately, how Raphael's studies and talent could be squandered if they deviated from that speculative freedom with which he identified himself and from his circle of friends, in whose company he experienced an intellectual fervour that would have been incomprehensible to many. Compared to the colourful explosion of the portrait of Lorenzo (for whom Raphael certainly felt no affection after Lorenzo had usurped the duchy of Urbino from Raphael's princely patrons), the sobriety of the portraits of himself and of his friends can hardly be coincidental. It is an affirmation of the incomparable power of intelligence and creativity, a power that these men appear to acknowledge here for the first time. In the portrait of Beazzano and Navagero, the bodily presence of the men is partly concealed by shadow, giving greater prominence to the feelings that take possession of their faces and make them immensely expressive.

Even the figure turning to look over Raphael's shoulder in *Double Portrait*, who is identified, according to legend, as Raphael's fencing master, communicates beauty and an air of majestic intelligence with his foreshortened pose, as if Raphael wanted to show how these men condensed beauty and knowledge through their movements without having to pose or to wear garments related to a particular status. Indeed, here the clothes vanish into the blackness which makes one expect the faces, as if in silent concentration.

Nor, lastly, can it be coincidental that, in painting all these portraits as private commissions and intimate studies, Raphael used canvas and not panels. The portrait of Castiglione and the double portraits of Agostino Beazzano and Andrea Navagero and of the artist with a friend, paintings that are without question the most enigmatic and modern in Raphael's entire output, are executed in oils on canvas. This technique allowed him to fulfil his insatiable desire to experiment and to explore the minds of those he loved and knew best in order to achieve the excellent results that he did. The lightness of the supports and the ease with which the paint dried or could be modified were ideal for this experimental research, which probably continued in the bedroom of Raphael's elegant palace. The unfathomable depth from which the faces in these portraits emerge is the result of successive layers of mellow oil glazes. It would be difficult to achieve a similar sense of spatial ambiguity using tempera, with its flattened metal or enamelled effects. The technical singularity of these portraits makes them even more valuable and provides the real key to the complex, restless psychology of the mature artist, which would also inspire his works for institutional patrons – who, in this capacity, were the recipients of a more conformist product. But the choice to experiment for the sake of experimenting, to use oneself as a focus of research, highlights the truly modern facet of Raphael's work – which anticipated the more restless streak in modern art before it became the norm, with the avant-garde movements of the late nineteenth century. This facet, namely his restlessness and his focus on experimentation, was to be buried when some of the artist's work was recycled to fit the graceful and devotional stereotype that the Counter-Reformation would extract from his output, overlooking the rest and thereby simplifying the artist and his work for its own purposes.

This dramatic manner, with its strong contrasts of light and shade, is also evident in the paintings commissioned by Leo X around 1518 in order to pay political homage to the French king, François I. Here too, the gracefulness of the drawing and of the poses, unquestionably the genetic characteristic of Raphael's paintings, is set in motion by the chiaroscuro that, from this spatially ambiguous and elusive background, only reveals those faces that contribute to the psychological dialogue. The gestures and the meaning of the painting can be immediately

grasped, both at a deeply spiritual level and through sensual perception, by tracing the ineffable light that touches on the figures, lighting up their expressions and telling the story. In *The Holy Family of François I* (Plate 35), the blinding glare of the white cushion in the cradle – too small in size – on which the Christ Child rests his foot moves up his spine and along his arm, which rests on his mother's, leading us higher towards the slanted face and radiant forehead, where it dissolves into waves of golden curls. Other shorter, more jagged flashes of light collect on the scarf around Saint Elizabeth's head, on the garland of flowers held by the angel, on the shoulders of Saint John the Baptist and on Saint Joseph's pensive forehead. The rest vanishes into a half-light where gestures become still, like the left leg of the Christ Child.

The same contrast can also be found in *Saint Michael Defeats Satan* (Plate 37), for which the preparatory drawing has also survived (Plate 36) showing how the dramatic light in which Raphael highlighted his figures could be used to empower the image. In the drawing the pose of the figure has a quality of lightness reminiscent of an adolescent dancer, and it is given added joyfulness by the movement of the long, swirling scarf to the left and right of the angel. In the painting, on the other hand, we are immediately struck by the enormous dark outline of the wing, which creates a disturbing vacuum in the vision and prepares us for the dazzling gesture of the arms lifting the lance that is about to stab the devil – an indistinct mass of muscle. In the drawing this same gesture does not seem so significant. But in the painting the colours are intentionally muted, so as not to interfere with the narrative entrusted to the light. The result is nearly monochromatic, which is surprising in view of the care and radiant beauty of Raphael's reds and blues. However, Raphael shows off, with almost desecrating pleasure, in the angel's wing, which resembles those of the parrots kept in Leo X's aviaries and painstakingly drawn by Giovanni da Udine with the accuracy of a zoologist. Satan's wings are copied instead from a fantastic fish and seem incapable of flight, condemning the creature to life in the underworld, whose surging flames can be glimpsed in the lower left-hand corner. The scene conveys a strong sense of verticality: Saint Michael seems to be balancing on one foot, standing on Satan's back and pinning him to the ground with his full weight. Faithful to the gracefulness of his figures, Raphael maintains in the painting the calm expression of

the saint – more so than in the drawing, where he frowns in concen-
tration. The painting calmly documents Satan's ineluctable fate, with
no dramatic participation, as befits the divinity. Raphael preserves this
decisively classical character by delegating the drama of the composi-
tion to the action and to the light. The scene captivates the viewers
but carefully avoids disturbing them: in this it complies with the art of
sprezzatura [nonchalance], as was appropriate for a painting intended
for the king of France.

2 A WEB OF JEALOUSIES

Almost a literal transposition of this model of composition, which was
rapidly moving towards the invention of a new and more dramatic
language – one aimed entirely at restoring human psychology – can be
found in one of Raphael's last paintings, *The Transfiguration* (Plate 54).
Here light and shade confront each other in the lower part of the paint-
ing, before swiftly incising in colour the full gamut of sentiments from
amazement to panic.

The painting was commissioned by Cardinal Giulio de' Medici for
the French cathedral church of which he was the titular archbishop. It
was intended to hang opposite another altarpiece, which formed part of
the same commission but was executed by Sebastiano del Piombo, and
depicted the *Raising of Lazarus*. *The Transfiguration*, too, was a premo-
nition of the resurrection, and Raphael brought together in it various
episodes taken from the Gospels. The reference is a passage from Saint
Matthew's gospel:

> And after six days Jesus took with him Peter and James and John his
> brother, and led them up a high mountain apart. And he was transfig-
> ured before them, and his face shone like the sun, and his garments
> became white as light. And behold, there appeared to them Moses and
> Elijah, talking with him. (Matthew 17: 1–9)

What is generally overlooked in the exegesis of this work – which is,
somewhat forcedly, seen as the start of the exasperated mannerist style
that followed – is the fact that Raphael had to come to terms with a
figurative tradition that had interpreted the event as having thrown the

witnesses' minds into complete confusion. One important precedent, which proves the existence and the diffusion, during Raphael's lifetime, of an iconography that vanished later on, can even be traced back to the Byzantine tradition of icon painting.[7]

In the lower part of the painting Raphael tells the story of Christ healing a boy possessed by an evil spirit* after the apostles had failed to cure him, because they lacked faith. The scene is extremely dramatic: on the right, the boy's stiff and twisted body and the desperation of his father, who holds him upright; in the foreground, a woman, in a complex, twisted position, points the boy out to the apostles. On the left, the apostles seem overwhelmed by the sight and Paul, wearing a red cloak, points to the apparition of Christ, who will give them the strength to heal the boy. Linking these different scenes to form a single painting, without losing the unity of space and time, represented a very difficult challenge. But Raphael resolved it by using the light, or rather the shade, which isolates the figures sufficiently to allow the viewer to read the narrative through the mimicry of gestures: these are highlighted, as in earlier works, by a dazzling light that leads the gaze through the key sequence of events, silencing the rest. To achieve this effect Raphael definitively set aside the laws of nature, following what he saw as Leonardo's example, namely the way Leonardo surrounded his later figures in shadow in order to concentrate on their gestural movements. Here, in this large altarpiece, the light miraculously illuminates only those parts included in the story. While Paul's shoulders are bathed in light, as is Peter's neck as he sits on the ground leaning over the open book, the front of their bodies is left completely in shadow, as if the night scene were lit by the brilliantly intense but narrow rays that spotlight each figure. Only the woman in the foreground, an allegory of faith and charity, is illuminated in full. She is already on her knees, praying, in an evocation of Christ. In this way, with the aid of drawings that painstakingly studied every detail, every drapery fold and every gesture, Raphael tells a complicated story without making it rhetorical and without letting the viewer relax; he augments the tension instead, as if in response to a single dramatic gesture.

* Epilepsy was known as *morbus daemonicus* because it was believed to be caused by demonic possession. (Translator's note)

In the meantime, by the summer of 1518 the paintings com-
missioned for François I of France had been carefully packed and
dispatched to France – but not before being put on display in the city, to
honour the generosity of their patron. Everyone noted the innovations
that Raphael, an artist who never tired of experimentation, showed in
his latest style [*maniera*]. People noted precisely the novelty of this
dramatic light. But they did not understand it. Above all, Sebastiano
del Piombo failed to understand it and sought complicity and comfort
from Michelangelo, who had shared his dislike of this upstart artist
from Urbino when they were in Florence. The result of the comparison
between Sebastiano's Polyphemus and Raphael's Galatea for Agostino
Chigi's palace had been humiliating for Sebastiano. He was impatient
to take revenge, and this personal hatred continued to distort his opin-
ion of Raphael's work. Cardinal Giulio de' Medici's commission of the
Transfiguration at last presented him with a suitable occasion. When del
Piombo saw the paintings ready to leave for France, he was anxious to
criticise them in a letter addressed to Michelangelo:

> I am sincerely sorry that you were not in Rome to see the two paintings
> by the prince of the synagogue* which have been sent to France. You
> cannot imagine what they are like, and I am certain you will never have
> seen anything so utterly different from your views. I will only say that
> the figures look as though they had been hung up in smoke, or were
> made of iron, either brightly polished or black. Leonardo [= Leonardo
> Sellaio, a mutual friend] will also tell you how they are drawn. Just
> imagine what will happen: two beautiful ornaments, received by the
> French.[8]

Consumed by jealousy for his rival's success and courage, poor
Sebastiano was under the illusion of being able to win the impossible
challenge simply by increasing the number of heads in the painting,
like a medieval painter who gauged the value of the picture by counting
the number of golden halos and saints' faces. Raphael was completely

* Art historians debate about the severity of this insult. Shearman thinks del Piombo
was not being quite as rude as it might seem: John Shearman, 'The Organization of
Raphael's Workshop', *Art Institute of Chicago Museum Studies*, Vol. 10, The Art Institute
of Chicago Centennial Lectures (1983), pp. 40–57. (Translator's note)

unaware of all this. He did not even realise that a possible challenge
was involved, because he did not associate with artists, but rather with
princes and philosophers, and no one was allowed to enter his palace
in Borgo. It was the right choice because, unlike what happened with
other artists, his literary friends understood him. Indeed, in his refined
prose, Pietro Bembo expressed a thought that has still not been phrased
better: for Bembo, Raphael had finally superseded the imitation of
nature that was the goal of the early Renaissance artists.

All this won the artist the friendship of the best intellects, who were
regarded as his peers. While Bembo was writing his letter to Bibbiena,
Raphael himself walked into the room, as if conjured up. He was imme-
diately followed by Castiglione. Charmed by this circularity of thought
and event, Bembo hastened to tell Bibbiena what had just happened,
knowing he would be envious of the company: 'Just as I finished writing
those words, I was joined by Raphael, as if he had guessed I was writing
about him [. . .]. By God, what a joke, I've also been joined by Messer
Baldassar, who tells me I should write to you [. . .].'[9]

Bound by their very close friendship, Bembo and Castiglione were
men who, alone, could have altered the Italian culture of the sixteenth
century. They shared a highly ambitious lifetime project: to marry
politics with civility and culture. Around them the Roman court, and
the city itself, had changed out of all recognition over the past years,
as was noted by travellers who had been absent for some time. Indeed
Raphael could not have lived anywhere except in that palace, whose
doors were barred to all but his friends; but they had access to him at
any time of day or night. One balmy September evening in 1519, when
the smell of burnt stubble hung in the air, the ambassador for Alfonso
d'Este unwisely tried his luck, in the hope of soliciting the long-awaited
painting his patron had requested:

> On my way home this evening I found the door into Raphael Urbino's
> palace open and therefore walked in, in the firm belief that I would
> see what you so desire. And having sent up a message, Messer Raphael
> replied that he could not descend; and having discouraged me from
> going upstairs, another servant came to say that he was with Messer
> Baldesera da Castione [sic], whose portrait he was painting, and that he
> could not be spoken to.[10]

How would the duke of Ferrara have received the news of this behaviour? What nobility of birth, what kingdom could Raphael of Urbino boast, to deny access to one of the duke's representatives? Yet he, too, surrendered to the desire of owning a work by the artist, and he continued to send imploring requests up to a few days before Raphael's death, without ever giving up hope. But Raphael's work, like his love, was not for sale – at least not to just any prince. Only the pope and his household could not be refused, although they, too, kept him so busy on numerous commissions that they exhausted him. For these papal commissions Raphael could not turn to his attentive collaborators except in a very marginal way; but they guarded his privacy at home and resolutely barred admission to all outsiders.

3 VENUS RETURNS

Even more vituperative than Sebastiano del Piombo's comments on *The Transfiguration* were those exchanged between Michelangelo, Leonardo Sellaio and, again, Sebastiano when the Loggia of Psyche was opened on 1 January 1519: 'The ceiling of Agostino Chigi's villa, which has been opened to view, is a disgrace for a great artist and a good deal worse than the last *stanza* in the Vatican Palace; so Bastiano has nothing to fear.'[11]

The distance between Raphael on the one hand and Sebastiano del Piombo and Michelangelo on the other could not have been greater, and not just because Sebastiano and Michelangelo had been ousted from the Roman market. Sebastiano had had to interrupt the decoration of Agostino Chigi's winter loggia when the latter had realised that Raphael might paint it himself. This possibility never materialised due to the artist's numerous commitments, but in the meantime it had resulted in Sebastiano's removal from the palace on the banks of the Tiber. Michelangelo, on the other hand, was too involved in his monumental enterprises to engage with private patrons, even first-class ones like Chigi, and all the commissions for the papal curia were firmly in the hands of his rival. The loggia that so scandalised the two artists was the last step in a creative process during which Raphael had revived the ancient pagan gods 'in flesh and bone', together with the *joie de vivre* they had represented. All this happened within a highly specialised

circle, which linked Chigi's immense wealth to the boundless culture of the artist's intellectual friends, and also to the Medici pope's uncensored power. It was a conjunction that would never be repeated in the centuries to come.

Until then his experiences of this pagan revival had been limited in essence to the Vatican loggias and to the small *stufetta* for Cardinal Bibbiena, where he had had to make allowances for the sacredness of the former setting and for the reduced size of the latter. In Agostino Chigi's palace, on the other hand, Raphael was dealing with a vaulted loggia measuring 20 metres by 8, which led into a garden and was filled with light. Finally, he could invite the ancient gods and their myths to partake in the Roman Renaissance.

The proximity of the garden suggested a new and fascinating solution, which transformed the illusionistic precedent set by Michelangelo's Sistine ceiling into sensual artifice. In the Vatican the Florentine had opened up the vault by using the illusion of marble ribs, between which the Old Testament stories are set. This device proved a brilliant solution to the tricky problem of the *volta unghiata* [barrel vault with lunettes] – with its spandrels, pendentives and lunettes, and a small, almost flat area running along the central axis at the apex of the ceiling. Raphael copied the same layout, but he transformed Michelangelo's heavy and solemn marble architecture into a light framework of garlands decorated with flowers and fruit, thereby allowing the colours and scents of the garden to fill the loggia through the five open arcades. The garlands or trellises of greenery support fake tapestries hanging from the top of the vault, on which Raphael intended to portray the two final scenes of the narrative. In this way the decorative theme prolonged the aerial effect of the exterior and at the same time involved the observer, who could examine the activities of the gods in the sky above as if these were not merely painted fables but real-life scenes taking place in the here and now.

The chosen theme was the marriage of Cupid and Psyche, a fable told by Apuleius in his poem *The Golden Ass*, written around AD 170, and containing clear initiatory allusions to those religions that combined the cult of Isis with worship of the gods of the Greek pantheon. According to the fable, a king once had a breathtakingly beautiful daughter, Psyche, who aroused the jealousy of Venus because the

people showed such regard for her beauty; in order to gain revenge, Venus condemned Psyche to marry the most monstrous being on earth. Venus charged her son, Cupid, to make the girl fall in love with a monster. However, Cupid disobeyed Venus and fell in love with the girl himself. He carried Psyche off to his palace, where he visited her every night, although he warned her that she must never to try to see him. Psyche's jealous sisters prompted her to discover Cupid's identity and, in anger, Cupid then abandoned Psyche, who became the object of Venus' fury. Having seen Cupid's beauty, she was consumed with desire for him and, in desperation, tried to take her own life by drowning herself in a river. However, the water, moved by her beauty, saved her and delivered her to Pan. Cupid forgot his anger and returned to his beloved, who had to overcome terrible challenges in order to marry him and be accepted among the gods. Venus, who was still determined to oppose the marriage, ordered Psyche to separate in a single day a heap of oats, millet, poppies, peas, lentils and beans, which were all mixed together. Then Psyche had to bring Venus some wool from a flock of golden sheep and, lastly, a portion of the elixir used by the terrible Proserpina, queen of the underworld. Having succeeded in all these tasks, Psyche finally celebrated her marriage to Cupid before all the gods, as shown in one of the fake tapestries hanging on the ceiling.

Agostino and Raphael used this fable to ennoble the former's illicit love for the ravishing Francesca Ordeaschi, a love affair that had lasted for almost ten years. Moreover, the story of Psyche was intended to demonstrate that, whatever the social barriers, the force of true love is unstoppable and will triumph in every endeavour. As an active participant in Apuleius' fable, Cupid had opposed his mother but had obtained divine aid, particularly from Jupiter – who, in a memorable spandrel undoubtedly by Raphael himself, kisses him affectionately on the mouth. In this way the god armed with love's arrows was celebrated as the cosmic force that moved the world and against which all resistance is in vain. Who could have known this better than Raphael, and who better than he could at last depict the fable freed from all false modesty? The strength of love is equated to the power of beauty and of gentility of spirit, and Raphael was involved in person in their portrayal: he did not limit himself just to preparing the drawings. Many of the most beautiful scenes in the Loggia of Psyche, for example those penden-

tives that could be painted within a short period of time, were almost certainly executed by him. The ceiling became the pagan response to Michelangelo's terrible and dramatically foreshortened scenes from the Bible in the Sistine Chapel. Here, too, the figures were depicted *da sotto in su* [as seen from beneath], and the way they hovered in the air posed a series of extremely difficult technical problems. But the overall effect was one of happiness and harmony, and everything had to contribute to creating this sentiment.

The festoons of flowers and fruits form the framework, but they also provide a key to understanding the beauty of the natural world. They were painted by Giovanni da Udine, who prepared the meticulous cartoons, and these were then transferred onto the plaster. The strict organisation of this teamwork reveals the harmonious and completely professional atmosphere within the master's workshop. Giovanni included many of the species recently imported from America, like the bizarrely shaped gourds – which also doubled as licentious sexual allusions, to the delight of Agostino, of the pope and of the Roman court (as Vasari was at pains to point out). Today they serve to titillate tourists in search of scandal. Each flower and fruit is drawn with the same care used for the figures, and the exuberant effect of this earthly paradise still testifies to this. Framed by garlands and set against a sky that once again resembles the luminous expanse of a Mediterranean spring, the ceiling is populated by the most beautiful figures, whose nudity is portrayed with an innocence that had not been seen on these shores for the past thousand years. Nor is it only the women who expose every detail of their most intimate parts, in every view and in every position, exalting the delicacy of their breasts, the softness of unveiled flesh and the gentle roundness of their buttocks. The triangle containing the three Graces to whom Cupid appeals for help is one of the greatest paeans to female beauty ever painted. Mercury, who was traditionally linked to the cult of male fertility and to commercial wealth, appears on several occasions, completely nude, his vigorous and lusty genitals in full view. In the banquet scene, Dionysius pours the wine bearing just a wreath of vines entwined in his hair, while above him winged putti play with the emblems they have stolen from the gods.

In January 1519 Sebastiano del Piombo wrote to advise Michelangelo that the ceiling in the loggia had been finished. This means that the

scaffolding had been dismantled late in the previous autumn, when Raphael's and Agostino's closest friends hastened to admire Rome's latest miracle. At that time of year, as the sun sank low over the horizon, the sky would have lightened to a hazy purple behind the silhouette of the palace, making its long wings seem even more majestic as they embraced the visitors entering the loggia. The gurgling water in the fountain close to the entrance was pumped up from the Tiber, which flowed placidly at the foot of the garden. Majestic plane trees rose up the slopes of the Gianicolo hill, the golds and rusts of their foliage blending with the narrow red leaves of the apples and other fruit trees, withered by the first cold autumn days, that lay scattered on the grass between the box and laurel hedges tended by Agostino's gardeners. From the outside the loggia looked like a conservatory used to shelter lemons and oranges, but the visitors standing at the top of the stone steps that led up to the central arcade found themselves surrounded by the eternal spring that Raphael had created. Michelangelo had brought to life figures overcome by a terrible destiny, framed against a similar sky. Here Raphael showed how much happiness that heavenly expanse could contain.

In the first spandrel framed by the pergola on the short left side, to which visitors' eyes instinctively turn as they enter, Venus sits on a cloud in a way that shows off her glorious nudity. Gleaming breasts can be glimpsed behind her arm, and even more private parts are clearly visible beneath her raised leg. The complete lack of propriety in her pose is barely mitigated by a scrap of gilded fabric lying between her thigh and the shell. She is pointing out to Cupid something that takes place on Earth, in that woeful realm where we can imagine beautiful Psyche being molested against her wishes by Venus' former worshippers. Cupid is an adolescent on the verge of succumbing to his own seductive charms; indeed he holds up a threatening arrow in his right hand. At this stage he is still unaware that he is about to fall victim to love's arrow and to disobey his own mother when she asks him to punish that girl solely on the grounds that she is too beautiful.

One's eye follows the scenes in the spandrels on the southern wall, which are crowded with nude women as enticing as the fruits surrounding them. The three Graces, whom Cupid summons to help him after he has fallen for beautiful Psyche, are seated on a cloud, offering views

from the back, side and front that reveal every detail of the female body (Plate 39). They are, respectively, black, blonde and auburn-haired, and their skin tones suggest they might come from different regions of the northern world. But their bodies reveal breasts so full that the smooth skin reflects the sun that highlights the aureola around their nipples and shimmers over their hips and across their buttocks and soft bellies. Only their cheeks are tinged with a mere hint of pink, as soft as new geranium blossom. The most beautiful – and also the most immodest – of the Graces wears an armband round her right arm, close to her breast. The tangible quality of the object transforms her into an ordinary woman and enhances the desire aroused by her voluptuous body.

In the next spandrel, the one opposite the entrance, another three women are engaged in discussion. Here Venus is shown appealing to Ceres and Juno (Plate 38), the former identified by a garland of wheat ears, the latter by a peacock whose feathers are a fitting match for her blue and gold robe made of shot silk. As Venus turns to leave, disappointed, she makes some attempt to cover herself with a small golden shawl. However, a disrespectful breeze lifts it in a flutter above her head, which gives depth and lightness to the sky and deliberately fails to hide her full breasts, her shapely legs, and her sensual hips and belly.

In another spandrel we find Venus flying on a minute golden carriage, pulled by her doves. Even in flight, she is naked and bathed in sunlight. Her skin is even paler and more luminous than in the previous scenes – a shining pearl, by comparison to the motled assembly painted on the ceiling above. Her purity is exalted by her golden hair, which is blown back by the wind. She is completely unaware of the rose nipples exposed to the sun, of her stretched yet soft stomach, or of her pubis, uncovered by a veil that artfully slips over the most beautiful mound ever seen in any woman, in heaven or on earth. She is not even distracted by the doves flying around her; her cheeks are reddened instead by her impatience to tell Jupiter of the torments inflicted by her son's lover. Only the curve of the drapery billowing behind her, perhaps in an attempt to hold her back, highlights the speed of her flight.

The next scene shows how Venus, having arrived before Jupiter, now re-asserts her self-control and proceeds to seduce him. Her features become virginal. Her hair, gathered loosely at the back of her long neck, is in disarray after her flight. Her breasts are those of an

adolescent, their soft hue given added prominence by the light that glides from her forehead to her shoulders, then to her arms and hips, creating a sequence of rapturous feminine curves. Jupiter, who is handsome and powerful and has the musculature of a young athlete despite his snow-white hair, listens to her, moved by her beauty. Jupiter's skin has been bronzed by the Greek sun during his amorous pursuits, and he has the weather-beaten appearance of a sailor. He holds a bolt of lightning as carelessly as a child might hold a toy, while an eagle peers from under a purple cloak between his legs. Even his power is subordinated to the goddess' urgent demands.

In the first spandrel on the short side to the right of the entrance, Mercury really appears to fly, completely nude, with the compact and solid body of a Roman youth. The brisk wind throws back his long golden cloak, off his shoulders, revealing every detail of his agile body, which is lit from below. To the delight of Agostino's friends, a carefully placed fold of cloth utterly fails to hide the twisted form of his penis, which dangles like some heavy fruit, hitting against his leg with the speed of the flight. An explosion of luxuriant pubic hair, painted with exaggerated naturalism, was not sufficient to celebrate the phallic triumph of the god of brothels. In the garland just above his head an enormous aubergine, shaped like an erect phallus, attempts to penetrate a split fig, promising joy and prosperity.

The story continues on the other side of the loggia, although here the scenes are more difficult to make out because of the contrast with the sky outside. Here Psyche is carried in flight by *amorini* – spirits of the wind. The girl is rigid with fear. She is at pains to protect the metal vase containing the essence stolen from Proserpina, the terrible goddess of the underworld. Psyche lifts it skywards with an uncharacteristically muscly arm, more suited in a wrestler than in a virgin, which is foreshortened in a pose that is not entirely successful.

In the next spandrel Psyche offers the essence to Venus, who is portrayed in a triumphal pose, with a matron's body, and given added solemnity by the large pendants she wears in her ears and by the crown on her head. In response, Venus' gaze does not soften, indeed the goddess raises her arms in surprise, or perhaps in disapproval, but certainly to show her sumptuous breasts, hips, belly and pubis – which is almost completely exposed by the tunic that has slipped between her thighs.

Such brazen nudity is exalted to the point that the figure pushes the very limits of decency (even today, many still peer closely to see how much of her most intimate anatomy is uncovered by the shining purple velvet).

Cupid is shown in the next spandrel being affectionately welcomed by Jupiter, who leans down to kiss him, as if this were not his son, but the beautiful Ganymede, whom he had helped to kidnap. The last scene shows Mercury again, now accompanying a shy Psyche up to the heavens, although this time their flight is more sedate. His athletic body, still in full view, is that of a more mature man. He appears to wish to protect the girl, who, with a show of modesty – a sentiment that she alone expresses – covers her breasts like a Christian martyr. Mercury's shameless nakedness seems to intimidate her even more than the prospect of meeting the Olympian gods. The man's penis brushes against her hip and his leg becomes entwined with hers as they ascend.

The story reaches its conclusion in the two large panels on the ceiling, which are stretched out like tapestries hung from the flower-decked pergola. In the first, which depicts Psyche's arrival, the solemnity and beauty of the individual poses is lost in a quasi-grotesque throng, which shows scant attention to detail and to the relations between individuals. This lapse in artistic tone, along with the erotic themes handled with such impudence, might have been the cause of Sebastiano del Piombo's harsh judgement. In the second panel, which presents the nuptials of Cupid and Psyche being celebrated before the gods, the spatial organisation of the scene is handled better and the anatomy of individual figures is more credible, which makes it likely that the work was thought out more carefully and better executed by Raphael's workshop.

Considering the decoration as a whole, Raphael's design undoubtedly gives an extraordinary stylistic unity to the narrative, even if his own hand only appears to be present in a very limited number of *giornate*. These include the spandrels framed by the garlands along the south side of the loggia, where the brightness of direct daylight illuminates every detail. Other autograph cameos were also included in places where they were most visible.

Raphael's intervention seems to have been characterised by a perfect gradation in the chiaroscuro contrasts on bodies and by a rapid vibration of facial colours that enhances the feelings expressed. In short,

his work reveals a radiant splendour, which is generated from within the body itself. His brush, the light, the design and the colours effortlessly glide over the bodies, which appear to be perfectly at ease even in the trickiest aerial foreshortenings. These stylistic characteristics are most evident in the four spandrels on the south wall and, on the opposite side, in the scene where Psyche presents the vase containing Proserpine's elixir to Venus.

By contrast, the hands of at least two different artists can be identified in the other scenes. One is that of Giulio Romano, who characteristically outlines his work with dramatic black marks, emphasising the design and contrasting the darkly clotted shadows with pale colours that always seem too bright. Mercury in flight and Jupiter kissing Cupid are good examples of this style, rather disorderly by comparison to the grace that informs Raphael's painting. Another hand, perhaps that of Giovan Francesco Penni, is more relaxed and more luminous and has well-controlled chromatic contrasts, but it is always uncertain in the construction of the figures. This is the artist who painted the other spandrels on the ceiling, and these traits – namely luminosity accompanied by dilatation and by a flattening of the design – can be found in the figures of Mercury, Psyche, Venus, Jupiter, Juno and Diana – as well as in the banquet scene, which is the most successful of the two large panels. These two artists also executed, between themselves, the pendentives with flying *amorini* playing with god's emblems, among which the painting of the putto riding a lion and another mythical beast is particularly beautiful.

4 VILLA MADAMA

All the scenes painted in the loggia were also visible from outside and, with a little imagination, they could be replayed in Agostino's garden. Psyche found her way through that difficult world solely on the strength of her beauty and manifest humility, like Francesca Ordeaschi, who had managed to acquire a legitimate semi-regal status. Leo X dragged his massive body – which was weighed down even more by the gold jewellery and purple cloth symbolic of his princely status – through that garden, enriched as it was by the flowers that Raphael was painting, and he sought the cooler air beside the water jets that sprang

from the ground. White apple blossom floated through the air and set-
tled on his scarlet *camauro*, eliciting admiring applause for this magical
setting from an eager crowd of dignitaries who saw no reason to regret
the luxuries of imperial Rome.

As the son of Lorenzo the Magnificent, who was among the first
to amaze Italy with his taste and the grandiose ambition of his artistic
patronage, the pope must have felt a slight frisson of envy. Following
the death of the pope's brother Giuliano in March 1516, plans for
a grand Medici palace that would have celebrated the Florentine
family's standing in Rome had fallen into decline. It was this that
prompted the idea of a villa that would outshine Agostino's and every
other similar building in Rome. The time had come to erect a villa
that would exceed even those described by Pliny the Younger, Cicero
and Vitruvius.

In 1516 Leo had acquired a piece of land from the chapter of St Peter
on the slopes of Monte Mario, on the outskirts of Rome, which included
a small but elegant residence with spectacular views of the city. Raphael
was commissioned to design a monumental villa there, while the pope's
cousin, Cardinal Giulio de' Medici, who had been nominated vice
chancellor in 1517, was charged with its realisation. Leo could not have
chosen two better men. Giulio, the bastard son of Giuliano de' Medici
who had been assassinated in the Pazzi conspiracy, had grown up in
the Sangallo family house, where he had acquired a professional eye
for art and architecture. His painstaking supervision of Michelangelo's
projects for the façade of San Lorenzo in Florence, and subsequently of
the family tombs in the same church, reveals a patron who was equally
outstanding in his own way – one who was almost on a par with the art-
ists and who could debate iconographic and stylistic questions as well
as technical issues without any need for further intermediaries. It was
from this experience and Raphael's now extensive architectural knowl-
edge that the project for Villa Madama was conceived. Building work
had certainly begun by the summer of 1518, while Raphael was still on
the scaffolding inside the Loggia of Psyche, and therefore Leo could
contemplate those works in the satisfaction of knowing that he would
soon have better ones of his own to admire.

Raphael's experience as an architect and as an archaeologist had
fuelled his desire to challenge the models of antiquity celebrated by

the classical authors. He soon devised plans that surpassed the ancient prototypes because they not only mastered the classical language but also brought it up to date with modern traditions by including functional innovations introduced by Alberti and other early Renaissance architects. In a letter to Baldassarre Castiglione dating from about 1519, when the final project had been completed, Raphael describes the villa on Monte Mario in a passage that immediately became a classic of architectural theory, on a par with Vitruvius' treatise, so much so that in the summer of 1522 Francesco Maria della Rovere asked Castiglione for a copy of the letter.

Unfortunately the construction of the villa would soon be interrupted by Raphael's death, which was soon followed by that of the pope; afterwards it was drawn into the tragic political events of Giulio de' Medici's own papacy. But the style of life that Raphael imagined for the Medici shortly before he died is described in the letter in his own words. The architecture would form part of a grandiose natural scenario, domesticated by gardens and fountains, which would be perfectly integrated in the architectural layout and carefully calibrated to match the proportions of the building:

> At the head of the courtyard is the vestibule, whose form and function is in the antique style, with six round Ionic columns and the piers which this type requires. [. . .] On the right there is a beautiful garden of orange trees, 11 *canne* long and 5½ wide, and in the middle, among the orange trees, is a beautiful fountain of water brought by various conduits from a natural source. [. . .] As I said earlier, the *diaeta* is circular, and has glass windows all around it, which the sun will successively fall on and shine through on its journey from sunrise to sunset. The place will thus be most charming, not only because of the continuous sunshine but also because of the view of Rome and the countryside, which, as Your Excellency is aware, the clear glass will not obstruct at any point. It will really be a most pleasant place in winter for civilised discussions – the customary function of the *diaeta*.[12]

Civilised discussions, the cultured occupation of philosophers, were only one of the possible pastimes offered by the sumptuous villa, which also had a hippodrome below the long façade, so that the pope and

his court could watch the horse races from the comfort of the central loggia.

Raphael even included plans for baths, drawing on ancient models, where baths had been a source of hedonistic pleasure for their wealthy owners. Indeed the Villa Madama boasted a system of baths that was worthy of those Raphael had seen in the imperial villas.

> From the left-hand side of this cryptoporticus, as one enters, one can go south, to the baths, which can also be reached by the private stair-case from the floor above. The baths have been arranged so that there are two changing-rooms and then a warm open space for oiling oneself after bathing or being in the hot room. There is also the hot dry room [itself], with its *temperatura*, and the hot water bathroom, with seats that permit the user to choose which parts of the body are to be bathed by the water. Under the window there is a place where one can lie down in the water, such that the servant can wash people without get-ting in the way. Then there is a warm bath, and also a cold one which is big enough to permit swimming if desired.[13]

It was here that the pope and the cardinals could abandon themselves to every form of physical enjoyment. In Raphael's words, the archi-tectural description becomes a detailed description of everyday life at the Renaissance court. Rubbed in sweet oils, massaged and perfumed like Roman patricians of old, Leo and his closest companions could then enjoy a banquet in one of the open loggias in summer, or in the glazed rooms in winter. There they would have been enchanted by the views of Rome, but above all by the frescos and stuccowork designed by Raphael (Plate 52).

In the afternoon, when the sun was not so strong, the guests could watch comedies being performed in the large theatre cut out of the hill. Rome, sunshine, friendship, and the air scented with plants and flow-ers, all these contributed to the papal court's quest for happiness and sensual beauty much more than the high standards of Western relaxa-tion would be capable of contributing today. In the intervals between banquets and comedies, or between saunas and massages, the cardinals and their guests could stroll around the gardens and fishponds. If they were so inclined, they could also admire the ancient statues standing in

the large niches in the loggias and in the centre of the vaulted rooms. The statues had been recently excavated in the gardens of Lucullus and at Hadrian's Villa. One in particular – the so-called Jupiter Ciampolini* – was intended to outshine the Vatican collections assembled by Leo's predecessor, Julius II.

This showcase, in which Raphael had brought together such beauty and such comfort, overlooked the city as a long horizontal volume, divided into three portions at two different levels. To the left and right the walls ended in solid circular towers, which acted both as corners and as links in the encircling wall. In the centre, the residential building was divided horizontally by a simple base, onto which opened the rusticated windows and the entrance doorway flanked by two heavy, rusticated columns. The upper floor, which was about three times higher than the base, was divided by Ionic pilasters grouped at irregular intervals, and their dimensions and gigantic proportions give a strong sense of uniformity to the façade. Around the central loggia, which was covered by a wide arch, untrammelled by the columns that divided the adjoining loggias, the pilasters became columns backing onto the wall, and the plastic effect of the jutting capitals helped to emphasise the centre of the building. Even in this last architectural task, Raphael did not resort to a schematic design but devised 'parts', separate yet linked with sophistication, in this case by the giant order that encompassed such strikingly diverse elements. Each part was developed autonomously but was linked to the rest through the continuity of the decorative elements confidently selected by Raphael.

The complex nature of Raphael's design is encapsulated in this wonderful façade, which constantly changes the way of organising the space occupied by the adjacent elements, linked and identified as they are by the unbroken horizontal cornice that runs halfway down the first floor and by the dimensions of the pilasters: these, although they lack any notable plastic projection, acquire strength thanks to a clever sculptural device. The pilaster bases and the frieze running above the entablature swell and curve as if compressed by force. This gives increased variety to the long wall, which in turn depends not only on the light grid of

* So named because it came from the collection formed by Giovanni Ciampolini. (Translator's note)

columns and cornices but also on a true sense of three-dimensional movement in the façade. Raphael combines the individual components of Vitruvius' plan, recreated with the scruple of an antiquarian, with the spatial awareness of an architect-cum-builder and, most unusually, with a highly pictorial awareness of vibration and variety, which was carefully controlled and connected to a higher level through the distribution of light and shade.

Inside, this evocation was re-established through colour and refined decoration. The models from the Domus Aurea, which he had already used in the loggias and in Bibbiena's *stufetta*, resurface again, on an even grander and more mature scale, in the rooms he just had time to build, although they were decorated, certainly with the help of Raphael's drawings, by Giulio Romano and Giovanni da Udine. Here, too, the theme chosen for the vault of the room overlooking the fish pond was the myth of Galatea: the choice of this classical legend, so closely linked to eros and to ancient literature, meant that Leo X had no longer any reason to regret Agostino Chigi's magnificent banquets.

5 THE STAR THAT FELL FROM HEAVEN

Raphael invented a new status for the artist, as a professional capable of setting his own course and of deciding on his own artistic goals. The court was in sway to his genius; the whole of Roman society followed his every move; and Raphael recognised this by developing such variety in his own social life as had never been seen before. Even Palazzo Caprini, the luxurious residence in Via dei Banchi, was no longer adequate. A new man must devise a new form of residence for a new way of living, and Raphael did just this. On 24 March 1520 he purchased a large plot of land in Via Giulia, the most elegant street in the city, very close to the Vatican, and he started to design a residence for himself and for his unique court of assistant artists.[14] The irregularly shaped plot did not lend itself well to the artist's own laws of architectural symmetry and rigour. Any other architect would have ignored the unusual outline and would have left the irregular boundaries to be empty spaces; but not Raphael. Instead he drew up a complex plan, which was adapted to the trapezoidal and oblique site. Drawing on every aspect of his antiquarian knowledge, he linked the various forms together

by using dramatic elements so that, in the end, the singularity of the site became its strength. With the utmost self-assurance, he moulded the walls into concave niches and convex curves, framing them with columns, trabeations, fountains and oval staircases. Inside these spaces he then created sumptuous bathrooms, hot spas, fountains and magnificent reception rooms. It was at this point that he also remembered one of the most striking features of his father's house, where, from the bedroom, one could hear the sounds and smell the resins from the workshop on the ground floor. In order to conjure up the memories of those happy childhood days, Raphael placed his pupils' studio – a large, well-lit room that faced north, to ensure the most constant light – right underneath his own bedroom. His life had come full circle: after an unprecedented career, Raphael's final achievement had brought him back where it had all started.

Thanks to his culture and talent, which were recognised as aristocratic attributes, Raphael was justified in fashioning himself, in this most fickle city, as possessing the dignity of a prince-artist. As recently as in his own childhood, an artist was regarded as no more than an artisan; but now Raphael proudly displayed the value of his art by living in a palace worthy of a powerful cardinal. The palace in Via Giulia was visible proof of the artist's new position in the social hierarchy. While Michelangelo sought social respectability by keeping his artistic profession in the background and by emphasising the bourgeois traditions of his family, Raphael demonstrated that the artist himself embodied a new and unsurpassable dignity. He even went as far as to emphasise certain biographical details of that career: namely how his mother had nursed him among the pungent odours of the paints and lacquers that wafted up from the ground-floor workshop. The staircase that now linked Raphael's bedroom directly to the studio below, where he would work with his favourite assistants, united not only a physical space, but the story of an entire life.

It is easy to imagine how someone like Raphael, so conscious of his own genius, would have ignored the criticisms made by Michelangelo and by Sebastiano del Piombo. With his amiable and sunny personality, he would have laughed about their remarks afterwards with his friends. Raphael admired Michelangelo, but he could not understand his tormented contradictions. 'How pleased I am, Messer Pietro,' Raphael

wrote to Aretino, who was enjoying, like him, the last golden years of Agostino Chigi's patronage and of Leo X's reign,

> that Michel'Agnolo is helping my young rival, etching the drawings in his own hand, so, given that it is said that his paintings cannot be compared with mine, Michel'Agnolo will soon see very clearly that I do not beat Bastiano (also because it would not do me credit to be better than someone who cannot draw) but rather himself, who is reputed (and rightly so) [to be] the Idea of drawing.[15]

Raphael struggled to understand why the great Michelangelo could live and create only when he imagined that he was tormented by the entire world. On the contrary, Raphael had always surrounded himself with friendship and harmony, and the result was that he was offered it by the entire city.

Indeed, Rome was experiencing a crescendo of enthusiasm for Raphael and for everything he did. Two months after the unveiling of Agostino's 'ignominious' loggia, the city was buzzing because it was carnival and the highlight of the celebrations was to be a comedy staged at the house of Cardinal Innocenzo Cybo, with scenery painted by Raphael.

> Yesterday, because S.r M. Antonio was not present, I stayed with Messer Petro Bembo at his house and we watched a race run by naked men; the only topic of conversation was the masque, and the comedy and scenery by Raphael of Urbino, which will be performed for Monsignor De Cibo next Sunday.[16]

Among so many other commissions, Raphael did not consider himself above the task of preparing stage scenery. Indeed, this was how he had first started. His father had carried out the stage preparation for comedies for the dukes of Urbino, while Raphael himself now worked for the pope who had stripped them of their duchy. He knew how precarious political fortunes were and that only artistic glory would survive – like that of the city of Rome, whose urban layout was being transformed under the watchful eyes of the entire world. The comedy was a success – starting with the curtain, on which Raphael had painted a caricature

of the pope's favourite buffoon, Fra Mariano, who had once amused Julius II and now made his successor roar with laughter. 'As the pipes played, the curtain fell and on it was painted Fra' Mariano surrounded by devils who attacked him from every corner of the cloth.'[17]

A few days later Raphael received 1,500 ducats as payment in arrears from the Apostolic Chamber for his supervision of the works at St Peter's: that amount alone would have made a man wealthy for life. Two months later, another triumph and further economic gratification awaited him. The pope held a concert to celebrate the completion of the second loggia for his Vatican apartment, and news of the latest marvel created by the artist from Urbino spread like wildfire throughout Italy.

> Our Lord the Pope is more devoted to music than ever and enjoys it in every form. He also takes great delight in architecture and is always adding something new to his palace. The latest addition is a loggia, which has just been finished and which is painted and decorated with stucco reliefs in ancient style. It is the work of Raphael and is as beautiful as possible – perhaps finer than any work of the kind that is to be seen today.[18]

The following month brought still greater triumphs. From Flanders there arrived tapestries woven in silk and gold thread according to Raphael's designs. Each had cost 1,600 ducats, which included the price of 100 ducats that the artist had been paid for each cartoon. The Venetian ambassador gave details in his dispatch to the Senate of La Serenissima. Other tapestries arrived in September, bringing the total in Leo X's inventory to ten. In November work started on the left hemicycle at St Peter's, which had been designed by Raphael: the magnum opus of Christianity was also progressing apace.

On 26 December 1519 a solemn mass was finally held in the presence of the pope and 30 cardinals in the Sistine Chapel, which was decorated for the occasion with the tapestries hanging on the walls. The following admiring comment appears in Paris de Grassis' diary: *sunt res qua non est aliquid in orbe nunc pulchrius* ['these are things such that nothing in the world can surpass them in beauty'].[19] Even in Venice, it was agreed that they were 'the most beautiful accomplishment of their

kind today'.[20] The huge scale of the task undertaken by the Flemish weavers made Raphael's designs even more exceptional, triumphantly introducing the artist into the setting that had been dominated by Michelangelo's genius for the past decade. The naked, bedraggled crowds of Old Testament figures, clinging to the ceiling, looked down with indifference at the river of gold and silk worn by the 30 cardinals as they walked across the ancient inlaid marble floor. The extraordinary impact of that spectacle, which would only be repeated a few more times before the tapestries were dispersed during the Sack of Rome in 1527, spread across Europe thanks to the prints of the cartoons that Raphael had the foresight to commission from Marcantonio Raimondi, thus assuring publicity and an unprecedented glory. Alone in his obstinacy, and blinded by jealousy towards Raphael's apotheosis, Sebastiano del Piombo – Raphael's stubborn rival – wrote to Michelangelo in an attempt to undermine this display of public adoration: 'I believe that my panel is better designed than the tapestries that have arrived from Flanders.'[21]

Raphael's art was now visible in all the new city's most significant places, while the old city was about to be resuscitated according to the plan that Raphael was drawing and that, in the cold early months of 1520, warmed the hearts of the humanists. Raphael was warming himself in another way. His palace not only contained a roaring fireplace, but also the woman he loved beyond all measure. He was putting the finishing touches to a very intimate portrait of her: a nude rendered even more mischievous by the artful addition of a transparent veil exalting her stomach and breasts. At that moment he had everything and, unlike others, he had it all at once: love, wealth and talent. Moreover, he had the capital of Christianity and its entire court at his feet.

The intense winter cold stiffened the plaster used for the frescos and hardened the oil paint into clots. Even art had to surrender to the relentless cycle of the seasons; inebriated by the carnival spirit, Raphael dedicated himself entirely to love. Not even the arrival of Lent, the time of penitence, could stop him: his passion was all-consuming, his ardour as bright as those pitch-black eyes. These amorous excesses resulted in a high fever, which the doctor was unable to cure because Raphael refused to confess its cause. He became delirious as he was lying in the helpless arms of his disciples, under the gaze of the obsessed

figures in *The Transfiguration*, which seemed terrorised at the events unfolding in that room.

Good Friday that year fell on 6 April, and the city celebrated the solemn, painful rites of Christ's death, which had remained unchanged for centuries, like every other liturgy in the Roman Catholic church. Among the travertine grottos of the Colosseum, illuminated by torch light, the Confraternity of the Gonfalone re-enacted the millenary scenes of the Passion; the actors were dressed in simple costumes that inflamed the popular commotion. As their cries died away, the torches faded and the Colosseum was plunged back into darkness. The mourning crowds proceeded towards St Peter's, passing beneath the walls of Palazzo Caprini.

Inside, Raphael was dying.

NOTES

Notes to Introduction

1 Passion plays were staged on Good Friday at the Colosseum by the
Confraternità del Gonfalone. The performance held on Good Friday in
1520, the day of Raphael's death, cost 122 ducats and 1 *bolognino*. The
list of expenses, which includes descriptions of the costumes and scenery
used, is in Archivio del Gonfalone, vol. 177, cartelle 68 v. 69, 69 v. 71,
71 v. ff. For the texts of the performances, all rigidly codified, see Marco
Vattasso, *Per la storia del dramma sacro in Italia*, Tipografia vaticana,
Rome 1903. On the exact venue of the play, see Pasquale Adinolfi, *Roma
nell'età di mezzo*, Fratelli Bocca e C., Rome 1881, vol. 1, pp. 377ff. On
the ritual celebrations performed by the pope and the curia over Easter,
see Francesco Cancellieri, *Descrizione delle funzioni della settimana santa
nella Cappella Pontificia*, Francesco Bourlie, Rome 1818. The Passion play
held at the Colosseum and the death of Raphael are mentioned together
in Marcantonio Michiel's diary entry for 6 April 1520: 'On 6 April
[1520], Good Friday, Cardinal Aginense celebrated Mass in the chapel,
and kissed the Cross, and the Passion was performed in the Colosseum.
After eating, a service was held in the chapel. Cardinal Rangone, Agostin
Ghisi and Raffaello da Urbino were ill.' The original document is cited
in the recent monumental collection of documents related to Raphael,
edited by John K. G. Shearman for the Hertziana Library and Princeton
University: *Raphael in Early Modern Sources (1483–1602)*, 2 vols, Yale

University Press, New Haven 2003, vol. 1, pp. 571–2 (Raphael's death is mentioned at p. 572).

2　Ibid., p. 575. Letter from Pandolfo Pico in Rome to Isabella d'Este in Mantua, 7 April 1520.

3　This judgement appears, with a shrewd comment, in the short essay by André Chastel, *Raffaello. Il trionfo di Eros*, Neri Pozza, Vicenza 1997, p. 25 (Original title: *La Gloire de Raphaël, ou, Le triomphe d'Éros*, Réunion des Musées nationaux, Paris 1995).

Notes to Chapter 1

1　Cennino Cennini, *The Craftsman's Handbook: The Italian 'Il Libro dell'Arte'* [1933], translated by Daniel V. Thompson, Dover Publications, New York 1960, ch. 47, p. 28. Cennini's treatise is now regarded as a rulebook for the activities of artists' workshops in Florence and central Italy, a fact that makes his instructions all the more reliable.

2　The Marches and Umbria are the Italian regions where a popular tradition of performing Passion plays first developed, a tradition that survives to our own times. On the possibility that Raphael may have been born on 6 April rather than on 28 March, see John K. G. Shearman, *Raphael in Early Modern Studies (1483–1602)*, 2 vols, Yale University Press, New Haven 2003, vol. 1, p. 48. However, there are no conclusive grounds for questioning the date of Good Friday, 28 March.

3　The original letter is in Alessandro Luzio and Rodolfo Renier, *Mantova e Urbino. Isabella d'Este ed Elisabetta Gonzaga nelle relazioni famigliari e nelle vicende politiche*, Roux e C., Turin 1893, p. 19.

4　The will mentioning the clothes is reproduced in Shearman, *Raphael in Early Modern Sources*, vol. 1, p. 54. '*Unam cammuram panni Londre, cum manicis rasi cremesini; item unam aliam cammuram vulgariter dictam uno boccaccino, cum manicis rasi pavonazzi cum suis fulcimentis*' ['One *gammura* [simple dress] of cloth from London, with crimson satin sleeves; again, another *gammura*, called in common parlance "a *boccaccino*" [a modest textile of cotton or linen], with purple satin sleeves with their own props']. Interestingly, it is possible to compare the clothes worn by the Magi with those of Battista Sforza in Piero della Francesca's famous portrait: see Paolo Peri, 'Tipologie dei tessuti nella ritrattistica principesca da Federico di Montefeltro a Vittoria della Rovere', in *I della Rovere*, Mondadori Electa, Milan 2004, pp. 85–93. On fifteenth-century fashion, see Maria Giuseppina Muzzarelli, *Guardaroba medievale, vesti e societa' dal XIII al XVI secolo*, Il Mulino, Bologna 1999.

5 The deed of purchase for the house is in Ranieri Varese, *Giovanni Santi*, Nardini, Fiesole 1994, p. 14.
6 Cennini, *The Craftsman's Handbook*, pp. 93–4.
7 Luzio and Renier, *Mantova e Urbino*, p. 21.
8 Cennini, *The Craftsman's Handbook*, pp. 64–5.
9 Ibid., p. 82.

Notes to Chapter 2

1 For the contract, see John K. G. Shearman, *Raphael in Early Modern Sources (1483–1602)*, 2 vols, Yale University Press, New Haven 2003, vol. 1, p. 71, letter of 10 December 1500: '*quod dicti magistri Rafael et Evangelista deberent, eorum sumptibus, facere unam tabulam altaris capelle dicti Andree* [. . .] *pro dicta pictura et structura dicte tabule, ducatos triginta tres auri largos solvendos per ipsum Andream in tribus pagis seu vicibus*' ['that, out of the cost of these things, the said masters, Raphael and Evangelista, should build a table for the altar in the chapel of the said Andreas [. . .] for the said painting and for the structure of the said tabula, 33 large golden ducats should be paid to Andreas himself, in three different instalments']. The painting was later cut up and the fragments dispersed to various European museums. On the painting, see most recently Hugo Chapman, Tom Henry and Carol Plazzotta, *Raphael. From Urbino to Rome*, National Gallery Company, London 2004, pp. 98ff.
2 For the standard and its attribution, see Chapman, Henry, Plazzotta, *Raphael*, p. 104. Currently undergoing restoration at ICR (Istituto Superiore per la Conservazione ed il Restauro) in Rome, the standard is unique for being painted on two canvases that have then been glued together, rather than on both sides of a single canvas. Already at this date, Raphael was introducing small technical changes to the accepted practice in order to improve the quality of the finished object. Unfortunately, this unusual technique accounts for the seriously damaged condition in which the standard arrived, given that the two canvases had been separated, which caused much of the colour to peel off.
3 On the self-portrait, see the entry in the catalogue for the exhibition *Raffaello a Firenze. Dipinti e disegni delle collezioni fiorentine*, Electa, Milan 1984, p. 47, complete with extensive bibliography, and also Chapman, Henry, Plazzotta, *Raphael*, pp. 68ff.
4 All the information on this painting has been taken from Ashok Roy, Marika Spring and Carol Plazzotta, 'Raphael's Early Work in the National Gallery. Paintings before Rome', in Ashok Roy (ed.), *National*

Gallery Technical Bulletin, National Gallery Company, London 2004, vol. 25, pp. 4–35.

5 See Pierluigi De Vecchi, *Lo sposalizio della Vergine di Raffaello Sanzio*, Tea, Milan 1996. According to this author, Raphael was asked to 'conform as much as possible (*ad modum et figuram*) to Perugino's painting, which was positioned close beside a highly venerated relic', p. 29.

6 Two different iconographies are merged in this painting: the Coronation, which generally shows the Virgin crowned by Christ in Heaven, and the Assumption, which shows an empty tomb surrounded by the amazed apostles. Although there had already been occasional paintings that had combined these two iconographies, it would seem that this new synthesis was conceived by Raphael or by his patrons. This question is discussed by Sylvia Ferino Pagden, 'Iconographic Demands and Artistic Achievements. The Genesis of Three Works by Raphael', in *Raffaello a Roma. Il Convegno del 1983*, Proceedings of the conference held in Rome on 21–28 March 1983, Edizioni dell'Elefante, Rome 1986, p. 13. For a long time the altarpiece was dated to 1503, but new documents have allowed a slightly later dating, at least to 1504; indeed, in stylistic terms, the altarpiece certainly reflects a more mature style. See Donald Cooper, 'Raphael's Altar Pieces in S. Francesco al Prato, Perugia. Patronage, Setting and Function', *Burlington Magazine*, 143, 2001, pp. 554–61.

7 The text of the letter has been passed down by Johannes Burchard, Pope Alexander VI's master of ceremonies: *At the Court of the Borgia, being an Account of the Reign of Pope Alexander VI written by his Master of Ceremonies Johann Burchard*, edited and translated by Geoffrey Parker, The Folio Society, London 1963, pp. 96–7. Many historians have raised doubts regarding the letter's authenticity, not knowing how to explain the informality of such a cynical alliance. However, there seems to be little doubt about the reliability of the documents transcribed by Burchard.

8 The atrocities were recorded by the Tuscan chroniclers. The first episode appears in Agostino Lapini, *Diario fiorentino dal 252 al 1595. Ora per la prima volta pubblicato da Gius. Odoardo Corazzini*, Sansoni, Florence 1900, p. 41, 17 May 1511. The second episode is in Luca Landucci, *Diario fiorentino dal 1450 al 1516. Continuato da un anonimo fino al 1542*, Sansoni, Florence 1883, p. 225, 18 May 1501. Niccolò Machiavelli followed Valentino's exploits very closely and was fascinated by his strong political will, which emerges in the chronicle he wrote, entitled *Descrizione del modo tenuto dal Duca Valentino nello ammazzare Vitellozzo*

Vitelli, Oliverotto da Fermo, el signor Pagolo e il duca di Gravina Orsini. He was writing immediately after the events in the autumn of 1502.

9 Burchard, *At the Court of the Borgia*, p. 194. Even in this case, Catholic historiography has attempted to highlight the unreliability of his account. However, other sources record the extraordinary entertainment laid on for the pope and his *familiari* that evening. See the note in Johannes Burchard, *Alla corte di cinque papi. Diario 1483–1506*, Longanesi, Milan 1988, p. 485: 'at least three other sources confirm these events: the letter to Savelli, also reproduced by Burchard [p. 371], a dispatch to the Florentine ambassador Francesco Pepi, and a letter from Agostino Vespucci to Machiavelli'.

10 Letter from Isabella d'Este to Chiara di Montpensier, her sister-in-law, dated 27 June 1502; the original is printed in Alessandro Luzio and Rodolfo Renier, *Mantova e Urbino. Isabella d'Este ed Elisabetta Gonzaga nelle relazioni famigliari e nelle vicende politiche*, Roux e C., Turin 1893, p. 125. This letter, like an instant photo, captures the devastation wreaked on contemporaries by Valentino's aggression and cruelty, and it does so without the political mediation operated by Niccolò Machiavelli in his famous work.

11 Isabella and Elisabetta, both women who were already renowned throughout Italy for their elegance and intelligence, played a role in these social gatherings, even if their self-assurance and showy clothes and hats provoked criticism among members of the Roman aristocracy, who were not accustomed to such female protagonism or to women who were confident enough of their own strength to describe themselves as 'the liveliest women around in the world'. Luzio and Renier, *Mantova e Urbino*, p. 123.

12 This terrifying description of Alexander Borgia's death appears in Burchard, *At the Court of the Borgia*, p. 221. See also pp. 225–6: 'Later after five o'clock, the body was carried to the Chapel of Santa Maria della Febbre and placed in its coffin next to the wall in a corner by the altar. Six labourers or porters, making blasphemous jokes about the pope or in contempt of his corpse, together with the two master carpenters, performed this task. The carpenters had made the coffin too narrow and short, and so they [. . .] pummelled and pushed it into the coffin with their fists.' All this under the grieving gaze of the young Virgin in whose lap, two years earlier, Michelangelo had laid the marvellous dead Christ.

13 On Julius II, see Ivan Cloulas, *Jules II: Le pape terrible*, Fayard, Paris 1989, and Ludwig von Pastor, *The History of the Popes from the Close of*

the Middle Ages: Drawn from the Secret Archives of the Vatican and Other Original Sources, translated by Frederick Ignatius Antrobus, vol. 6, London 1898, pp. 540ff.

14 The letter, which has been known since the seventeenth century, is reproduced (in Italian) and extensively commented upon by Shearman, *Raphael in Early Modern Sources*, vol. 2, pp. 1457ff. Shearman does not believe that the document is authentic, but it seems to be confirmed by numerous references. See, more recently, Chapman, Henry and Plazzotta, *Raphael*, p. 34.

Notes to Chapter 3

1 This description is given in the manuscript in the Biblioteca Nazionale di Firenze: *Anonimo Gaddiano*, Cod. Magliab. XVII, 17, reproduced in Luca Beltrami, *Documenti e memorie riguardanti la vita e le opere di Leonardo da Vinci*, Treves, Milan 1919, p. 163.

2 The accusation is reproduced in Beltrami, *Documenti e memorie*, p. 4. On the meaning of the colours used in late Renaissance clothing, see Maria Giuseppina Muzzarelli, *Guardaroba medievale, vesti e società dal XIII al XVI secolo*, Il Mulino, Bologna 1999, p. 165. 'Black was a difficult colour to obtain, and the substances that would eventually produce a black tint had to be applied to cloth that had already been dyed using a blue or faun-coloured base. Precisely because of this complicated process, which called for special controls, by the end of the Middle Ages black had become a valuable colour, one that could therefore represent all the pomp of ceremonial clothing. It was not only a colour that served to indicate mourning, but also one that was used when attending the most solemn events. This made it appropriate for feasts, weddings and court life in general. Both on her formal entry into Ferrara and at her marriage to Alfonso I d'Este in 1502, Lucrezia Borgia was dressed in magnificent black and gold garments, and the most illustrious guests also wore black.'

3 Paolo Giovio, *Elogia virorum illustrium*, published by Girolamo Tiraboschi in his *Storia della letteratura italiana*, vol. 9, Modena 1781, p. 290; this English translation is cited from André Chastel, *The Genius of Leonardo da Vinci*, The Orion Press, New York 1961, p. 4.

4 The letter is in Jean Paul Richter, *The Literary Works of Leonardo Da Vinci*, Oxford University Press, London, New York and Toronto 1939, vol. 2, p. 325. The letter is commented upon by Serge Bramly in his book *Leonardo da Vinci: The Artist and the Man*, Mondadori, Milan 2005, p. 143.

5 Letter from Isabella d'Este to Leonardo dated 14 May 1504, reproduced Beltrami, *Documenti e memorie*, p. 90. The English translation is taken from David Alan Brown, Sylvia Ferino Pagden, *Bellini, Giorgione, Titian, and the Renaissance of Venetian Painting*, Yale University Press, 2006, p. 108, where the letter is dated 25 May 1504.

6 The cartoon is now lost, but the one in the National Gallery London is very similar. On the influence that it had on Raphael, see most recently Hugo Chapman, Tom Henry and Carol Plazzotta, *Raphael. From Urbino to Rome*, National Gallery Company, London 2004, p. 34.

7 Pietro de Nuvolaria to Isabella d'Este; letter written in Florence on 4 April 1501, reproduced by Beltrami, *Documenti e memorie*, p. 66.

8 On the competition between Leonardo and Michelangelo, see Antonio Forcellino, *Michelangelo. A Tormented Life*, translated by Allan Cameron, Polity, Cambridge 2009, pp. 93 ff.

9 The episode is reported in Beltrami, *Documenti e memorie*, p. 163; the English translation comes from Robert Wallace, *The World of Leonardo, 1452–1519*, Time Life Library of Art, New York 1966, p. 76.

10 On the Doni family, see *Notizie intorno à ritratti d'Agnolo e Maddalena Doni, dipinti da Raffaello, scritte da varj a Francesco Longrena*, Sonzogno, Milan 1828. An entry on the painting with a complete bibliography can be found in *Raffaello a Firenze. Dipinti e disegni delle collezioni fiorentine*, Electa, Milan 1984, pp. 105 ff.

11 Astorre Baglioni, *I Baglioni*, Olschki, Florence 1964, p. 135, n. 2.

12 Very interesting observations about the painting emerged during the course of the latest restoration, and these are included in *Raffaello a Pitti. 'La Madonna del Baldacchino'. Storia e restauro*, catalogue of the exhibition curated by Marco Chiarini, Marco Ciatti and Serena Padovani, Centro Di, Florence 1991. For reasons of symmetry, the altarpiece was extended by 32 centimetres: on the top part, see *Raffaello a Firenze*, p. 121. On the derivation of the background showing the architecture of the Pantheon, which Raphael studied from contemporary drawings, see Christoph Luitpold Frommel, Stefano Ray and Manfredo Tafuri (eds), *Raffaello architetto*, Electa, Milan 1984, p. 17.

13 In particular, Frommel, in *Raffaello architetto*, p. 17 comments on the vicinity of the arms of the throne to those of the throne of Jupiter Ciampolini, a statue that was much admired and often sketched in Rome at the time.

14 This translation is based on Vilhelm Wanscher, *Raffaello Santi Da Urbino: His Life and Works*, Ernest Benn: London 1926, p. 5 (with integrations

from Shearman). The letter is printed in Italian, with extensive commentary, in John K. G. Shearman, *Raphael in Early Modern Sources (1483–1602)*, 2 vols, Yale University Press, New Haven 2003, vol. 1, pp. 112ff: Raphael in Florence to his uncle Simone Ciarla in Urbino, 21 April 1508. Shearman includes a complete exegesis of the letter over the past centuries. Many have interpreted the request for a recommendation by linking it to the commission of the Great Council Hall in Palazzo Vecchio, Florence, which was left unfinished as a combined result of Michelangelo's planned final departure for Rome and Leonardo's protracted stay in Milan. It is possible that Raphael wished to be part of this commission, but in any case the substance of the letter does not change. On the verge of a major breakthrough, which he hoped would launch his career, Raphael resorted to the age-old form of protection, political patronage, which, as he realised, was crucial to his growing success.

Notes to Chapter 4

1 On the attraction that Raphael felt as soon as he arrived in Rome, see Howard Burns, 'Raffaello e "quell'antica architectura"', in Christoph Luitpold Frommel, Stefano Ray and Manfredo Tafuri (eds), *Raffaello architetto*, Electa, Milan 1984, p. 381.

2 The news reported by Manetti is published in Frommel, Ray and Tafuri, *Raffaello architetto*, p. 397; this English translation appears in Antonio Manetti, *The Life of Brunelleschi*, edited by Howard Saalman, translated by Catherine Enggass, Pennsylvania State University Press, University Park 1971, p. 54 (cited in *Architectural Theory: Vitruvius to 1870*, vol. 1, ed. Harry Francis Mallgrave, 2006, p. 29).

3 The original document is in K. G. Shearman, *Raphael in Early Modern Sources (1483–1602)*, 2 vols, Yale University Press, New Haven 2003, vol. 1, p. 112.

4 Giuliano della Rovere's family history is given in Ivan Cloulas, *Giulio II*, Salerno Editrice, Rome 1993.

5 Michelangelo Buonarroti, *Rime*, Mondadori, Milan 1998, p. 18; the English translation is cited from Christopher Ryan, *The Poetry of Michelangelo: An Introduction*, Fairleigh Dickinson University Press, Madison 1998, p. 46.

6 Virgil, *Aeneid I*, lines 204–5, translated by H. R. Fairclough (Loeb Classical Library, vol. 63). Quoted in Cloulas, *Giulio II*, p. 148.

7 The sonnet is well contextualised in Ottavia Niccoli, *Rinascimento anticlericale*, Laterza, Rome-Bari 2005, p. 83. A sonnet of identical tenor is

quoted by Sanuto in his *Diaries*: '*Julio secondo e' qui/ ritieni el passo / Hebbe la mente a tuorlo in cul si amicha / che morto e chiuso in questo marmo, ficha / Non possendo far altro, il cul al sasso*' ['Julius the second is here, / stay your pace. / He had in mind an egg yolk winking like an arse / dead and encased in this marble; / and, unable to do otherwise, he pressed his arse to the stone', Marino Sanuto, *I diarii*, vol. 15, Deputazione di Storia Patria per le Venezie, Venice 1886, p. 563.

8 The dialogue is reported – in Italian – by Johannes Burckardus, *Alla corte di cinque papi. Diario 1483–1506*, Longanesi, Milan 1988, p. 437.

9 In October 1512 the pope gave a dinner in his apartments in honour of Mattia Lang from Switzerland, during which '[a]n erudite blindman sang in accompaniment to the lyre and improvised in Latin verse in praise of the pope and of Gurgens' [= episcopus Gurgensis = the bishop of Gurck, Girolamo Balbo]. In Alessandro Luzio, 'Federico Gonzaga, ostaggio alla corte di Giulio II', *Archivio della Reale Società Romana di Storia Patria*, vol. 9, Rome 1886, p. 544.

10 Information regarding the technical details of the paintings in the Stanza della Segnatura was provided by the restorer Maurizio De Luca at a lecture given on 3 November 2005 at the Faculty of Arts and Philosophy of the Third University of Rome. De Luca found detailed signs of pouncing on the mouldings where the architectural features were usually transferred using more summary incisions. Early in his career the artist took the greatest possible care to achieve his goal. The technical complexity is the best indication of the artist's intentions. For an innovative interpretation of *The School of Athens*, see Glenn Most, 'Reading Raphael: "The School of Athens" and Its Pre-Text', *Critical Inquiry*, vol. 23 (1996), pp. 145–82. Much less persuasive is the proposed interpretation offered by Giovanni Reale, *La 'Scuola di Atene' di Raffaello. Una interpretazione storico ermeneutica*, Bompiani, Milan 2005. In Reale's erudite exegesis of the painting it is precisely the interpretation of the images that seems extremely arbitrary. This is illustrated by the figure of Apollodorus: Reale sees him threatening Protagoras with his gesture and ordering him to leave – see p. 81: 'As can be clearly seen in the detail reproduced here (pp. 78ff.), the last figure in the group of Socratic philosophers is holding his hand up, gesturing emphatically at the Sophists, as if to say: "Go away!", "Get out!".' But the gesture can easily be read as a polite invitation to return rather than as a threat. On the contrary, for all its erudition, Reale's exegesis appears to confirm the impossibility of making *The School of Athens* fit into any precise programme of meaning

(in this case, the birth and development of Greek thought, painstakingly arranged by school and philosopher) other than the triumph of philosophical thought and the splendour of the court of Julius II. On the cartoon in the Ambrosiana, see Konrad Oberhuber and Lamberto Vitali, *Raffaello: Il cartone per la Scuola di Atene*, Silvana editoriale d'Arte, Milan 1972.

Notes to Chapter 5

1 'The evening of the pope's arrival it started to snow and blow most terribly. Indeed, I had never seen such bad weather in all my life, and it went on forever, and never let up at all [. . .] At all events [the pope] wants to continue with the attacks on both Mirandola and Ferrara, saying: in all this time this bastard the Duke of Urbino had failed to defeat a cheating whore with twenty thousand men': published in Italian by Alessandro Luzio, 'Federico Gonzaga, ostaggio alla corte di Giulio II', *Archivio della Reale Societa Romana di Storia Patria*, vol. 9, Rome 1886, p. 569.

2 Dispatches from the ambassador Hieronimo Lippomanno to the Venetian Senate, 7 January 1511, in Marino Sanuto, *I diarii*, vol. 11, Deputazione di Storia Patria per le Venezie, Venice 1884, p. 724 and in Ivan Cloulas, *Giulio II*, Salerno Editrice, Rome, 1993, p. 197.

3 The dating of the Stanza of Heliodorus is mainly based on the fact that, in the *Decretals* (the panel with which the adjoining Stanza della Segnatura ends), Julius II is shown with a beard and therefore the painting must be later than autumn 1511; therefore Raphael could only have started work on the adjoining room after this date. This is further confirmed by an inscription under the window below the *Mass of Bolsena*, which bears the date of 1512, 'the ninth year' of Julius' pontificate: 'Iulius. II. Ligur. Pont. Max. Ann Christ M.D.XII Pontificat. Sui VIIII.' See John K. G. Shearman, *Raphael in Early Modern Sources (1483–1602)*, 2 vols, Yale University Press, New Haven 2003, vol. 1, p. 162.

4 The sermon is commented on by Cloulas, *Giulio II*, p. 230.

5 Marino Sanuto, *I diarii*, vol. 16, Deputazione di Storia Patria per le Venezie, Venice 1886, p. 161: '*hordine di la incoronatione fu fata a Papa Leone decimo a Roma a di 11 April 1513*' ['the order of incoronation was made for Pope Leo X at Rome on 11 April 1513']. Leo X's guard of honour cannot have been very different from Julius II's. Many scholars, including Oberhuber, have affirmed, without much evidence, that these men can be identified as the Swiss Guards, although at this period their uniforms were much more modest and they had not yet attained such a

prominent function as they would later. This is confirmed by Sanuto's description, ibid., p. 162: '*La guardia di sguizari* [= *svizzeri*] *vestita a la livrea dil Papa*' ['The Swiss guard dressed in the pope's livery']. This livery was very different from the luxurious garments worn by the men in the foreground; moreover, it was not as garish and each uniform would have been identical, while the men in the foreground wear completely different colours among themselves.

6 On the *Pax romana* that followed the pope's recovery, see Manfredo Tafuri, 'Roma Instaurata', in Christoph Luitpold Frommel, Stefano Ray and Manfredo Tafuri (eds), *Raffaello architetto*, Electa, Milan 1984, p. 70.

7 Marino Sanuto, *I diarii*, vol. 15, Deputazione di Storia Patria per le Venezie, Venice 1886, p. 503: Dispatch of 16 January 1513.

8 Ibid., p. 531: Letter from the Venetian orator Foscari, dated 28 February.

9 Luzio, 'Federico Gonzaga', p. 578.

10 'In this way she will be adorned with good manners; she will perform with surpassing grace the bodily exercises that are proper to women; her discourse will be fluent and most prudent, virtuous and pleasant [. . .] worthy of being considered the equal of this great Courtier, both in qualities of mind and of body.' Baldassarre Castiglione, *The Book of the Courtier, Third Book*, translated by Charles S. Singleton, Norton, New York 2002, p. 153.

11 The sonnets are in Shearman, *Raphael in Early Modern Sources*, vol. 1, p. 131. They are annotated on preparatory drawings for the *Disputa* and are therefore dated by Shearman to 1509, the year when the fresco was painted. In my opinion they should bear a later date, because they could only be written on the drawings when these were no longer in use; only then would the paper have been used by Raphael for other purposes. This translation is by Jennifer Craven, '*Ut pictura poesis*: A new reading of Raphael's portrait of *La Fornarina* as a Petrarchan allegory of painting, fame and desire', *Word and Image* 10, 1994, pp. 371–94.

12 A detailed account of these festivities is given by Luzio, 'Federico Gonzaga', pp. 557ff.

13 The most recent studies on Agostino and his immense wealth are in Ingrid D. Rowland, *The Correspondence of Agostino Chigi (1466–1520), in Cod. Chigi, R. V. C.*, Biblioteca apostolica vaticana, Città del Vaticano 2001; see p. 2: 'he reputedly became the richest man of the continent'.

14 In a memorable study of 1934, Fritz Saxl analysed the horoscope painted by Peruzzi at the Farnesina and used it to calculate the banker's date of birth, which he supposed to have occurred some time between late

November and early December 1466. Years later Chigi's birth certificate was found, and it confirmed Saxl's hypothesis and the interpretation provided by the astrologer who helped him: Fritz Saxl, *La fede astrologica di Agostino Chigi. Interpretazione del dipinto di Baldassarre Peruzzi nella sala di Galatea della Farnesina*, Reale Accademia d'Italia, Rome 1934.

15 Giuseppe Cugnoni, *Agostino Chigi il Magnifico*, Forzani e C., Rome 1881, p. 112. The list of property was registered in May 1496: '*In castro Bracchiani in Palatio Illustris domini Virgini*' ['In the fortress of Bracciano, in the palace of our distinguished lord Virginio [Orsini]'] etc.

16 The relationship between Agostino and Raphael is explored by Frommel in his work on the Villa della Farnesina: Christoph Luitpold Frommel, *La villa Farnesina a Roma*, Franco Cosimo Panini, Modena 2003. On the dating of the paintings, see also Konrad Oberhuber, *Raphael: The Paintings*, Prestel, Munich, London and New York, 1999, p. 138: 'Vasari said that the frescos were painted before the Sistine ceiling was unveiled but after Raphael had seen the Florentine's fresco and thus changed his style. He therefore implies a date before August 1511, when the ceiling's first half was uncovered, as we have seen.' This date is uncertain, like all those based on stylistic comparisons. Nonetheless, that Chigi and Raphael were in contact by late 1510 is proved by the contract to design the bronze tondi, as reported and amply commented upon in Shearman, *Raphael in Early Modern Sources*, vol. 1, pp. 143ff. '*Die X a novembris 1510* [. . .] *Magister Cesarinus Francisci de Perusio aurifex in Urbe, in regione Pontis, confessus fuit habuisse a domino Augustino Chisio mercatore Senensi* [. . .] *secundum ordinem et formam eidem dandam per magistrum Raphaelem Johannis Sancti de Urbino pictorem*' ('10 November 1510 [. . .] Master Cesarino, son of Francesco from Perugia, goldsmith in Rome, Regione Ponte, has confessed to having received from signor Agostino Chigi, merchant from Siena [. . .] in conformity with the structure and shape to be given to it by master Raphael, son of Giovanni Santi, painter from Urbino').

17 The marriage contract, which also contains a description of the solemn ceremony held in Agostino's house on 18 August 1519, clearly highlights the unprecedented triumph of the Venetian girl who had bewitched Agostino. It is reproduced in Ottorino Montenovesi, 'Agostino Chigi, banchiere e appaltatore dell'allume di Tolfa', in *Archivio della Reale Societa Romana di Storia Patria*, 60, Rome 1937, pp. 107–47; the key document for an understanding of this love affair appears at p. 122: '*Cum sit quod magnificus vir dominus Augustinus Chisius, patritius Senensis, ut*

asseruit, dominam Franciscam Ardeaceam, venetam, tunc puellam, virginem, et solutam, egregia forma insignique pudicitia, ac multis animi dotibus conspicuam, ad domum suam traduxerit ac secum illam per septem annos et ultra affectione coniugali retinuerit, et ex ea sobolem procreaverit; nunc autem intendat de cetero idem dominus Augustinus similiter solutus cum eadem domina Francisca canonice vivere, ac sue et ipsius Francisce animarum saluti matrimonii consulere, ad hoc a prefato Sanctissimo Domino Nostro, cui admodum gratus existit, paterne et salubriter sepius exortatus; id circo tam Augustinus quam Francisca prefati, anno, indictione, die, mense, et pontificatu quibus supra, coram prelibato Sanctissimo Domino Nostro [. . .] ac interrogati a prefato Sanctissimo Domino Nostro, Augustinus videlicet an vellet Franciscam in legittimum maritum suum [. . .]. Ipseque Augustinus in signum veri et legittimi matrimonii inter eum et ipsam Franciscam contracti, certum annulum aureum, cum gemma annulo inclusa, eidem Francisce in digito annulari manus sinistre immisit, ipsaque Francisca eundem annulum in signum matrimonii huiusmodi honeste et reverenter ab eodem Augustino recepit, ac prefatus Sanctissimus Dominus Noster subiunxit hec verba, videlicet: quos Deus coniunxit homo non separat. Post que idem Augustinus summam trium millium ducatorum [. . .] in dotem dedit [. . .]. Et in signum divine et humane societatis, Augustinus et Francisca predicti ad invicem dexteram dextere iniunxerunt; et osculantes pedibus Sanctissimi Domini Nostri, actum hunc solemnem et legittimum fore motu proprio et ex certa scientia declarantis, ab eodem benedictionem suam, cum ea qua decuit reverentia et humilitate, receperunt. Pro quibus trium millium ducatorum in dotem datione [. . .]. Acta fuerunt hec Rome, in dicta domo prefati domini Augustini, sita in regione Transtiberim, ad portam Septimanam, in quadam camera prope logiam dicte domus, presentibus ibidem rev.mis in Christo patribus et dominis Bonifacio, Tituli Sanctorum Nerei et Achillei.' ['And so it happened that, by his own declaration, Agostino Chigi, that great man and lord, patrician from Siena, took to his house a certain signora Francesca Ordeaschi from Veneto, she was just a girl at the time, virginal and independent, of exquisite beauty and great modesty, and she was endowed with many blessings of the soul. He kept her lovingly, like a spouse, for more than seven years, and had progeny from her. Now, being of a similar mind in all other respects, signor Agostino intends to live canonically with signora Francesca and to take [the vow of] marriage: he was often prompted to do this, in a fatherly and healthy spirit, by Our Holy Father, to whom he is already indebted. Therefore both Agostino and Francesca were told in advance as to the year, the [15-year] period, the day, the month, and the pope in function

[. . .] before Our Holy Father and they were asked by Our Holy Father whether Agostino would take Francesca to be his legitimate wife [. . .] And Agostino put on the fourth finger of her left hand a ring of solid gold with a precious stone encased in the ring, as the symbol of the true and legitimate marriage contracted between himself and Francesca; and Francesca received this ring from Agostino in good faith and respectfully, as a sign of such marriage; and Our Holy Father said over them the following words: What God unites, man cannot separate. After this, Agostino gave the sum of 3,000 ducats [. . .] as dowry [. . .]. One after another, as instructed beforehand, Agostino and Francesca picked up each other's right hand with their own right hand, in sign of divine and human companionship; and, kissing [each other] at the feet of Our Holy Father – who proclaimed, with firm knowledge, that their action would now be consecrated and legitimate just by itself – they received his benediction with due respect and humbleness. The offer of a dowry of 3,000 ducats in return for these [. . .]. These events took place in Rome, in the house of signor Agostino, which is situated in Trastevere, by the Porta Settimiana, in a room that was close to the loggia of the said house, in the presence of reverend Christian priests and lords [and] of Bonifacius, [titular] from the church of Santi Nereo e Achilleo.']

The fact that Agostino and Francesca were living together at the Farnesina from the summer of 1512, as is highlighted in the document, is also borne out by a letter of 21 November 1512 from the archdeacon of Gabbioneta, who declared that the marriage negotiations had fallen through some time previously: '*che essendo in la eta de XLV anni et piu, era risoluto che havendo a pigliar donna la dovesse pigliare per consolatione commune, et non perche una de le parte fosse malcontenta*' ['that, being over 45 years of age, he resolved that, if he had to take a wife anyway, he should do it in such a manner that each party would find equal support in the other, and not so that one would be left wanting'] (Luzio, 'Federico Gonzaga', p. 531). Because Blosio Palladio's panegyric of January 1512 makes no mention either of *Galatea* or of the lunettes of Sebastiano del Piombo, which were painted after that date, the painting of *Galatea* can certainly be dated at least to the early summer of 1512, when Agostino decided to break off marriage negotiations with Margherita. The close stylistic and physiognomical parallels between the nude of the nymph to the right of Galatea and St Barbara in the *Sistine Madonna* argue for a later dating of the fresco, moving it to the end of 1512 or the middle of 1513. For a reliable dating of the *Sistine Madonna*, see Jürg Meyer zur

Capellen, *Raphael: A Critical Catalogue of His Paintings*, Arcos, Landshut 2005, vol. 2, pp. 107ff. For a different date and interpretation of the painting, see Frommel, *Villa Farnesina*, who dates it to the autumn–winter of 1511/12 and links it to the planned marriage to Margherita Gonzaga. The two poems in praise of the Farnesina are the 1510 one of Egidio Gallo and the one of Blosio Palladio, printed in January 1512; however, neither mentions the painting of Galatea. On Egidio Gallo, see Mary Quinlan McGrath, 'Aegidius Gallus, De Viridario Augustini Chigii vera libellus', *Humanistica Lovaniensa*, 38, 1989, pp. 1–99; on Blosio, see the same author's 'Blosius Palladius, Suburbanum Augusti Chigii', *Humanistica Lovaniensa*, 39, 1990, pp. 93–156.

18 The letter is in Luzio, 'Federico Gonzaga', p. 530.

19 Marino Sanuto, *I diarii*, vol. 28, Deputazione di Storia Patria per le Venezie Venice 1890, p. 350: '*Et per el fiume li vene incontra do delphini, che erano do batelli coperti in forma de diti delphini, et sopra de uno li stava el dio Netuno cum el tridente in mano*' ['And two dolphins were swimming across the river towards them: these were in fact two covered ships made in the shape of dolphins, and above one of them stood the god Neptune with the trident in his hand']. It is possible that Chigi saw one of these contraptions during his stay in Venice; this might explain the presence of the wooden paddle on the side of the shell.

20 Luzio, 'Federico Gonzaga', p. 556.

21 Reported in Cloulas, *Giulio II*, p. 290.

Notes to Chapter 6

1 Marino Sanuto, *I diarii*, vol. 15, Deputazione di Storia Patria per le Venezie, Venice 1886, p. 29. The account given by the Prato exiles was very different, as appears from the documents collected in the excellent study by Jacopo Modesti, 'Il miserando Sacco dato alla terra di Prato dagli Spagnoli', in *Archivio Storico Italiano* (1842–1941), Vieusseux, Florence 1842, vol. 1, pp. 241ff.

2 This is the meaning of a passage in Sanuto's *Diarii*, p. 9, for September 1512: '*poi a dito a l'orator nostro, non li piaceria che Medici intrasse in Fiorenza col favor di spagnoli, e che i havesseno tanti denari, perche Medici li hanno promesso ducati 50 mila*' ['then [the pope] told our orator that he did not like the idea of [Cardinal Giovanni de'] Medici entering Florence with Spanish support, and of [the Spanish] having so much money, because the Medici had promised them 50,000 ducats']. It is not clear whether the money promised to the Spanish was then pocketed by

the pope, but undoubtedly the Medici were ready to pay whatever was necessary to regain control over Florence.

3 On the festivities held for Leo X's coronation the richest source is Marino Sanuto, *I diarii*, vol. 16, Deputazione di Storia Patria per le Venezie, Venice 1886, p. 158, letter of 12 April 1513: '*Scrive la incorona-tion fata ozi a San Janni coperte le strade di Roma, fato molti archi triunfali, coperto il ponte di Sant'Anzolo. É sta fata gran spesa per cardinali e fioren-tini di vestir, e sta speso in questa coronation da ducati 150 milia.*' ['He [= Sanuto] records that the coronation was made today at San G[iov]anni [in Laterano]; the streets of Rome were covered; many triumphal arches were raised; the bridge of Sant'Anzolo [Angelo] was covered. The cardi-nals and the Florentines are spending vast amounts of money on clothes; 150,000 ducats are being spent on this coronation.']

4 On the banquet, see Fabrizio Cruciani, *Il teatro del Campidoglio e le feste Romane del 1513*, Il Polifilo, Rome 1968.

5 Ibid., pp. 41ff.

6 Ibid., p. 42: '*VIII piatti con VIII gran pastelli dorati, fatti in forma di palle, pieni di cunigli vivi tanto mansueti et domestici che alcuni (aperte che furono le palle) non se partivano della tavola, ma, saltellando sopra essa, se pascevano di quelle cose che piu al suo gusto dillettavano*'['Eight dishes with eight large gilded pastries, made in the form of balls, filled with live rabbits that were so gentle and tame that some (once the balls had been opened) did not run off the table, but instead hopped along it and nibbled at the things that they liked best'], and p. 43: '*VIII gran piatti pieni di botticelli dorati et depinti con arme di Nostro Signore et de Romani, pieni di pere guaste*' ['Eight large dishes filled with small gilded barrels painted with the arms of Our Holy Father and the Romans, filled with over-ripe pears matured in wine']. The allusion was to the balls on the Medici emblem.

7 Ibid., p. 55.

8 Alessandro Luzio, 'Federico Gonzaga, ostaggio alla corte di Giulio II', *Archivio della Reale Societa Romana di Storia Patria*, vol. 9, Rome 1886, p. 549; entry for 19 February 1513. Raphael's grief for his protector's death was sincere and profound, especially if it passed the scrutiny of such a practised gossip as Isabella d'Este's ambassador in Rome: he was always on the ball, ready to pick up any tidbits of scandal in order to amuse his patron – and she was even more avid for rumours and slander than he was.

9 Raphael's involvement in architecture was recently analysed in the excel-lent studies included in Christoph Luitpold Frommel, Stefano Ray and Manfredo Tafuri (eds), *Raffaello architetto*, Electa, Milan 1984.

10 John K. G. Shearman, *Raphael in Early Modern Sources (1483–1602)*, 2 vols, Yale University Press, New Haven 2003, vol. 1, p. 180: Raphael to his uncle Simone Ciarla, 1 July 1514 (in Italian).

11 Giorgio Vasari, *Le vite*, 1550, p. 992. The whole life of Raphael from the 1550/1 edition of Vasari is reproduced by Shearman in *Raphael in Early Modern Sources*, vol. 2, pp. 972–97.

12 See Simone Fornari's commentary, produced in 1549–50, on Ludovico Ariosto's *Orlando furioso*: '*Ultimatamente, per continovare fuor di modo i suoi amori, se ne morì in età di 37 anni l'istesso dì che nacque*' ['In the end, by continuing his love affairs to excess, he died at the age of 37, on the very day of his birth']. Cited by Shearman, *Raphael in Early Modern Sources*, vol. 2, p. 968.

13 See Lorenza Mochi Onori's reconstruction of the story of the painting and of its legend in *Raffaello. La Fornarina*, Edizioni De Luca, Rome 2000, pp. 11ff.

14 From the Botti collection the painting then passed to the grand ducal collections, and it can be identified with reasonable certainty as the painting now exhibited at the Galleria Palatina. On the portrait, its story and identification, see *Raffaello a Firenze. Dipinti e disegni delle collezioni fiorentine*, Electa, Milan 1984, pp. 174ff.

15 For stylistic reasons, the painting can be dated around 1514–15, coming between the portraits of Inghirami and Julius II and that of Bibbiena, which certainly dates from around 1516.

16 In *Raffaello a Firenze*, p. 267: 'The x-ray image of the mantle differs from what meets the naked eye. White stripes can be seen that do not correspond with the sleeves and the mantle; these are signs that the folds, and possibly even the left arm itself, were positioned differently.'

17 The passage cited in the text appears in the letter of 12 February 1512 sent from Rome to Isabella d'Este in Mantua, in Luzio, 'Federico Gonzaga', p. 534. '*Grandissima quantita di cortesane li andorno e pompe assai, e assai vestite da homni chi in su mule, chi su cavalli; et me par* [. . .]' ['Large numbers of courtesans went there in considerable pomp, many dressed as men, some riding on mules, others on horses; and I believe [. . .]']. The 'chaste' interpretation of the painting is instead taken from *Raffaello a Firenze*, p. 174: 'Basing his interpretation on a detailed and precise iconographical analysis, Oberhuber recently affirmed that the sumptuous garments – which are certainly not those of an ordinary woman – the veil reserved for a matron, a married woman who has borne a child, and even the gesture of the hand placed on the heart, typical

of a betrothed or a faithful wife, rule out any possibility that the sitter for the Pitti portrait is the same as the *Fornarina*.' The passage sounds particularly ironic when compared to the sixteenth-century evidence. In view of the private nature of the painting, which is a token of profound and loving devotion, we can presume that Raphael would have felt free to celebrate his lover as he wished.

One iconographic detail helps us to understand another worrying detail of Raphael's work, namely that the same Roman-style turban headdress is worn by the naked *Fornarina* and by the ecstatic *Madonna della seggiola*. But Raphael's modern censors are even more embarrassed by the fact that the *Velata* closely resembles the *Sistine Madonna*. Raphael's love for women was not constrained by moral categories. The erotic attraction he felt for his model provided the urge that enabled him to create a portrait of such fascination, even in the *Sistine Madonna*. His creative process cannot be trammelled into moral or, worse still, theological categories.

18 Ottavia Niccoli, *Rinascimento anticlericale*, Laterza, Rome–Bari 2005, pp. 88ff. Erasmus' bitterly critical view of Leonine Rome was thought for many years to have contributed to Luther's outburst.

19 Ibid., p. 97.

20 Ibid., p. 92. Even if it was exaggerated, this flurry of antipapal satire reflected the widespread perception, in Rome and elsewhere in Italy, of Leo X as a hedonistic pope, one who focused exclusively on the splendour of his temporal kingdom – so much so that Pietro Aretino, who spent these years in Rome, described him as the 'inventor of papal grandeur'.

21 Ibid., p. 94.

22 Francesco Guicciardini, *The History of Italy*, translated by Sidney Alexander, Princeton University Press, 1984, pp. 319–21. See also p. 328: 'A Prince in whom were many things worthy of praise and great blame; one who had greatly failed to fulfill the expectations that had been aroused at his assumption to the pontificate, since he governed with more prudence but much less goodness than everyone had foreseen.'

23 Shearman, *Raphael in Early Modern Sources*, vol. 1, p. 366.

24 Ibid., p. 367.

Notes to Chapter 7

1 Konrad Oberhuber, *Raphael. The Paintings*, Prestel, Munich and London 1999, p. 143, dates it one year earlier, also on purely stylistic grounds: 'This grand, new Michelangelesque style can be found even in the

intimate Madonnas that Raphael must have painted in the time of 1513 to 1514.' Still essential for an understanding of the painting is Ernst H. Gombrich's excellent essay 'Raphael's Madonna della Sedie', in his *Norm and Form. Studies in the Art of the Renaissance*, Phaidon, London 1966. Jürg Meyer zur Capellen, *Raphael: A Critical Catalogue of His Paintings*, vol. 2, Arcos, Landshut 2005, p. 137, also dates it to 1514, and on good grounds.

2 Oberhuber, *Raphael*, p. 212.

3 Christoph Luitpold Frommel, Stefano Ray and Manfredo Tafuri (eds), *Raffaello architetto*, Electa, Milan 1984, p. 241.

4 John K. G. Shearman, *Raphael in Early Modern Sources (1483–1602)*, 2 vols, Yale University Press, New Haven 2003, vol. 1, p. 735; this English translation is taken from Julia Cartwright, *Baldassare Castiglione: The Perfect Courtier, His Life and Letters 1478–1529*, John Murray, London 1927, p. 389.

5 Cartwright, *Baldassare Castiglione*, p. 397. Raphael adds his own holograph technical notes to the manuscript: see *Vitruvio e Raffaello: il 'De Architectura' di Vitruvio nella traduzione inedita di Fabio Calvo ravennate*, edited by Vincenzo Fontana and Paolo Morachiello, Officina, Rome 1975. For a comment on Raphael's interest in antique artistic techniques, see Antonio Forcellino and Elisabetta Pallottino, 'La materia e il colore nell'architettura romana tra Cinquecento e Neocinquecento', *Ricerche di Storia dell'Arte*, 41 2, 1991, p. 12.

6 Shearman, *Raphael in Early Modern Sources*, vol. 1, p. 512. The source of this English translation is Vaughan Hart and Peter Hicks, *Palladio's Rome. A Translation of Andrea Palladio's Two Guidebooks to Rome*, Yale University Press, New Haven and London 2006, pp. 177 92 (at p. 182). On the genesis of this letter, see also the excellent chapter by Christof Thoenes in *Raffaello a Roma. Il Convegno del 1983*, Edizioni dell'Elefante, Rome 1986, pp. 373–81.

7 Shearman, *Raphael in Early Modern Sources*, vol. 1, p. 510; this English translation is again from Hart and Hicks, *Palladio's Rome*, p. 180. On the progress of technical research in Raphael's Rome, see Forcellino and Pallottino, 'La materia e il colore'.

8 On the building that started Rome's architectural Renaissance, see James S. Ackerman, *The Cortile del Belvedere*, Biblioteca Apostolica Vaticana, Città del Vaticano 1954, and Antonio Forcellino, 'Le fabbriche cinquecentesche di Roma: note sulle finiture esterne', *Ricerche di Storia dell'Arte*, 27, 1986, pp. 81–93.

9 Michelangelo wanted to use stucco for the ceiling of the new sacristy in San Lorenzo, Florence. The letter is in *Il carteggio di Michelangelo*, 5 vols, posthumous edition by Giovanni Poggi, revised by Paola Barocchi, Renzo Ristori, SPES-Sansoni, Florence 1965–83, vol. 3 (1973), p. 35, and it is very important for the history of artistic techniques during the Renaissance. It proves that Raphael did indeed give an extraordinary boost to contemporary artistic research, in order to acquire the means – not only technical – for competing with antiquity. The outcome of this research was highlighted by his disciples, who continued Raphael's project, in particular Giulio Romano at Mantua. See Antonio Forcellino, *I rivestimenti superficiali nelle fabbriche di Giulio*, in Ernst H. Gombrich, Manfredo Tafuri, Sylvia Ferino Pagden, Christoph Luitpold Frommel, Konrad Oberhuber, Amedeo Belluzzi, Kurt Forster and Howard Burns (eds), *Giulio Romano*, Electa, Milan 1989, p. 305.

10 Frommel, Ray and Tafuri, *Raffaello architetto*, p. 368. An in-depth study of Bibbiena's *stufetta* can be found in Heikki Holme, 'La stufetta del Cardinale Bibbiena e l'iconografia dei suoi principali', in *Quando gli Dei si spogliano. Il bagno di Clemente VII a Castel Sant'Angelo e le altre stufe romane del primo Cinquecento*, exhibition catalogue edited by Bruno Contardi and Henrik Lilius, Romana società editrice, Rome 1984.

11 David S. Chambers, 'Spas in the Italian Renaissance', in his *Individuals and Institutions in Renaissance Italy*, Ashgate Variorum, Aldershot – Brookfield, USA 1998: Article XI, p. 27, n. 111 (cited in Italian). The erotic freedom that runs through this letter is a pervasive trait of the entire Italian Renaissance, at least until the Council of Trent. The recipient of this letter, Francesco Gonzaga, was renowned among his contemporaries for his lack of inhibition; he was seen in the company of men and women from whatever social background, provided they were willing to indulge in purely carnal pleasures.

12 Pier Nicola Pagliara in Frommel, Ray and Tafuri, *Raffaello architetto*, pp. 197ff.

Notes to Chapter 8

1 John K. G. Shearman, *Raphael in Early Modern Sources (1483–1602)*, 2 vols, Yale University Press, New Haven 2003, vol. 1, p. 203.

2 Ibid., p. 477: original letter from Alfonso d'Este in Ferrara to Alfonso Paolucci in Rome, 10 September 1519. The complexities of the matter that set the duke of Ferrara against the great artist from Urbino were revealed in a memorable study by Giuseppe Campori, 'Notizie inedite

di Raffaello da Urbino tratte da documenti dell'Archivio Palatino di Modena', in *Atti e memorie delle Deputazioni di Storia Patria per le Provincie Modenesi e Parmensi*, Vincenzi, Modena 1863, vol. 1, pp. 111–47.

3 Shearman, *Raphael in Early Modern Sources*, vol. 1, p. 379. Letter from Alfonso d'Este in Paris to his secretary Remo Obizzone in Ferrara, 29 December 1518.

4 In Domenico Laurenza, *Leonardo nella Roma di Leone X (c. 1513–16)*, Giunti, Florence 2004, p. 17, n. 62. Laurenza's perspicacious work raises for the first time key questions on the real relationship between science, art and philosophy during the High Renaissance in Rome. Relations between Leonardo and Raphael in those years spanned a much broader sphere than the purely artistic, an aspect that art historians have hardly ever explored seriously. It was a time when both men, albeit in different ways, were moving beyond the intellectual and social constraints imposed on artists in earlier centuries. The force of the attraction that Leonardo exerted on Raphael throughout his life is still far from being fully understood, unlike the decidedly overstated influence that, according to the Vasarian legend, Michelangelo had on Raphael. However, Giorgio Vasari was no longer in a position to grasp the scope of Leonardo's and Raphael's movements, constrained as he was by the repressive Counter-Reformation atmosphere to limit himself to considerations of 'stylistic manner', which simplified – in fact impoverished – the explosive effect of those earlier decades of artistic research.

5 Shearman, *Raphael in Early Modern Sources*, vol. 1, p. 238. Letter written by Pietro Bembo in Rome to Cardinal Bernardo Bibbiena in Fiesole, on 3 April 1516. This translation appears in Eugène Muntz, *Raphael: His Life, Works and Times*, translated by Walter Armstrong, Chapman & Hall, London 1882, p. 331.

6 Ibid., vol. 1, pp. 240–1. Letter from Pietro Bembo in Rome to Cardinal Bernardo Dovizi from Bibbiena in Rubiera, on 19 April 1516.

7 An imposing icon depicting the *Transfiguration*, painted in 1395 and originally housed in the Church of the Transfiguration, Podgorica, near Rostov Veliky, shows the psychological anguish provoked by the event. It was exhibited at the Guggenheim Museum in New York; see *Russia!* – exhibition catalogue edited by Gerold Vzdornov, Sergei Androsov et al., Guggenheim Museum Publications, New York 2005, p. 5.

8 Sebastiano del Piombo in Rome to Michelangelo in Florence, 2 July 1518, in *Il carteggio di Michelangelo*, 5 vols, posthumous edition by

Giovanni Poggi, revised by Paola Barocchi, Renzo Ristori, SPES-Sansoni, Florence 1965–83, vol. 2 (1967), p. 32.

9 Letter from Bembo to Cardinal Bibbiena, 19 April 1516.

10 Shearman, *Raphael in Early Modern Sources*, vol. 1, p. 478. Letter from Alfonso Paolucci in Rome to Alfonso d'Este in Ferrara, 12 September 1519.

11 *Il carteggio di Michelangelo*, vol. 2 (1976). Letter from Leonardo Sellaio in Rome to Michelangelo in Florence, 1 January 1519, p. 138.

12 The letter is included, together with extensive annotations, in Christoph Luitpold Frommel, Stefano Ray and Manfredo Tafuri (eds), *Raffaello architetto*, Electa, Milan 1984, pp. 324ff.; the English translation is from Roger Jones and Nicholas Penny, *Raphael*, Yale University Press, New Haven and London 1983, Appendix 1, p. 247.

13 Frommel, Ray and Tafuri, *Raffaello architetto*, p. 326; English translation, Jones and Penny, *Raphael*, p. 248.

14 On the projects completed between 1519 and 1520 by Raphael for his own house in Via Giulia, see Luigi Spezzaferro, 'La casa di Raffaello', in Luigi Salerno, Luigi Spezzaferro and Manfredo Tafuri (eds), *Via Giulia, Un'utopia urbanistica del 500*, Staderini, Roma 1973, pp. 265ff., and Manfredo Tafuri, *Ricerca del Rinascimento*, Einaudi, Torino 1992, pp. 308ff.

15 Ludovico Dolce, *Dialogo della pittura intitolato l'Aretino*, Venice 1557, in Shearman, *Raphael in Early Modern Sources*, vol. 2, p. 1062.

16 Shearman, *Raphael in Early Modern Sources*, vol. 1, p. 439. Letter from Alfonso Paolucci in Rome to Alfonso d'Este in Ferrara, 2 March 1519.

17 Ibid., p. 441.

18 Ibid., p. 459. Letter from Baldassarre Castiglione in Rome to Isabella d'Este in Mantua, 16 June 1519. This translation is taken from Julia Cartwright, *Baldassare Castiglione: The Perfect Courtier, His Life and Letters 1478–1529*, p. 54.

19 This is Paris de' Grassis' diary entry for 26 December 1519; see Shearman, *Raphael in Early Modern Sources*, vol. 1, p. 490. '*In die Sancti Stefani fuit missa papalis solita in Capella, presente Papa cum cardinalibus 30. Eam missam cantavit Cardinalis de Valle, licet non satis bene. Hodie papa jussit appendi suos pannos da Rassia novos, pulcherimos et pretiosos, de quibus tota capella stupefacta est in aspectu illorum, qui, ut fuit universale juditium, sunt res qua non est aliquid in orbe nunc pulchrius; et unumquodque petium est valoris II milium ducatorum auri in auro.*' ['On St Stephen's day it was the custom to have the pope's mass in chapel; in attendance were the

pope himself and 30 cardinals. That mass was sung by Cardinal de Valle, and not well enough, let it be said. Today the pope ordered to hang his exquisitely beautiful and precious new tapestries [*panni/pezzi di/da (A) razzo/i*], and the entire chapel was amazed by their look: the universal judgement was that these are things such that nothing in the world can surpass them in beauty; and each one was equated to the value of 2,000 gold ducats in gold.']

20 From Marcantonio Michiel's diary, dated 27 December 1519; reported in Shearman, *Raphael in Early Modern Sources*, vol. 1, p. 491. '*Queste feste di Natale il Papa mese fuori in Capella 7 pezzi di razzo, perché l'ottavo non era fornito, fatti in Ponente, che furono giudicati la più bella cosa che sia stata fatta in eo genere a' nostri giorni* [. . .]. *Il disegno de' ditti razzi del Papa furono fatti da Raffaello da Urbino pittore eccellente, per li quail el ne hebbe dal Papa ducati 100 per uno, e la seda et oro, de li quali sono abundantissimi, e la fattura costorono 1500 duchati el pezzo, si che costavano in tutto, come il Papa istesso disse, duchati 1600 il pezzo, per benché si giudicasse e divulgasse valer duchati 2000.*' ['For the Christmas festivities the pope had seven tapestries displayed in the chapel because the eighth had not arrived. Made in the West, they were deemed to be the most beautiful accomplishment of their kind today [. . .]. The said tapestries were designed by Raphael of Urbino, the excellent painter, who was paid 100 ducats for each by the pope; the silk and gold, which abound, and the making of the tapestries cost 1,500 ducats for each. In all, as the pope himself said, each piece cost 1,600 ducats, although it is thought – and the rumour has spread it – that they are worth 2,000 ducats.'] The diarist's political insight did not prevent him from including a detailed account of the cost of these artworks.

21 Letter from Sebastiano del Piombo in Rome to Michelangelo in Florence, 29 December 1519; in Shearman, *Raphael in Early Modern Sources*, vol. 1, p. 493.

INDEX